JOURNEY *to the* MAGHREB
and ANDALUSIA, 1832

JOURNEY TO THE

MAGHREB

AND ANDALUSIA,

1832

THE TRAVEL NOTEBOOKS AND OTHER WRITINGS

· · · · · · · ·

EUGÈNE DELACROIX

Translated by Michèle Hannoosh

THE PENNSYLVANIA STATE UNIVERSITY PRESS

UNIVERSITY PARK, PENNSYLVANIA

Library of Congress Cataloging-in-Publication Data

Names: Delacroix, Eugène, 1798–1863, author. |
Hannoosh, Michèle, 1954– translator.
Title: Journey to the Maghreb and Andalusia, 1832 :
the travel notebooks and other writings / Eugène
Delacroix ; translated by Michèle Hannoosh.
Description: University Park, Pennsylvania :
The Pennsylvania State University Press, [2019] |
Includes bibliographical references and index.
Summary: "A comprehensive, annotated English
translation of Eugène Delacroix's most significant
writings during his travels in Morocco, Algeria, and
southern Spain, recording his observations of places,
people, costume, landscapes, and architecture"—
Provided by publisher.
Identifiers: LCCN 2019004818 |
ISBN 9780271083346 (pbk : alk. paper)
Subjects: LCSH: Delacroix, Eugène, 1798–1863—
Travel—Morocco. | Delacroix, Eugène, 1798–1863—
Travel—Algeria. | Delacroix,
Eugène, 1798–1863—Travel—Spain—Andalusia. |
Morocco—Description and travel. | Algeria—
Description and travel. | Andalusia (Spain)—
Description and travel.
Classification: LCC DT309.D45 D45213 2019 |
DDC 916.404/3092—dc23
LC record available at https://lccn.loc.gov/2019004818

Published by The Pennsylvania State University Press,
University Park, PA 16802–1003

The Pennsylvania State University Press
is a member of the Association
of University Presses.

It is the policy of The Pennsylvania State University
Press to use acid-free paper. Publications on uncoated
stock satisfy the minimum requirements of American
National Standard for Information Sciences—
Permanence of Paper for Printed Library Material,
ANSI Z39.48–1992.

·········

For Claude Imbert

·········

CONTENTS

· · · · · · · · · · · · · · · · · · · ·

ILLUSTRATIONS

· ·

Figures

Maps

ACKNOWLEDGMENTS

· ·

The work for this translation was carried out in many places: from Ann Arbor, Michigan, to Thessaloniki, Greece, with stays in London and Paris in between. To my friends in Thessaloniki, George and Maria Giannakis, I express my thanks for their unstinting support and their many kindnesses. I am also grateful to Sofia Asaridou for her warm reception over several months. In Paris, I benefited from a Visiting Research Professorship at the Université de Paris Ouest-Nanterre-La Défense, at the gracious invitation of Ségolène Le Men: her personal and scholarly generosity, as well as her hospitality, did much to make my time in Paris productive and enjoyable. I am fortunate to have had the resources of many outstanding libraries and institutions: in Paris, the École normale supérieure; in London, the British Library; and in Ann Arbor, the University of Michigan library system. I am grateful to Marie-Pierre Salé, of the Département des arts graphiques at the Louvre, for crucial help with one of Delacroix's notebooks. I thank Emmanuel Hecre, of the Conseil départemental de Meurthe et Moselle, for information on Charles Cournault, and Karl Longstreth and Erin Platte, of the Stephen S. Clark Library at the University of Michigan, for help with the maps. Bertrand Fillaudeau, director of the Éditions José Corti and publisher of my 2009 French edition of Delacroix's *Journal*, generously allowed the use of copyrighted material. My editor at Penn State University Press, Ellie Goodman, was instrumental in helping to devise the project and has supported it enthusiastically from the start. Two anonymous readers for the Press made extremely useful suggestions, which I have adopted, notably about the order of presentation. As always, I thank my husband Richard Janko for his encouragement and support, his excellent advice on matters of translation, his unsuspected skill as a cartographer, his talent for finding the *mot juste* from *bimbashis* to harbor booms, and his wise insistence that I put aside the original and read the translation as English.

I regret that Chris Michaelides did not live to see this book appear.

It is dedicated to one who has taught me much and been a model of intellectual rigor and creativity for nearly thirty years; a traveler and citizen of the world; and a great admirer of Delacroix.

Never translated in their entirety, Delacroix's writings about his trip to the Maghreb and southern Spain in 1832 have long deserved to be made available to English-speaking readers. Re-edited with commentary in the 2009 French edition of his journals (Eugène Delacroix, *Journal*, ed. Michèle Hannoosh, 2 vols. [Paris: José Corti, 2009]), these important texts are translated here in full. In addition, the 2009 edition brought to light numerous newly discovered writings by Delacroix about his journey, as well as new sources contemporary with the trip. These are translated here for the first time.

The translation is based on the 2009 French edition, with some differences. Delacroix's narratives about the trip are placed first. These include his long, unfinished article, "Memories of a Visit to Morocco," which I rediscovered in 1996, and his short article, "A Jewish Wedding in Morocco," published in 1842. Although they were written well after the trip, they present a broad, continuous picture by which readers can get a sense of the whole, before engaging with the detailed, and sometimes fragmentary, notes and jottings from the notebooks that he kept during the trip itself. Thus the notebooks, dating from 1832, are placed after the narratives, written in 1842 and 1843. The newly discovered notes for these articles are also translated here.

Delacroix did not use his notebooks in an absolutely methodical way. Although the Tangier notebook and the one for Meknes and Andalusia correspond more or less to specific stages of the journey, there is some confusion between them, as well as between them and the other three currently known. For this reason, it has not been possible, in establishing the text, simply to reproduce each notebook as such. In the cases where I have had to rearrange them, I have followed a chronological order, grouping the notes from a single date even when they come from different notebooks, and indicating the source of the notes.

I have generally striven to render Delacroix's style and tone in readable English: the more literary, indeed affected, tone of the narratives that were aimed at a cultured audience, and the more familiar, abbreviated quality of the notebooks. As the latter are full of drawings to which the notes often refer, and which, with a few exceptions, are not reproduced here, I have clarified any obscurities in square brackets or a footnote. I have indicated the drawings in

italics between square brackets. For the actual drawings, readers may consult the facsimiles (see the introduction, notes 23 and 47).

The footnotes have been updated and amended from the French edition. Due to the large number of parallels and cross-references in the "Notes and Drafts for 'Memories of a Visit to Morocco'," I have indicated them in a collective footnote after each block of text.

Biographies of the people who figure in the text are at the back, along with a glossary of Moroccan terms.

The notebooks contain some notes that are unrelated to the journey. These I have placed in appendix A, with an indication of their origin. The history of the manuscripts is given in appendix B.

The letter *J* followed by a number (or by a letter and number) refers to Lee Johnson's *catalogue raisonné* of Delacroix's paintings (*The Paintings of Eugène Delacroix: A Critical Catalogue*). *Journal* refers to the 2009 French edition of Delacroix's *Journal*. "Louvre" followed by a number designates the Louvre inventory of Delacroix's drawings: Musée du Louvre, *Inventaire général des dessins. École française. Dessins d'Eugène Delacroix.* "Piron archive" refers to the archive of Delacroix's papers that I discovered in 1996 in the possession of the descendants of the family of his legatee, and which were sold at auction in 1997: *Vente Eugène Delacroix.* I have provided the catalogue number and the current location of these papers, where known. "Corr." refers to André Joubin's edition of Delacroix's correspondence: Delacroix, *Correspondance générale*. "Arama *Voyage*" followed by a volume number indicates *Eugène Delacroix, Le voyage au Maroc*. Full references to these are provided in the bibliography.

INTRODUCTION

"Only the South Can Produce Such Emotions": Delacroix's "Orient"*

You are going to bring us back some incredible booty. Your lively, spontaneous, and independent way of grasping what is fit for painting is perfectly suited to your duties as a traveller-historiographer; and your sensibility, which had already dipped into Oriental creations, will be burnished further, as it were, under the warm sky of Africa. You understood that sky, you really did, you had already foreseen those Eastern peoples, the only ones who are truly fit for painting and who are ruined for us when they are forced into a European mold. [. . .] So I am convinced that, on your return, your exhibitions flavored with the Orient will cause a revolution. Up to now, with a few exceptions such as Byron, Decamps, etc., we have been treated like such fools by painters of Oriental masquerades, who have given us a little costume, but no great and true history! You will really shake all that up for us with your brush, on your return!

—FÉLIX FEUILLET DE CONCHES, IN PARIS, TO DELACROIX, IN MOROCCO, 29 FEBRUARY 1832

Delacroix's writings from his 1832 journey to the Maghreb and Andalusia are among the classics of travel narratives about what was then quaintly called "the Orient." French and British travelers, in particular, had long visited the countries of the southern and, especially, eastern Mediterranean, but a confluence of commercial, scholarly, political, and military interests in the late eighteenth and early nineteenth centuries focused renewed attention on these regions. Control of Gibraltar had given the British a key position at the entrance to the Mediterranean since 1713, while the East India Company's ascendancy in the mid-eighteenth century opened up routes to India in the east. Napoleon

*The phrase "only the south can produce such emotions" is drawn from Delacroix's note of 12 February; see p. 4. The epigraph quoting Félix Feuillet de Conches comes from Delacroix, *Nouvelles lettres*, 111–12.

Bonaparte's campaign in Egypt and the Levant (1798–1801), and the scholarly publication that resulted from it, spurred interest in ancient and modern Egypt and the Holy Land, as Britain and France vied for influence and territory.[1]

Painters and writers drew inspiration from these events. In France, Antoine-Jean Gros and Anne-Louis Girodet painted scenes from the Napoleonic campaigns, and Chateaubriand's *Itinerary from Paris to Jerusalem* recounted the writer's travels through Greece, Turkey, Palestine, and back to France via Spain (1806–1807). Lord Byron's works on Oriental themes enjoyed great popularity, which his death at Missolonghi in 1824, during the Greek war of independence against the Ottoman Empire, only increased. Byron had joined the Greek cause, and major movements in support of the Greeks formed in Britain, France, and the United States. In the 1820s, Delacroix had himself played a significant role in spreading the Oriental vogue, with historical and allegorical paintings on the Greek war such as *Scenes from the Chios Massacres* (1824) and *Greece on the Ruins of Missolonghi* (1826), subjects from Byron such as *The Death of Sardanapalus* (1827), and odalisques such as *Woman with a Parrot* or *Odalisque Reclining on a Divan* (both 1827).[2] These reflect certain key aspects of what would come to be known as Orientalism: the (male) gaze that brings into being and dominates the submissive, subjugated (female) object; the Orient as a space for the projection of private fantasy; Eastern subjects portrayed as having an erotically charged mystery, for the delectation of the viewer. In this context, it is noteworthy that most literary and pictorial treatments of the "Orient," including Delacroix's, dealt not with the Maghreb but with the eastern Mediterranean—Greece, Turkey, the Holy Land, Mesopotamia, and Egypt—until the French conquest of the Regency of Algiers in July 1830.

Delacroix's written account of his travels is one of the fullest and most detailed that we have from this early period of the modern history of the Maghreb. From January to June 1832, he visited Morocco, with shorter stays in Andalusia and Algeria, keeping extensive notebooks as he went; he later wrote more elaborate narratives of the trip based on his notes. These writings are virtually the first non-military eyewitness testimony about the Maghreb after the conquest of Algiers, and they thus provide precious information about the region during the first years of the French presence there. Moreover, the importance of the trip for Delacroix's thought and work cannot be overestimated. It provided a rich store of images that fed his imagination for the rest of his life: North African subjects constitute the second-largest category of his entire pictorial *œuvre*, ahead of all the major genres apart from his other lifelong

1. A group of scholars and artists accompanied Napoleon's campaign to Egypt to gather information on antiquities, modern society, and natural history. The result of this was the *Description de l'Égypte* (Description of Egypt), published in twenty-three volumes from 1809 to 1829.

2. *Chios,* J105; *Greece,* J98; *Sardanapalus,* J125; *Woman,* J9; *Odalisque,* J10.

passion, subjects from literature; and motifs from the trip—landscapes, accessories—were used in many other paintings too. In his letters, he wrote about his "discovery" of antiquity, the image of which had been so falsified by neoclassical painting; about his admiration for a "natural" way of life that European culture had lost or abandoned; about his appreciation of the intense feeling of life created by light and sunshine; about a real sense of the beautiful, which he distinguished from sensual pleasure, that cliché of travel narratives about the East.[3] But at the basis of the wonder that runs through everything that he wrote about the trip—in letters, diaries, notes and jottings, and longer narratives—and that made him return over and over to it throughout his life, was the overwhelming experience, disconcerting and exciting at the same time, of seeing *differently*, and of recognizing that, up to then, he had been seeing "with the eyes of others."[4] As he was to say, thirty years later, about another experience that changed the way he saw, that is, photography, the journey "gave him back his own eyes," and showed him how much his vision, and his views, had been determined, and constrained, by the pictorial and literary tradition, by convention, and by the techniques of painting and writing.

Indeed, the journey would significantly revise Delacroix's presuppositions and prejudices about the "Orient." He even notes the vagueness of the word— "The term 'oriental' is generally applied to the whole race of turban-wearing people, dressed in long clothes, etc."—and he is sarcastic about the travel accounts that he read in preparation: "During the long hours of idleness and tedium that we had spent at sea, I had read an already very old account of Morocco, and I constructed from it a very definite and specific world that the sight of the first street in Tangier was to dispel completely."[5] As he learned, the reality of the East in no way matched the clichés of these accounts: "During the sea crossing I read a work on the Moors in which I found nothing, or almost nothing, of what I would find on arriving in the country."[6] Not that Delacroix was without the stereotypes of his era: in his writings, we find the usual allusions to timelessness, cruelty, religious fanaticism, indolence, and the like, which characterize other accounts. But counterbalancing them is a close attention to detail, specificity, and individuality, which leads him to appreciate not only so many fine, or as he so often states, "admirable," aspects of Moroccan

3. "The heroes of David and co., with their rose-colored complexion, would look pitiful next to these children of the sun. [. . .] you must come to Barbary, where you will see a naturalness that is always concealed in our parts; you will sense, in addition, the rare, precious influence of the sun that gives everything a keen vitality" (*Corr.*, 1:317); "All that smells neither of ambergris nor of incense; but I did not come here for the pleasure of the senses, and the pure love of beauty makes you ignore a lot of disadvantages" (ibid., 1:315).

4. *Journal*, 19 November 1853 (1:710). See "Memories," cahier 5-b and c (below, p. 34).

5. "Notes and Drafts," second unnumbered cahier-a (below, p. 145); "Memories," cahier 5-b (p. 34).

6. "Memories," marginal note to cahier 2-b (*Journal*, 2:1893). Delacroix uses the word "Moor" in its nineteenth-century sense, meaning the Muslim inhabitants of North Africa.

culture, but also its status as an autonomous culture, with its own values and traditions.

This respect was translated into his paintings after the journey. Although Delacroix is considered one of the most important Orientalist painters, the actual effect of the trip on his Orientalism bears serious reexamination. While the paintings done before the journey convey a frenetic sensuality and cruelty, and appeal to the voyeuristic eye that delights in the image of the female nude submitted to violence or to the fantasized violence of desire, this is not the case with paintings done afterward. At the most basic level, the nude woman, that cliché of Orientalist painting, all but disappears from these works. Despite the celebrity of the two versions of *Women of Algiers* (1834 and 1849), Delacroix's Oriental pictures from after the journey represent women only infrequently, and focus more on scenes of horsemen, hunts and cavalry charges, soldiers and chieftains, feasts and customs, architecture and landscape, and the recurrent theme, to which he returned four times from 1832 to 1862, of *The Sultan of Morocco and His Entourage.* Of the seventy-five or so known paintings on subjects from the Maghreb that are posterior to the journey, only ten can be said to focus on women, and of those, only three remotely approach a nude. The representation of women in the two versions of *Women of Algiers* is of a striking simplicity, particularly in comparison to the frenzied sensuality of *The Death of Sardanapalus*, done before the journey, a veritable invitation to voyeurism.

Similarly, *The Sultan of Morocco and His Entourage* (1845), painted at a time when the sultan had recently been defeated by the French at the Battle of Isly, presents an image of high nobility and grandeur, in contrast to the contemporary situation. Far from affirming the French victory, the picture may rather *restore* to the sultan the power ravished from him by the French. The contrast between it and the picture hung alongside it at the Salon, Horace Vernet's *Capture of the Smala of Abd el-Kader*, an image less equivocal about the French operation, seems to confirm this. The picture conveys not the cultural superiority of the European traveler or the victorious colonial, but the singularity of the foreign, its internal coherence, its identity as a culture distinct from Delacroix's own, resistant to the translation, which the painter, like the writer, nevertheless attempts, in full awareness of its difficulty. The evolution from the openly Orientalist paintings of before the journey, spaces of erotic and imaginative fantasy, to the more distant, monumental paintings that followed it, giving to the Orient an integrity, identity, and grandeur of its own, testifies to an experience that disrupted Delacroix's conception of the Orient in fundamental ways. There is arguably no painting *less* "Orientalist," in the usual sense of the term, than that which *follows* the journey to the Maghreb.

This greater complexity in Delacroix's attitude toward the "Orient" is borne out by an unfinished article that he drafted over a decade after the trip and

provisionally entitled "Memories of a Visit to Morocco."[7] Uniquely, he there reflects in hindsight upon his experience in the Maghreb, attempting to translate for a French public his impressions of a vastly different culture, which he found complex and fascinating. He articulates the experience of this difference by probing it, interpreting it, and considering it sympathetically. Delacroix does not hesitate to bring out the absurdity of European customs, the poverty of our architecture, the bleakness of our cemeteries, or the tastelessness of our dress, compared to what he saw in Morocco. Exceptionally, in this period of intense colonial crisis, he notes with an almost bitter irony the destructive effects, on the local cultures and their society, of the early years of French colonialism in Algiers: the damage wrought by "that mob of civilised men who came to take the place of the Arabs," and whose "civilizing" legacy, as he presents it, was to demolish the beautiful interiors, ruin the gardens, cover over the wall decoration, raze the mosques to the ground, vandalize the cemeteries, and brutalize the sensibilities and traditions of the conquered people. Conscious of his public, Delacroix excuses himself for this blow to the national pride of his readers—"this little digression, for which I apologise especially if it wounds our national pride"—but does not refrain from denouncing the "barbaric courage" of the supposedly civilized French, and describing at length the numerous questionable "benefits" of French domination.[8]

Such criticism is rare, although not unheard of, in the period. At the time of Delacroix's visit, the destructions at Algiers were already controversial. An article hostile to the French occupation, which appeared in the *Foreign Quarterly Review* in 1834, cites several French works that supplement—and confirm—his account.[9] Demolition of the old town had begun right after the 1830 occupation, and a series of sequestration orders beginning in June 1831 expropriated official, and some private, property and revenues. Streets were widened for the easier circulation of military vehicles, buildings were converted for military and administrative use, and those in the way were knocked down; the historic center was replaced with a modern European plan that would facilitate surveillance and celebrate the new French dominance. So rapid was the destruction that time was not taken to survey and map the area, which remains poorly understood to this day. Delacroix notes the "wanton" ruination of the architecture, the ransacking of the gardens, the deliberate breaking of the water conduits, and the driving of straight, wide roads through the old, winding streets. Louis-André Pichon, who in 1833 published a book on Algiers under French control, was likewise highly critical of these practices. A career diplomat, Pichon (1771–1854) had been head of the civil administration in Algiers

7. See below, pp. 24–55.
8. "Memories," fols. 15–16, pp. 41–43.
9. *Foreign Quarterly Review* 13 (February 1834): 74–106.

in the first six months of 1832; he was fired in May for his opposition to the aggressive colonial policy of the Duc de Rovigo, general in chief of the army of occupation, and for his advocacy of the rights of natives. He left on 20 June, just five days before Delacroix's arrival.[10] Pichon decried the zeal of what he terms the "exterminating party" to destroy the mosques, houses, and shops, calling Pruss, the chief engineer, a "determined demolisher": "The demolition of houses and shops in various quarters of the town, in order to form squares, enlarge streets, clear the approaches to the Cassauba, &c., has added to the fears of the inhabitants. A spirit of demolition has seized the engineers: the houses hold so fast together, that in pulling down one the downfall of several others is threatened."[11] And he criticized the soldiers who "found it more expeditious to get at the water [in the pipes] with a stroke of the pickaxe, than to suffer thirst till they reached the next well or fountain."[12]

Delacroix condemns the destruction of the mosques, which, he adds sarcastically, "were serving no purpose but to encumber the public highway." A report in the *Moniteur* gives a taste of the attitudes that he was confronting: "It was no small thing to knock down a mosque in the presence of a fanatical people. The French engineers thought of a trick: for several nights they posted miners who worked without a break, and after they had mined it they left it for a few days; finally they set fire to the mine, which, to the great surprise of the Arabs, brought the mosque down. The Arabs thought that it was a punishment from God, and they are saying that the great Mohammed is abandoning them" (*Moniteur*, 9 August 1832).

The desecration of cemeteries, which Delacroix describes in detail and characterizes as a "barbarous" act that awakened justifiable feelings of bitterness and anger in the local population, was singled out for special censure. The military engineer and geographer Claude-Antoine Rozet, who had been part of the 1830 invasion, wrote: "From the first period of our conquest, we have violated their tombs; I have seen our soldiers open them to ascertain if they concealed any treasures. The bones of the dead were thrown on the dunghill; I have seen corpses yet entire, and enveloped in white sheets, lying by the road side. The natives with downcast eyes gazed at this sad scene without daring to utter a word: some of them came with religious veneration to gather the scattered bones, and carried them away."[13] Edmond Pellissier de Reynaud, bureau chief for Arab affairs in Algiers in 1833–1834, provides a macabre example: "We should have acted with less brutality than we did, and not caused the scandal of a civilized people violating the sanctity of graves. We needed to proceed with

10. Pichon, *Alger sous la domination française*, xix.
11. Ibid., 94, 258–59 (cited in *Foreign Quarterly Review*, 91, 89).
12. Ibid., 284 (cited in *Foreign Quarterly Review*, 86).
13. Rozet, *Voyage dans la Régence d'Alger*, 2:103 (cited in *Foreign Quarterly Review*, 93).

order and decency, and transport the bones to an appropriate place. Instead, those poor remains were dispersed at random, and you could see vulgar men playing in the most vile manner with human skulls. In the process of clearing the terrain, when the route drawn dispassionately by the engineer divided a tomb, the pickaxe cut both the tomb and the skeleton in two; the part that fell away would serve as fill in some other part of the road, and the part that remained was exhibited for all to see on the side of the road. Those gaping sepulchers were like so many accusing mouths, from which the laments of the dead seemed to emerge and mingle with those of the living."[14]

In most cases, however, the criticism has to do with the extent of the change and not with the necessity of it; this, on the contrary, was usually defended in the name of progress. The official contemporary French press rarely questions the superiority of the conquerors, "called to civilize that beautiful land" by the "salutary influence" of their religion, legislation, and *mores* (*Moniteur*, 20 May and 12 August 1832). In contrast, Delacroix contests the colonizing mission itself by turning its own rhetoric against it and bringing out, via irony, the sometime inferiority of the supposedly superior civilization.

In this respect, the difference is striking between his account and so many others from the period, of a sometimes-repulsive Orientalism.[15] With neither arrogance nor sentimentalism, those two standard traits of Oriental travel narratives, he admits his complete ambivalence about the experience of the foreign culture, the mixture of admiration and distaste that it inspired at the time, and the ambiguities and violent contrasts that it encompassed. These made writing about it—or, to use his own metaphor, *painting* it, as *peindre* means both "paint" and "depict" in French—very hard: "To depict such people, you must confront the greatest of all difficulties in the art of writing, that is, to move constantly from an elevated register to a colloquial one that is suited to the depiction of the grotesque."[16] One finds such a brutal yoking of opposites in the text itself, accomplished now with wry humor, now with an honesty and directness that bring one up short: "I scorned them when I was among them, yet when I saw the Moroccans again in Paris, my heart beat as though I were seeing my own brothers."[17] In the end, this particular experience of Morocco, extreme, ambiguous, excessive, casts a most (perhaps *the* most) revealing light, for the writer a decade or so later, on his *own* culture: "What has no place there, or almost no place, is triviality, that very sustenance of our own little world,

14. Pellissier de Reynaud, *Annales algériennes*, 2:7.
15. See, for example, Genty de Bussy, *De l'établissement des Français dans la Régence d'Alger*, and Pellissier de Reynaud, *Annales algériennes*, vol. 2.
16. "Memories," fol. 17, p. 43.
17. Ibid., fol. 18, p. 44.

which we come up against absolutely everywhere, on our streets, in our drawing-rooms, and especially, alas, in our arts."[18]

The Political Circumstances of the Journey

Delacroix traveled as part of a diplomatic mission to the sultan of Morocco, one of the early chapters in the history of French colonialism in the Maghreb. The mission was led by Count Charles de Mornay, a young aristocrat and dandy who would go on to other diplomatic postings under the July Monarchy. Mornay was just then embarking on his career under the patronage of his relative by marriage, the powerful marshal Jean de Dieu Soult, who was then minister of war.[19]

Delacroix's participation came about almost by chance. Mornay was seeking a traveling companion for the long months away. He learned of Delacroix through mutual acquaintances, notably Henri Duponchel, the future director of the Paris Opera who had collaborated with Delacroix on stage designs, and Armand and Édouard Bertin, sons of the influential editor of the *Journal des débats* and friends of the painter.[20] Mlle Mars, a famous actress who at the time was Mornay's lover, elaborates: "Charles did not wish to go alone [. . .]; he had thought about asking Isabey junior, but he *[Isabey]* had already been to Algiers and, no longer possessed by the demon of curiosity, he refused; so I asked Duponchel to look around among his friends for someone who would welcome such a trip, and the matter was settled to the great satisfaction of both parties."[21] Delacroix was recommended as "a young painter of talent, with a social sense and an excellent character [. . .], which is not to be looked down on when you must spend four or five months side by side and probably put up with some hardship."[22] The arrangement was decided quickly, in the course of November 1831, Mornay having been appointed on 11 October; on 5 December, the minister of foreign affairs authorized Delacroix to go along. He was to pay his own way except for the crossing from Toulon to Tangier.[23] For the return journey,

18. Ibid., fol. 17, pp. 43–44.

19. This patronage is mentioned in the memoirs of Julius Lagerheim, the Swedish consul. On these valuable memoirs, see below, pp. 19–22. Mornay's brother was married to Hortense Soult, the marshal's daughter.

20. *Corr.*, 1:314–16. On Delacroix's work with Duponchel, see *Journal*, 14 May 1824 (1:160), where Duponchel consults him about costumes for a historical play; on 26 December 1824, Delacroix had lunch at Duponchel's with Talma, the great classical actor (*Journal*, 2:1447). In 1821, the two men had worked together on decorations for Talma's house.

21. Letter of 4 February 1832 (quoted in *Lettres intimes*, 193).

22. Ibid.

23. On these details of the journey, see Mornay's personal papers, Archives nationales (A.N.) 402/AP/16; the volume of documents included with the facsimiles of Delacroix's notebooks edited by Maurice Sérullaz, Arlette Sérullaz, and Maurice Arama: Eugène Delacroix, *Le voyage au Maroc* (*Voyage*, vol. 6); and the passenger list reproduced by Arama in *Le Maroc de Delacroix*, 204–5.

Delacroix considered stopping in Spain to see Spanish art collections; to this end, he obtained from his friend, the writer Prosper Mérimée who had traveled in Spain and had contacts there, a letter of introduction to Mme de Montijo, mother of the future Empress Eugénie of France, to visit the Prado in Madrid, and another to the second Duke of Gor, a well-known collector, for Granada.[24] In the end he was unable to visit these cities, but did spend two weeks (17–30 May) in Cádiz and Seville. In Africa he visited Tangier, Meknes, Oran, and Algiers. In all, the journey lasted six months.

From the notebooks that Delacroix kept during the journey, with their stunning images and terse commentary, one would never suspect that the mission unfolded in the most precarious of diplomatic contexts. The French occupation of the Regency of Algiers in 1830 had provoked fierce opposition in the local populations. In the summer of 1831, a Moroccan detachment led by the *kaïd*, or commander, Mohammed ibn al-Hamri, had crossed the border into the district of Tlemcen and organized the resistance. The official documents given to Mornay before the mission employ bellicose language, calling al-Hamri an "agent provocateur," and alluding to "hostilities," "aggression," and "invasion." Yet the ministry acknowledged that the people of Tlemcen had recognized Sultan Moulay Abd al-Rahman as their legitimate sovereign, and that the sultan had not sent al-Hamri to sow revolt.[25] As France's aggressive reaction suggests, control of the conquered region in late 1831 was still fragile; the new government of King Louis-Philippe, installed following the July Revolution of 1830, was uneasy about this problem inherited from the Restoration, and keen to suppress any appearance of a threat to its authority.

In response to this crisis, the French government adopted two strategies: first, a massive show of force, reinforcing the garrison at Oran and sending warships off the Moroccan coast to give "effective support" to French claims; second, the diplomatic mission of Mornay, who was to communicate to the sultan the requirements of Louis-Philippe's government. The situation was exacerbated by the execution at Oran, by order of General Pierre Boyer, of two Moroccan subjects who were accused of conspiring with al-Hamri and supplying arms to the Arabs. "Firmness and moderation" was the advice given to Mornay by the ministry; but intimidation played no less a part, as France counted on the effect that the conquest of Algiers would have had on the sultan, showing him that "the power that could conquer the territory of Algiers could also enforce respect for its rights and authority."[26] The interim minister wrote: "It must not be forgotten that impressions of this sort, and in

24. Mérimée, *Correspondance générale*, nos. 106, 106 bis, 12 December 1831.
25. Mornay's personal papers, A.N. 402/AP/16: notes for Mornay's use and letter from Horace Sebastiani, minister of foreign affairs, 16 December 1831.
26. Ibid., letter to Mornay, 8 December 1831 and 2 May 1832.

general everything that tends to recall the greatness of France and the power of its government, help to guarantee success in negotiations undertaken with Orientals. Your language and actions must exude a sense of the power, accompanied by justice and moderation, of the sovereign whom you are representing." Mornay was to make the sultan understand "France's unshakeable resolve to extend to the province of Tlemcen the right of possession that the conquest of Algiers gives her."[27]

Mornay had a difficult task, with multiple strands: (1) to obtain al-Hamri's recall, the evacuation of Moroccan troops from territory taken by France, and a formal undertaking by the sultan not to interfere in the conquered territory; (2) to satisfy the claims of the families of the Moroccan subjects who had been executed; (3) to obtain the restoration of three French ships captured during the war with Algiers and detained in Moroccan ports; (4) to guarantee that the French ship *Neptune*, captured in 1820 by the inhabitants of Andjera, east of Tangier, would be returned and her owners compensated;[28] and (5) to institute a fixed customs rate to strengthen commercial ties. The mission succeeded, at least in the short term. The sultan agreed to France's principal demands: he renounced his claims to Tlemcen, promised not to support his coreligionaries against the occupiers, and agreed to hand over the captured ships. The demand about the *Neptune* was dropped, since Morocco had a similar grievance against France; and there was a compromise on the question of the customs rate. In return, the sultan required that the fortunes confiscated from the executed Moroccans be returned to their families, which was accepted.[29] The news was announced in the *Moniteur algérien* by the Duc de Rovigo, to serve as a warning against future attacks. Citing part of Mornay's letter that announced the agreement, he continued: "After bringing the present letter to the attention of all Arabs in the Regency, the general in chief will consider as an enemy of France all those who not only do not immediately abandon the impostors claiming to act in the name of a sovereign who is an ally of France, but also do not use every means at their disposal to arrest those enemies of public safety or chase them from the territory of the Regency."[30]

France's great rival for influence in the Mediterranean, Britain, did not stay on the sidelines. Throughout the visit, Mornay reported back to his government on Britain's influence in Morocco, mediated by Edward Drummond Hay, the British consul: "The vicinity of Gibraltar means that England has her eyes open on all our moves [. . .]. She fears our spread across the Mediterranean and knows very well that a war *[between France and Morocco]* that would give us a few more

27. Ibid., letter to Mornay, 28 February 1832.
28. Ibid., letters of 11 and 17 December.
29. But, according to Arama, delayed for twelve years (*Voyage*, 6:242 n. 44).
30. *Moniteur*, 22 May 1832.

ports would make her possession at the entry to the Strait, so important up to now, illusory. [. . .] The English nation alone accounts for almost all commerce in the interior of the country. [. . .] Sweden and Denmark, who consent to paying an annual tribute of 120,000 francs, have already placed themselves, in some ways, under the protection of the English and gather round this power."[31] What Mornay may not have known is that Drummond Hay played a role in the sultan's acquiescence to French demands. In a letter to the Colonial Office of 5 March 1832, the day the French mission left for Meknes (a journey that Delacroix records in detail), Drummond Hay states that, a few days before, two of Moulay Abd al-Rahman's closest advisors, the commander Ben Abou and the customs administrator Bias, had come to see him to ask what advice they should give the sultan if he asked for it, Britain being "the strongest and the steadiest friend Morocco had."[32] According to Drummond Hay, the two were aware of the dilemma faced by the sultan, who, without seeking to expand his realm, felt obliged to defend a territory whose inhabitants had chosen him as their own sovereign; but they also feared that this duty might make him persist in a policy that would lead to war. Drummond Hay laid out the dangers of such a policy, reminding them of France's strength, the opposition of many of the country's leading men to the sultan's approach to this matter, and the fragility of his power, recently tested by the revolt of the Oudaya militia in June 1831, which had almost succeeded in overthrowing him. Finally, he led them to understand that, although Britain regretted the French occupation, she could not contest France's "rights of conquest," which were recognized by the community of nations, such that, in the event of war, Morocco would find itself alone. Drummond Hay authorized them to communicate his opinion to the sultan. Britain's refusal to oppose French action would certainly have contributed to the sultan's decision.

But while the sultan may have been appeased or intimidated this time, a more implacable enemy arose, in this same year 1832, to rally the Algerian resistance. The young Abd el-Kader, at the time the emir of Mascara, was to become an effective and intrepid adversary of the French. Twelve years later, he would appeal to the sultan, who could no longer ignore his brother in religion and was forced to defend the kingdom of the Prophet against the French invasion. In 1844, Morocco would go to war with France.

The crisis of 1844 had been building for several years. Since the spring of 1842, Morocco had been drawn increasingly into the conflict between Abd el-Kader's forces and the French. In March of 1842, pursued by French troops under the command of General Lamoricière, Abd el-Kader took refuge in

31. Mornay, report of 16 February 1832, *Voyage*, 6:206.
32. London, The National Archives, FO 174, no. 162, pp. 108–19.

Morocco where, according to the French, he was assembling fighters, receiving munitions sent from Gibraltar by the British, and launching raids into Algeria. France demanded an explanation from the Moroccan government about its "cooperation" with him. The sultan's response, that the Moroccan authorities had been unaware of this and that he had ordered his forces to maintain a strict neutrality, was judged inadequate.[33] The French press spoke of a possible invasion, holding the sultan responsible for Abd el-Kader's actions.[34] On 11 July 1842, shots were fired at the French frigate *L'Américaine* in the harbor of Tangier, provoking a French ultimatum to the pasha of the city.[35] More confrontations followed in 1843: pillaging raids by Moroccan tribes in territories recently conquered by France led French troops to attack deep inside the country; in the course of the negotiations, the French escort was fired upon.[36] The *smala* ("camp") of Abd el-Kader was captured in May 1843; he again fled to Morocco and reportedly tried to persuade the sultan to declare war on France.

This did not happen, of course, until 1844, but when it did, it was on the basis of a very similar situation: to block Abd el-Kader's new offensives, French troops occupied Maghnia, in Moroccan territory, refusing to recognize the frontier of the Tafna River that divided the two countries. General Bugeaud went further, announcing that he would march on Oujda "unless Morocco commits to not sheltering Algerian migrants and giving refuge to Abd el-Kader."[37] The sultan was in a difficult position: his territory was violated, Abd el-Kader's charisma was finding a sympathetic reception among his subjects, and Bugeaud's threats were rapidly being realized. He asked to negotiate; the British consul, Drummond Hay, sent to Rabat to present the sultan with France's demands, wrote in a letter that all had been accepted. But by this point the march to war was not to be stopped: France claimed that there had been "so much bad faith that her patience was exhausted"; it was "necessary to give a lesson to the Moorish government and people"; she had "no other option than to resort to arms."[38] Drummond Hay complained bitterly that the French were waiting neither for his return nor for the arrival of his dispatch announcing that the sultan had accepted their demands, but instead were preparing "to cast

33. L. Godard, *Description et histoire du Maroc*, pp. 598–99.

34. *Revue des deux mondes,* "Chronique de la quinzaine," 14 and 30 April 1842.

35. The matter ended, according to Godard, with a public whipping, "which French clemency cut short, but which gave the Moroccans an eloquent lesson" (*Description et histoire du Maroc,* 597–98).

36. Ibid., 599.

37. Ibid., 602. Even Godard, openly hostile to the Moroccan cause, admits that the sultan had forbidden his military commanders to go on the offensive (ibid., 601).

38. Edward Drummond Hay, account of his meeting with the Prince de Joinville, 7 August 1844 (Bodleian Library, Oxford, MS Eng.hist.e.351, p. 168); letter from Antoine Doré de Nion, the French consul general, to Drummond Hay, 10 August 1844 (MS Eng.hist.c.1075, fols. 102–3).

fire and the sword on this unhappy country."³⁹ On 6 August 1844, Tangier was bombarded by the Prince de Joinville; on the fifteenth, Mogador; the Moroccans were beaten at Isly on the twenty-fourth; the peace treaty was signed on 10 September, on terms hardly different from those to which the sultan had already consented.⁴⁰

Mornay's mission was thus only a pause in a drama that was to continue almost without let-up, even after the surrender of Abd el-Kader in December 1847. Some, at the time of Delacroix's visit, already foresaw the trouble to come. A letter from the younger Hay of 6 November 1845 reports the account of his father, who had died a few months before: "When Algiers was first taken, my late father, who was an old soldier and knew the character of the Arab, remarked to the French chargé d'affaires, who was boasting of the importance of their newly acquired colony, that 'it would prove a very dear conquest,' and that he felt positive that 'before twenty years elapsed, a hundred thousand men would be required to hold the country, and that each year would bring fresh demand for troops, not to protect their colonists, but to destroy the Arabs.'"⁴¹ In the same letter, and in the light of events that had been taking place over the previous fifteen years, the younger Hay is even more stern: "The French start from a wrong principle in their mania for destroying Abd el-Kader; for if this French hydra were killed tomorrow, few months would elapse before another arose. It is to the hostile and fanatical feeling of the inhabitants that they must attribute all their troubles, and until they find a better cure for this feeling than a system of violence and retaliation, battle and murder will never cease in that territory as long as an armed Arab exists."⁴²

The British were not alone in this view. With greater cynicism, but perhaps also pragmatism, the Swedish consul Julius Lagerheim wrote in his memoirs that it was "useless to bombard the city so as to force the government into a better policy, since the Emperor cares so little about the inhabitants of Tangier that he would not change his policy for their sake; he knows, in any case, that most of the damage would affect the consulates of the European powers. The result of Morocco's wars with Christian states has usually been to sustain the Emperor's pride and conviction of his own superiority. During the 1829 conflict with Austria, [. . .] the Austrian government sent to Morocco a brilliant

39. Letter of 26 July 1844, cited in the memoirs of his son, John Drummond Hay (*Memoir of Sir John Drummon Hay*, 67). The younger Hay specifies in a letter that the bombardment of Tangier took place five hours before his father's return, even though he was expected "hourly" (ibid., letter of 12 September 1844, p. 69).
40. Ibid., letter of 12 September 1844, pp. 68–69.
41. Ibid., 76–77.
42. Ibid., 76. The image compares Abd el-Kader to a hydra (for the French), with its ability to regrow its heads after they are chopped off.

ambassador, who for a million Spanish piastres bought a peace that they had not been able to gain by war."[43]

Delacroix's Writings About the Journey

The artist's writings about his trip took multiple forms. Until recently, the best known was a series of four notebooks and albums of drawings, out of a total of seven that he is known to have had with him. Two more albums have now come to light, and we have a few indications of what the remaining ones, still unlocated, may have included. Most of these notebooks contain drawings in pencil, ink, and watercolor, interspersed with text. Mornay reported that they were done "as we travelled, on the pommel of the saddle or at our stops under the shade of fig-trees; then in the evening, when everyone, overcome with fatigue, had fallen asleep, they were touched up with watercolor in the silence of the tent."[44] They were of course an *aide-mémoire*, which continued to inspire Delacroix until his death, despite the fears that he expressed in the moment: "When I am away from the land where I first had those impressions, they will be like trees uprooted from their native soil; my mind will forget them and it will be awful to have to render coldly and imperfectly that striking, living sublime that runs through the streets here and that overwhelms you with its reality."[45] The notebooks are not a diary, but a travel account in the simplest sense, dry, factual, and abbreviated, recording places visited, routes followed, and scenes observed, with little reflection to speak of. Unlike his *Journal*, which has almost no drawings, these memories are pictorial, providing Delacroix forever after with themes and subjects, motifs, forms, and colors for paintings. They were the source of visual correspondences as well: on 20 September 1854, observing the women of Le Tréport in Normandy, he remembers "the natural ease of the Jewish women in Tangier at home"; on 6 August 1850, the impression of grandeur that he has in Cologne Cathedral reminds him of Seville; in March of that same year, as he was searching for subjects for his painting for the Apollo Gallery in the Louvre, he notes an ancient story according to which the sun set in the ocean near Gibraltar and that "from the shore near Cádiz" one could hear it sizzling in the waves.[46] At the same time, these notebooks have a visual eloquence: they are among the most resplendent

43. Lagerheim, *Minnen från mitte vistande i Africa: Marocco 1831 och 1832 [Memoirs of My Stay in Africa: Morocco, 1831–1832]*, 61. On these valuable memoirs, see below, pp. 19–22. The term "Emperor" was commonly used to designate the sultan, as was *sharif,* "prince."

44. Philippe Burty, "Eugène Delacroix à Alger," p. 77.

45. Letter to his friend Jean-Baptiste Pierret (*Corr.*, 1:319).

46. See *Journal*, 2:1683.

and beautiful of all Delacroix's sketchbooks; their rapid, free, vigorous draw-ings and bright, pure watercolors surrounded by a swirl of text create a visual richness that is unparalleled in his work. For this reason, the two that were available were reproduced in facsimile as early as 1909, and the same two, with two more, in 1992.[47]

In addition to the notebooks, Delacroix wrote two articles about the trip. The first was a short piece, published in *Le Magasin pittoresque* of January 1842, on a Jewish wedding that he had witnessed in Tangier and that had inspired his painting for the Salon of 1841, *Jewish Wedding in Morocco* (J366).[48] This was a kind of trial for a longer project on the journey as a whole, of which the unfinished article, "Memories of a Visit to Morocco," discussed above (pp. 4–5), remains.[49] He had specifically asked that the manuscript of the article on the Jewish wedding be returned to him when the printer had finished with it, since "it might make me feel like doing more."[50] Clearly it did, and in early 1843 he drafted the longer narrative, noting for it a possible title, "Memories of a Visit to Morocco." Unlike the notebooks, "Memories" starts with the party's depar-ture from Paris, referring to stops along the way in Fontainebleau, Avignon, and Marseille, and continuing with the crossing of the Mediterranean and arrival in Tangier. At this point, there is a break in the narrative, where Dela-croix leaves readers "a moment to catch their breath a bit" (cahier 6-c, below, p. 36), thus bringing the first part to a close. The second part resumes with the party's entry into Tangier. Numerous pages of notes and jottings for these articles also exist, and are printed here.

Given its length—more than 13,000 words—"Memories" would have been destined for a periodical that carried substantial articles. It is ten times longer than the article on the Jewish wedding that appeared in the *Magasin pittoresque*. A reference in a draft of the text indicates that Delacroix was invited to write it, perhaps to respond to the renewed public interest in Morocco owing to increased political tensions between that country and France: "When you kindly asked me to describe my impressions of that expedition to a country that today is attracting attention, it seemed to me that the distance in time from when I went

47. Jean Guiffrey, *Le Voyage d'Eugène Delacroix au Maroc. Fac-similé de l'album du musée du Louvre*, 1909, and *Le Voyage d'Eugène Delacroix au Maroc. Fac-similé de l'album du musée de Chan-tilly*, 1913. The 1992 facsimile edition (see above note 23) includes the three Louvre notebooks and the Chantilly one (vols. 1–4) and two volumes of text, notes, and documents (vols. 5–6).

48. *Le Magasin pittoresque* 10, no. 1 (1842), reproduced in Piron, *Eugène Delacroix: Sa vie et ses œuvres* (452–56). The original manuscript, which provides a few variants to the published text, was in the Claude Roger-Marx collection and is taken into account in the text printed below (Institut national d'histoire de l'art [henceforth INHA], carton 120, autog. 1397/1).

49. Piron, *Eugène Delacroix: Sa vie et ses œuvres* (90) confirms Delacroix's plan: "Later he tried to write out at greater length all the circumstances of the journey, and he prepared on loose sheets an account to which he never returned, or at least that he never put into shape."

50. *Corr.*, 2:90.

would be an obstacle."[51] The *Revue des deux mondes* and the *Revue de Paris* are strong possibilities: both were directed by Delacroix's friend François Buloz, and in his text, the painter praises the novelist George Sand (cahier 3-a, below, p. 26), who was associated with both these periodicals. Perhaps significantly, he cites her *Letters of a Traveller*, which had been published in the *Revue des deux mondes* between 1834 and 1838.

Although there are overlaps and correspondences between all Delacroix's writings about the trip, they are also very different from one another. The jottings in the notebooks were written in the moment, for himself, and thus are brief, fragmentary, unexplained, and casual in tone. One, which I call the "Tangier notebook," largely covers the period spent in Tangier; another, which I designate the "Meknes notebook," deals mostly with the journey to Meknes for the audience with the sultan, and with Delacroix's trip to Andalusia. The other four—called "Chantilly," "Louvre," Burty no. 30, and "ex-Mellon"—have drawings and sketches, with just a few notes. These are largely lists and summaries, or annotations relating to the drawings.

The articles have a different tone altogether. They are more "ethnographic," recounting at length the main events of the journey, the *mores* and customs of the inhabitants, and the impressions that a European visitor, very struck by what he had seen, wished to convey to a French public. Aimed at an educated audience, they are more literary in style, indeed at times stilted and affected. The unfinished article, in particular, testifies to Delacroix's struggle to find the right turns of phrase, as he tries one, then another, crossing out, starting anew, and rewriting in the margins and on the back of the sheets. Its first pages, concerning the journey through France to Toulon, are heavy and awkward, evoking numerous macabre details to attract the reader's interest, in the manner of a Gothic novel; it stops and starts, breaks off in midsentence, and is peppered with "etceteras" as if Delacroix is unsure of, and impatient with, his approach. Only after a few pages does he hit his stride.

When he does, the result is a fascinating text with all the interest of Delacroix's best style, especially the experimental writing of his later *Journal* (1847–1863) and his "Dictionary of the Fine Arts" (1857). The painter was keenly aware of the difficulties of representation, the problem of finding the right way to express experience, feeling, and thought, especially for himself: others may be satisfied, but "will the one painting those scenes [. . .] ever find in his own picture the exact features and subtle nuances of his impressions?"[52] For the painter who was also a *writer*, the task of translating what he saw posed a particular challenge: "But where can one find those vivid colors, those words that

51. "Memories," variant to fol. 1bis (*Journal*, 2:1891).
52. "Memories," fol. 1r, p. 24.

are like images?"[53] Recounting his memories is here interwoven with a serious, and perhaps formative, reflection on writing and its relation to painting. Delacroix plays constantly on the French word *peindre*, which, as noted previously, means both "to paint" and "to depict," and its derivatives—*peinture*, "painting" and "depiction," *peintre*, "painter" and "person who depicts"—as well as on other terms that toggle between the two arts, for example "tableau," "picture," and "portrait." The painter-writer expresses his frustration with the shortcomings of writing: a simple line or tone, or the special touch of a great master, speaks more than volumes of tedious description, and "the end of every description is always a kind of acknowledgment of the impossibility of describing."[54] On the other hand, the "richness of detail" that description entails provides a way of letting oneself go: "It is so hard to rein yourself in when you are holding forth!"[55]

For the writer of "Memories," the passage of time, far from being an "obstacle," as he at first feared, guarantees the distance necessary to temper the overwhelming feeling, the overload on the mind and senses, of the present moment: "The more recent one's memories are, the harder it is to leave things out when writing them down. [. . .] Conversely, at a certain distance from the events, the narrative will gain in simplicity what it would seem to lose in richness of detail and minutiae. You can slide more easily, and with less regret, over many circumstances that, by their novelty, may seem more important than they really are."[56] The proliferation of detail in the notebooks, the myriad sketches and drawings interwoven with annotations and jottings, preserve the fullness of the moment, but confusedly and without reflection; in its greater "simplicity," the narrative concentrates on what "matters." We recognize the themes that will dominate Delacroix's later *Journal* and "Dictionary of the Fine Arts":[57] the conflict between detail and whole, between the "composition" that our memory creates and the loss of little details that are forgotten with time, between seeing up close and seeing at a distance, between the pleasure and "effusiveness" of description and its very sterility. Together with that is the search for a literary style that Delacroix associates with painting—expressive, attentive to nuance, characterized by an apparent "absence of artifice" and by a movement that is capricious, proceeding "according to chance," following the processes of thought—a style whose naturalness will compensate, as he hopes, for the "abruptness of the transitions."[58]

53. Delacroix crossed this sentence out on fol. 1 (*Journal*, 2:1891).
54. Delacroix crossed this sentence out on fol. 1r (ibid.).
55. "Memories," fol. 1r, p. 25.
56. Ibid.
57. See Hannoosh, *Painting and the* Journal *of Eugène Delacroix*, chapter 3, pp. 93–127.
58. "Memories," fol. 1r, p. 25.

All these texts complement one another not only in style but also in content. Many details of the notebooks are absent from the narratives, and vice versa. Part I of "Memories" deals with the journey through France and the sea crossing, which had been unknown up to now, since the notebooks begin only with the arrival in Tangier. "Memories" and the preparatory notes for it contain much other information that appears nowhere else. Some of this confirms stories that had been passed down and thought to be spurious, for example that Mornay and Delacroix observed some women bathing in a stream, saw en route some gravediggers, which inspired Delacroix's *Hamlet and Horatio in the Graveyard* of 1835 (J258), and witnessed the festival of the "convulsionaries" sect in Tangier.[59] Other episodes described were completely unknown, for example, the comical incident involving some British soldiers on Gibraltar who were stripped bare and made to dance the saraband by the bandit José María. This hero of the people and "universal righter of wrongs" who made women swoon was a legend in his time.[60] Mérimée gives a full picture of him in his *Letters from Spain* (1831–1833):

> The very model of a Spanish brigand, the prototype of a hero of the high road, the Robin Hood [. . .] of our times [. . .]. Handsome, brave, courteous [. . .]. Does he take a valuable ring from the hand of a lady?—"Ah, Madam," says he, "such a beautiful hand does not require the aid of ornaments." [. . .] José María has been represented to me as a fine young man of twenty-five to thirty years of age, of handsome figure, with an open and joyous expression of countenance, teeth white as pearls, and particularly expressive eyes. He wears commonly the dress of the *majo* (an Andalusian beau) of an extremely rich description. [. . .] His relations had intended him for the church, and he was studying theology at the University of Granada. [. . .] A price has been set upon his head; his description is posted upon the gates of every town [. . .]. Meanwhile José María holds on with impunity to his hazardous career, and extends the range of his exploits from the frontiers of Portugal even to the kingdom of Murcia. [. . .] It follows as a matter of necessity that the Spanish people [. . .] must take an interest in the only man, who, in times so prosaic as those we live in, revives the chivalrous virtues of the ancient worthies.[61]

59. Ibid., fol. 35, pp. 54–55; cahier I-b, p. 26; below, p. 21.
60. Ibid., cahier 3-c, p. 30.
61. Prosper Mérimée, "Letters from Spain—No. I: From the French of Prosper Mérimée," *Dublin University Magazine* 3 (April 1834): 391–93. José María soon became head of the Civil Guard, a role that he assumed in exchange for a royal pardon: having learned that Queen Cristina was to pass through a dangerous forest, he showed up with his band to escort her; when they had crossed the forest without incident, the queen heard her protector's petition. José María revealed his identity and asked for amnesty, which was granted on condition that he help put an end to banditry. He

In his introduction to "Memories," Delacroix acknowledges the discrepancy between what he noted on the trip and what he remembered: "I no longer see but through a kind of mist a host of details that had then caught my attention; some of these now just seem so many dreams. A slew of notes jotted down in haste are unintelligible to me now. On the other hand, I see clearly in my mind all those things that one does not need to note down, and that are perhaps the only ones that deserve to be retained in the memory, or at least presented to readers." For a full picture of Delacroix's journey, the texts must be read together and in their entirety.

The Testimony of Julius Lagerheim

The unpublished memoirs of the Swedish consul Julius Lagerheim contribute valuable, indeed unique testimony about the Morocco of Delacroix's time, and fill many gaps in our knowledge of the painter's stay in Tangier.[62] They consist of 130 manuscript pages in Swedish, which Lagerheim drafted several years after his stay there.[63] The former consul in Algiers, Lagerheim was posted to Tangier in the spring of 1831 after the consul there, Johan Ehrenhoff, was recalled to Stockholm. Ehrenhoff had committed some "foolish mistakes" that might compromise relations between the two countries; in particular, he had allegedly used for himself a year's worth of the tribute that Sweden was meant to pay to Morocco. Lagerheim was charged with putting the financial affairs of the consulate in order and restoring Sweden's good relations with the sultan. Since his assignment ran from May 1831 to November 1832, he was in Tangier for the whole of Delacroix's stay (January–June 1832). The people mentioned by Delacroix, including some previously unknown, are dealt with, often at length, by Lagerheim, who had lived among them: the consuls and their families, of whom we had had only limited knowledge; the Moroccan authorities (the customs administrator Bias, the sultan's chief minister Muchtar, the pasha of Tangier Sidi El Arby, the sultan himself), in addition to "ordinary" people (the servant Misauda, Ali the gardener of the Swedish consulate who was a "convulsionary," and the Rabelaisian friar Padre Pavón, all mentioned or painted by

............

was killed by another brigand in 1845 (Hay, *Memoir of Sir John Drummond Hay*, 11–16; Standish, *Shores of the Mediterranean*, 23).

62. I discovered these memoirs during research for the 2009 edition of the *Journal*. I thank Mr. Peter Hogg for translating them for me.

63. Lagerheim, *Minnen* (see above, note 43). Undated, they were probably written around 1844, and certainly after 1837, since that year is referred to on page 97. Lagerheim's mention, in the passage cited above, of the fruitlessness of a French bombardment suggests a date close to the conflict of August–September 1844, but before its outcome was known. Moreover, on page 65 he suggests that the French have not yet established their authority in Africa ("if and when the French establish themselves . . .").

Delacroix). Lagerheim explains and comments on places (gardens, excursions), habits and customs (religion, the consuls' way of life, meals in the open air), feasts (the Bairam, weddings, the festival of the "convulsionaries" or "Issawa"), all alluded to, sometimes enigmatically, by Delacroix; and he gives pride of place to the most important event of his stay, the visit of the Mornay mission itself.

> The arrival of the French mission in Tangier [. . .] pleasantly interrupted our tedious existence and was the occasion for parties and entertainments. The personnel consisted of the ambassador Charles de Mornay, lieutenant colonel of the cavalry regiment of the Paris National Guard, M. Desgranges, the interpreter [. . .], and the excellent painter Delacroix [. . .]. Count Mornay and Delacroix were a real gain for our society, the former cheerful, amiable, with the best social graces [. . .]; wherever he appeared he brought pleasure and happiness. [. . .] Delacroix was an artist in the best sense of the word, learned and sensitive, but genial and lively like a true Frenchman.[64]

Delacroix and Mornay were especially friendly with Jean Fraissinet, the Dutch consul, and with Lagerheim himself, spending the mornings with one or the other, and the afternoons with the British consul, Edward Drummond Hay, or at the French consulate. An amusing portrait emerges from these memoirs: "The three Frenchmen, who all had fine voices, entertained us in the garden singing French national songs accompanied by the guitar. It was a year [sic] after the July Revolution. [. . .] They all sang the *Marseillaise*, the *Parisienne* or Béranger's songs. Later, when I met him *[Mornay]* in Stockholm in 1837 and reminded him of our concerts in Tangier, which I would have liked to hear again, he replied: "My dear friend, times have really changed; now nobody sings the *Marseillaise* anymore."[65]

Similarly, when Mornay, returning to Tangier after his trip to Cádiz, spotted the consuls waiting for him on the beach, "not because etiquette required it, but simply to show him the pleasure they had in seeing him again," he stopped the sailor who was carrying him to shore on his back and, "standing up on the man's shoulders, his cap in his hand, which therefore sank into the water, he gave a fine speech to thank them for this courtesy. The scene was so

64. Ibid., 96.
65. Ibid., 97–98. The crackdown on civil liberties and the press after the 1835 assassination attempt on Louis-Philippe had made the euphoria of the 1830 July Revolution a distant memory. The *Marseillaise*, written in 1792 by Rouget de Lisle, had been banned under the Restoration and reallowed in 1830; *La Parisienne*, written in 1830 by Casimir Delavigne and set to music by Daniel Auber, was the *de facto* anthem of the July Monarchy.

ridiculous that even the Moors who were gathered on the beach burst out laughing."[66]

One of the most important events that Lagerheim's testimony confirms is the frenetic ceremony of the Issawa (or "Issawiya"), a religious sect whom Delacroix calls "convulsionaries" and depicted in three paintings.[67] Mornay stated that Delacroix observed this ceremony from a hiding place while the party was in Tangier. But because the seat of the sect was at Meknes and not Tangier, and because the main festival in 1832 fell in August, after Delacroix had left Morocco, some have suggested that the scene was invented, and that he "reconstituted" it from "descriptions by the vice consul" and others in the know in Tangier.[68] However, Lagerheim states that, *several times a year*, the Issawa came from all over the kingdom and gathered in a disused mosque outside Tangier. They spent the first night consuming *kif*, and entered the city the following morning. He describes the terrible shouting and gunshots that, the first time he witnessed the scene, he heard from far off as they approached. The Issawa, sometimes naked to the waist, their long hair fluttering, could be distinguished from other Muslims (who normally had their head shaven except for a lock of hair on the crown). Frothing at the mouth, their bodies covered in blood, they grabbed any animal that they encountered—dogs, cats, and so on —and tore them to pieces. "Unfortunate the Jew or Christian who came across them in this state": to prevent murders, they were surrounded by Moroccan soldiers who kept them from spreading about the city (hence the figure on horseback in Delacroix's paintings) and led them to the mosque, where they were shut in until their intoxication wore off. The fact that Delacroix chose this subject for the album that he gave to Mornay suggests that the episode actually happened and indeed that they experienced it together.[69]

As the end of Delacroix's stay in Tangier has left no trace, in either his notes or his letters, another event that Lagerheim describes has a special interest. Among many festivities held in honor of the French visitors as their departure approached, a masked ball given by the Sardinian consul, Girolamo Ermirio,

attracted a lot of attention among the citizens of the town and almost caused a riot among the people. The street outside the Sardinian house

66. Ibid., 98.

67. Ibid., 84–85. See Chantilly notebook, p. 2 (below, p. 124). The term "convulsionaries," as the sect was called in French in the nineteenth century, is by analogy with the eighteenth-century sect of Saint Médard in Paris, whose members experienced convulsions on pilgrimages to the tomb of the Jansenist François de Paris.

68. *Delacroix: Le voyage au Maroc*, cat. Paris, p. 71; Arama, *Le Maroc de Delacroix*, 41.

69. Delacroix later refers to the Issawa in the *Journal* of 16 April 1853, where he records a conversation with Prosper Bourrée, a former chargé d'affaires in Tangier (*Journal*, 1:634–35).

was full of Moors looking at the costumes and saying that, given how they were dressed, the Christians had lost their minds. But in general they treated the whole matter politely until Delacroix came walking up dressed as a Moor, with a fine fake beard, and so well costumed and made up that at first they took him for one of the locals. When they realized their mistake and found that the Christian was wearing both the dress and the look of a believer, they became so upset that it was only with difficulty that he escaped being attacked."[70]

Lagerheim retained fond memories of this time forever after. When Mornay was appointed minister to Stockholm, he sent him a letter reminding him of days spent in Tangier in the company of Fraissinet, Drummond Hay, and Delacroix. "You will allow me, Sir, to express to you in writing my heartfelt gratitude for the flattering attention with which you honored me during your stay in Tangier. The delights of your company and those of good M. Delacroix and M. Fraissinet enable me still to think with pleasure about my time in Morocco, which otherwise had nothing very interesting about it. [. . .] It has been a long time since I had any news of Tangier. I think, however, that M. Hay must still continue to take travellers to the old Roman bridge [. . .]."[71] The footnotes to this translation will show how much these memories have helped to clarify and explain Delacroix's own texts, as well as elements of his art.

The translation begins with "Memories of a Visit to Morocco," the unfinished article that Delacroix drafted in early 1843, and is followed by the short, related article on the Jewish wedding that he published in Le Magasin pittoresque in 1842. "Memories" is the only text to recount the start of the journey. The painter left Paris for Toulon on the night of 30 December 1831 in the company of Mornay, François Ferrary, the secretary assigned to Mornay, and Claude Marignaut, Mornay's valet; snow and cold weather made the trip difficult. Arriving in Toulon on 4 January 1832, they met up with their interpreter Antoine Desgranges and his servant Pierre Boispon, and on the tenth boarded the corvette La Perle, commanded by Captain Ange-François Jouglas.[72] The ship left on 11 January and arrived at Algeciras on the twenty-first, after having passed

70. Lagerheim, Minnen, 84–85.
71. Letter from Lagerheim to Mornay, 9 January 1836 (A.N. 402/AP/16). Delacroix drew this bridge: see the Tangier notebook, fols. 50v and 51v (below, p. 68).
72. For the names and dates, see the ship's log (Arama, Voyage, 6:117) and passenger list (Arama, Le Maroc de Delacroix, 204–5). A letter from Jouglas to Mornay testifies to the good relations between the travelers: "I speak for myself and these gentlemen [the officers of La Perle] in asking you to give our best wishes to M. Desgranges and M. Delacroix, and to assure them that the day when we will have the pleasure of seeing you all aboard once again will be for us all a real day to celebrate" (letter of 15 February 1832, A.N. 402/AP/16).

Minorca, Mallorca, Málaga, Grenada, and Gibraltar; Delacroix went ashore on the twenty-third.[73] This was his first view of Spain; he would go back there as a tourist in May. In Algeciras, the French vice-consul, Angrand, joined them and they left again for Tangier on 23 January, arriving the following morning.

The notebooks pick up at this point, in the harbor at Tangier. The text, more abbreviated, proceeds chronologically through the stay in Tangier, the trip to Meknes for the audience with the sultan, Delacroix's visit to Andalusia, his return to Tangier, and the trip back to France via Oran and Algiers. The text comes from four notebooks: the "Tangier notebook," the "Meknes notebook," the "Chantilly notebook," and the "Louvre notebook 1757." It includes newly discovered pages originally from the Chantilly notebook, but separated from it in 1864 and now in a private collection. And it makes reference to two more notebooks, which have recently come to light (see appendix B).

The notes and drafts for "Memories" are placed after the notebooks. These are in small cahiers and also on large sheets, some numbered, some not. They are full of information and clarifications not found elsewhere, and thus shed valuable light both on the trip and on aspects of Delacroix's paintings.

Pages from the notebooks that date from after the journey and do not relate to it are in appendix A. Appendix B sets out the full history and state of the manuscripts.

73. Louvre notebook 1757 contains a fine pastel of the Spanish coast, annotated "Salobreña, 19 Jan[uary]" (fols. 3v–4r, Johnson, *Pastels*, no. 21). A similar view in watercolor is in a private collection (New York, Artemis Fine Arts). A view of Vélez Málaga or Málaga, which Delacroix mentions in his notes, has not been located.

MEMORIES OF A VISIT TO MOROCCO

[This unfinished article was discovered as a consequence of research undertaken for the 2009 edition of Delacroix's Journal. *In all likelihood it dates from the first months of 1843. For the history and dating of the project, see appendix B.*

The text given here is that of the whole narrative, consisting of six cahiers of four pages each (referred to as 1-a, 1-b, 1-c, 1-d, 2-a, 2-b, etc.) and twenty-nine individual sheets (7–35). I provide the page or sheet number in italics between square brackets []; as the text often runs on from one page to the next, the number may be in mid-sentence.

The second part reads relatively continuously; in contrast, the first part, rougher and more hesitant, often breaks off, resumes, and goes off in a different direction before coming back to the original point. In both parts, Delacroix wrote in the margin the ideas that he planned to develop later. When those marginal notes are taken up in the narrative, I do not print them; but when they are not taken up, and they thus preserve an idea that was abandoned or lost, I print them in the section "Marginalia" below.

Delacroix noted a possible title in the first unnumbered cahier-a (see below, "Notes and Drafts," p. 140).

For Delacroix's itineraries, see maps.]

[Part 1]
[fol. 1r]
Is it possible to recount to your own satisfaction the events and varied emotions that made up a journey? Success in depicting the experience to others' satisfaction is a matter of talent; but will the one painting those scenes, whatever talent he may have, ever find in his own picture the exact features and subtle nuances of his impressions?[1] No person of good faith would deny the difficulty, and even impossibility, of the task.[2]

1. See the introduction on Delacroix's use of the ambiguous verb *peindre*, "to paint" or "to depict," and related words: *peintre*, "painter," "person who depicts," and *peinture*, "painting," "depiction."
2. On the circumstances of the writing, see the introduction, pp. 15–16.

It should also be acknowledged that, the more recent one's memories are, the harder it is to leave things out when writing them down. This statement at first seems almost a contradiction. Certainly, if it were only a matter of notes about the places visited, or about material information or statistics, you would get more out of the facts when your memory of them was still fresh. But if you are trying to describe the fleeting impressions that a thousand different sights could have left in your mind, something in your narration always falls short of your feelings. Those feelings are so vivid and fresh, and are attached to so many specific circumstances, that it would seem almost a profanation to let the public in on them and to hand them over to the indifference and frivolous curiosity of readers.

Conversely, at a certain distance from the events, the narrative will gain in simplicity what it would seem to lose in richness of detail and minutiae. You can slide more easily, and with less regret, over many things that, by their novelty, may seem more important than they really are. It is so hard to rein yourself in when you are holding forth! Many texts by modern writers make the mistake of having too many *intimate revelations* that bury the content under the form, and fail in the very effect that they are trying so hard to achieve.[3] The description of a journey should not be like a love letter that is delightful only because you read it with the same feeling that inspired it; you never tire of its repetitions and subtleties; they are the very basis and whole purpose of the letter.

The date of this journey is already long past; what would have prevented me from writing about it a few years ago is precisely what gives me the strength to do so today. I no longer see but through a kind of mist a host of details that then caught my attention; some of these now seem just so many dreams. A slew of notes jotted down in haste are unintelligible to me now. On the other hand, I see clearly in my mind all those things that one does not need to note down, and that are perhaps the only ones that deserve to be retained in the memory, or at least offered to readers. In recounting them, I will preserve only the kind of order in which chance presented them to me; this lack of artifice in the composition will, I hope, compensate for the abruptness of its transitions.[4]

3. As the italicized *intimate revelations* followed by a crossed-out "as they say" suggests, the confessional vogue—prefaces, memoirs, fictionalized personal writings—was in full swing in the 1840s: Walter Scott, Chateaubriand, Alexandre Dumas, Alfred de Musset, George Sand, among others, were well-known examples.

4. This disavowal of the literariness of the narrative somewhat resembles the foreword to the reader in Pidou de Saint-Olon's *Relation de l'empire de Maroc* (see below, note 26): "This work was not at all done for the public [. . .] I am not gifted with the talent necessary to hold myself up as an author. Therefore, do not expect to find either the arrangement, ornament, or eloquence of those in that profession. [. . .] It is only a very simple and very natural memoir of what I noticed on my journey." On the relation between Delacroix's style here and that of his *Journal* and "Dictionary of the Fine Arts," see above, pp. 16–17.

[cahier 1-a] We were setting off for an unknown land about which we were being given the most bizarre and contradictory ideas. It was a year and a half after the capture of Algiers, at a time when every Muslim alive was deeply offended by the blow delivered to the time-honored reputation of the Barbary states. Our departure took place on the coldest of December nights.

[1-b] At that time a journey to Morocco could seem as strange as one to a land of cannibals. All sorts of ridiculous or lugubrious occurrences became so many omens that would have given the ancients pause. On the way, we encountered only dead or dying people, broken mirrors, etc.

In Avignon. Going to visit the Palace of the Popes and entering the church, after lamenting the state of abandon in which, [turned into a barracks, it had fallen],[5] the first thing that we set eyes on was a coffin barely covered with a sheet, lying there by chance and as though forgotten. A sacristan, who had just opened the door when we entered that church dimly lit by a feeble glimmer, told us that it was the remains of the last Créqui, who had died the day before.[6]

No more cheery a sight awaited us in a kind of little cemetery next to the church. Gravediggers were in the process of performing a tragedy without [1-c] knowing it and parodying the graveyard scene in Shakespeare.[7] Those gentlemen, occupied with digging up the bones that had accumulated over centuries (no doubt to make way for more remains), were tossing the skulls to one another, not without mixing their curious entertainment with prayers and supplications.

We arrived in Marseille in the evening, in the most appalling weather.

I remember that at a place called, I think, the Vista[8] and where the road overlooks the sea, we heard for the first time the roar of that furious sea that was waiting for us to do with us as it pleased.

Description is not painting. A certain sentence by a great master in the art of writing, a certain choice, a certain harmony of syllables, presents a whole, a

5. The idea of this unfinished sentence (Delacroix writes simply "etc.") is provided by another sentence a little further on: "We deplored the fate of this palace turned into a barracks." The Palace of the Popes had been converted to a barracks in 1810. In a footnote, Delacroix adds: "We have learned that the Minister has just ordered, etc." This refers to a ministerial decision to protect the Palace, notably the Saint-Jean tower and the paintings attributed to Giotto that it contained. The meeting of the Commission of Historic Monuments of 27 January 1843 records the decision. See appendix B (p. 168).

6. There is no evidence of a Créqui who died in Avignon at this time. The last one seems to have died in 1803 and was from northern France. Delacroix may have mistaken the name.

7. "Hamlet and Horatio in the Graveyard" was one of Delacroix's favorite scenes, represented by him numerous times in different media: paintings, J(L)140, J258, J267, J(L)148 (see Johnson, 3:336 and Musée des Beaux-Arts de Rouen, Delacroix. La naissance d'un nouveau romantisme, exhibition catalog, 1998, no. 62), J332, J(L)158; lithographs, Delteil-Strauber 75 and 116; and watercolor (Vienna, Graphische Sammlung Albertina). Apart from the name of the town, this mention confirms Mornay's statement that the scene of J258 had been inspired by a cemetery at Toulon (Burty, Maîtres et petits maîtres, 70; see J258).

8. District on the northwest side of Marseille.

picture, to the mind. A long description has as its primary effect to be boring, and doubtless to introduce confusion.

The scourge of literature is description: yet what traveler does not want to describe at every moment? So you must still allow me, Sir, the description of that beautiful sea at Toulon, that ever so clear day, etc., or else the storm.

[1-d] One of the things that preoccupied me the most was to know whether it was really a storm that I was witnessing. It is no doubt very satisfying to be able to say that you have seen a storm, but, not to mention the possible draw-back of being served up to sea-monsters, nothing is more disagreeable at sea than a storm, or even just bad weather. If you stay on deck, [you have] continual spray, the wind howling in the rigging, etc.; if you go down into your room, the periodic rocking of the ship, now to the right, now to the left, the banging of the partitions, the jumping around of the furniture that is not secured and that comes, under its own steam, to meet you when you are expecting nothing of the sort.

I am not going to undertake to describe for the thousandth, for the hundred thousandth, time the varied effects of a storm. However, after reading about all different kinds, like everyone who will read this, I cannot help protesting about how unfaithful or mistaken most descriptions of them are, omitting as they do some of the most striking aspects. First, when you say a storm, you think that it must necessarily be accompanied by clouds blown about and ripped apart by the wind or the lightning. In mine, there was none of that. I had [cahier 2-a] never seen the stars so bright and the moonlight so clear. However, the pitching of the ship made the whole celestial vault dance around, and that multitude of constellations went back and forth over my head in an immense arc.[9]

Nothing serious happened in our storm, which perhaps was not one—except that, as I had neglected for a moment to hold fast on the deck where I was perversely enjoying that great dance of constellations that I mentioned above, I received the rudest whack from a [boom?].[10]

I also remember that, another night (for the bad weather lasted two or three days), although I had got used to it as much as possible, I was thrown [cahier 2-b] rudely out of my bed, or rather my box, right in the middle of my sleep, by a pitching movement more abrupt than usual. It must be said that experienced people take care to block the opening of their bed with a kind of guardrail that is called a "pitch rail."[11]

9. Delacroix returns to this storm, describing the same effects, long after: see *Journal*, 19 October 1856 (1:1041).
10. The sentence is unfinished.
11. *Planche à roulis*. English has no exact equivalent.

Once I was outside that box-like bed, and disturbed in my deepest slumber, it was impossible for a long while for me to recover [unfinished][12]

All these nocturnal adventures, and others, will make the least experienced sailor laugh with pity.

A calm had preceded all this turbulence.

The Spanish coast was the most varied and beautiful imaginable.

If I remember well, we first saw one of the Balearic Islands, Minorca, I think, with its low land and its ring of rocks hollowed out in deep caverns where the sea entered raging and with a tremendous roar. Then the magnificent mountains that can be seen in the distance, permanently covered in snow.[13]

[2-c] Vélez Málaga, Málaga.[14] The sky was so clear that it seemed as though we were only a short distance from this whole coastline. The next to last day, I think, of our trip we saw all of a sudden, like a great looming shadow, the bizarre rock of Gibraltar.[15]

It was not without emotion that we glimpsed this sort of pillar that the imagination of the ancients had placed at the end of their world.

[cahier 3-a] We had put down anchor in the harbor that stretches between Algeciras and Gibraltar, but were forbidden from going on land. We conjectured from afar what the latter must have been like. What is most interesting about it, certainly, is the rock's imposing look. You can also see here and there rather menacing openings, caves bristling with cannons and all the means of defense that have made Gibraltar a masterpiece of fortification. But none of that offered much interest for the imagination. We glimpsed next to those marvels of security the narrow little houses and paltry promenades that are England itself. I heard that they have transferred all their habits there. That tenacious need to be only themselves, which makes them separate themselves off from people of other countries, also insulates them from the climate and other aspects of any country they inhabit. One of the greatest writers of our time has very cleverly explained, in her *Letters of a Traveller*, the cause of this perfect isolation within Creation. It is the British atmosphere, that layer of English air that they have around them as planets do, in which they move, breathe, and act

12. My calm? my self-control? my sleep?

13. After the Balearic islands, and before Vélez Málaga, this would be the Sierra Nevada. A view of Salobreña (Louvre notebook 1757, see above, p. 23) depicts the Sierra Nevada in the distance.

14. Delacroix notes above this: "The view that I did." Vélez Málaga, a town in the province of Málaga on the Vélez river, had a Moorish citadel; the town of Málaga, one of the most important ports in Spain, is 45 km to the southwest. The drawing is unlocated. Louvre notebook 1757 has the trace of a sheet that is missing between fol. 4, which has the pastel view of Salobreña, a town located more to the northeast, and fol. 5. The view of Vélez or Málaga may have been on the missing sheet.

15. A drawing annotated "Gibraltar, 10 June," done as Delacroix left Morocco, is in Burty no. 30 (private collection), fol. 39r.

like true Englishmen, and that forms a kind of coating to protect them from human contact.[16]

[3-b] We therefore experienced only moderate regret at being deprived of the ability to go and admire that barrack-like place close up. It was not the same for Algeciras. That was the first Spanish town that we could see from so close. From our ship we could clearly make out the people strolling on the beach and even the women on their balconies. I got permission to go in a rowboat that was going into port to get provisions, especially fruit and vegetables, things that are very highly prized on board ship because of the difficulty of preserving them during a crossing of any real length. We thus stepped onto Spanish ground, but with pistols keeping us away from any human being. They handed us, so to speak, with pitchforks the provisions that we needed. We might have been considered in that period to be doubly plague-stricken: we were in quarantine and, in addition, French. Ferdinand VII was still alive and Algeciras province had just witnessed bloody executions following a military conspiracy that was getting a lot of attention at the time.[17] Thus kept at bay, I made do with admiring from afar a dozen idlers draped in their torn coats, who seemed to me so many heroes from Lesage or Cervantes.[18] I even managed to have some chocolate brought to me, that was put on the sand at the distance of a fishing rod. We set down some coins, likewise on the ground, in exchange for all those provisions, and the gentlemen who had brought them did not refuse to take our money, despite our suspect qualities.

16. Delacroix is referring to Letter X of George Sand's *Letters of a Traveller*, first published in the *Revue des deux mondes* of 15 November 1836 and then in volume form in 1837: "The natives of Albion carry about with them a peculiar fluid, which I will call the British fluid, and in the midst of which they travel; thus they are as little accessible to the atmosphere of the regions they traverse as a mouse is in the centre of the 'exhausted receiver.' It is not only to the thousand precautions with which they surround themselves that their eternal impassibility is owing. [. . .] It is because the exterior air has no hold over them; it is because they walk, drink, sleep, and eat in their fluid, as though they were in a glass bubble twenty feet thick, through which they look pityingly at people on horseback whose hair is blown about by the wind, and at pedestrians dirtied by the snow" (*Letters of a Traveller*, 276, adapted). The image of the mouse in the "exhausted receiver" (a vessel from which the air has been withdrawn, creating a near-vacuum) is one of total isolation from the world, as in a laboratory.

17. Delacroix alludes to the execution in Málaga, on 11 December 1831, of General José María Torrijos and his "army" of fifty-two men. for having fomented the overthrow of the reactionary absolutist regime of Ferdinand VII, and fought to reestablish the liberal Constitution of 1812. Attracted by the false promise of an uprising of the Málaga forces, the band left Gibraltar, was rapidly surrounded, and had to surrender; they were shot before the crowd, with Torrijos shouting, "Long live liberty." Algeciras is in Cádiz province, and Cádiz had been the seat of the constitutional Cortes, Spain's first national assembly. The government of Louis XVIII had intervened in 1823 to restore Ferdinand VII to the throne and to suppress the revolution, whence the hostility of the inhabitants that Delacroix mentions here.

18. Alain-René Lesage, author of the comic novel *The Adventures of Gil Blas of Santillana*, about a young Spanish valet and his many masters, first published in 1715. Cervantes's *Don Quijote* was first published in 1605.

Algeciras is situated, as is well known, at the head of a vast bay opposite Gibraltar, that is joined to land by a stretch of sand; here, on the Spanish side, the British have placed a camp that is the first line of defense of their installa- tion. At the time, everyone was talking [3-c] about an unfortunate incident involving the officers of the regiment then stationed in Gibraltar who, to have a little fun, had gone out hunting beyond the limits of the camp. They had been caught by the troop of José María, a notorious bandit of the time, the terror of respectable people and praised to the skies by the Andalusians, who considered him a righter of wrongs. His adventurous character and his fights with the police had made him the universal righter of wrongs.[19] Women were crazy about him and the people were infinitely grateful to him for the episode with the British officers. They had been stripped as bare as the back of your hand and forced to dance the saraband in this state to the accompaniment of a guitar. They had been taken back in that state not far from the lines of the San Roque camp, and dispatched with a "bon voyage."[20]

Our ship stayed only a morning in sight of Algeciras and we entered the Strait, with Apes' Hill on our left, which is like a pendant to the rock of Gibral- tar. Those two mountains are the Calpe and Abila of the ancients, the Pillars of Hercules that their imagination had placed at the ends of their world.[21] The African mountain has a less daunting look than its supercilious companion. Through a remarkable oddity, the European rock is, like the other one, inhab- ited by a race of monkeys that are an anomaly, they say, on Spanish and Euro- pean soil. Those monkeys are very inconvenient for the residents whose gardens they ruin. Scholars have run wild with conjectures to explain the presence of these animals on that stretch of seacoast. They have even gone so far, I'm told, [3-d] as to maintain that an underwater passage used to link Europe and Africa there, and conveniently brought them from this latter continent.[22] Scholars often go to great lengths to come up with explanations. Instead, it

19. Lagerheim writes: "This genuine Spanish robber-chief had long had his residence in the Alpujarras mountains, and led a corps of several hundred men with which he had on numerous occasions defeated the royal troops that had been sent against him. He was, according to popular legend, young, handsome, and very polite towards women, whom he had never mistreated. He took only from the rich, and generously shared with the poorer people, whose hero he consequently was, and who alerted and hid him when he was in danger" (*Minnen*, 101). On José María, see the introduction, p. 18.

20. A report on this episode, dated 26 December 1831, was sent to Palmerston, the British Foreign Secretary (London, The National Archives, FO 187, no. 9). San Roque was the Spanish camp near the border with Gibraltar.

21. The ancients called Gibraltar *Calpe*; Apes' Hill (Jebel d'Zatute, or Jebel Musa), near Ceuta, on the African coast, was their *Abila*. A drawing annotated "Apes' Hill, 10 June," done as Delacroix left Morocco, is in Burty no. 30 (private collection), fol. 38r.

22. This explanation is alluded to by Lagerheim too (*Minnen*, 29): "Because [the monkeys] are on both, a legend has arisen that there is a communication under the sea between these two mountains. The monkeys that dwell on the rock are protected by the governor, so no one can kill them, however much damage they do to the gardens, which they visit at night and plunder."

would make sense to grant that Nature put monkeys there just as she deprived the environs of Paris or Saint Petersburg of them, and that the anomaly, if it is one, did not worry the common father of men and monkeys any more than any other one did.

The two sides of the Strait are very similar, as far as you can tell at the distance you sail from the two coasts.[23] Traveling in Spain, you can appreciate the extreme similarity of these two lands, or rather of this one land obviously divided by a sudden incursion of the sea. The same character in the features of the terrain, everything, in fact, shows that these continents were violently torn asunder. If we wanted to be scientific here, this would also provide an explanation as natural as the scholars' for that colony of monkeys that we mentioned earlier. Caught by the disaster, they would have taken refuge temporarily on this sliver of continent as one hangs onto a plank in a shipwreck.

[cahier 4-a] In the Strait you constantly encounter small boats manned by Spanish coastal sailors or smugglers, their little pointed white sails crisscrossing it in all directions. On the prow of their craft, at water level, they usually have the painted figure of a head. They are considered to be very adventurous sailors; they are the humble descendants of those intrepid men who discovered new worlds and conquered continents, and, I dare say, the remains of that powerful Spanish navy that is now only a shadow of its former self. I do not recall having seen on that entire journey a single boat manned by Moors. It is the Spaniards who generally make the run between Gibraltar and Tangier. The British get a great quantity of goods from this latter place: livestock, horses, leather, wax, cereals, etc. In return, the Europeans, and especially the consuls, stationed in the African city get from Gibraltar all sorts of items for their use that Moroccan industry cannot supply. The time is already long past when the Mediterranean was covered with the sails of Barbary vessels that terrorized an immense stretch of the coast. Some of the northern powers still pay Morocco a tax that is supposed to protect them from piracy. But that piracy, especially since the destruction of Turkish power in Algiers, is a pure phantasm, and no doubt the second-order powers, such as Sweden and Denmark, who submitted to this tax, will take advantage of the hostilities between us and the Moroccans to free themselves of it altogether.[24]

23. A watercolor, annotated "Coast of Africa, strait of Gibraltar, 23 J[anua]r[y]," is in the Louvre (1626).

24. That is indeed what happened. Sweden and Denmark usually paid 120,000 francs per year so that their vessels would not be attacked (report from Mornay, reproduced in *Voyage*, 6:206). In 1844, they sent troops into Moroccan ports to demand that the treaty that had established this tax be revoked. The matter was resolved after peace was concluded with France. See Hay, *Memoir of Sir John Drummond Hay*, p. 66 and 68–70, as well as Godard, *Description et histoire du Maroc*, p. 613.

For nearly the whole length of the Strait, the terrain on the African side appears almost *[4-b]* streaked from the lines formed by cactuses and agaves. These seem like natural hedges around fields that lack only farmers and laborers. Here and there, you catch sight of a few crude huts, which are the houses of the primitive inhabitants. Nothing gives the sense of any agriculture or civilization. Here and there on the Spanish side you glimpse white dots that are little towns or isolated dwellings. Except for the rock of Gibraltar, that side of the Strait is less steep. Everywhere there are woodlands of holm-oak and rhododendrons, intermingled with great bare spaces.

Although the weather had been fine for a few days, the wind was only mildly favorable and we advanced very slowly, so that we took a long time to make our way through the Strait. Finally, in the first rays of dawn on January 24th, we caught sight of Tangier and the mountains that dominate it in the distance: to be sure, it was still somewhat through a grayish fog, and rather faint, but overnight the wind had turned favorable and the sails, gently swollen by the morning breeze, soon carried us speedily toward the harbor. We took repeated soundings. The harbor is vast and seems reliably sheltered. However, it is not without danger, according to the sailors. Almost everywhere it offers only poor conditions for mooring, and we proceeded *[4-c]* with the appropriate precautions.

The rising sun at last showed us our journey's end. We saw Tangier with its Kasbah holding pride of place above the port. Long, crenelated walls descend from it down to the town, which is nestled in a little valley that spreads out and rises a bit from the seashore.

The look of a Moorish city has something enchanting about it. It is not, as ours are, bristling with ugly pointed rooftops like so many threats hurled at the sky, and its walls are not riddled with windows and dormers that at a distance offer the eye only confusion. When you arrive by sea at Brest, Fécamp, Le Hâvre, or any other European port, you will glimpse a confusing heap of grayish houses in which the eye can discern no form whatsoever. A Moorish town, in contrast, is surrounded by high walls, which define its position and do not offer the eye those miserable neighborhoods and buildings adjacent to the town itself, which prevent you from taking in the whole and seeing exactly how far it extends. Every one of those cities, like Tangier, Algiers, and Oran, offers the eye a distinct cluster, buildings that are easy to make out by their simple square shape; their bright white color stands out strongly against the deep green of the countryside, in the season when the greenery is still fresh, or against the golden color that the landscape becomes when the heat has parched the earth and made the vegetation wither.

The day of our arrival was a Sunday; on that day the consuls of the various nations raise their flags, *[4-d]* the colors of which, as they flutter in the breeze,

contrast sharply with the white of the houses. You can also see the small flags that are raised at the different prayer-times flapping on the tops of the mosques. I had never seen anything like that and I found it enchanting. I entered those buildings in my imagination. We passed the spyglass round to try to distinguish one from the other and to make out the inhabitants and the activity in the port. We made the usual salute, to which the city responded by raising a red flag, which is the Moroccan flag. The way in which our salute was answered won the approval of the sailors, who were very punctilious on the matter of etiquette and were not expecting so much observance of the rules. However, although the intervals between each shot were very well observed, you could see that they were fired from three or four different batteries.

Soon we saw leaving the port a large dinghy, which brought our consul out to us.[25] The crew of the dinghy consisted of Moors, whose faces we thus saw for the first time. The sailors smiled at the sight of this heterogeneous crew *[cahier 5-a]* made up of men of every age and type. Some wore the costume of the sailor, which is the same in all the Barbary states. It is that of the Moors of Algiers, that is, an embroidered jacket and baggy trunks fastened with a belt. Others were covered in a djellaba, a type of garment used by the people and very common only in Morocco. It is a large cassock or rather a kind of sack with a hood and sleeves, usually striped and all in one piece, which covers a man from head to toe and gives him something of the look of a monk. This garment of coarse cloth is a kind of shelter in which a Moor can brave the elements in every season. When he does not need to move, he withdraws his hands under this coarse cloak and takes refuge in his casing like a tortoise in his shell.

The consul came aboard and was greeted by us and the commander of the corvette; the strange figures who had brought him were on deck in the blink of an eye, scrambling up the sides of the ship like cats, without the help of any ladders. This sudden incursion, and their boisterous and curious look, made the most perfect contrast with the composure and military bearing of our sailors, who very calmly let themselves be examined by these guests who were as black as soot.

[5-b] After a visit of about an hour, the consul returned to Tangier. It had been agreed that we would disembark only the following day, no doubt to give the Pasha or Kaïd, who governs the province and resides in the Kasbah, the time to organize the protocol and prepare to receive us. This necessity of waiting a whole day to be admitted within those walls where I could make out so many interesting things was no small disappointment. That day alone seemed to me longer than the entire crossing, and from then on, the imposing sight of

25. Jacques-Denis Delaporte, the administrator of the French consulate. See 24 January.

what we could glimpse of the city ceased to have the same appeal. Nonetheless, the slightest movement there attracted our attention.

There is no traveler who does not indulge beforehand in the sterile activity of imagining the look of the people and things that he is going to encounter. During the long hours of idleness and tedium that we had spent at sea, I had read an already very old account of Morocco, and constructed from it a very definite and specific world that the sight of the first street in Tangier was to dispel completely.[26] We had the good fortune, for a traveler, of arriving with no transition among a people who were entirely new to us and about whom we had almost no information. On overland journeys, [5-c] each new object that you discover prepares your mind for those to come, and makes the change of *mores* and customs less abrupt. We assumed overall that we were going to see something similar to Turks. For an inhabitant of Paris, every follower of Mohammed is considered to be Turkish, and we take as such those marginal individuals, shivering with cold, whom we meet on the boulevards, sporting a beard and turban along with a sports jacket and boots.

The next day finally arrived, and on 25th January, in the most beautiful sunshine imaginable, we reached the port of Tangier. Our sailors had to take us in their arms and carry us knee-deep in water so as to set us on land. It is hard to believe that the port of one of the most important cities of the Empire does not even have a pier so that you can disembark without getting your feet wet.[27] The port of Tangier is only a beach surrounded by buildings, and probably not a single voice has been raised for centuries against this bizarre drawback. We did not pay much attention to it ourselves, since our curiosity was so piqued by the military [5-d] display that the Pasha had staged in our honor. He was waiting for us himself in a little open boat that was fifty feet from the shore, and he had two or three dignitaries or officers near him. Nothing had prepared us for the majestic simplicity of that reception. Instead of the gaudy, showy luxury with which our imaginations adorned in advance, if you will, a throng of pashas, spahis, and bimbashis[28] in ceremonial or theatrical costume, we saw before us three or four handsome old men, with white beards, wearing togas like members of the Roman senate, without any weapons or ornaments

26. See the introduction, p. 3. Of the works published before 1832, two stand out for their parallels with Delacroix's text: Léon de Chénier, *Recherches historiques sur les Maures et histoire de l'empire du Maroc* (1787); and François Pidou de Saint-Olon, *Relation de l'empire du Maroc* (1695). Although considerably older, the latter contains, more than Chénier's, numerous points in common with Delacroix's notes and narrative. Delacroix could have nevertheless gotten details from Chénier, whose work was more historical. I indicate in the notes the main parallels between these works and Delacroix's.

27. The sea was so shallow that large vessels could not approach: men and supplies had to be carried by the sailors, and most often Jews (Lagerheim, *Minnen*, 51).

28. *Bimbashi*, "commander of a thousand men," a major, naval commander, or squadron leader in the Ottoman army; *spahi*, a cavalry soldier in the same.

whatsoever. The soldiers who formed a line were dressed likewise, except that they were a little less hidden in their robes.

White dominates in all those outfits and brings out beautifully their black or bronze-colored faces. Ordinarily a caftan of a brightly colored cloth—scarlet, sulphur yellow, pastel blue—hangs down to a little below the knee, and is covered by a caftan of same type in fine white cotton or dimity. This lets the other one show through only via an opening a little toward the bottom, because of the unevenness of the folds that fall from the belt and at the sleeves; the latter are wide and roll back at the slightest movement, leaving the arm free *[6-a]* and completely bare. On this type of dazzling white overcoat, which just lets you guess at the garment underneath, they wear silk cords of bright colors that cross their chest; these support the saber or dagger suspended at their side, or a kind of sack or "sabretasch" of very finely worked leather.[29] There are none of those enormous shawls twisted and rolled around the hips, and going almost all the way up to the chin, as with the Turks. A very narrow belt in very finely worked leather and velvet—red, yellow, or light green—clasps the waist with a truly martial elegance. Sometimes the belt has other cords hanging from it, which, knotted, support a powder-flask in the shape of a horn, a very inconvenient accessory, but with a very graceful look. Their legs are bare and their feet shod in slippers of a traditional shape, which are uniformly yellow, and go up to the shins like the footwear of the Ancients. The turban is always white and, leaving the forehead uncovered, is wound around a raised, pointed cap of an oxblood-red color, which is the distinctive headdress of the soldier.[30] Over all that is draped the burnous, the edges of which, thrown back, clear the arms and fall on the shoulders, forming those straight folds that *[6-b]* we admire in classical statues, and that I had thought were an invention of the sculptor. The burnous is not made of a limp fabric and does not crush the head as in Algiers, where they have the habit of tightening it around the head with an ugly black cord that attaches it to the turban and spoils its shape. In Morocco, it is almost starched, and comes to a raised tip on their head, adding to their height and giving the opening at the shoulders a very imposing look.

This description, which will perhaps seem a bit long, is absolutely necessary to explain the type of joyous excitement that I felt at such an unexpected

29. A leather satchel suspended on the left side by long straps from the sword-belt of a cavalry officer.

30. Notes in the margin complete this description of the military outfit, which Delacroix represented many times: "The silk handkerchief that hangs from the belt and is in the hand that holds the rifle. Often worn alone, the cap, like the Emperor's soldiers. For Meknes." As this last remark indicates, Delacroix intended to discuss the costume when he reached the part of the narrative that dealt with Meknes (the soldiers' dress is depicted in detail in *The Sultan of Morocco and His Entourage* [J370]). See the watercolors from the Baltimore Museum of Art and from a private collection reproduced in *Delacroix: Le voyage au Maroc*, nos. 17 and 18, cat. Paris. Numerous studies of turbans and haiks are in Burty no. 30 (private collection), fols. 18–21.

sight. The good consuls were very surprised by my transports of admiration; they had long since become blasé about the feelings aroused by this country, and were more occupied with champing at the bit while they waited for a better posting than admiring those rarities that they had ceased to notice.[31] Those gentlemen had all come in full uniform to receive us politely when we disembarked, and I confess that their drab, somber outfits, next to which those of our own officers looked no better, seemed to me very inferior to those of the Africans; certainly a god who came down from Olympos to spend some time on earth, and was asked to choose [6-c] one or other way of dressing, would not have hesitated to prefer the majestic dress of the Moors, who, compared to us, could be taken for so many kings.

I neglected to say that, after the little welcome, no doubt very obliging, that was adressed to us by the Kaïd, unfortunately in the language of the country, the drums and music had created a sudden diversion, no doubt to spare both sides the difficulty of paying more tributes. That music, which will appear often in this narrative, for it is part of every celebration, not to say every moment, deserves a separate description. Suffice it to say for the time being that it greatly surprised us by its strangeness, while it also had a martial character that roused one to action.

It remained for us to get to the consulate where we were to stay, through the bronze-toned crowd that surrounded us and blocked the streets. The consuls obligingly formed a kind of escort around us amid that mob of people. In addition, the Pasha provided for the security of our passage by placing his chamberlain at the head of the procession. Armed with a big stick, he struck, right and left, into the thick of [6-d] that hooded throng. We perceived him twenty feet in front of us, gesticulating to open the way before us, and pursuing with his curses those he could not reach with his stick. We also noticed a great number of women on the terraces, covered up to their eyes, who added their cries to the tumult and crowned all the houses on our route. We were finally able to take a break from all that commotion; and with that, I will leave my readers a moment to catch their breath a bit, too.[32]

[Part 2. For a plan of Tangier, see Map 1, p. 61.]
[7] Waking up in the morning in a strange and completely new place that you have come from far away to discover is one of the most pleasant sensations you

31. Lagerheim confirms this statement: "On the way to the French consulate where we were accompanying him *[Mornay]*, it was funny to see his astonishment and to hear his amusing remarks about all those things, so strange for a Parisian, that he encountered with each step" (*Minnen*, 96–97).

32. Here ends the first part of the narrative. In the manuscript, the rest of the page is taken up with notes that will be used for Part 2. See "Notes and Drafts," pp. 137–38.

can have. You go over in your mind everything you noticed the previous day through the confusion and turmoil of the arrival, with a new desire to see all those marvels again in detail. The consul's residence was a Moorish house, which had been converted into European-style quarters as best it could. We already had before us a striking sample of the local architecture.

In the daytime, we were to be received by the Pasha inside the Kasbah.[33] We got ourselves ready for this visit, and around noon we went back along a part of the route that we had taken the day before to come from the port; then, entering a maze of little streets, we arrived at the foot of the ascent that leads to the fortress. We went into a vast courtyard surrounded by buildings placed seemingly at random and piled up one next to the other. A striking feature of all Moorish houses is a completely bare external appearance that gives no indication of the elegance and charm of their architectural design, which they reserve for the interior decor. What is also remarkable everywhere is the dilapidation and abandoned look of all those structures. At first glance, you see only ruins, and you wonder how it is possible even to shelter there. The walls are full of cracks [8] in which grass grows profusely and you see whole trees living and thriving very happily. Looking at these shacks, a French person can be justly proud of his straight streets and his fairly well maintained monuments; yet it must be acknowledged that the traveler who returns from England or Holland has, upon re-entering our country, something very much like the impression of these Oriental cities overrun with dogs, chickens, rubbish and waste, and all those natural consequences that result from negligence and carelessness.[34] The most beautiful provinces of France, after one has just seen Holland, for example, seem dreary places ravaged by plague and war. The run-down look of the villages in Picardy and around Paris inspires a deathly gloom, and they seem as though they must be inhabited by the poorest and most unfortunate people on earth. The horrible costume of our peasants, and the tasteless, baggy tatters that cover them, do not inspire any better opinion of their social condition. Perhaps the elegant native dress of the Moors, and the nobility of their look, made the contrast that we noticed everywhere between the splendor of their dress and the dilapidated appearance of their buildings all the more striking. Moreover, the most magnificent sunshine, and a sky so pure it could only inspire happy thoughts, clashed in our minds with the apparent poverty of those buildings.

We were let into the palace by a little doorway that opened onto a lane full of rubble. You got to that doorway by a few irregular steps that [9] seemed to be formed of blocks that were hardly even squared. The garden that we crossed

33. The Kasbah, "Dar Al-Makhzen," is in the eastern part of the citadel. It dates from the early eighteenth century and is now the Regional Ethnographic and Archeological Museum.
34. Delacroix had been to England in 1825 and to Holland in 1839.

presented the same lack of care, but its unusual layout attracted our attention. The Moors are very fond of arbors over their walkways. It is an artificial way of creating shade. The paths are not winding as in our gardens: they are built of masonry and laid out straight, and are raised above ground level so as to let the rainwater run into the cultivated parts. It is the opposite of what you see in our country, where the paths, unless they are continually maintained, become on rainy days like so many ditches, to the detriment of the planted areas, which they deprive of water. The sight of orange trees, jujubes, and other species rare in our climate made the rather dreary look of this garden, surrounded as it was by high walls, considerably more cheerful.

We were led up to the Pasha's, whom we found settled in a kind of pavilion with a view of the sea.[35] He was seated in a recess one step up, which is found in nearly every room and which is undoubtedly the place of honor. This platform-like structure was covered in rugs and, above, with little flattened mattresses and cushions of all shapes, especially round ones. He had near him two people, crouching like himself, of whom one was Bias, the customs administrator, a very important man whom we will discuss later; also his son, a fat man with an oily, dazed-looking face, who did not breathe a word and hardly even raised his eyes the whole time of the meeting. It seemed to me that we cut a ridiculous figure, seated on rattan chairs in the presence of those three people who were imposing at least by their size, and crouching like idols in their shrine. A great effort of imagination was needed to come up with something to say to those beings who seemed of a different nature from our own, and God only knows how our interpreter translated for them all our attempts at conversation.[36] [10] That interpreter was a rich Jew from Tangier attached to the consulate, and who sweated blood and tears to translate, from Arabic into French, and from French back into Arabic, phrases of complete satisfaction, mutual esteem, and other banalities usual in such presentations. We were served tea and some local sweets. Tea alone would merit an entire chapter in a history of Morocco; it plays a great role in all social relations, and was another of our surprises in that strange land where, being Muslim, people do not consume either coffee or tobacco. This tea, which they drink at every moment, is strongly flavored, and very disagreeably so for people who come from Europe, with an

35. On the people mentioned in this paragraph—Sidi El-Arby ben Saïdi, pasha of Tangier, Sidi Ettayeb Bias, the customs administrator, and Abraham Benchimol, the interpreter, see 25 January.

36. As a letter from Drummond Hay explains, "On a late visit by the Count de Mornay to the kaïd of Tangier, Mr Desgranges' Oriental Arabic was found so unintelligible by the Moors, and himself so little capable of following the discourse of the kaïd, that the Jew interpreter of the French consulate is said to have been of necessity sent for" (London, The National Archives, FO 174, no. 162, p. 102).

infusion of herbs similar to mint or sage, which they mix in and which changes the taste.

We ended the session and left the Pasha; but he had the good grace to have us taken back another way, passing through the most interesting parts of the Kasbah, including a vast courtyard. We saw numerous structures that could be called composite. We noticed this especially in a large square courtyard with columns and marble paving that bore the mark of European handiwork, either because the Portuguese, who long occupied Tangier, had finished off buildings begun by the Moors, or because the Moors, after the expulsion of those temporary masters, had used materials prepared by the foreigners.[37] The union of those styles has nothing disparate about it: a taste both simple and austere gives to the ensemble the necessary elegance and unity.

[11] First thing in the morning, the Mouna, or supply of provisions, had been received at the consulate; the Emperor, during the whole of our stay, continued to send us this at regular intervals, and with a wholly imperial munificence.[38] We well imagined that all that abundance did not in the least impoverish His Majesty's treasury. Everything in that country seems to come from the Emperor, but assuredly everything returns to him too. Like the sea whose waters rise liberally to form clouds, only to fall elsewhere as rain, and that at the same time is not above absorbing the most humble streams, that prince unscrupulously appropriates whatever is to his liking of the fortune of his subjects great and small.[39] The system of extortion, that simplification of the financial apparatus, is the nerve-center of power in these half-barbarous countries. The Pasha had charged some individual with providing fruits and vegetables, and another sheep, fowl, milk, and butter for our consumption. By a kind of poetic justice, the Pasha, himself enriched by the same means, is threatened from time to time with seeing himself pressured to fill the imperial

37. The white marble columns with composite capitals that surround the central patio are indeed European, the capitals having been made in Italy by a supplier to the Ottoman court at Constantinople. See Kamal Lakhdar, "Palais de la Casbah," in Discover Islamic Art, accessed 11 May 2017, http://www.discoverislamicart.org/database_item.php?id=monument;ISL;ma;Mon01;18;fr/. The Portuguese ruled Tangier from 1471 to 1662.

38. The Mouna, an offering of hospitality given to travelers, is described in greater detail in Delacroix's notes: "Cattle, sheep, chickens in Biblical plenty" (2nd unnumbered cahier-d, p. 148); "dozens of fowl, enormous baskets of oranges and lemons, fruits, vegetables, meat" (1st unnumbered fol. r, p. 149). Robaut (L'Œuvre complet de Eugène Delacroix, no. 388) reproduces a drawing highlighted in watercolor, annotated "28 January, the mouna," representing baskets full of fruit, fowl, eggs, etc. (unlocated). Delacroix considered doing a painting on this subject (see the "sheets of Moroccan subjects," Journal, 2:1517).

39. "The fundamental aspect of the organisation of the state is that the Emperor decides everything and his subjects nothing. He can at will deprive an individual of the wealth that he has acquired through his own work, without anyone finding this unusual. For he possesses it only by grace of the Emperor, who will take back whatever he wants, which only leads the poor man to say "Allah kherim der" [God is merciful] and to start again from scratch, considering himself lucky if he has not been beaten" (Lagerheim, Minnen, 63).

coffers. There are few provincial governors who can pride themselves on being able to transmit to their children the fruits of their plunder. When they die, the Emperor, that source of all favor, does whatever he fancies with their post and their fortune, which ordinarily devolves to him.

[12] That precarious position, far from inspiring in the kaïds and provincial governors a laudable spirit of equality and humility in the enjoyment of worldly things, only increases their natural avidity. Everything becomes an occasion for them to exercise to their own advantage the absolute authority that the Emperor liberally grants them over his subjects, and which is all they get from him. The poor Jews, as might be imagined, are the primary and most constant victims of these abuses. Thus they carefully hide their wealth under the most simple exterior, keeping to themselves what they can save from the claws of the Pasha, to enjoy in their own houses and among their own family.[40] Although human life counts for little in that country, corporal punishment is rare; for you must not count as such those beatings on solemn occasions, which we saw so liberally applied on our arrival so as to clear the way for us, and which, falling on everyone, fall on no one in particular.[41] All offenses can be bought off with money, and everything is easily converted into an offense. In that country where it is claimed that Sultan Moulay Ishmael, the Moroccan Nero, regularly cut off the head of the man who held his stirrup for him every time he went riding, there had not been, when we arrived, an execution [13] for seven years.[42] In contrast, every Moor whom I managed to tempt to the consulate to sit for me consented only reluctantly, and only with the promise of compensation. At first I attributed that aversion to their religious scruples, for, as we know, the Qu'ran does not allow depictions and representations of the human face. But I soon learned that they trembled at the idea of the fine that the Pasha, attentive to heaven's interests, was quite ready to inflict on them if he learned about their transgression.

The interior of Tangier does not live up to the favorable idea that you have of it when you see it from afar, and especially from the sea; for anyone more sensitive to comfort and the regularity of buildings than to the charms of the picturesque, that city must seem lower than even our poorest villages. You have to exclude, however, certain monuments such as the Kasbah, which I have

40. Pidou de Saint-Olon (*Relation de l'empire du Maroc*, 84) makes the same point, as does Lagerheim: "Many of them were able to amass a fortune and live in luxury behind the doors of their houses, all the while wearing rags and tatters and affecting poverty when they appeared outdoors" (*Minnen*, 47).

41. See above, cahier 6-d, p. 36.

42. In contrast, a note in "Notes and Drafts," 1st unnumbered cahier-b (p. 141), mentions the French executions in Algiers. Moulay Ishmael, "the Bloodthirsty," reigned from 1672 to 1727.

already discussed,[43] the mosque,[44] and a few prominent buildings; and it should also be understood that I mean only the exterior of the houses. On the outside, these are just square shacks in the form of a cube, very rarely of two stories, and with no opening onto the street except a very small, low doorway, on which you need to be careful not to bang your head if you go in too quickly or without paying attention. An aversion to windows is another character trait peculiar to the people of the East. Communication with the outside world must be as restricted as possible, and the purpose of the door itself seems less to give access to the interior than to thwart *[14]* curiosity and hide the life of the inhabitants of the house. You find, on entering, a kind of dark corridor that turns back on itself before leading to the courtyard, so that you see only a wall in front of you. In the houses of the poor, the interior does not offer many more refinements than the exterior promises. As for the layout, it is the same for all dwellings: it is always bedrooms, or rather a single bedroom, placed on each side of a square courtyard, and getting light only from that courtyard via a doorway in the middle.[45] When the door is closed, it is completely dark in the room, and you can appreciate, when you see the same parsimony in the distribution of openings inside as well as out, that it does not only come from the need to avoid being observed: such a layout would be as ridiculous in our country as it is sensible in a climate where the temperatures are scorching for three-quarters of the year. Out of a similar precaution, the walls are decorated with faience to a man's height. This keeps it cool, and you have less bother from insects, which have trouble settling on it, and can be seen and killed easily. In Marrakesh, where reptiles, especially, and scorpions are very common, a channel of water is laid out around each room. In the middle of the courtyard, paved with little squares of faience or marble of all different colors, you normally find a little cistern adorned likewise: sometimes a pretty fountain is placed in the angle of the courtyard and the gallery of *[15]* elegant columns that form a peristyle around the perimeter.

Everything that we have since seen in Algiers has no doubt blunted the intense surprise that could still be felt at the sight of these delightful houses. You would think that, having imagined them to some extent, you should be very struck by their elegance when you see them in reality, comparing them in your mind with our dismal dwellings that bristle with precautions against the inclemency of the climate, and where the least ornament seems a useless

43. See fols. 8–10 4-c, pp. 37–38.

44. The Great Mosque, Djama el-Kebir, built in the reign of Moulay Ishmael (see above, note 42).

45. In the margin, Delacroix writes: "Door curtains on these doorways. Talk about them in Meknes." Cf. 22 March, p. 97.

excrescence.[46] However, it was left to the Europeans to destroy in Algiers, as if wantonly, everything they possibly could in the arrangement and ornamentation of the Moorish houses.[47] It was supposed to be the case that, with our caps and uniforms, we would introduce a different climate and new conditions of existence into the land of Africa. I saw in 1832, in Algiers, only a year and a half after our conquest, the most bizarre changes: in the magnificent gardens of the dey, the orange trees had already been uprooted; the paths and the entire terrain were horribly churned up, the marble basins filled in and the water sources dried up because the conduits had been broken.[48] We seemed especially eager to knock windows everywhere according to our fashion, and to paste wall-paper over the paintings on the walls. I saw, in a multitude of palaces, brick or wooden partitions erected to wall up the intervals between the pretty columns that form a gallery around the courtyards and support the upper floors. Little doorways were cut into them and rooms made out of them for the use of that mob of civilised men who were taking the place of the Arabs. The roads were widened too, as much as possible, so that carriages, cabs, and even diligences could pass, objects that seemed supernatural to the Arab imagination.[49] [16] In place of those winding streets that seem like underground cellars, where two people could barely walk side by side, and where the walls, running close together just above the heads of the passers-by, kept it delightfully cool (a primary advantage in that climate), fine, wide, perfectly straight roads were opened up, with beautiful shops exposed to the burning heat of the African sun; ignoring the fact that, even if there were shopkeepers tough enough to set themselves up there, they would have to force potential buyers to patronize them at the risk of their lives.[50]

I have no doubt that, during the twelve years that have passed since that conquest, we have outdone ourselves still more in these cruel executions visited upon the innocent marble and the plashing fountains, the delight of the former inhabitants. The pick and the digger, those instruments of progress, have done justice to the mosques, which were serving no purpose but to encumber the public highway;[51] we had the barbarous hard-heartedness,

46. In the margin: "The beams, the ceilings painted. Moorish ornaments as opposed to Turkish ornaments later." See also "Notes and Drafts," cahier 6-d, p. 138.

47. On the destructions in Algiers, see the introduction, pp. 5–7.

48. See the introduction above, p. 6. An order was issued by the Duc de Rovigo, general in chief of the army of occupation, on 12 June 1832 prohibiting the destruction of conduits (Pichon, *Alger sous la domination française*, 244, cited in *Foreign Quarterly Review*, p. 87).

49. In a crossing-out, Delacroix compares the strangeness of these vehicles, for the Arabs, to the difformity of the camel for Europeans, an example of cultural relativism that he later used in his article "*Des variations du beau*" ("On the Variations of the Beautiful") of 1857.

50. See the introduction above, p. 5.

51. Delacroix is referring to the destruction of the Sayidda mosque for the creation of the main square. The demolitions began in April 1831, were interrupted for several months, and were completed in June 1832 (see Zineb Merzouk, "1er avril 1831, démolition de la plus belle mosquée d'Alger,

under the same pretext, to ransack the Moorish cemeteries on the outskirts of the towns, whose graves, still fresh, I saw torn up and piled high, along with human remains, to the great and justified distress of sons, fathers, and husbands, reduced to watching helplessly the troubled remains of their loved ones exposed to the light of day.[52] We all know of the respect and superstitious devotion of Orientals for the dead; it is thus not hard to understand the bitter feelings and ferocious rancor that these acts must have awakened in their hearts, already so little disposed to feel any warmth for the benefits of our rule.

This little digression, for which I apologize, especially if it wounds our national pride, will perhaps not be too much out of place in a somewhat whimsical narrative like this one, which proceeds very much at random like the memories that are its subject. As I do not claim to be giving a *[17]* scholarly description, and as I have not paid attention either to politics or to official statistics, a science that is much abused, I may be forgiven the personal reflections, the repetition, disorder, distractions, and even contradictions contained in it. I will even dare to say that the people whom I was observing seemed to me by turns horrible and admirable, and I will say as much for their habits. I found men who were more men than we are, who combined the simple, vigorous feelings of a young civilization with the most diabolical guile and sordid vices that seem the result of corrupt societies. It would be no small feat, for someone who could carry it out skillfully, to present a true picture of those bizarre contrasts. To depict such people, you must confront the greatest of all difficulties in the art of writing, that is, to move constantly from an elevated register to a colloquial one that is suited to the depiction of the grotesque. You must, as it were, change pens constantly. You see the most imposing things transformed before your eyes, and with no transition, into the most ridiculous. You find *mamamouchis* as amusing as Schabaham himself,[53] alongside Classical figures who seem to have stepped off a pedestal to tap you on the shoulder. There is practically no middle ground between these two extremes. What has no place

............

Djamaa Es-syida," accessed 25 February 2017, http://www.babzman.com/1-avril-1831-dem olition-de-la-plus-belle-mosquee-dalger-djamaa-es-sayida/, and Pichon, *Alger sous la domination française*, 119). See the introduction, p. 6.

52. A large cemetery was dug up outside Bab el-Oued gate in order to construct an esplanade; tombs and funereal monuments were also displaced outside Bab el-Zoun, the eastern gate, to make way for a new road, and to build a flight of steps leading to the Fort de l'Empereur (Pichon, *Alger sous la domination française*, 280–81, cited in *Foreign Quarterly Review*, p. 93). Pellissier de Reynaud reports, like Delacroix, the scandalous sight of corpses "exhibited for all to see by the side of the road," and the "gaping sepulchers [. . .] like so many accusing mouths from which the laments of the dead seemed to emerge and mingle with those of the living." See the introduction, pp. 6–7.

53. Schabaham is the grotesque sultan in the novel by Crébillon fils, *Le Sopha* (1742), seemingly a caricature of Louis XV. Delacroix writes "Shaabahm." Mamamouchi is the fake Turkish title given to the absurd M. Jourdain in Molière's *Le Bourgeois Gentilhomme* (1670).

there, or almost no place, is triviality, that very sustenance of our own little world, which we come up against absolutely everywhere, on our streets, in our drawing-rooms, and especially, alas, in our arts. Cato polishes your boots, *[18]* Brutus hands you your coat. The spy from the consulate, charged with reporting all the little stories that were circulating in Tangier, and who earned twenty cents a day from this "honest" profession, was a great, robust old man who gave the most perfect impression of strength, equanimity, and leadership; he was Agamemnon, king of kings. I could go on with these examples, and perhaps the sequel to this narrative will bring out some more. I scorned them when I was among them, yet when I saw the Moroccans again in Paris, my heart beat as though I were seeing my own brothers.[54]

As is clear from the above, there was no lack of material to pique our curiosity. We spent our time visiting the city or the interiors of Jewish houses. The precautionary features that the Moors' houses presented should make it obvious that they were off-limits to us. Yet in their layout, the houses were all the same. An exception was nevertheless the British consul's, which was an English house in every respect, with the bareness, and also the comforts, of a little house on Oxford Street.[55] The Jewish houses presented nowhere near the same resources for this dull and self-centered comfort, the sole god worshipped by northerners; but they offered in compensation the whimsy and elegance of the Moorish style. *[19]* The women whom we met in them were not the least of their charms: for you needed to see them at home and not in the streets, where they usually went wrapped in a large veil that hid the beauty of their dress. These women are both beautiful and pretty; their clothes have a kind of dignity that is both elegant and charming. Their headdress consists ordinarily of silk kerchieves piled on their head and held in place by a pearl diadem that falls down slightly onto the forehead and is gracefully raised up over the temples *[fig. 8]*. The ends of these kerchieves fall down their back, along with ribbons that flutter behind them when they walk. These pieces of fabric are usually joined to a cord, interwoven with their braids of hair, and which, attached at their hips by a belt, falls almost to their feet, where it ends in a very ornate tassle. Enormous earrings laden with uncut gemstones, like gothic or Byzantine jewels, frame their pretty faces.[56] The massive form of these

54. Delacroix is referring to the troupe of Moroccan acrobats from the sultan's court players who gave three performances at the Théâtre de la Gaîté from 16th to 27th February 1837: "Ten Arabs, or the Moroccans from the Atlas Mountains," They attracted enormous crowds, including Delacroix's students Pacifique-Henri Delaporte, son of the French vice-consul in Tangier during his stay there, and Charles Cournault (letter of Cournault to his father, in Hecre, "Des objets d'Orient," n. 45; see also *Figaro: Journal — livre — revue quotidienne*, 15 February 1837, 139).

55. "Drummond Hay was well paid and had the best appointed house in Tangier" (Lagerheim, *Minnen*, 37).

56. Several drawings correspond to this detailed description of the headdress and adornment of the Jewish women of Morocco, such as Louvre 1611 and the series of drawings beginning on fol.

ornaments seems not at all inelegant: it adds by contrast to the delicacy of their features; however, because of their weight, the rings are attached to the head-band by a little metal chain. Everyone knows the charm of those Oriental eyes, and especially what they owe to the little black line that women paint around the edge of their eyelids. They use, for this purpose, a mixture of antimony that they call kohl.[57] This little trick gives the eye a very special appeal [20], something leonine and almost wild that livens up their sweet, regular little faces. The extreme whiteness of their complexion is justifiably surprising in that climate; but as can easily be imagined, this kind of charm is found espe-cially among the Jewish women who belong to rather well-off families, and are not obliged constantly to go out into the town like those whose lower status forces them to work. Bracelets, necklaces, and an embroidery that covers the bodice and part of the skirt, which is very simple and usually of a plain dark color, complete this outfit.

Along with all that, they have (and it is their main attraction) little bare white feet, lightly fitted into pointed slippers that, open at the back, show off their charming pink heels.[58] When they are at home, they leave this footwear off, and set their lovely feet freely on rugs or mats. On the lower part of the leg they wear a very wide silver bracelet, which embellishes its bareness and brings it out very gracefully.

The brothers and spouses of these goddesses inspire nothing like the same interest. Generally they have fine features and especially fine eyes; but a look of obsequious attentiveness, and at the same time a kind of cunning gaze, remind you that they are allowed only under the harshest conditions to breathe the same air as the followers of the Prophet.[59] [fol. 20 bis] They are subjected to all sorts of humiliations. For example, when in the presence of the Emperor or important dignitaries, they are made to go barefoot and must do likewise when they pass in front of a mosque; and their women are not in the least exempt from these harsh conditions. Those delightful creatures must take off their shoes whenever they walk along the walls of the mosque. You see them proceed with difficulty, holding their slippers in their hands, setting

.............

27r of the Chantilly notebook. The diadem of pearls is called the *sfifa*; the enormous earrings, *alkhorsas*; the large bracelets worn above the ankle, *kholkals* (Godard, *Description et histoire du Maroc*, 18).

57. Delacroix later obtains, through the intermediary of Sander Rang, a naval officer then in Toulon and the husband of his friend, the painter Louise Rang, "a little Moorish vase containing that black substance that is put on the eyes with a little wand" (letter of 20 December 1837, quoted in F. Legré-Zaidline, "Louise Rang-Babut, une amie de Delacroix," 22).

58. Pink because tinted with henna (see "Notes and Drafts," cahier 6-d, p. 138).

59. As Delacroix's irony implies, and as a marginal note confirms, he attributes the "obsequi-ousness" of Jewish men to their subjugation within Islamic society: "Although they are generally handsome, a look of obsequious attentiveness and self-sacrifice that comes from the submission and dependency of that unlucky race, which has yet so many admirable traits of character . . ."

their little bare feet on the uneven ground and amid the stony channels that constitute the streets.[60]

Moreover, their vices are those of all slaves. *[21]* In their defense, it must be said that such a constrained and unhappy position only strengthens the powerful bond between them, which maintains the unity of this remarkable people, still very much alive among the ruins of their tyrants and persecutors. Excluded from the general laws of the State among his jealous masters, the Jew finds a homeland under his own roof and amid his own family. The practices of Mosaic law are observed rigorously and those of the sabbath, in particular, cannot be modified.[61] That venerable day is celebrated by a universal idleness. Men and women, all decked out in their finest clothes, get up, sit down, wander around their houses or visit one another, but without doing any activity that might pass for work. Christians have much cause for complaint from this pious habit—I mean those who have relations with Jews, especially those who employ them as servants; there can be no question of chores or services of any sort; cooking, even less; touching the stove or pans is an enormous wrong. Among the servants there is a kind of competition not to serve you on the day reserved for religious practices. Thus it constantly happens that people living in Tangier, Marrakesh, or Fez who have numerous servants are forced to serve themselves for part of the week. You must not expect that a Muslim will break the rules so as to bring you your slippers on a Friday, the day devoted to prayer; we have seen that the Jew is very careful not to work on a Saturday; *[22]* as for the Christian servants, they do their utmost to deprive you of their services on the pretext that Sunday is sacrosanct.

Since Ramadan started on February 4th, that is, a few days after our arrival, we very soon had occasion to witness, and suffer from, the fervor of the faithful. On the evening when this solemn month began, we were surrounded by the din of gunshots and trumpets or horns. That was nothing compared with what followed overnight, and for all the subsequent nights until that holy time of prayer ended. Apart from the noise from the instruments, they seemed to be busy banging with all their strength on all the tables in their houses, and letting out cries that sounded more like howls of rage than shouts of joy. In the morning everything went back to normal, in appearance, at least. Every Muslim is required, for the whole day, to observe a strict fast, including every type of food and even every enjoyable sensation. I remember that one of us, smoking

60. The requirement that Jews remove their shoes was pointed out by many travellers: Pidou de Saint-Olon (*Relation de l'empire du Maroc*, 56) and Chénier (*Recherches historiques sur les Maures*, 3:131–33).
61. Delacroix expresses the same idea on 25 January. Chénier points out that the Jews, "who, amid persecutions, have taken their religion and practices everywhere, observe in Morocco, more scrupulously than elsewhere" certain customs that they practiced in ancient times, those concerning death, for example (*Recherches historiques sur les Maures*, 3:134).

a cigar near Caddour, the soldier from the consulate, noticed that he very carefully covered his nose, *[23]* for fear of taking pleasure in breathing in the tobacco smoke.[62] This did not prevent that observant Muslim from happily accepting my money whenever I had him surreptitiously pose for me, despite the express prohibition of the law.[63]

During this period of penance, around sunset, smoke can be seen rising from all the kitchens; everywhere you meet men and women busily moving about, carrying on their heads covered dishes that they are taking to put in the oven, or bringing back from it. A cannon shot goes off and is greeted by a general ovation. It is the signal that everyone is impatiently waiting for, to break the fast and enjoy themselves.

The end of this important period was celebrated with several festivities. One of them drew the whole population out of Tangier. The garrison was put under arms, and for the first time I had the chance to see a great number of horsemen together, and to admire their elegance on horseback and the bravery that they display in their exercises. I will speak at length of their military attire and principal maneuvers when I recount the trip that we had to take to Meknes to meet the Emperor.[64] I think this ceremony was the Courban Baïram, one of the most renowned among Muslims.[65] All those people scattered across the countryside, together with the soldiers, some resting in the shade of their horses, *[24]* others exercising theirs amid the cactuses and agaves that grow everywhere to a very great height, all came together at a certain moment. Silence fell on the crowd, which was filled with emotion; two or three talebs could be seen climbing up onto a little square building reserved for religious uses, and which is found a short distance from every town. These doctors of the law said the prayers facing the sun. Nothing was as imposing as the sight of those old men wrapped in great shrouds and dominating the crowd, which was on its knees, the soldiers prostrate like everyone else, with one arm passed

62. The smoker was Delacroix ("Notes and Drafts," fol. 1 bis, p. 155). Pidou de Saint-Olon also notes this prohibition on pleasant smells during Ramadan (*Relation de l'empire du Maroc*, 43). Lagerheim recounts that the guide who accompanied him on a hunt, having eaten some of his sausage not knowing that it contained pork, "was so upset when he found out that he took the flask and drank from it to wash out the impurity" (*Minnen*, 75).

63. Thus Caddour is the model in some of Delacroix's drawings. On the back of the sheet, at the bottom, Delacroix had noted: "Caddour's scruples."

64. This part of the narrative that recounted the trip to Meknes, if it ever existed, is not in the manuscript. Delacroix probably abandoned the project before drafting it.

65. In fact, it was not the Qurban Baïram, or "great feast," Turkish for the Aïd el-Adha or Aïd el-Kebir, which marks the end of the hajj, and which is celebrated by sacrificing lambs, but rather the Seker (sugar) Baïram or "little feast" (Aïd el-Fytr), which marks the end of Ramadan, so called because of the custom of exchanging sweets and pastries. The confusion is common in travel literature (for example, in Nerval's *Voyage en Orient*). Delacroix considered a painting on this subject, as shown by a list of projects (see *Journal*, 2:1660): "The scene of the Courban Baïram, at the gate of Tangier. The marabouts up on the prayer monument; the horsemen, etc." In 1832, the actual Qurban Baïram fell at the end of May, when Delacroix was returning from Spain.

through their horses' bridles. The end of the prayer was signaled by a new commotion, shouting, horseraces with plenty of gunshots, flags flying in the air, and the sound of drums and oboes.[66] We returned to the city as if in a procession and mixed in with the line, at the head of which marched the Pasha and his officers in full ceremonial dress. We went back through the streets, all decked with flags and signs of celebration of every kind.

A few days before, we had witnessed a remarkable example of the fury of those horses that we were now seeing perform, with the greatest docility, all kinds of movements and tricks when ridden by the Pasha's horsemen.[67] We used to go on frequent excursions in the environs, accompanied by our soldiers, an indispensable precaution if you do not want to risk being insulted and even piously murdered as a Christian. Some of the consuls often joined [25] our cavalcade to show us the curiosities of the area. One of those gentlemen had a little gray horse that was very highly esteemed for its speed and had been given to him by the Emperor on one of his missions to the court. But it had not taken him long to realize that the gift was an alarming one because of certain faults that were revealed in the animal, and which were very consistent with its spiritedness. It was, under its horse's exterior, a beast as ferocious as a tiger: it was known to have once killed a soldier. At another time, when it caught in its teeth a man who was walking by, the poor victim owed his survival only to the speed with which he extracted himself from his djellaba; he slipped out of it as if from a sheath, leaving it prey to the animal that, biting and trampling it furiously, shredded it into a thousand pieces.

The consul to whom this horse belonged,[68] and who was riding it that day, sang its praises in spite of its little tricks, and strongly urged us to try it out. Just as he was reaching the height of his encomium, I saw, from afar, that wonderful horse, with a sudden, completely unexpected movement, throw its front legs onto the neck of a black horse that was trotting alongside, ridden by one of our companions.[69] Our friend, taken by surprise, started to beat vigorously on the head and muzzle of the aggressor with the handle of his riding-whip. But those blows, though well applied, were mere pin-pricks, and the animal continued to bite its adversary on the neck even more. The black horse, furious in its turn, then began, [26] before our very eyes, the most amazing defense. The situation was really dangerous. The unfortunate consul, almost suspended in mid-air and hanging onto the flanks of his mount, did not take long to hit the ground. Our companion, who saw himself becoming the battle-ground, managed, with much skill and self-control, to dismount, abandoning

66. On the Moroccan oboe, see p. 62 n. 7.
67. The notes that served for this section are in the Tangier notebook under 29 January.
68. Drummond Hay.
69. Mornay.

his horse, and leaving to fate the outcome of a quarrel in which humans could do nothing.

With a kind of stupor, we then watched the most relentless, the most furious struggle imaginable unfold between those two horses, now even more riled up by the forced withdrawal of their riders. Kicking and biting while emitting ferocious little cries, seeming to clasp one another as they flung their front legs at one another and walked upright, on their hind legs, like two wrestlers locked in an embrace to tear each other to pieces, their nostrils aflame, their eyes throwing sparks, all that created a scene such as none of the most inspired painters of horses, like Gros or Rubens, in all the passion of their imagination, ever dreamed of. Sometimes their manes, mingled together and falling on their heads, hid them from one another, and made them bite each other at random with even more fury. Finally, with one chasing the other unremittingly, they found themselves beside the little river in Tangier, with its sloping banks. They both slipped, or fell, in, and the struggle seemed to begin all over again in the water that [27] spurted up around them, and the mud in which they were sinking. But soon one of the two, gradually losing control, found itself separated from its enemy and they stopped, panting, spattered with mud and blood that streamed down their neck and flanks, unable to grasp one another again, and perhaps with no strength left.

The one that had been gradually carried along by the current needed to be rescued. This fell to one of the soldiers who was accompanying us, and who had dismounted to follow the horses' movements, though with great composure and as if used to such episodes. It was very comical, after the fight that we had just witnessed, to see that unwieldy man bundled up, as he was, in his billowing robes, which he hitched up around him to go into the water and run after the horse that was in the most trouble. It was the black horse, the one that had suffered the first attack and, calmed down after so much effort and by the cool water, let itself be caught and led back to land in the most docile way. As for the devilish gray horse, it was hardly removed from danger when it was all ready to start biting an English groom again. He was trying to readjust its bridle so as to return it to its owner, who, having recovered from his accident, persisted even so in congratulating himself on the good qualities of his horse.

To return home, we crossed the little river that I just mentioned. This flows into the sea a short distance from some ruins called "old Tangier," which I confess I did not visit, despite making plans several times to do so. So I mention them here only for the record.[70] They are located along the beach and near the end [28] of the bay, which is terminated on one side by a long promontory that

70. These ruins, mainly Byzantine and medieval, are east of the city, near the El-Halk River (see notes 71 and 214). Roman Tingis was on the site of the present city.

protects the harbor, and on the other by the city of Tangier itself. The completely flat beach, which stretches out in a half-moon, is level almost everywhere and, formed of a very fine sand, is used as a hippodrome or bridleway for people on horseback.

We crossed the river on a bridge of Moorish construction, which is nothing other than the great mast of a Spanish flagship that perished in the battle of Trafalgar, a piece of which washed up on the coast.[71] The ship, nicknamed *El Major del Mondo*,[72] was armed with 146 cannons. The size of the mast, now being used for peaceful purposes, gave a fearsome impression of what the ship must have been like. Although it had lain there for almost thirty years, the Moors, who used it continually, had not taken the trouble to square it off so as to make it easier to cross. However, they had taken care to make off with the iron bands that had formerly served to reinforce it.

Coming back to Tangier from this side, you get a favorable idea of its extensive and commanding situation. But this impression soon vanishes when *[29]* you get close to the walls, which are built in a very uneven fashion on rocks of slate that jut into the sea and, landward, extend unevenly into the countryside, following the contours of the terrain. A great part of this wall is the work of the Portuguese, and here and there presents wide breaches that no one has troubled to repair. One part of the ramparts that form the defensive line seaward is still in the state in which the British left it in [1684]:[73] after a brief occupation, they dug mines and blew them up to destroy the walls, which you see lying about in blocks heaped up or split apart by the effects of the explosion.

This area borders the Jewish cemetery, that last refuge where their remains, at least, are not disturbed. I noticed that, in the Barbary towns that I had the chance to visit, the form of these tombs differs in every place, although they are all similar within each one. Their bareness and uniformity inspire respect; at the same time, they are so close together that it is almost impossible to put your foot between them. They offer no special sign, like a tree or decoration, to distinguish them. It seems that, packed together and set apart in this way, these graves perpetuate, after the death of those unfortunate people, the idea of their

71. On this curious bridge, see 29 January and "Notes and Drafts," cahier 6-d, below, p. 138. In his memoirs, John Hay explains that the masts of the Santissima Trinidad, a Spanish vessel sunk by the British at Trafalgar, were washed ashore on the African coast near Cape Spartel; the Moors took possession of them and floated them down to the mouth of the El-Halc River near old Tangier; from there they floated them to the village of Sharf, where they were placed across the high banks of the river; parapets of masonry were built on each side to form a bridge for pedestrians. At the time when he was writing, Hay specifies that the bridge was still in use "twenty years ago," presumably around 1865, but that after one of the masts collapsed, it was dismantled on the Sultan's orders and a stone bridge erected in its place. Hay, *Memoir of Sir John Drummond Hay*, 192–93.
72. El Mayor del Mundo, "the greatest in the world."
73. Delacroix leaves a blank so as to fill in the date later. The British occupied Tangier, which they had acquired as part of the dowry of Catherine of Portugal for her marriage to Charles II, from 1662 to 1684.

isolation on enemy soil, and are a silent protest against any relationship with Gentiles. The cemetery is relegated to a place near a very smelly tannery that marks the edge of the town on that side, and where, from afar, we could see the famous Moroccan leathers being prepared, one of the most lucrative branches of commerce in the Empire. This leather, it should be said in passing, certainly deserves its reputation for the fastness of its colors and especially for its prodigious durability. It is made with the skin of a nondescript little black goat, which is particular to that country.

[30] The appearance of the countryside in the surrounding area has something very cheerful about it, although there are very few signs of cultivation. The landscape is almost everywhere divided by fences formed of agaves, gigantic cactuses, and large reeds, which sway in the faintest breeze. The consuls' gardens, generally just a little outside the town, offer delightful retreats under the beautiful shade of fig and orange trees. The latter, when we arrived (and it was the end of January), were covered in flowers and fruit. It is a very pleasant surprise, for someone who arrives from nothern Europe, to wander through entire groves of these beautiful trees, which, although not very tall, provide an exquisite shade under their thick, shiny foliage, so effective at repelling the heat of the sun. Nothing is as delightful as that profusion of lovely golden fruit standing out strongly against the dark of the greenery. Those oranges are delicious: picked off the tree where they seem to offer themselves up, and at their most ripe, they have a taste that you cannot imagine when you are used to the oranges brought to Europe, which are harvested when still green. The mildness of the temperature and the beauty of the sky, so new to us in that season, were not the least of the delights that we enjoyed in those lovely places. Almost all these gardens are laid out on a slope opposite the city and overlooking the sea. From there you can see the Spanish coast and especially the beach at Tarifa, always easy to pick out by the long pink line that snakes along it and, from afar, makes it seem to undulate. I imagine that it is the sand that takes on this color and reflects it back.

Turning round, you can see on the horizon some mountains covered in snow, which shimmer in the sunshine with tones of mother-of-pearl. These are the ridges of the Atlas range, which rise in succession all the way to the frontier of the Empire, that is, to Marrakesh where one could say that it indeed holds up the sky.[74] I heard from one of the consuls, who had been there, that the beauty of those mountains [31] surpasses anything imaginable. He described to me in the liveliest terms the surprise and admiration that they had inspired in him, as well as the awe of the members of his convoy and his servants, who were tempted to prostrate themselves. Shining in broad patches on the flanks of

74. In Greek mythology the Titan Atlas was condemned to hold up the sky.

these mountains are large areas formed of a kind of crystal the color of ame-
thyst, which, when struck by the sun, dazzle your eyes and conjure up the
wonders of *The Thousand and One Nights*.

The garden of the Swedish consulate was the closest to the city walls. That
is where we spent a great part of our days. From the terrace, whence you had a
view of the sea, you could also watch the very lively spectacle of a market that
was often held in front of the gates, where the shouting of the Moors, their
disputes and frantic gesticulations, were very entertaining. On Fridays we also
used to watch the women who went off, fully veiled, to visit graves in the coun-
tryside.[75] They climbed devoutly up the hill to go and crouch here or there on
the knolls and little white monuments scattered across the green landscape.
We found that custom very touching; but we soon learned that respect for the
spirits of the dear departed was not always the sole motive for this devotion,
and that many of these ladies very skillfully used that pretext to carry on certain
intrigues in which piety played no part.[76]

One would almost be tempted to say, by way of excusing them, that the
look of these graves has nothing funereal about it, and instead inspires cheerful
thoughts. Nothing in them reminds you of death, that frightful, stinking death,
hidden from view and relegated to those sinister places that are our own horri-
ble cemeteries, *[32]* and where we seem eager to dump our dead so as to exile
them as much from our hearts as from our homes. In those lugubrious death
pits of ours, everything is depressing, right down to the neat, stunted trees that
we artificially cultivate on that pile of corruption, and which thrive on it. How
much more interesting and worthy of their purpose, in contrast, are these graves
located along the routes and in the middle of the countryside. The proximity of
a field or fountain, the shade of a tree that has grown up freely, the birdsong,
the passing of herds that come to graze, all these things drive away the idea of
destruction, and remove what is repellent about it. Sometimes the grave is only
a simple enclosure formed of humble stones placed any which way by the hand
of a friend.[77] The monuments of the rich or of famous people are elegant con-
structions, isolated amid the landscape and often surrounded by a sort of sacred
grove. It is the same with the tombs of saints. Instead of displaying them to be
venerated in the form of a hideous mummy that crumbles into dust in a case,
they build their tombs in pleasant and cheerful settings, high up on hills where
they seem to lend their protection to the country all around. It is reminiscent

75. The Swedish garden was situated on the slope of a hill on the southwest side of town, above
Bab el-Fas, the "land gate," where the market took place. The Muslim cemetery was on a hill above
the garden. On this garden, see below, p. 73 n. 61.

76. In the margin of fol. 21v Delacroix had noted, à propos of the Muslim men: "They are said
to be accommodating husbands."

77. Delacroix later paints such a scene in *Arab Soldier by a Grave* (J362).

of the ancient custom of placing man's remains in nature. There they seem nearer to their origin, *[33]* closer to the elements from which they come and to which they must return.

The trees in the countryside are not planted as densely as in ours. You can even see very large areas with only underbrush and dwarf palms. In the environs of Tangier, the fields in many places are completely ravaged by boars, which are very numerous and churn up the earth by digging deep furrows in it.[78] Seeing this completely bare terrain, you would think that large trees could not grow there. But that is only an apparent barrenness. In all those lands, as in Andalusia and many other parts of Spain, the inhabitants do not let trees grow, or they fell them when they are still young. I suppose that they do not have the patience to wait for them to reach a certain height, and destroy them for firewood or some other use. I prefer this explanation to the one that a Spaniard solemnly gave me, when I complained about the bareness of the countryside around Seville and all the other towns in the region. He told me that nothing is more harmful to agriculture than trees, since they serve as sanctuaries for birds that, when they are very numerous in an area and find an easy way to shelter, destroy the crops. I saw on the seashore, on the way to Cape Spartel, some trees of extraordinary height and beauty; but in such cases they are in clumps or in the gardens of country-houses and dwellings. In fact, everything attests to the vigor of *[34]* the vegetation. The fig trees grow to an unbelievable size. It is not unusual to see examples where the branches, reaching all the way to the ground, create a kind of dome that would easily shelter, around the trunk, thirty or forty people. In the garden of the French consul you could see something that was even more remarkable: an apricot tree that covered an area equally wide and presented the same form. On the way to Meknes you can find olive trees as tall as the biggest limes in the Tuileries.

If the tombs are far from depressing one's spirits by looking gloomy, the country houses, on the other hand, look more like tombs than places of enjoyment. The total absence of external architecture that you have in the towns looks all the more somber and menacing in the country houses. Lacking windows and even doors, they seem like fortresses: the only exit, carefully hidden, is made so little that you hardly notice it, so that you think the owner himself must have to scale the walls to enter his house.

78. Lagerheim, too, discusses these boars that inhabited the thick, marshy undergrowth around Tangier, from where they made devastating incursions into the fields and vineyards. He recounts at length the boar hunts of the Arabs: forty or fifty men plunged into the underbrush, shouting and followed by their barking dogs, which, along with the roaring and grunting of the boars, made a tremendous noise. The vegetation was so thick that one only noticed the animal approaching through the increased movement of the branches; it could not be seen until it was a few feet away, foaming at the mouth and clapping its long fangs. One hunter would fire right away, while his companion held his shot for defense in case the animal attacked (*Minnen*, 74).

The women whom you meet in the street are like those houses. They are walking bundles: under the massive blanket in which they are wrapped, you glimpse only two eyes that serve to guide them, and the tips of their fingers, which hold a great swath of that shroud-like covering over the rest of their face *[35]*. Only slaves walk with their faces uncovered; but they are normally Negresses who might do as well to cover themselves.[79] This use of the veil throughout the Orient, if you set aside the slightly grotesque shape that it confers on women, does not fail to have something very enticing about it. You are free to consider them all beautiful under those wrappings; and when you see them pass near you, armed, as their only attraction, with that dark, expressive glance that heaven gave to nearly all those creatures, you experience something of the tantalizing curiosity that you feel at a masked ball. Moreover, it is the same with the modesty of those ladies as with their devotion to the dear departed, whom they go to mourn at the graves. When they happened to meet one of us in a remote street, and were very sure that they would not be seen by some bearded and turbaned passerby, they very obligingly drew aside a few folds of that shroud in which their charms were hidden, and showed themselves in a little more human guise. Caught in the act of taking such inexcusable liberties, they probably would not have hesitated to say that infidels were not men anyway. One of the sultans of this country had insulted a European envoy, who could not help telling him that he should be ashamed of what he had said. The sultan answered with total composure: "Need one feel shame toward dogs?"[80]

[Here ends the manuscript of the narrative as we have it. The multiple crossings out and rewritings suggest that Delacroix meant to continue. A marginal annotation gives an idea of what would have followed:"The finest encounter of this type that we had, the women at the stream." This note relates to the famous story that Mornay told to Philippe Burty, about two women washing clothes in a stream while being watched by Delacroix, Mornay, and Abraham Benchimol.[81] One of the women, noticing her admirers, lifted up her dress, as here, "very obligingly," and began to bathe, a scene that Delacroix set about rendering in a sketch.[82] Alerted by the cries of Benchimol to the approach of some men, the woman began to scream, a clever trick which, as in the example cited here, where the women might say that infidels are "not men anyway," exempts her from the crime and helps the guilty men

79. An uncharacteristically racist remark, which has no equivalent in the notebooks. Delacroix represented a black African woman in one of the watercolors for Mornay, *Black Slave-Girl Fetching Water* (see biographies, p. 178).

80. The envoy was British (see "Marginalia," fol. 35, p. 136).

81. Philippe Burty, "Eugène Delacroix à Alger," 96.

82. As Burty states, the woman "played along."

*to escape. The scene supposedly ended in a wild chase, with the Europeans in flight and the Moroccans in hot pursuit amid the sound of gunfire. Long thought to have been invented, this episode is here confirmed by the marginal jotting: Delacroix indicates that he planned to use it as an example of the women's willingness to show themselves, and to use a subterfuge if caught. One can thus appreciate the associations of the watercolor that commemorated it—*A Moorish Woman with her Servant on the Bank of a River—*which was in the album given by Delacroix to Mornay in memory of their trip, and is now in the Fogg Museum at Harvard.]*

A JEWISH WEDDING IN MOROCCO

[This text was published in Le Magasin pittoresque *in January 1842 (10:1), follow-ing the success of Delacroix's painting,* Jewish Wedding in Morocco *(J366), at the 1841 Salon. It was accompanied by a woodcut after a drawing by (Karen Cohen coll.), representing the seated musician playing the violin in the center of the paint-ing. The text was reprinted in Piron,* Eugène Delacroix: Sa vie et ses œuvres, *pp. 451–56. The manuscript, formerly in the Claude Roger-Marx collection, is now in the INHA (carton 120, autog. 1397/1). Many of the details come from the entry of 21 February in the Tangier notebook (see below, pp. 75–76).]*

Our aim was to publish an engraving of the painting of *The Jewish Wedding* that M. Delacroix exhibited at the last Salon. But the artist was only able to provide us with this drawing of a musician. The article was written by M. Eugène Delacroix himself, who traveled in Morocco several years ago.[1]

The wedding ceremonies of Jews and Muslims are completely different from those of most Europeans. Ours are entirely soulless, with no outward indication of the importance of such a solemn act: the engagement, the reading of the contract, the ceremony, the administrative formalities, all of that has no more apparent importance than any other official transaction; the nuptial blessing itself has nothing that distinguishes it in essence from any other religious ceremony. Conversely, among Oriental peoples, including the Jews, who live under harsh constraints that have the effect of strengthening the ties that unite them and reinforcing their ancient traditions, the great events of life are marked by external rituals that derive from the most ancient practices. Marriage, espe-cially, is accompanied by ceremonies that are for the most part symbolic, and is the occasion for great rejoicing by the friends and relatives of the bride and

1. The manuscript shows that this note by the editors, meant to figure at the start of the article, was written by Delacroix.

groom. The engagement, first, takes place far in advance and with much fan-fare; but the wedding itself occupies several days, which are a sequence of very wearisome trials for the bride. She is truly a victim of all this pageantry, with its infinite amount of detail. While her parents' house is given over to the commotion of a continual ebb and flow of people coming and going and taking part in the festivities, and amid singing and dancing that last throughout the day and night, she is relegated to a dark room; at the very back of this room is a bed that occupies its whole width, and in the corner, nestled against the wall, is the young bride wrapped in a great woollen cloth that hides her almost com-pletely from sight. On this very bed are her companions and friends, dressed in all their best finery, sitting and crouching near her, but seeming not to pay her any attention at all. She must constantly keep her eyes closed and seem oblivious to everything going on around her, such that she appears to be the only person for whom the rejoicing is *not* intended.

While she is thus perched, and almost hidden, on that vast bed, her relatives and friends sit eating and drinking around a very long table that often takes up the rest of the room. In the courtyard of the house, an immense crowd gathers; the upper galleries, bedrooms, and stairways are all given over to the guests, who are made up of nearly the whole town. At one of these weddings, which I attended like everyone else, the approach on the street and inside the courtyard was so encumbered that I had the hardest time getting in. The musicians were leaning against one side of the wall, and the entire surround of the courtyard was likewise lined with spectators. On one side, Jewish women were crouching, dressed in a special costume for the occasion, in particular wearing on their head a great starched piece of cloth placed cross-wise over a very high, very graceful turban that they wear only for weddings.[2] On the opposite side were distinguished Moors, standing or seated, who were supposedly honoring the wedding by attending it. It is hard to imagine the din made by the musicians with their voices and instruments; they sawed away pitilessly on a kind of two-stringed violin that is special to the country, and which gives off more noise than sound. They also had the Moorish guitar, a very graceful instrument in shape, the sound of which resembles that of a mandolin. Added to that was the tam-bourine that accompanies every song. But these songs, whose chief merit seems to consist in the fact that they are shouted, are the truly deafening part of the concert; their monotony also contributes to making them tedious.

Amid all that accompaniment, the female dancers come, in turn, to per-form; I say female dancers, because women alone engage in an exercise that is

2. Delacroix did several pictures of women wearing this headdress, which is not that of the bride, but of women attending the ceremony. See the two versions of *Jewess of Tangier* (J388, J389), and the drawings and watercolors reproduced by Johnson in "Delacroix's *Jewish Bride*." The head-dress of the bride is the miter-shaped one represented in a watercolor in the Louvre (1588).

forbidden to men, who are supposed to be serious. Everyone who has been to Algiers knows this dance that is, I believe, the same in all Oriental lands, and that would no doubt be considered here, at least in respectable society, to be in very bad taste. As it consists of postures and contortions that you make almost without moving your feet, you can appreciate that it is possible to engage in it in a space as encumbered as that courtyard full of onlookers was. Only a very small space is therefore needed for each of the dancers, who appear one by one. When each of them has finished this short performance, which she varies according to her taste and her particular art, those in the audience who want to demonstrate their interest in her take out of their pocket a coin meant to pay the musicians; but it is customary, before dropping your offering onto a plate that is left out for this purpose, to go touch the shoulder of the dancer that you like with the coin. I saw some distinguished members of the audience give, with a certain ostentation, even gold coins, no doubt to be noticed by us Christians.

When the end of the last day arrives that the bride spends under her parents' roof before going to live with her husband, she is arrayed in her wedding clothes; on her head is placed a type of miter made up of a number of kerchieves that are piled one onto the other, but in such a way that only a small piece of each is visible [fig. 2]. She is put on a table, seated against the wall and as motionless as an Egyptian statue. Candles and torches are held aloft near her face so that the audience can enjoy the whole dressing ritual as they like. Next to her, old women make a continual noise by tapping their fingers on little drums, formed of parchment stretched over a kind of clay pot painted in different colors.[3] Other old women paint her cheeks, forehead, etc., with cinnabar or henna, or blacken the insides of her eyelids with kohl. Hard as it is to believe, the poor girl suffering these wearisome attentions cannot even open her eyes during this latter operation, for it would be a very bad sign. The little silver or wooden stylus that is used to tint her eyelids is slipped under them while they are closed; finally, long-suffering and resigned, the victim is offered in sacrifice to the curiosity of this boisterous audience.

After a certain number of procedures related to dressing her, she is taken down from that sort of stand as a statue would be, and the moment arrives when she is led out of her father's house. Half poised on her feet, half supported under her arms, she advances, followed and surrounded by all the witnesses. In front of her, young people carrying torches walk backward up to the husband's dwelling. Here you find, as everywhere in that country, ancient traditions. Nothing is more extraordinary than the walk of this poor girl who, her

3. Drummond Hay identifies this single-headed clay drum as the agwal (Bodleian Library, Oxford, MS Eng.hist.e.354, p. 139).

eyelids still closed, seems not to make any movement of her own volition. Her features are as impassive during this procession as during her other trials. I was assured that to make her break that imperturbable solemnity, they take their mischief so far as to pinch her on the way. I think it is very rare to see these poor creatures give the least sign of impatience or even just attention to what is happening. It is in this procession that she arrives at her husband's, where no doubt she must consider it her greatest fortune to be relieved of so many attentions.

The next day at the bridegroom's there is yet another ceremony, which seemed to me purely religious, between the couple, the rabbi, and the witnesses. That one, I believe, brings all the others to an end, and must in consequence be the most welcome to the principal participants.

NOTEBOOKS

Tangier

Chantilly Notebook [Piron/Roger-Marx pages. See appendix B.]

[Tangier, Tuesday, 24 January]
Opposite Tangier. Tuesday 24 January 1832

This morning we dropped anchor in front of Tangier. We had weighed anchor at Toulon on the 11th of this month. The crossing was a mix of wearisome periods of calm with some nice sunshine, and bad weather. The look of that African town, especially seen through a telescope, gave me an intense feeling of delight. This reached a peak when I saw a rowboat approach, full of local people who were bringing us the consul.[1] I thought I was dreaming. I had so often wanted to see the Orient that, when I fixed my eyes on those people, I could hardly believe my eyes. I had experienced the same thing at Algeciras the day before yesterday (Sunday) and yesterday morning (Monday), when I went there in the boat for provisions.[2]

[Tangier, Wednesday, 25 January]
Wednesday 25 January

This morning we arrived in our rowboats at 11 o'clock. I was in the second boat with the officers from the corvette. The beach was covered with people from all around, curious to see us. A Spanish warship was firing all its guns. We were saluted by the cannons from the fort, which responded to the corvette with an equal number of shots. The smoke rising from those gray walls created a very nice white and blackish effect. Those figures, all gray and white, that you

1. Jacques-Denis Delaporte, the former French vice-consul in Tangier (a post eliminated in 1831), was still "administrator" of the consulate and served as a guide, interpreter, and advisor to the Mornay mission. See biographies. On this welcome, see "Memories," cahier 5-a, p. 33 above.
2. On this stop in Algeciras, see "Memories," cahier 3-b and 3-c, pp. 28–29 above.

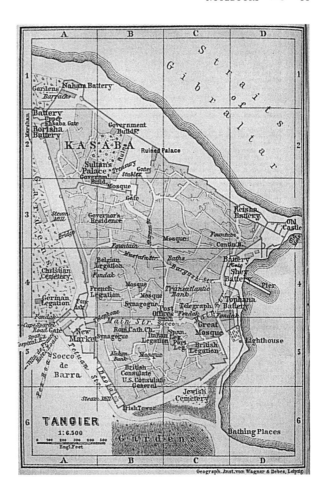

MAP 1 Plan of Tangier, from Karl Baedeker, *Spain and Portugal: Handbook for Travellers*, 1901.

could see from afar were an extraordinary sight. I was extremely struck by three figures especially, sitting solemnly halfway up the hill below one of the forts, the middle one completely in red. It was the most solemn, the most extraordinary sight for a modern to behold: exactly the three Evangelists from Dante's time that I have in my series of old Italian engravings after Orcagna, etc.[3] These men are remarkably reminiscent of the costumes of that time. The hood that almost all of them wear gives them that look.

Taken ashore by the sailors who bore us on their backs,[4] we passed in front of a row of armed soldiers: the burnous over the rest of the outfit, but the hood down. The hood worn on the head is a sign of authority. For example, someone who commands twenty-five men wears his hood when he is at the head of his

3. Presumably the *Peintures à fresques du Campo Santo de Pise dessinées par Joseph Rossi et gravées par le Prof. chev. J.P. Lasinio fils* (1822), from which Delacroix did studies of the frescoes then attributed to Orcagna (Louvre 1749, fols. 21v–25r, and 1750, fols. 26v–29v).

4. There was no pier in Tangier at this period ("Memories," cahier 5-c, p. 34).

detachment. When he is subordinate to a kind of centurion, or commander of a hundred, he puts his hood down.

Across from us, under a kind of hangar that is located at the back of the square forming the port, and which is a sort of a guardhouse graced with Moorish doorways, was the Kaïd, or governor of the town, a kind of Pasha (the Arabs say *Basha: p* does not exist in their language), wearing the same costume as the soldiers—the burnous, etc.[5] Next to him were several old men, one of whom, holding a string of beads in his hand, was a kind of customs administrator, supposedly a very influential person.[6] These people were in half-shadow in that little room; in their simplicity, they created a most imposing effect. Around the little room, which was entirely white, like everything in their houses, there was only a scrappy rug at the very edge, spread over a kind of bench against the wall.

Turning round to leave with M. de Mornay and all the consuls who had received us, I saw, opposite the area outside where the soldiers were, a Negro leading a horse that the Basha had ordered out of courtesy for the French envoy. At the same time, in the same area, musicians were starting up the strangest music on drums that were rather small and hung fairly high at their sides, as far as I can remember, and a kind of oboe that is played like a clarinet, but which I could not see very well, provided the essence of the music, which it is impossible to describe.[7] We at once walked up into the city via winding, ill-paved streets, surrounded and pressed by that crowd of curious people who resembled, in their gray sacks and with their black and yellow faces, so many escaped lunatics. I noticed on the roofs of the houses Muslim women who showed just the tip of their nose. The Jewish women [were] freer, etc. Finally we arrived at the consul's house with the whole cortege. The music could still be heard outside for a while longer.[8]

During the day, took a walk in the town. The shops are pitiful and all clustered together. You can see shopkeepers crammed in and having trouble moving among their pots, candles, etc.—tailors, shoemakers, etc. The barber who was shaving the head of a child: a net half-covered his doorway.

5. Despite Delacroix's use of the word "kaïd" here, he is referring to the governor Sidi El-Arby ben Ali Saïdi, the pasha of Tangier; kaïd was often used in this sense. It was El-Arby, and not the kaïd Ben Abou (see 7 March below, note 95) who, with Amin Bias, the customs administrator, received foreign diplomats, as is confirmed in "Memories" (cahier 5-b and 5-d), and in Lagerheim's memoirs (*Minnen*, p. 32). Lagerheim writes at length about El-Arby (see biographies). On the soldiers' costume, see "Memories," cahier 5-d and 6-a (above, pp. 34–35).

6. "The Emperor, who considered Sidi El-Arby more skilled in collecting money than in [. . .] negotiating with ambassadors, had set up one of his confidants, Sidi [Ettayeb Bias], in Tangier with the modest title of customs administrator" (Lagerheim, *Minnen*, 33). Delacroix did a portrait of Bias, one of the sultan's closest advisors, for the album of watercolors that he gave to Mornay in memory of the trip (Louvre 1607, see below note 289).

7. The Moroccan oboe is called a *ghaita* (French *rheita*) (Sachs, *History of Musical Instruments*, 248). Describing the arrival of the French mission, Lagerheim also mentions this "infernal" music that "lacerated their ears" (*Minnen*, 96).

8. On the reception of the group, see "Memories," cahiers 6-c and 6-d (p. 36 above).

At one of the city gates, in one of those recesses that they open up everywhere in their walls, there were rifles hanging from the ceiling, and two or three soldiers dressed like all the others were solemnly weaving baskets.

Saw old women, childen, etc.

At Abraham's house, the interpreter for the consulate.[9] I admired how neat and clean it was, like that of his sister, which is opposite. These Jews, here reputed to be unclean, and required to remove their shoes and walk barefoot in the mud when they pass in front of the mosques, find in their own homes, as in a castle, a peaceful retreat where they can enjoy their wealth and the comforts of family life. There is something Biblical in those interiors. The large room where everyone dines together, etc., etc.

His wife, his daughter, and in general all the Jewish women are the most tantalizing imaginable, and of a ravishing beauty. His daughter, I think, or his sister's, had very distinctive eyes of a yellow color surrounded by a bluish circle with her eyelids edged in black. Nothing could be more enticing. Their dress is lovely.[10]

In the evening, after dinner, spent a few delightful moments on the terrace looking at the upper town, the sea, the passers-by in the streets, etc.

Took the officers from the corvette back to the shore with the soldier who was accompanying us. I remember those three or four soldiers, I think, from the neighboring post, who watched us as we passed, lit up by the lantern that was carried in front of us.

The Moorish doorways, etc.—The men in the guardhouse.—The public inn.—The open mosque.

Tangier Notebook (Louvre 1755)

[Tangier, Thursday, 26 January]
26 Jan.[11]

At the Pasha's.[12]

9. Abraham Benchimol, "a rich Jew from Tangier" (see "Memories, fol. 10, p. 38), dragoman of the French consulate. Delacroix painted his portrait for the album of watercolors that he gave to Mornay (see below, note 289). Lee Johnson ("Delacroix's *Jewish Bride*," 759 n. 9) rightly contests the usual identification of the figure in Louvre notebook 1757 (fol. 14r) as Benchimol; there is indeed no resemblance between it and the portrait. In addition to being interpreters, dragomans were businessmen, creditors, middlemen, and advisors in practical matters.

10. Delacroix would later paint a watercolor of Benchimol's wife and daughter for the Mornay album (see below, note 289).

11. Notes from this day, similar to the first jottings here and accompanied by sketches, are in Burty no. 30 (private collection), fol. 41r: "At the Pasha's. The entrance to the castle. The courtyard. The guardhouse. The façade."

12. See the account of this visit in "Memories," fols. 9–10 (above, pp. 37–39).

The entrance to the castle.[13] The guardhouse in the courtyard. The façade. The alleyway between two walls. At the end, under a kind of vault, seated men stand out brown against a bit of sky. [sketch]

Up on the terrace, three windows with a wooden balustrade, Moorish doorway on the side where the soldiers and servants came from.

Before that, the row of soldiers under the arbor: yellow caftan, various headdresses; pointed cap; no turban, especially the ones up on the terrace.

The good-looking man with green sleeves.

The mulatto slave who poured out the tea, with a yellow caftan and the burnous tied behind. Turban. The old man who gave us a rose, wearing a haik and deep blue caftan.[14]

Plan. [here a plan of the castle]

The Pasha[15] with two haiks or hoods, plus the burnous. All three[16] on a white mattress, with a long squared cushion covered in Indian cotton. A little round cushion with a Harlequin pattern; another leather one with various designs. Tips of the feet bare. Inkwell of horn. Various little things scattered about.

The customs administrator,[17] leaning on his elbow, his arm bare, if I remember rightly. Very full haik on his head. White turban on top, reddish cloth, which hung down on his chest. Dark blue burnous crossing over his chest very naturally, his hood not up. His legs crossed.

We met him on a gray mule on the way up. His leg was very visible; a bit of colored breeches. Saddle covered in the front and back by a scarlet cloth. A red band was wrapped around the horse's rump and hung down. The bridle likewise red, or rather the harness. A Moor was leading the horse by its bridle.

[sketch]

Only the ceiling was painted, and the sides of the pilaster on the inside were of faience. In the Pasha's niche the ceiling was a radiating pattern, etc. In the antechamber, little painted beams.

13. As Arama observes (Voyage, 5:63), the Kasbah, or citadel, of Tangier was begun in the reign of Moulay Ismail (r. 1672–1727), shortly after the city was retaken from the British in 1684. Surrounded by crenellated walls, it enclosed the pasha's palace, the law court, a mosque, batteries, a prison, soldiers' quarters, and stables. According to Lagerheim, the pasha lived in town but received consuls and envoys in the Kasbah (Minnen, 45). Drummond Hay identifies the gate to the Kasbah near the guardhouse as Bab el-Assà, or "gate of Bastinado," so called because floggings were administered in front of it (Bodleian Library, Oxford, MS Eng.hist.e.354, p. 21).

14. This is typical Moroccan dress. The burnous is a cloak, often striped, with a hood; the haik is a woollen garment draped somewhat like a toga over and under the arms (on women, it also covers the head and forehead); the caftan is a tunic, normally blue or yellow. This outfit was completed by yellow leather slippers and a silk turban. Delacroix notes and sketches all these clothes during the trip.

15. Sidi El-Arby ben Ali Saïdi (see 25 January).

16. The pasha, his son, and Bias.

17. Bias. See 25 January and note.

The third person was the Pasha's son. Two haiks on his head, or rather two rounds of the same one, as far as I could tell. Dark blue burnous on his chest letting a little white show through. Feet. Enormous head. Oily face. Dazed look. *[sketch]*

The good-looking man with the green sleeves. Overshirt of dimity.[18] The mulatto during tea. Barefoot before the Pasha.[19] *[sketch with color notes]*

The garden divided by paths covered with arbors. Orange trees covered with fruit, and large. Fruit on the ground. Surrounded by high walls.[20]

Wended our way through the old palace. Marble courtyard, fountain in the middle. Capitals of a bad composite style; the upper level of very simple stones. *[sketch]* Completely dilapidated. Niche for a throne. Rather tall cupboards. Doorways leading down corridors to other parts. This plan is of only one of the sides. *[plan]*

The ceilings of the niches and even of the little rooms are full of sculptures in perspective, painted like the rosettes on a mandolin.[21]

The columns around the courtyard are of white marble, and the courtyard paved with the same.

Turning around, noticed a lovely stairway on the right. *[sketch]* A good-looking man who was following us, with a disdainful expression. *[sketch]* Haik, burnous.

Left by the room where supposedly the Pasha dispenses justice. To the left of the door at the back, by which we had entered, a kind of platform made of planks about two and a half feet high, and running from the doorway to the corner, on which the Pasha sits.[22] Along the walls, in the spaces between the pilasters that support the vault, stone juttings that serve as seats. The soldiers, without rifles, were waiting for us at the gate in two rows, ending at the guard-house by which we had entered.

[sketch] Platform. Pilaster. Benches.

Went back down. Saw a very nice-looking Jewish woman. Looked like Mme R.[23] *[sketch]*

Very handsome soldier at one of the consul's. Red caftan. *[sketch]* Niche for the soldier.

Negro whom Mornay pointed out. Seemed to have a particular way of wearing the haik. No turban. The haik alone. *[sketch]* Very beautiful child, a little girl, as I was leaving one of the consul's. *[sketch]* The Negro as I went home. Trinkets in his hair. *[sketch]*

18. A light cotton fabric woven in raised patterns.
19. Bare feet were a sign of submission.
20. On these orange trees, see "Memories," fol. 30, p. 51.
21. Ceilings of sculpted wood. On the interior of the Kasbah, see p. 39.
22. Delacroix describes this in "Memories," fol. 9 (p. 38).
23. Perhaps the painter Louise Rang, a student of Delacroix's (see biographies).

The brown striped meschla sometimes has red in the trimming and hood.[24]

House of the American consul.[25] *[sketch]*

Garden of the Sardinian consul.[26] *[sketch]* Cistern in the middle. Flowers along the top of the walls. Succulents. *[sketch]*

Saw the mosque from the side as I was going to one of the consul's houses. A Moor was washing his feet in the fountain that is in the middle. The Muslim who cleans his feet before entering the mosque. *[sketch]* The prostrate man. Another who is washing in the middle, crouching on the edge of the fountain. *[sketch]*

Lamps attached to the wall of the mosque—the basin that forms the entrance of the false door.

The wedding; lanterns in the evening. *[sketch]*

[Tangier, Saturday, 28 January]

28th Saturday

At the synagogue in the morning. The lamps. Other lamps in the synagogue.[27] At Jacob's, portable lamp.[28] *[sketch]* Little stool to put under your feet.[29] Take home samples of paint.

The interior of Jacob's courtyard with the large vases, etc. In the evening, Schmarreck with his shorts and a leather apron.[30] *[sketches]*

A young Jew with the inside of his coat lined in red. *[sketch]*

Abraham with his black burnous.[31] *[sketch]*

24. A watercolor study of a meschla is in the Musée des Arts décoratifs (see *Delacroix: Le Voyage au Maroc*, cat. Paris, p. 174).

25. Moulay Suleiman, sultan from 1795 to 1822, had given the American government a fine house in the Medina. Rebuilt and expanded after the French bombing of 1844, it is now the Tangier American Legation Institute for Moroccan Studies. George A. Porter was interim consul from 29 January 1831 until 3 July 1832 (Archives of the US Department of State, Ralph J. Bunche Library; cf. Lagerheim, *Minnen*, 40).

26. On Girolamo Ermirio, "of loose morals and similar opinions," an able gambler who "handled cards with a skill indicating that he held fortune itself in his hands" (Lagerheim, *Minnen*, 40), see biographies. It was at Ermirio's that the fancy dress ball took place, which Delacroix attended in Moroccan dress, to the consternation of the locals and at the risk of his life. See the introduction, pp. 21–22.

27. These lamps consisted of crystal vases inscribed with the names of the dead and hung from the ceiling by chains (*Voyage*, 6:21).

28. Jacob Benchimol, Abraham's brother. Delacroix took a lamp of this type back to Paris (see below, p. 123).

29. Such a footstool can be seen in several of Delacroix's paintings, for example under the feet of the Jewish woman in *Jewess of Tangier* (J388 and J389).

30. According to Arama (*Voyage*, 5:67 n. 12), Schmarreck was an assistant in the tannery that Benchimol ran with José Colaço, the Portuguese consul. A fine watercolor of him is in a private collection (*Delacroix*, cat. 73, repr. p. 83).

31. The Jews of Morocco were required to wear a black burnous, a black cap tied with a silk kerchief that they had to remove in the presence of the Muslim authorities, and a black or dark blue coat (*yallak*). See Godard, *Le Maroc*, 34–35.

The interior of the little courtyard of the house—a little bench.

In the morning, the little Jewish woman's house with the arbor.

[Tangier, Sunday, 29 January]
Saturday *[sic for* Sunday*]* 29th

In the evening, the story of M. de Talleyrand's valet gazing at the bust of Voltaire.[32]

Around one o'clock, at the English consul's.[33] The soldier on horseback. Boots.

On the way home from this visit, saw a Negro with a black burnous with frogging in the front. Noticed the fountains. The mosque.

In the evening, the English soldier.[34] The burnous coming to a point on the head, the lock of hair at the end. *[sketch]*

In the morning, drew the little courtyard of the house.[35] The large vases in the corners. The oven with great earthenware dishes, very shallow.

The manner of riding on horseback. The stirrup is turned around. *[sketch]*

The terrace at the English consul's. Drew the view of the town from there.[36] The cage of canna reeds. *[sketch]* The trunk arrived from Tetuan with the paints.

Noticed the fountain above the town past the barber's. The edge of the basin in lead. *[sketch]* Misauda's red vest.[37]

32. Presumably a story told by Desgranges who, according to Lagerheim, had been a "pupil" of Talleyrand's (*Minnen*, 96). Talleyrand had been minister of foreign affairs during Desgranges's early years in the ministry (see biographies).

33. "An honest, upright, learned gentleman, as well as fussy, conceited, and pedantic, who, like a true Englishman, always considered himself first among his colleagues" (Lagerheim, *Minnen*, 37), "a learned and active man who keeps his government very up to date on everything that happens" (Mornay, report of 16 February 1832, *Voyage*, 6:206), Edward William Auriol Drummond Hay, consul general of Great Britain, played an important role in the diplomatic history of Morocco. See biographies. In a letter of 6 February, he informed his government of the arrival of the Mornay mission: "The count [. . .] is accompanied also by M. Eugène de la Croix, a painter of considerable talent. [. . .] The count [. . .] is a young man of excellent presence who has lived some two or three years in England and Scotland, seems attached to British customs and institutions, and appears gratified by numerous efforts I have made to entertain, with all the hospitalities [*sic*] in my power, himself and suite [. . .]" (London, The National Archives, FO 174, no. 162, pp. 102, 104).

34. That is, the Moroccan soldier of the British consulate.

35. This drawing is in Louvre 1757, fol. 6.

36. Drawings by John Hay, son of the British consul, show the view at this period from the terrace of the British consulate, located near the Great Mosque a few steps from the sea: the minaret of the mosque on the right, up through the city toward the Kasbah on the heights (Bodleian Library, Oxford, MS Eng.hist.c.1088, fol. 38). Seaward, there was an impressive view of the bay of Tangier and the Spanish coast (MS Eng.hist.e.371, fol. 17v. Also Hay, *Memoir of Sir John Drummond Hay*, 221).

37. A Jew employed as a valet for Mme. Ehrenhoff at the Swedish consulate (Lagerheim, *Minnen*, 80).

Going out the gate of the city, noticed the soldiers in the niche. Near the rifles, a little flask for gunpowder or something else, I'm not sure.[38] *[sketch]*

As I went out into the market, a child. He was using his belt as a turban. *[sketch with color notes]*

Spectacular view going down along the walls. Then the sea, etc. Enormous cactuses and agaves.[39] Canna-reed fences; spots of brown vegetation on the sand. *[watercolor drawing]*

On the way back, the contrast of the yellow, dried canna-reeds with the green of the rest. The yellow of the sand. The blue of the mountains. The nearer mountains a greenish brown, spotted with blackish dwarf shrubs. Lines of agaves. Huts. The soldier returning. *[watercolor with annotations]*

The Moorish bridge. The bridge built on the masts of the 145-gun vessel El Major del Mondo. The Moors stole the iron bands.[40] *[sketch]*

The scene with the horses fighting.[41] First they reared up and fought with a determination that made me tremble for those gentlemen, but which was truly admirable for painting. I actually saw, I'm certain, everything that Gros and Rubens could imagine as the most fantastic and spirited thing possible. Then the gray one passed his head onto the other's neck. For a seemingly endless time, impossible to get him to let go. Mornay managed to jump down. While he held him by the bridle, the black one kicked furiously; the other one kept biting him relentlessly from behind. In the midst of all this struggle, the consul fell off. *[sketch]*

Soon released, they move toward the river without letting go of each other. Then the two of them falling in and continuing the fight, and at the same time trying to get out; legs stumbling in the slime and on the bank. All dirty and gleaming with sweat. Their manes wet. With blows raining down on him, the gray one lets go and floats to the middle of the river. The black one comes out, etc. On the other side, the soldier trying to hitch up his clothes to go pull the other one out. Peasant with a rifle. Another peasant with a jug on his back.

The soldier's dispute with the groom. Sublime in his heap of drapery. The look of an old woman and yet something martial about it. Enormous head under the pile of cloth. Green cord on his saber. *[sketch]* Remember the ford.

38. One of these powder-flasks, which Delacroix took back to France, is in the Musée Delacroix (Font-Réaulx, *Delacroix: Objets dans la peinture,* no. 47). The gate near the British consulate was Bab el-Bhar, the "sea-gate" (Drummond Hay papers, Bodleian Library, Oxford MS Eng.hist.e.354, p. 22).

39. Delacroix calls these plants "aloes," but, as a later comment (below, p. 130) and his many drawings show, he is referring to agaves.

40. El Mayor del Mundo, "the greatest in the world." Delacroix explains this remark in "Memories," fol. 28 (p. 50).

41. "Memories" contains an elaborate description of this scene (fols. 25–27, pp. 48–49). Delacroix also describes it in a letter to his friend Pierret of 8 February (*Corr.,* 1:311).

On the way back, magnificent landscapes on the right. The mountains of Spain of the smoothest tone; the deep blue-green line of the sea. The hedges, yellow at the top because of the cannas, and green lower down from the agaves.

The shackled white horse that wanted to pounce on one of ours.

On the beach, almost home, met the kaïd's sons, all on mules. The eldest, with a dark blue burnous, a haik almost like our soldier's but very clean. Canary-yellow caftan. One of the young children all in white, with a kind of cord from which a weapon probably hung.

Climbing up the ramparts, magnificent boulders on the seashore. Bright green grasses, etc.

The tannery. On the way up, a woman down below with a bundle. *[sketch]* The shirt was arranged like this *[sketch]*. Little gate to the city.[42] *[sketch]* The doorway of the school next to the mosque.

The mosque, as we were leaving. The fence that surrounds the pool is open on one side, with mats all around and on the pillars, up to a height of about four feet. The top of the arcades around the courtyard is filled in with planks and glass panes much like ours.

The stirrup in the middle of the horse's belly. *[watercolor]*

In the morning, the two soldiers share the meat. *[watercolor with color notes]* Do the saddles against the wall. Try to see saddles embellished with metal.

[Tangier, Monday, 30 January]

30 January. Visited the English and Swedish consuls.[43] M. Delaporte's garden.[44] Tombs in the countryside. *[sketch]*

The fountain. The Turk at the English consul's. *[sketch]* The donkey driver who gives water to his asses. The beggar crouching at the city gate. *[sketch]* The woman carrying the child. *[sketch]* Dog on the terrace. Cats too.

In the countryside, the Muslim crouching on the well at ground-level, doing his ablutions. *[sketch]* His friend getting ready.

[Tangier, Monday, 31 January]

31 January. Drew the Moor from the Sardinian consulate. Rain. On my way to the English consul's, noticed a fairly neat shopkeeper in his shop. The floor and

42. The tannery was outside Bab dar dbag, or "tannery gate," a "postern," in Drummond Hay's words, on the south side of town, leading east toward the sea (Bodleian Library, Oxford, MS Eng. hist.e.354, p. 22).

43. Drummond Hay and Lagerheim.

44. "M. Delaporte, whose kind hospitality and profound erudition about everything to do with the East I can never praise enough," Delacroix later wrote in a variant to "Memories" (fol. 18 variant a, *Journal*, 2:1902). Delacroix stayed in touch with him, as numerous mentions in the *Journal* attest. See biographies.

surround covered with mats. Planks with pots and merchandise only on one side. *[sketch]*

The entrance to the caravanserai.[45] Men crouching. Horses in light at the back. A man then came forward towards the front, standing out white against the background. *[sketch]*

[Tangier, Thursday, 2 February]

2 February, Thursday. Drew Jacob's daughter in Moorish dress.[46]

Went out around 4 o'clock. A Moor with a very striking head who wore a white turban over his haik. Like Rubens' Moors.[47] Pure skin; nostrils and lips, etc., a bit thick. Bold gaze. *[drawing]*

The mosque open. The fountain surrounded by a bench. *[sketch]* There are white burnouses that have stripes here and there.

Noticed the gate that leads to the port.[48] A man leaning against the wall on the right had a red cap that made a nice effect, etc. *[sketch]*

Noticed the cannons. *[sketch with color notes]*

Saw the pious person again, with his blind eye edged in black. Two burnouses. *[sketch]*

Coming down from the citadel. *[sketch].*

The ancient fountain. *[sketch]*

The old Jew in his shop as I came back down to the house (Gerard Dow).[49] *[sketch]*

Women with their heels and, I think, their feet painted yellow.

A very black Moor going out of his doorway. The interior very light. The skirting painted a yellow Easter-egg color, to a height of four feet. *[sketch]*

In the day, two Moors with a tambourine crouching in front of the door of the house. Only one haik. *[sketch]*

Going up to the citadel, saw a young Negress rushing along a little street. Nipples under her shirt. *[sketch]*

[Tangier, Saturday, 4 February]

4 February, Friday *[sic]*. After lunch, drew the Moor from the Sardinian consul. Went out around two. Went to see the Danish consul's.[50] Saw a sailor.

45. A large courtyard surrounded by buildings in which travelers could stable their animals and spend the night.

46. Jacob Benchimol's daughter, Abraham's niece.

47. There are numerous examples in Rubens's work, including in two *Hunts* that Delacroix mentions in the *Journal* of 25 January 1847 (1:333–34).

48. Bab el-Bhar, sometimes called Bab el-Mersa, according to Drummond Hay (Bodleian Library, Oxford, MS Eng.hist.e.354, p. 22).

49. Perhaps an allusion to Dou's *Moneylender* (1664, Louvre), depicting a moneylender weighing gold.

50. Peter Kofod Anker Schousboé, Consul general of Denmark since 1800, a well-known botanist and dean of the consular corps in Tangier, who was to die three weeks later.

Red turban. Haik. Red breeches. Sleeves in the Christian style. Red vest. Passed in front of the school. *[sketch]*

Incinctus [unbelted], people who are not warriors. *Cinctus* or *accinctus [belted]*, military men. The distinction that the ancients had is here too![51] The djellaba, costume of the people, merchants, children.[52] I remember that djellaba, exactly the same as in antiquity, in a little figurine in the Louvre on its own. Hood, etc. The cap is the Phrygian one.

The palimpsest is the tablet on which the children write at school. Mutual instruction is native to these countries.[53] In moments of hardship, the children go around as a group carrying that tablet on their head.[54] It is coated with a kind of clay on which they write in a special ink. It can be erased, I think, by dampening it, and then drying it in the sun.

The door at the Danish consul's. The hinges *[sketch]*. I noticed some similar ones at the castle today.

In the Jewish quarter, saw some remarkable interiors as I went by. A Jewish woman stood out vividly: red cap, white drapery, black dress.

In the main street, met a young, rather slim officer. Sleeve olive green, like the caftan. Dark blue burnous. His trousers hung on his leg from behind, as here *[sketch]*.

The negro: woollen shirt, trunks likewise. *[sketch with color notes]*

The Swedish consul's gardener.[55]

51. In the *Journal* of 10 April 1850 (1:499), Delacroix notes this same point, after a visit from Delaporte.

52. The djellaba, a long, rough woollen cloak with holes for the arms, resembling a sack. See "Memories," cahier 5-a, p. 33.

53. Mutual instruction was a system of peer instruction developed by the Scotsman Andrew Bell (1753–1832), in which a teacher taught a small, usually older group of children, who then taught another, usually young group. The same point is made in "Shaler's Sketches of Algiers," an article published in the *North American Review* of April 1826 (p. 426) and translated in the *Revue britannique* of July 1826 (p. 70): "From the invariable character of the customs of these countries, I am induced to believe that their practice is the probable origin of the Lancastrian *[mutual]* system of tuition. Each scholar is provided with a board, upon which anything may be fairly written with chalk and easily effaced; a lesson from the Koran is transcribed in fair and legible characters upon one of these boards, which is then copied upon all the others, the scholars mutually teaching each other, both in the meaning and in the formation of the letters of the text. These lessons are loudly rehearsed to the pedagogue, who sits upon his heels in a corner with a long rod, through the terror of which he maintains order and due attention among his scholars."

54. In times of distress—drought, floods—bands of children roamed the streets praying for help (Windus, *Journey to Mequinez*, 62). Delacroix notes the same fact on 28 April (below, p. 108). Drummond Hay explains that the tablet was dampened, then covered with a whitish clay, and that the ink was made from a dry pigment of burnt wool mixed with water (Bodleian Library, Oxford, MS Eng.hist.e.354, p. 111).

55. According to Lagerheim (*Minnen*, 86), this gardener, named Ali, belonged to the Issawa sect, Delacroix's "convulsionaries," as depicted in his three paintings on the subject: "[He] was wild when he had eaten kif during their festivals, but otherwise was a calm and quiet man. He regretted that he belonged to this sect but could do nothing about it." See Chantilly notebook, p. 2 (below, p. 124), and the introduction, p. 21 above.

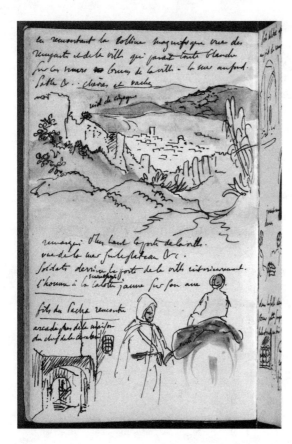

FIGURE 1 Eugène Delacroix, page from the Tangier notebook, 4 February 1832. Watercolor and ink on paper, 16.5 × 9.8 cm. Paris, Musée du Louvre 1755 (RF 39050), fol. 16v. Photo © RMN–Grand Palais (Musée du Louvre) / Michèle Bellot.

Going back up the hill, magnificent view of the ramparts and the town, which appears completely white against the brown walls of the town. The sea in the background. Sand, etc. Goats and cows. *[ink and watercolor drawing, annotated* stork's nest, *fig.1]*

Higher up, noticed the city gate.

On the plateau, view of the sea, etc.

Soldiers behind the city gate on the inside. The man with the yellow cap (kerchief) on his donkey. *[sketch, fig. 1]*

Met the Pasha's son. *[sketch, fig. 1]*

Arcade near the commander of the cavalry's house.[56] *[sketch, fig. 1]*

After view of the ramparts, dilapidated gate. Thatched cottage at the base of the rampart, with palm tree. Poor man seated, very long face. *[ink drawings]* Son of the cavalry commander. *[ink drawings, with annotations]*

56. On Mohammed ben Abou Abd el-Malek, commander of the cavalry, see 7 March.

Playing checkers. *[sketch]* Soldier in the room. Painted ceiling. Saddles on the ground. One completely leather—bags for the camels, bags on the saddle-tree. Sabers on top.

In a corner of the room, obscure little wooden cupboard with balustrade painted red. *[sketch]* The guardhouse. *[sketch]*

On my way out, the children blowing into reeds. The man whom I took for Caddour's son.[57] Hood of his djellaba under his haik. Blond animal-hair.[58] *[sketch]*

Jewish woman in rags. Lovely face, patched dress. The child. *[sketch]*

At M. Freycinet's.[59] Women [seen] from his terrace. He promised to show me the costume of an Algerian woman. The woman grinding wheat.

It is the first day of Ramadan.[60] At moonrise, with some daylight still, they fired shots into the air, etc. This evening they are making an infernal din with their drums and horns.

[Tangier, Sunday, 5 February]
The 5th. In the Swedish consul's garden after lunch.[61] The man in a shirt who was working in the garden. Earlier, went by the other city-gate when passing by the courtyard where the camels were. Camels' packsaddles and bags. *[sketch]*

Man with a rifle in a scabbard on his shoulder. At noon to Abraham's.[62] Passing by his sister's door, noticed two little Jewish women crouching on a carpet in the courtyard. *[sketch]* In his house, his entire family in the sort of little niche that is in the courtyard. *[sketch]* From up above noticed that same niche and the balcony above with the stair door. Nice subject. The woman on the balcony. *[sketch]*

The lamps hung on the wall and suspended from the high wall.

57. Caddour, soldier from the French consulate (see "Memories," fols. 22–23, pp. 46–47).
58. Presumably in the wool of the djellaba.
59. Jean Fraissinet, the Dutch consul since 1827. Lagerheim's memoirs provide numerous details about this "old friend" whom he had first met in Algiers and encountered again in Tangier (*Minnen*, 32): a man of the world who spoke several languages, a poet, musician, and painter of landscapes, seascapes, and portraits, a skilled horseman, a fine judge of food, with a gift for conversation and a taste for women. See 12 February and biographies.
60. A watercolor in Grenoble (D836) is annotated "4 February, 1st day of Ramadan." Delacroix recounts the feast of Ramadan at length in "Memories," fols. 22–24 (pp. 46–48).
61. In a letter to Pierret (*Corr.*, 1:310, 8 February 1832), Delacroix refers to "the moments of delightful idleness" that he spent in this magnificent garden planted with trees and flowers from different regions of the world, and which Lagerheim describes at length. Criss-crossed by paths shaded by vines that led to a high point with a view of the sea and the market, and enclosed by a wall and a hedge of canna reeds, it contained hundreds of trees such as oranges, pomegranates, figs, chirimoja, dragon blood trees, palms, acacia, and so forth, as well as northern European species—apples, pears, cherries—including a fir that, in its adopted climate, "had not exceeded an ell in height and seemed to throw envious glances at the high peaks of the Alpujarras on the other side of the strait" (Lagerheim, *Minnen*, 53). On this garden and those of the other consuls, see "Memories," fols. 30–31, pp. 51–52.
62. Benchimol. See 28 January.

In the evening, went out to a shop. Mats against the wall. On the wall, Arabic letters in red. A glass as a lamp.

The night before, on the terraces when the shots were being fired, etc. Women on the terraces. Two wrapped in the same haik. *[sketch]*

The Negress who came to the house. *[sketch]*⁶³

[Tangier, Saturday, 11 February]

11 February. On the 11th, the Muslim saying his prayers in one of the niches near the city gate.

Moulay Suleiman had fifty-four children. Even so, he abdicated in favor of Moulay Abdou Rachman [sic], his nephew, believing that his children were not very capable.⁶⁴

[Tangier, Sunday, 12 February]

Sunday, 12 February—Drew the Jewess Laetitia in Algerian dress.⁶⁵

Afterwards, went to the Danish garden.⁶⁶ Delightful route. Tombs among the agaves and irises (aegyptiaca).⁶⁷ The one on the hillock. *[sketch]* Purity of the air. M[ornay] as taken as I was by the beauty of this landscape. White tints on all the dark objects. The little square tower in the background. *[sketch]*

The almond-trees in flower. Persian lilac, a large tree.⁶⁸ The fine white horse under the orange trees. Interior of the courtyard of the little house. On the way out, the orange trees black and yellow through the doorway of the little courtyard. As we left, the little white house in shadow amid the dark orange-trees. The horse through the trees.

Dinner at the house with the consuls. In the evening, M. Rico sang Spanish songs.⁶⁹ Only the south can produce such emotions. Unwell and stayed home

63. Cf. the watercolor in Arama, *Delacroix: Un voyage initiatique*, p. 94.

64. Sultan Moulay Suleiman (ruled 1795–1822) had a generally beneficent, but tumultuous, reign: as Arama points out, he had to confront drought, famine, cholera, civil war, and social unrest. Having deposed his brother Moulay Hicham (ruled 1792–1795), and considering none of his own children worthy to hold power, he named the latter's son, Abd al-Rahman, as his successor (ruled 1822–1859): "He does not drink, commit adultery, lie, steal, or spill blood and he takes money from others only for good reasons" (cited in *Voyage*, 5:79). On Abd al-Rahman, see 22 March and biographies.

65. According to Arama, Letitia Azençot, niece of Abraham Benchimol and sister of David Azençot, a trader (*Le Maroc de Delacroix*, 153). Fraissinet had promised on 4 February to show Delacroix an Algerian costume.

66. The Danish consul's garden was one of the highest points along the coast. On the consular gardens, see "Memories," fols. 30–31, pp. 51–52.

67. *Orobanche aegyptiaca*, or Egyptian broomrape, a short parasitic plant with an iris-shaped flower, native to the Middle East and North Africa.

68. *Melia azederach*.

69. José Rico, the Spanish vice-consul to Tangier. "[. . .] judging by the number of military decorations, [he] must have been a great warrior; but he was a fanatical ultra-royalist who cruelly persecuted the [Spanish] liberals who escaped to Morocco under Ferdinand VII" (Lagerheim,

alone in the evening. Delightful reverie in the moonlight in the garden. Effect of the moon in the little courtyard.

Effects of the moon and the lights in the courtyard of the house. *[sketch]* Schmarreck in the soldier's niche.[70]

The night before, 11th. Went to M. Frayssinet's garden.[71] On the way up, groups of Moors in the market square. Little tent. The gardener. *[sketch]* View of the mountains. *[sketch]*

[Tangier, Wednesday, 15 February]
Wednesday 15 February
Went out with M. Hay.[72] Saw the muezzin calling from the heights of the mosque. *[sketch]*
The school for little boys.
All had tablets with Arabic writing. The expression "table of the law" and all the ancient indications about writing show that it was done on wooden tablets. The inkwells and slippers in front of the door. As we left the ramparts, soldiers in the guardhouse. *[ink drawing]*
The Jewish cemetery. *[sketch]*
The fisherman. *[sketch]*
M. Bell's house.[73] Little window with a grill in the Moorish style, upstairs near the bedroom. *[sketch]*
The fondouk.[74]
The cord right along to hobble the horses. The horses' harness. A black Moor, with the small nose of a Negro, crouching. Moor leaning against the parapet on the seashore. *[sketch]*

[Tangier, Tuesday, 21 February]
21 February, Tuesday.—The Jewish wedding.[75] Moors and Jews at the entrance. The two musicians. The violinist, thumb in the air, the hand, the bow, the

............

Minnen, 39). Lagerheim recounts numerous adventures involving Rico, whose political attitudes were abhorrent to him. See biographies.
70. Schmarreck, see 28 January.
71. Fraissinet had laid out a beautiful garden at the top of the highest hill, near the city, with a view over the bay, the Strait, and across to the Spanish coast (Lagerheim, *Minnen*, 54). In a letter from 1836, Lagerheim referred to "the excellent M. Fraissinet" who, as he imagined, "divides his time as usual between his garden, his palette, his cigars and the Jewish women" (letter to Mornay, 9 January 1836, A.N. 402/AP/16).
72. Drummond Hay, the British consul (see 29 January).
73. The doctor John Bell had been British vice-consul since July 1831. Drummond Hay's letters give a very sympathetic portrayal of him. See biographies.
74. Caravanserai, inn.
75. Delacroix later used these notes for "A Jewish Wedding in Morocco" (above, pp. 56–59), and for his painting of the subject (J366).

underside of the other hand in shadow, bright behind.[76] The haik on his head, transparent in places. White sleeves, the violinist's dark at the back. Sitting on his heels, and the djellaba. Black between the two of them low down. The guitar case on the player's lap. Very dark near the belt, red vest, brown orna-ments. Blue behind, around the neck. Projected shadow from the left arm that comes in front, on the haik on his lap. Shirt sleeves rolled up, revealing his biceps. Green woodwork alongside. Vein on his neck; short nose.

Next to the violinist, pretty Jewish woman. Vest, sleeves gold and reddish. She stands out half against the doorway, half against the wall. Further toward the front, an older woman with a lot of white who hides her almost completely. A lot of reflections in the shadows—white in the shadows.

A pillar standing out dark in the front. On the left, women in tiers like flowerpots. White and gold dominate, and their yellow kerchieves. Children on the floor in the front.

Next to the guitarist, the Jew who plays the tambourine. His face stands out in shadow and hides a part of the guitarist's hand. The underside of the head stands out against the wall. A bit of djellaba under the guitarist. In front of him, legs crossed, the young Jew who holds the plate. Gray garment.

Leaning on his shoulder, a young Jewish boy of about ten. *[sketch]*

Against the doorway to the stairs, Prisciada;[77] kerchief violet-colored on her head and under her chin. Jews also on the steps. One, half against the door, lit very intensely on his nose, etc. One standing upright in the stairway; strong, reflected shadow standing out against the wall with reflections in light yellow.

Upstairs, the Jewish women leaning over. *[sketch]* One, on the left, bare-headed, very dark, standing out against the wall lit by the sun. In the corner, the old Moor with the crooked mouth; fuzzy haik, turban worn low on his forehead. Gray beard against the white haik.—The other Moor, shorter nose. Very masculine, turban projecting. One foot outside its slipper. Sailor's vest and sleeves. On the floor, in the front, the old Jew playing the tambourine. An old kerchief on his head. You can see the black cap. Djellaba torn. You can see the garment torn near the neck.

Women in the shadow of the doorway, which has a lot of reflections.

76. On the violin, *rebab*, see below, p. 155, note 67.

77. According to Arama (*Voyage*, 5:84 n. 40), Presciada Benchimol, the daughter of Saada and Abraham Benchimol. Several drawings of her, including a watercolor, are in the Chantilly note-book. Supposedly, she is depicted with her mother in the watercolor from the Mornay album mentioned above (note 10). However, according to Alexandre Dumas, who visited Tangier in 1846, David Azençot named the Benchimol daughter depicted in the watercolor (his sister-in-law) as Rachel (Dumas, *Impressions de voyage*, 57).

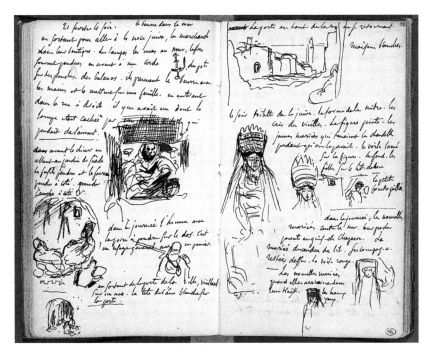

FIGURE 2 Eugène Delacroix, pages from the Tangier notebook, 21 February 1832. Ink on paper, 16.5 × 9.8 cm. Paris, Musée du Louvre 1755 (RF 39050), fols. 21v–22r. Photo © RMN–Grand Palais (Musée du Louvre) / Image RMN-GP.

[Tangier, Tuesday, 21 February, evening. See fig. 2.]
21 February, in the evening. The butter in the wall.

Going out to the Jewish wedding, [saw] shopkeepers in their shop. The lamps, some on the wall, most often hung forward from a cord. *[sketch]* Pots on planks. Scales. They take the butter in their hands and put it on a leaf. Entering the street on the right, there was one whose lamp was hidden by a tulle curtain that hung from the awning. *[sketch]*

Before dinner, on the way to the Swedish garden, the rifles hung up and the scabbard hung next to them. Large jug beside them, etc. *[sketch]*

Earlier in the day, the man with the powder-flask on his back. That is a general practice. With a basket. *[sketch]*

Going out of the city gate, old man on a donkey. The donkey's head white against the gate. *[sketch]*

The gate at the top of the street as you turn around. White houses. *[sketch]*

In the evening, the Jewish bride's preparations.[78] The form of the miter.[79] [sketch] The old women's cries. Her face painted.[80] The young brides who held the candle while she was being dressed. The spangled veil on her face. The background. Girls on the bed, standing.

In the daytime, the recent brides against the wall. Their near relative as a chaperone. The bride brought down from the bed. Her companions remained on it. The red veil. [sketch]

The recent brides when they arrived in their haik. Their lovely eyes. [sketch]

Arrival of the relatives. Wax torches. The two painted different colors. Din. Faces lit up. Moors mixed in. [Bride] held on both sides. Someone behind supports the miter. On the way, Spanish women watching through the window. Two Jewish or Moorish women on the terraces, standing out against the black of the sky. M. Hay said that they sometimes pinched them—or took them past certain places.[81]

To M. Hay's in the evening. Gave his daughter the drawing of the Moorish woman seated.[82]

On the way, the elderly Moors up on the rocks. The lanterns. The soldiers with batons. The young Jew who was holding two or three torches, the flame rising up into his mouth.

At Abraham's, the three Jews playing cards. [sketch]

Women near the city gate. Straw hats. Selling oranges, etc., branches of hazelnuts.

Peasants bareheaded, crouching with their milk jugs.

78. See above, pp. 57–58, for Delacroix's description of this scene in "A Jewish Wedding in Morocco." Dumas also describes a Jewish wedding that he attended in Tangier, with numerous points in common with Delacroix's account (Le Véloce, 78–93).

79. A magnificent watercolor of the Jewish bride wearing this miter is in the Louvre (1588).

80. A bride was very made-up: one traveler wrote that it was like the makeup of the clown Grimaldi (Ford, Letters of Richard Ford, 119).

81. The procession leads the bride, immobile, impassive, her eyes closed, to the groom's house. Delacroix explains that, to trouble her composure, "they take their mischief so far as to pinch her on the way" (above, p. 59). "Certain places": perhaps smelly ones, for the same purpose.

82. Unidentified drawing. At this period Drummond Hay had eight children, including three daughters (London, The National Archives, FO 174 no. 162, p. 47, letter of 4 November 1831; see biographies). In a letter to Pierret of 29 February, Delacroix refers to "a little romantic fling that I'm involved in with a very pretty and proper little English girl," who has been thought to be one of Hay's daughters (Corr., 1:318). But as the eldest Hay daughter was only fifteen in 1832, he may be referring to another member of the Hay household, whom Lagerheim mentions in his memoirs: Miss Agnes Wilson, a friend of the family and tutor to the children, "a particularly educated and talented young lady," innocently courted by Mornay, at least (Minnen, 37, 96). Indeed a letter from Mornay's relative (cited below, note 261) notes Delacroix's flirtation with "a young Englishwoman living in Tangier."

[Tangier, Thursday, 23 February]

23 February. Around four o'clock, to the Swedish garden. At the end of the market. Camels going downhill. Men sitting on stones. *[sketch]*

Interior of the courtyard at M. Bell's.[83] Wooden trunk near the door. Reeds against the wall. Vegetables on the ground. Mats. Carpets.

Man saying his prayers.

The young Jewish girl from M. Bell's. *[sketch]*

[Tangier, Friday, 2 March]

2 March, Friday. Walk with M. Hay. Dined with him in the evening, next to M. L[agerheim].[84]

The man at the castle, soldier in a short tunic. White breeches like the Jews. The little mosque. *[sketch]*

The next day, met M. Hay on the beach. The Moor and the horse that was rolling in the sand. Negro on the way back.

On the way, on the path that goes down, two very handsome men. *[sketch]* Near the well, other ones.

[Here, in the middle of fol. 23v, Delacroix sets the Tangier notebook aside and takes up another one that he will use on his trip to Meknes. He resumes using the Tangier notebook after his return from Meknes, filling a few pages (see below, 12 April). Then he abandons it again for the Meknes one, which he takes with him to Spain.]

Journey to Meknes

Meknes Notebook (Louvre 1756)

[After more than a month in Tangier, the party set out for Meknes for the audience with the sultan. They had meant to leave sooner: it was thought that the sultan would schedule the audience for Ramadan so that they would see him "in all his magnificence and surrounded by immense populations under arms" (Mornay's report of 12 February, Voyage, *6:201). But it was deferred because of the death of his brother, Moulay Maimoun—seemingly, at least. For Drummond Hay reports that the sultan put it off to avoid an embarrassing situation: an Algerian delegation of five hundred, bearing rich gifts, had arrived in Meknes to ask for the sultan's help*

83. Delacroix did a watercolor of this courtyard (see *Journal,* 24 January 1862, 2:1392). On John Bell, see biographies.

84. A watercolor of a Moroccan standing, inscribed "2 March. Walk with M. Hay. Dined with him," is in a private collection (*Delacroix: Le voyage au Maroc,* repr. cat. Paris, 140). See also the Meknes notebook, fol. 3 (below, p. 82).

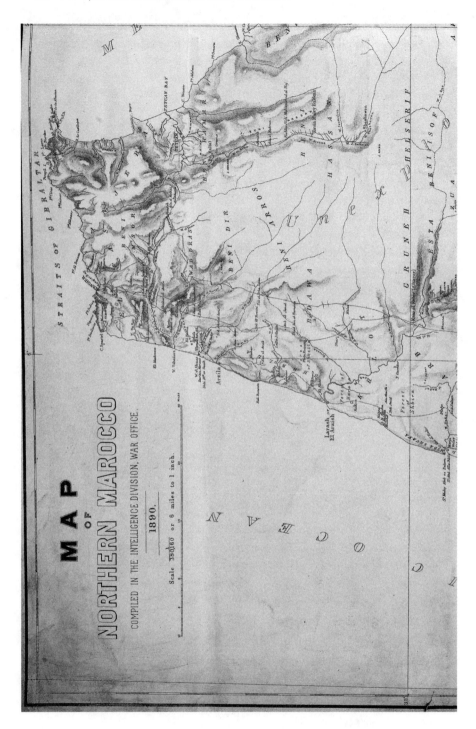

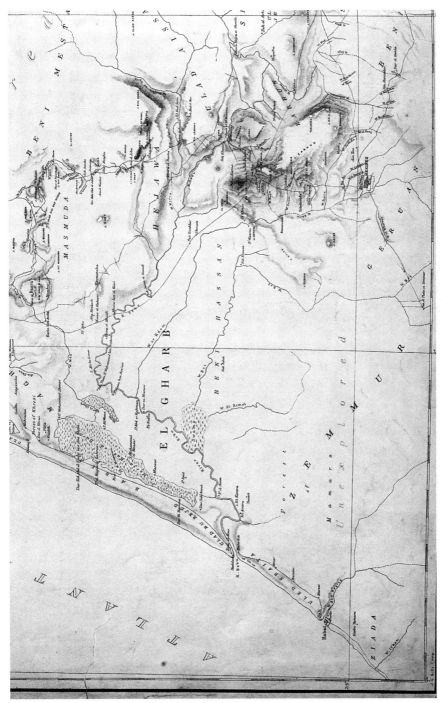

MAP 2 Map of northern Morocco, 1890. J. G. Kelly, Intelligence Division, War Office. British Library, Maps MOD ID 808. Photo: The British Library Board.

and protection against the French invaders, and to declare their loyalty to him.[85] *The party left Tangier on 5 March and arrived in Meknes on the 15th. After the audience on 22 March, they left Meknes on 5 April and arrived back in Tangier on the 12th. For the route, see Maps 2a and 2b.]*

[fol. 1r, watercolor, view of Tangier from the heights, sea and mountains in the distance] *1st March Tangier

[fol. 2r, watercolor, landscape with agaves in the foreground, mountains in the distance]*

[fol. 3r, ink drawing] *Friday, 2 March. Walk with M. Hay. Dined with him. Vicino a J.[86]*

[fol. 4r, turning the notebook upside down, pencil drawings of women] *Man turned over to the children[87]*

[fol. 5r, pencil sketch of an interior with a door]*

[from fol. 5v]
[Tangier to Ain Dalia, Monday, 5 March]
1st day. Aïn El Daliah.[88] Left Tangier at one.

The foot sometimes sideways in the stirrup.

The flag in its sheath, planted in front of the tent.

The plain, and the tribe lined up, receding toward the back.—In front, half a dozen horsemen in the smoke, one further to the front. Blue burnous. Very dark.—In front, with their backs turned to us, the line of soldiers preceded by the kaïd and flags.

The charge with five or six horsemen.

The bareheaded young man, piss-green caftan.

The half-Negro, pointed cap. Blue caftan.

The men illuminated on the edge from the side. The shadow of white objects [had] strong reflections in blue. The red of the saddles and of the turban almost black.

At the ford,[89] the men climbing, a white horse sideways on. *[watercolor sketch and drawing of the horse seen sideways]*

85. Letters of 5 March and 9 April 1832, London, The National Archives, FO 174 no. 162, pp. 107 and 137.

86. I do not know why Delacroix used Italian to indicate that he was "next to" Julius Lagerheim (cf. above, 2 March). Could he be alluding to the little farce that the consuls played on Drummond Hay about his insistence on using English? See the entry on Drummond Hay in biographies.

87. In "Notes and Drafts," 2nd unnumbered fol. r (p. 151), Delacroix seems to contrast the composure of a man who could strip a dead man, and his disarray when handed over to a group of children.

88. Ain Dalia, about ten miles south of Tangier. In what follows, the place that Delacroix indicates at the start of his note is usually the day's destination.

89. At Oued Mera.

[watercolor sketches and drawings: tent, saddled horses, camp]

Arrival at the camp. Uncultivated, black mountains on right,[90] sun above. Walking in dwarf palm undergrowth and stones.

The whole tribe lined up on the left crowning the heights; further on, horsemen against the sky. Further still, tents.

Walk in the camp in the evening. Contrast of the white clothing against the background.

In the evening, the imam calling to prayer.

[Ain Dalia to Had el Gharbia, Tuesday, 6 March]
6 March. To Garbia.

Left around 7 or 8 o'clock. Climbed a hill, sun on our left. Mountains standing out one behind the other against a clear sky. *[sketch]*

Met various tribes. Fired shots as they jumped up in the air. Crossed a very picturesque mountain (Lac Lao).[91] Stones. I stopped for a moment. Men under the trees near a fountain. Men through the brush. *[sketch]*

Very beautiful view at the top of the mountain, a half-hour before the camp. The sea on the right and Cape Spartel.[92]

Cavalry charges in the plain before the river.[93] The two men who collided. The one whose horse hit its rump on the ground. One especially in a blue-black caftan with a rifle scabbard across his chest. *[sketch]*

Later, a man in a sky-blue caftan.

The tribe following us, chaos. Dust. Preceded by the cavalry. Charges. The horses in the dust, the sun behind. Arms upraised in the surge. *[sketch]*

On our descent from Lac Lao, on the left, meadows very greenish-black; the mountain ditto; in the distance, mountain of an intense blue. *[sketch]* The flag, cashmere, design. *[sketch of the design]*

90. The hills to the west of Ain Dalia—Jebel Dar Zhirou, Jebel Achngour, Koudyet Dekdak, at about 250 meters.

91. Ghabat (Dar) Akloo, a wooded hill range just south of Ain Dalia.

92. Promontory to the west of Tangier.

93. Mornay writes: "Everywhere, I found numerous detachments of horsemen and armed infantry gathered on the route to escort me and give us the spectacle of the *jeu de la poudre*, a military exercise that they perform on solemn occasions or for people whom they wish to honor with a mark of special distinction. These honors are not, by the way, without danger for the Christians who receive them, for the Moors delight in aiming straight at us to see whether we take fright." Delacroix describes these exercises, which consist in "launching their horses at top speed and stopping them suddenly after having let off their shot; it often happens that the horses carry off their riders and fight one another when they collide" (*Corr.*, 2:38). He depicted this subject many times: *Arab Horseman Practicing a Charge* (J349), *Arab Cavalry Practicing a Charge* (J351, J353, J376), *Collision of Arab Horsemen* (J355, J367), plus a watercolor for the Mornay album (Louvre 1571). He calls them *courses de poudre* or simply *courses*, which I have rendered as "cavalry charges" or "charges." He does not use the current term *fantasia*, which entered the language only later.

At the camp, soldiers running around in confusion, their rifles on their shoulders, in front of the Pasha's tent and then getting themselves in line. The Pasha said . . . *[blank]*

The soldiers coming by four or five in a square and bowing, in front of the cavalry general's tent. Then all in a row, receiving their orders in little squadrons. The others crouching while waiting their turn. *[sketch]*

The tribes going to pay homage to the Pasha and bringing provisions. *[sketch]*

[Had el Gharbia to Tlata Raisana, Wednesday, 7 March]
7 March. To Teleta deï Rissana.

The plain bordered by very large olive trees on the hill. We had eaten lunch on the bank of the Ayasha river. *[sketch with annotations]*

The man in the black caftan. Haik on his head knotted under his arm.

The man who was mending something on his saddle. Turban without a cap. Black burnous draped behind in the Roman manner, very high boots, yellow piece on the heel. *[sketch]* Burnous on his head attached by a cord. *[sketch]* Buttons on his white robe. *[sketch]*

Negro in a red and white turban. *[sketch]*

The five hares caught in the plain.

The meeting with the other pasha.[94] Damask on the rump of the pasha's horse. Music on horseback. *[sketch]*

Prayers near the commander's tent. *[sketch]*

The people carrying the plate of couscous in a carpet, and sheep. *[sketch]*

The naked man arranging his haik near the saint's tomb. *[sketch]*

Tree near a little pile of stones. *[sketch]*

Mountains green and yellow-earth color in the distance.

Spent the evening with Abou in our tent.[95] Conversation about horses. The music box that would not stop. Urge to laugh.[96]

94. The pasha of each province escorted the caravan as far as the edge of his territory (Mornay's report of 4 March, *Voyage*, 6:211). Here Delacroix refers to the pasha of Larache, Hamid Abd al-Salam Al-Slawi (Mornay's report of 23 March, ibid., 213).

95. "In truth, the kaïd Ben Abou could be considered [. . .] a rare breed in that country and, by his demeanor and habits, brought to mind exactly what we imagine about the Moorish knights of old who conquered Spain" ("Notes and Drafts," 2nd unnumbered fol. r, p. 151). "Even the name of Ben Abou was enough to inspire terror" (Godard, *Le Maroc*, p. 69). Mohammed ben Abou Abd el-Malek, then commander of the cavalry at Tangier, left a profound impression on all who met him: he is often mentioned by Delacroix, who admired his skill on horseback, authority as a military commander, behavior as a warrior, and "beauty in the cavalry charges—the horses taking off like thunder" ("Notes and Drafts," 1st unnumbered fol. r, p. 149). He depicted him numerous times (see biographies).

96. It is unclear what Delacroix means here. See also p. 147.

The anecdote about the cheeses that the Pasha of Tangier was arranging.[97]

[Tlata Raisana to Ksar el Kebir, Thursday, 8 March]
Thursday 8th. Alcassar El-Kebir[98]

Rain as we left.[99] Climbed a hill and entered a pretty wood of holm-oaks called *[blank].*[100] Entered the plain of *[blank]* in which Don Sebastian's army was defeated.[101] Crossed the river *[blank].*[102] Had lunch near the river *[blank].*[103]

Cavalry charges in the plain. Mountain in half-tone. *[sketch]*

Before getting to Alcassar. Immense crowd, endless cavalry charges. The Pasha's brother hitting people with his baton and saber.[104] A man breaks through the crowd of soldiers and tries to shoot us in the face. He is grabbed by Abou. His fury. They drag him off by his unrolled turban and throw him down further away. My terror. We run away. The saber was already drawn, etc.[105]

97. He said that he was dealing with affairs of state ("Memories," marginalia to cahier 2-c, p. 134).

98. Formerly a Roman colony, Ksar el Kebir was fortified in the twelfth century and became a major trading center in the sixteenth century.

99. For three days Delacroix's hat was soaked from this rain ("Notes and Drafts," 1st unnumbered fol. r, p. 149).

100. Delacroix leaves many blanks, intending to fill in the names later. Here he is referring to the Forest of Shbella.

101. The Portuguese army, commanded by Don Sebastian and allied with the dethroned Sultan Abdullah Mohammed II, was defeated by Sultan Moulay Abd el-Melek in the Battle of Alcazar (or Oued el Magzen) on 4 August 1578. The battle took place in the plain at the confluence of Oued el Magzen and Oued el Kus, which early sources say the Portuguese called "Tamista" and the locals "Oudriaga" (the latter meaning "shield"). A watercolor for the Mornay album (unlocated, see note 289) was entitled *A Camp Opposite the Town of Alcassar el-Kebir on the Battlefield Where Don Sebastian of Portugal Perished.* See the drawing annotated "Alcassar, Thursday 8 March" in Louvre notebook 1757, fol. 18r; a drawing of the same subject (Louvre 1640); and an engraving published in *L'Illustration,* 10 August 1844.

102. Oued el Magzen.

103. Oued el Warur.

104. A drawing in the Nationalmuseum, Stockholm (65/1949), dated this day, is annotated "the Pasha of Larache's brother."

105. The man was about to be executed but was saved by the intervention of Mornay, who tells the story in his report to the Ministry: "One of those poor devils who were practicing a charge had the imprudence to throw himself amid my escort's horses to have the sorry satisfaction of shooting me at close range. The Pasha had him arrested and ordered him to be beheaded right then and there. I just had time to rush over and ask for mercy, which was granted. One minute more and the sentence would have been carried out" (quoted in *Voyage,* 5:97). Lagerheim's memoirs provide the aftermath: "The commander of the guard, who was responsible for the safety of the envoys, [. . .] had the Moor seized; he was thrown to the ground and his turban undone [. . .]. That took a few minutes. At Mornay's request he escaped this ordeal, but gained nothing, as Mornay could not prevent him being killed by beating" (*Minnen,* 97–98). Drummond Hay presents this episode as an example of the explosions of popular hatred against the French (letter of 3 June 1832, London, The National Archives, FO 174 no. 162, p. 148).

On the top of the hill on the left, various flags. Designs on varied backgrounds, red, blue, yellow, white; others, with the footsoldiers, were multicolored. *[sketch]*

[several sketches of musicians with drums and horns, annotated another way of carrying the drum over the left shoulder; children on foot; dirty-yellow saddle; Abraham's leg; scabbard of the bayonet on the saddle; spur dangling*]*

The big trumpets on our entry into Alcassar.

[Ksar el Kebir to Fouarat, Friday, 9 March]
Friday, 9 March. Camped at Fouhouarat.[106]

Left the Alcassar encampment late. Rain. Entered Alcassar to pass through it. Crowd; soldiers slapping [at them] with great blows of their belts. Horrible streets; pointed roofs. Storks on all the houses, on the tops of the mosques; they seemed very big for the buildings.[107] All brick. Jewish women at the windows.

Crossed through a large passageway bordered by hideous shops and covered in canna-reeds put together any which way.

Got to the riverbank.[108] Large trees (olives) on the edge. Dangerous descent.

In the middle of the river, shots fired from one side, then the other. Got to the opposite bank, and for more than twenty minutes had to cross a rather threatening line of snipers. Shots fired at the feet of our horses. Half-naked man. *[sketches with annotations]*

Arrival of the Pasha's brother, violet burnous, charming appearance; little band of cashmere above his turban. Gray horse. *[sketch]*

Had lunch in some mountains near a spring. Driving rain.

Found the other Pasha in a plain. Cavalry charges. Gunshots. Rabble.

The other [horse?][109] with the Pasha's lieutenant. *[annotated sketches]*

The man who fell on his back and his horse on top of him. Got up half dead. Back on his horse a minute later.

.

Ben Abou never forgot this story, which he told later, with variants, to Drummond Hay's son John. By his own account, when he was kaïd, in command of a body of cavalry, the sultan ordered him to accompany a European envoy to the royal city of Marrakesh; en route they stopped near a large village where a *marabout* (holy man) venerated by the inhabitants lived. This fanatic, having seen the envoy in his tent, fetched his gun and shot at him; he missed the envoy but the shot hit the horse of one of the soldiers of the escort. Ben Abou had the fanatic arrested and was preparing to behead him to make an example of him, but was stopped by the European envoy on the pretext that the man was mad (Hay, *Memoir of Sir John Drummond Hay*, 196–97).

106. This inspired a painting, *Encampment of Arab Mule-Drivers* (J364). A drawing of the same scene is annotated "the day when we passed through Alcassar. Rain" (Louvre notebook 1757, fols. 18v–19r).

107. These storks were particular to Alcassar.

108. Oued el Kus.

109. The sketch suggest thats "horse" or "mule" should be supplied here.

Voracity of the Moors. In the evening, Abraham told us about it in the tent.[110]

[Fouarat to El Arba, Saturday, 10 March]
Saturday 10 March.—El Arba de Sidi Eisa Bellasen

Ill the previous night. We were unsure whether we would stay because of the weather. The Jews did not want to leave. The sun appeared. Crossed the Mda river, which winds round in three bends. Paid a visit to Ben Abou. He had a garment of white serge. The hood of his burnous. *[sketch]* Turkish coffee pot. *[sketch]* Little board like a box to put the tea on. The soldier with the cord around him serving tea. *[sketch]*

He *[Ben Abou]* told us that the Emperor sometimes practiced a cavalry charge, sometimes with twenty or thirty horsemen whom he designates.

Their horses spend the night outside, in rain, heat, etc., and are the better for it.

He put herbs in the tea.[111]

The man who practiced a charge in the big plain before we arrived. His arm bare up to the shoulder, and his thigh also bare.

Before the river, in a charge, the saddle of the commander for the Pasha turned over; he lost his turban.

We met another second-in-command to the Pasha of the province.

The wind is very cold, the sky clear. We are in the El-Gharb province, divided between two administrations.

Some children threw stones at us. The whole village was arrested. They probably will not get off for less than fifty piastres. No doubt the two cows given to Mornay in the evening came from that.[112]

[El Arba to the El Aitem crossing of the Sebu, Sunday, 11 March]
Sunday 11 March. To the Sebu river, the El-Aïtem crossing.

For three days we have been followed by a prince from Fez, a friend of Bias's, who absolutely wants to have a gift. Fine weather, nothing remarkable. Men with the gun scabbard on their head.

110. Windus (*Journey to Mequinez*, 73) also refers to this voracious appetite: he recounts that, while European travelers could eat only a little of the couscous that they were brought, a serving so huge that seven people could hardly lift the plate, the mule drivers emptied it in a few minutes, forming it into balls as fat as those you would give to a horse and swallowing them at one go.

111. Delacroix describes this seasoned tea in "Memories," fol. 10 (pp. 38–39).

112. Mornay reported: "Leaving the province of Gharb, I found myself in the territory of the Beni Hassan tribe whose chiefs had likewise come to meet me. They treated me with all possible honors and, as I left, offered me two cows and their calf. This ridiculous liberality toward a European obliges me to give them some gifts" (report of 23 March, *Voyage*, 213).

When the Moors want to obtain something, like a pardon, etc., and not be refused, they go get a sheep or even a bullock as a present, and slaughter it, as a sacrifice and to designate it as an offering. You are bound very strongly by the obligation that this action creates.

The horses rolling on the riverbank.

The day we camped at Alcassar, three sheep were killed, one in front of Bias's tent, a second at the kaïd's, and the third at ours, to obtain a pardon for a man accused of murder. Bias is looking into the matter.

Meanwhile, that day, the whole evening was taken up with a poor Jew who had been beaten because of the brandy that he refused to hand over to Lopez, the French agent in Larache, who probably was meant to give it to the brother of the kaïd in whose tent we spent the evening.[113]

The Pasha and his brother always had a man on each side of their horse, walking beside them and taking their rifle when they had finished a charge.

I did not mention, at Alcassar, the visit to the Pasha in his tent.[114] His saddle on his right. His saber on his white mattress. Blankets. A man sleeping at his feet, all bundled up. [sketch] Burnous knotted behind. [sketch]

Almost always, the back of the saddle is in shadow because of the clothing. The Pasha's second-in-command, not having any boots, had put the scabbard of his rifle on one of his legs and a kerchief on the other. They have nearly their whole leg cut by the stirrup. [sketch]

The white horse that slipped and shied during a charge. [sketch] The horse shod cold, the sole cut in the front. [sketch]

[drawing of the camp, with tent, seated figures, and horses, annotated fire and standing out light at the top and dark at the bottom. See fig. 3.]

[At the Sebu River, Monday, 12 March. See fig. 3.]
Monday, 12 March.[115] To [blank[116]] on the banks of the river Sebu.

Crossed the Sebu in the morning. Ridiculous boarding. The horses fleeing and showered with blows to get them to board. Naked men herding the horses in front of them.[117]

113. Unlike wine, brandy was not forbidden to Muslims (Pidou de Saint-Olon, *Relation de l'empire du Maroc*, 92). It was distilled by the Jews, who were meant to sell it only to Christians and other Jews.

114. Delacroix later noted this visit as the subject for a painting (see "sheets of Moroccan subjects," *Journal*, 2:1515). A drawing in Louvre 1757 (fol. 20r) corresponds to the sketch here and thus represents Hamid Abd al-Salam Al-Slawi, pasha of Larache and Ksar el Kebir, not Ben Abou, as previously thought.

115. A drawing bearing this date and representing some Moroccans, of whom one is pulling an animal, is in the ex-Mellon notebook (see appendix B, p. 164).

116. Mechra bel Ksiri.

117. Delacroix describes this "ridiculous" crossing, in oarless boats pushed by men swimming alongside, in "Notes and Drafts," 1st unnumbered cahier-a (p. 140).

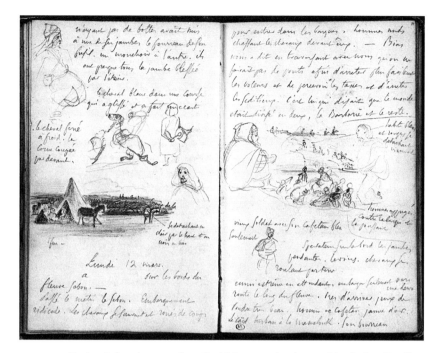

FIGURE 3 Eugène Delacroix, pages from the Meknes notebook, 11–12 March 1832. Pencil on paper, 19.3 × 12.7 cm. Paris, Musée du Louvre 1756 (RF 1712 bis), fols. 13v–14r. Photo © RMN–Grand Palais (Musée du Louvre) / Michèle Bellot.

As we crossed, Bias told us that there were no bridges so that thieves could be stopped more easily, taxes collected, and rebels arrested. He is the one who said that the world is divided into two, *Barbary* and *the rest*.[118]

Red and white clothes standing out vividly. *[sketch]*

Men leaning against the boat and pushing it along. *[sketch]*

Old soldier with only his blue caftan. *[sketch]*

Observers on the bank, their legs dangling. Greyhounds. Horses rolling on the ground.

Extremely tedious wait. Boarded only at one o'clock. Followed the river. Close to our arrival, very beautiful cavalry charges. Man in a golden yellow caftan. The kaïd: turban in the mameluke style. His executioner. *[sketch]* Turbans flying behind and getting all tangled up.

When one of the leaders of a charge came right up to us, Abou stepped up to him and the man tore his cloak a little. When he got to the camp, Abou tore

118. "Notes and Drafts," 1st unnumbered cahier-b (p. 142) reveals that Delacroix intended to refer to Bias's remark in discussing the Moroccans' notions of geography.

his cloak to pieces, preferring to burn it rather than to let anyone have the benefit of it. Someone also broke his pipe. He was brutal and uncompromising with the soldiers.[119]

In the evening, after a lively dinner, went down to the banks of the Sebu on my own. Lovely moonlight.

[Mechra bel Ksiri to Sidi-Kasem, Tuesday, 13 March]
13 March, Tuesday. To Sidi-Kassem.

Very intense sunshine. Journey over an immense plain.[120] [annotated sketch]

[Sidi Kasem to Zerhoun, Wednesday, 14 March]
14 March, Wednesday. Zar Hône.[121]

Left in the morning in lovely sunshine. Went first along the little river.[122] The figures lit from the side by the rising sun. Mountains clear against the background. [drawing] White of the cloth, and very bright colors. Blue sky.

Entered a gorge in the mountains. Men and children in haiks and naked beneath.[123] Marabouts. Bonhali (idiot).[124] Prince. Taleb.[125] [sketch]

Descended through flat rocks to the bank of a stream and had lunch. [sketch][126]

Continued in gorges, but wider, along paths on the edge of deep ditches. Talked about the trip to Persia.[127] Saw a woman who brought the commander a drink; she was wearing fibulae. [sketch]

Got to a plain and saw Zar Hône from afar.[128] Went down to the bank of a lovely river.[129] The banks covered with little laurels. [drawing]

119. See "Notes and Drafts," 2nd unnumbered cahier-c (p. 146) and also 7 March.
120. The Maamora Plain, 35 km across.
121. Zerhoun, or Moulay Idriss Zerhoun, a holy city closed to non-Muslims, is located at the foot of the mountain of the same name. It houses the tomb of Moulay Idriss (745–791), the founder of Fez and the first Moroccan dynasty, who introduced Islam into Morocco.
122. Oued Rdem. On one of the "sheets of Moroccan subjects" (Journal, 2:1517), Delacroix wrote "The banks of the Erdem river." In Louvre notebook 1757, a drawing dated this day is annotated: "Before getting to Al Zarón. The banks of the river as we left" (fol. 23r). The ex-Mellon notebook has a drawing of a horse in a landscape, annotated "Erdem river."
123. A drawing in Louvre 1757 (fol. 23r) represents a man in a haik with his shoulder bare.
124. "Idiots" were venerated as saints.
125. Taleb: priest, scholar. Lagerheim mentions the absolute necessity, in any communication with the Sultan, of using a taleb, "who clothes your thought in the Oriental stilus curiae [courtly style] and makes you seem humble and submissive" (Minnen, p. 91). Delacroix did a watercolor of a taleb writing at a table (repr. Daguerre de Hureaux, Delacroix. Moroccan Journey. Watercolors, 89).
126. A drawing annotated "In the morning, had lunch near a stream. In the evening, at Al Zarón," is in the ex-Mellon notebook.
127. Desgranges, the secretary and interpreter, had visited Persia in 1808.
128. Drawings are in Louvre notebook 1757, fols. 24r, 24v–25r.
129. Probably Oued Faraun.

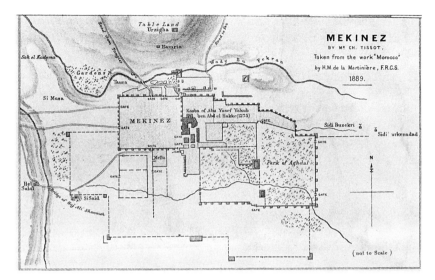

MAP 3 Plan of Meknes, 1890. J. G. Kelly, Intelligence Division, War Office. British Library Maps, MOD ID 808 (detail). Photo: The British Library Board.

Continued on the flank of the mountain amid stones and ruins.[130] Approaching Zar Hône, saw laborers in the fields. The plough. The fountain seen from afar. *[annotated drawing]* The man sowing.[131] *[sketch]*[132]

[Zerhoun to Meknes, Thursday, 15 March]
Thursday, 15 March. Meknes.

Left in the morning. Fine weather. The town of Zar Hône with its puffs of smoke. The mountains on the horizon to the right, half covered in cloud. Went into the mountains and, after some way, discovered the great valley in which Meknes is located. *[sketch]*

Stopped after having crossed a little river. It is the same one that we crossed the day before and that loops around.[133] Oleander, etc. *[sketch]*

Met some horsemen who did a cavalry charge. Sleeve of multicolored design, yellow and violet. *[annotated sketches, enhanced with watercolor]*

Stayed in full sun a little while.

130. Probably the ruins of Volubilis, one of the most important ancient sites in Morocco. In Delacroix's time it had not been excavated, but remains of a triumphal arch (the arch of Caracalla, 217 AD), a city wall, a basilica, and inscriptions were visible. See below, p. 121 and n. 280.
131. Mentioned again in Louvre 1757, fol. 25v (below, p. 95).
132. Drawings of the camp are in Louvre notebook 1757, fols. 24r, 24v–25r, and in the ex-Mellon notebook.
133. Probably Oued Faraun.

Meknes was on our left, and from afar we could see the Emperor's guard ahead of us on the right, up on a hill. Below, in the plain, they were doing cavalry charges, a number of them together. *[sketch]*

Crossed a rapid stream amid total confusion.[134] The Pasha of Meknes and the chief of the Mechouar had already come to meet us.[135] We scrambled up the hill. Met the Emperor's spokesman. Ugly mulatto with a mean look. Very beautiful white burnous. Pointed cap without a turban. Yellow slippers and gilded spurs. *[drawing]* Violet belt embroidered with gold. Cartridge case very embroidered, the horse's bridle violet and gold. Charges by the Black Guard, caps without turbans.[136] Looking behind us, very beautiful view. That large number of dark-toned or black figures, the white of the plain clothes against the background. *[watercolor drawing]*

Did the tedious rounds.[137] Continual cavalry charges on our left. On the right the infantry firing rifles. From time to time we arrived at circles formed by seated men who got up as we approached and fired right in front of us. Preceded by music. Sardanapalus head.[138] *[pencil and watercolor drawing, fig. 4]*

Walking behind the flags, went down on the left. Meknes looked like this *.[watercolor drawing, fig. 4]*

One of the ancestors of the present Emperor wanted to extend all the way to Marrakesh the wall that passes on both sides of the bridge.[139]

White spots all over this hill. Figures of all types, white always dominating.

Lovely effect as we went up, the flags, etc., looking almost dull against a sky of the purest blue. *[watercolor, fig. 5]* Twenty or so flags.

134. Oued Bu Fekran.

135. The chief of the Mechouar (parade ground), master of ceremonies, introducer of foreigners, a favorite of the sultan's in this period: Sidi Mokhtar (Muchtar) el-Jamaï. As the sultan never responded directly to anyone, "either in writing or in person," everything went through him (Godard, *Le Maroc*, 64). An able, self-assured man whose favor had to be won with gifts, he is referred to by Lagerheim and Drummond Hay (see biographies). Godard, varying a famous adage, notes ironically that, according to Mokhtar, "language was given to man to say the opposite of thought" (ibid.). See 24 March.

136. The Black Guard, or Bokhari, were a royal guard created around 1692 by Moulay Ishmael. The turban was not worn in the presence of the Emperor, only a cap (Pidou de Saint-Olon, *Relation de l'empire du Maroc*, 95).

137. According to a letter to Pierret (*Corr.*, 1:321), the group had to circle round the ramparts of the city before entering, so as to take the measure of their reception. Delacroix complains of the "deafening" din and the "maniacs" who ran up to shoot in his face (in fact, a mark of honor). The celebration lasted from morning until 4 p.m.

138. The drawing shows a head similar to that of the main character in Delacroix's painting, *The Death of Sardanapalus* (1827, Louvre, J125).

139. Moulay Ishmael, nicknamed "the bloodthirsty," governed with an iron fist from 1672 to 1727, supported by the Black Guard. He wished to link Meknes to Marrakesh, a distance of about 250 miles, by a wall.

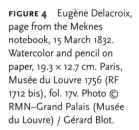

FIGURE 4 Eugène Delacroix, page from the Meknes notebook, 15 March 1832. Watercolor and pencil on paper, 19.3 × 12.7 cm. Paris, Musée du Louvre 1756 (RF 1712 bis), fol. 17v. Photo © RMN–Grand Palais (Musée du Louvre) / Gérard Blot.

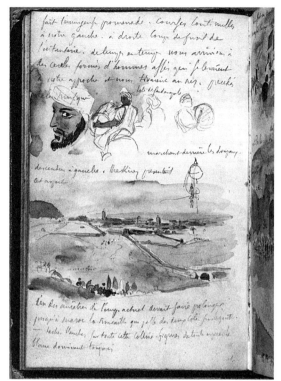

Passed by a saint's tomb.[140] Palm tree nearby. Built of brick. City gate very high. Various types of tile.[141] Once we had entered, horsemen and tents on the ramparts on the left. *[watercolor, fig. 5]*

Other entrance to the city.[142] The flags hanging under the gate. I found myself next to a man on a donkey with a child. The walls under which we passed beforehand, seen from this gate as we turned round. *[sketch]*

Inside the gate [drawn] above, immense crowd. On the right, the colossal main gate.[143] In front of us, a street. On the left, a long, wide square, and the infantry, who fired their guns, lined up in a semi-circle in front of us. The cavalry behind the footsoldiers. Populace behind, on mounds and on the houses.

140. Tomb of Sidi Mohammed Ben Aïssa, founder of the Issawa sect (see below, p. 124).

141. Bab el-Berdaïn, the finest of the nine gates of the Meknes wall. It was notable for its faience decoration.

142. From Delacroix's description and sketches, this seems to be Bob Zine el-Abidine, now destroyed. It stood at the entrance of El-Hedim Square, to the south of Bab el-Mansour.

143. Bab el-Mansour, finished ca. 1732.

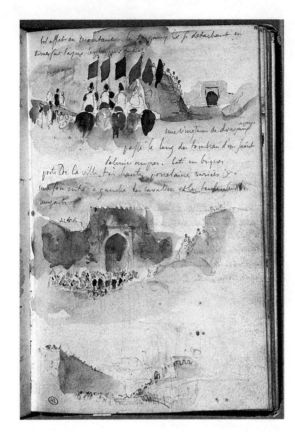

FIGURE 5 Eugène Delacroix, page from the Meknes notebook, 15 March 1832. Watercolor and pencil on paper, 19.3 × 12.7 cm. Paris, Musée du Louvre 1756 (RF 1712 bis), fol. 18r. Photo © RMN–Grand Palais (Musée du Louvre) / Gérard Blot.

Circled round some of the ramparts before entering. Going by a gate, gigantic palm-trees on the right. Before going in another gate, went along a rampart. Women in great numbers on a mound on the right, shouting.

[In Louvre notebook 1757, fol. 25v, some brief jottings in pencil, several of which are similar to the preceding.]

The clouds on the mountain. Second gate of the city. *[sketch]*

Bricks, one layer straight, one layer diamond-shaped.

The panne caftan.[144]

ditto tablecloth

Sardanapalus.[145] The drums. Sleeveless caftan. *[sketch]*

Great wall, men camped out on top of it. The spokesman. Stirrups. Purse. Belt embroidered in violet and gold. Buckskin-colored horse. *[sketch]*

144. Panne is a material similar to velvet but with longer fibers.
145. See above, note 138.

Saddle and green bridle. Border of the saddle, amaranth. Horses' blankets, red and sky-blue. Men on the shacks. *[sketch]*

Negro, green sleeveless caftan. Caftan underneath red.

Blue spurs against yellow boots.

The fountain and oleander where we stopped. Man who offered a drink from the jug hanging from his belt.

Lovely view climbing up before the first shots by the infantry. The buildings and the mountains behind, and the mingling of the soldiers.

The man who was sowing, the morning we left. *[sketch]* The haik. Probably folded in two.

The child in front of us before the first cavalry charges.

The old man in a red turban near the flags.

The entrance at the first gate. Saint's tomb, palm-trees, bricks.

[Here the Meknes notebook resumes (Louvre 1756).]

[Meknes, Thursday, 22 March]
22 March, Thursday. Audience with the Emperor.

Around nine or 10 o'clock, left on horseback; preceded by the kaïd on his mule, by a few soldiers on foot, and followed by those who carried the presents.[146]

Passed in front of a mosque; beautiful minaret that can be seen from the house.[147] A little window with woodwork. *[sketch]*

Crossed a passageway covered by canna-reeds as at Alcassar. Houses higher than in Tangier. *[sketch]*

Got to the square in front of the great gate.[148] Crowd kept in check with ropes and batons.[149] Gate of iron plates studded with nails. *[sketch]* Whitewashed half-way up.

After dismounting, entered a second courtyard and passed through a line of soldiers. On the left, great esplanade where there were tents and soldiers with tethered horses.[150] *[sketch]*

146. A letter to Mornay from the minister of foreign affairs (A.N. 402/AP/16, 30 December 1831) details the gifts sent by the French government to the Sultan: jewelry, gold, arms, a watch, silk cloth, the whole valued at 26,500 francs. The government had long wished to renounce the custom of sending gifts (ibid., letter of 11 December 1831) but, convinced of the "avidity of the authorities of that country," and wanting to dispose the Moroccan government in their favor, they continued it. Rumors of magnificent gifts filled Tangier, according to a letter from the British consul (London, The National Archives, FO 174 no. 162, p. 105, 6 February 1832; cf. *Voyage*, 6:244).

147. Jamaa El Kebir, the great mosque. For Delacroix's itinerary, see Johnson, "Delacroix's Road to the Sultan of Morocco."

148. El-Hedim square, in front of Bab el-Mansour gate.

149. In "Notes and Drafts," Delacroix twice refers to this practice of crowd control (2nd unnumbered cahier-d, and fol. 1 bis v, below, pp. 148 and 155).

150. Lalla Aouda square.

After waiting a bit, went on and got to a great square where we were to see the king.[151] [sketch]

Before he came out, we heard: *Ammar Seidna!* Long live our Lord (that is, God).[152]

From the plain, unimposing gate [drawn] above, there first appeared, at brief intervals, little detachments of eight to ten black soldiers in pointed caps who lined up left and right. Then two men carrying lances. Then the king, who came forward and stopped very near to us. Looks a lot like Louis-Philippe, but younger. Thick beard, more or less brown.[153] Burnous fine and almost closed in the front. Haik over it on the upper part of his chest and almost entirely covering his thighs and legs. String of white beads with blue silk around his right arm that could hardly be seen. Silver stirrups. Yellow slippers, not closed in at the back. Harness and saddle of a rose-color and gold. Gray horse, mane cut short.

Parasol with an unpainted wooden handle; a little gold ball at the end. Red above and in sections; underneath, red and green.[154]

Having replied with the usual compliments and stayed longer than is customary in such visits, he ordered Muchtar to accept the letter from the king of the French and granted us the exceptional favor of visiting some of his apartments.[155] Bidding us farewell, he turned his horse round and disappeared into the crowd on the right to the sound of music.

The carriage that had followed him out was covered in green cloth and pulled by a mule caparisoned in red. The wheels gilded. [sketch] Men who fanned him with long white kerchieves like turbans.

151. The square containing Koubbet el-Khiyatin, the pavilion where the sultan received foreign ambassadors.

152. In fact, it means "May God give long life to our lord," that is, the sultan.

153. An article by Gråberg di Hemsö, published in *La Presse* and cited in the *Times* of 15 July 1844, describes the Sultan: "The person of Abderrahman is more graceful and agreeable than imposing and severe; his constitution is robust and his stature majestic. He generally dresses in the simplest manner. [. . .] If he be not remarkable for address in bodily exercise, we know that his mind is not without cultivation and his sentiments and conversation are generally noble and interesting." See biographies.

154. These details, with some variations, can be found in the 1845 painting, *Muley-Abd err-Rahmann, Sultan of Morocco, Emerging from his Palace at Mequinez Surrounded by His Guard and His Principal Officers* (J370). The parasol was the imperial emblem. The protocol of the reception—the sultan on horseback as a sign of his authority, the ambassadors on the ground, standing—was long decried by Western governments. In the painting, the scene is set in Lalla Aouda square.

155. Mornay read a letter from Louis-Philippe that Benchimol translated into Arabic and that, after polite formulas on peace and friendship between the two countries, got to the contentious point: "We learned with sadness that this peace, the object of our keenest desires, had been troubled by the arrival in Oran province of a deputy of Your Majesty's [al-Hamri, see the introduction, p. 9], who behaved in a hostile manner and with no legitimate motive that could authorise such conduct" (A.N. 402/AP/16). The visit to the apartments was a favor occasionally granted to European envoys (*Corr.*, 1:323; Mornay's report of 23 March, *Voyage*, 6:218). See Windus, *Journey to Mequinez*, 101–11; Chénier, *Recherches historiques sur les Maures*, 3:58. On Muchtar, see 15 and 24 March.

Entered by the same gate. There, climbed back up on horseback. Passed through a gate that led to a kind of street between two great walls bordered by a line of soldiers on both sides.[156] *[sketch]*

Dismounted in front of a little door and knocked for a while. We soon entered a marble courtyard, with a basin in the middle flowing with water. Above, little painted shutters. *[sketch]* Little covered armchair. Went through some little rooms with small children, Negroes for the most part and not very well dressed. Went out onto a garden terrace. Dilapidated doors, paint worn away. Found a little wooden pavilion, unpainted, and a sort of drum-shaped settee in wood, with a kind of rolled mattress. *[sketch]*

On the left, went through a doorway better painted. Very beautiful courtyard with a fountain in the middle. At the back, green, red, and gold doorway. *[sketch]*

Walls of faience up to a man's height.[157] The two sides leading to rooms with a columned peristyle. Lovely paintings on the inside and in the vault. *[sketch]*

Faience up to a certain height. On the right, bed a little in the English style. On the left, mattress or bed on the floor, very clean and very white; in the corner, on the right, cheval mirror.[158] Two beds on the floor. Pretty carpet toward the back. In the front, mat up to the entrance. From this room, saw Abou and one or two others leaning against the wall near the entryway. *[sketch]* Net over the courtyard.

In the room opposite, European-style bed in brocade, no other furniture. Door-curtain of red cloth pulled up halfway. On the left of the little doorway in the red and green courtyard, a kind of recess with a sort of landscape or mirror, etc.

Painted cupboards in the bedroom, in shadow.

In the garden pavilion, which is reached by a kind of arbor supported on the side by green and red pillars. *[sketch]* In another garden, fountain in front of a kind of wooden hut with peeling paint, in which there was a low covered armchair. In front, a brick-lined pool at ground level, in front of which they stopped us to delight in our admiration.[159]

156. The gate is Bab er-Rih. The "street" is the "assarag," an eight-hundred-yard-long open corridor between two twenty-foot high walls, connecting the Dar al-Madrasa and Dar al-Mehencha palaces. Delacroix's description, here and in Louvre 1526 and 1527, suggests that he visited the Dar al-Madrasa palace. See Marianne Barrucand, *Architecture de la Qasba*, 78–88 and plan 3.

157. The garden terrace is the "sqala," 200 meters long, containing some wooden kiosks. From it, one entered the part of the palace known as Dar es-Soltan, with its courtyard decorated up to 1.5 meters in tiles of geometric design.

158. A framed mirror that tilts and is mounted on a stand.

159. The pavilion is the Qubbet el-Qett el-Ghaliya (Barrucand, *Architecture*, 91). The pool is the Agdal basin, dug in the reign of Moulay Ishmael to irrigate the royal gardens. But it is not brick-lined.

The general of the cavalry, crouching in front of the door to the stables. From that doorway, turning round, lovely effect; the base of the walls, whitewashed. [sketch]

There we found our horses and our escort still under arms, and went into another, more rustic garden. Went out by the place where the Emperor's horses are put out to pasture.[160] Soldiers and populace accompanied us. The child with the charming shirt.

[Meknes, Friday, 23 March]

Friday, 23 March.—Went out for the first time.[161] The gate with wood carvings over it. [sketch]

Type of market with dried fruit, pottery, etc.[162] Huts of canna-reed built against the city walls. Partitions of canna-reeds in the shops like the garden trellises. Man in the shade of a cloth held up by two sticks. [sketch] Gate closed for prayer.[163] Men beating the wall of tapia (rammed earth),[164] shouting at a signal from one of them each time. [sketch]

Went into the Jewish quarter.[165] Bought some small items in copper. The child to whom I gave my hand, the man who passed between us, etc. At the bazaar, belt. Men playing chess.

[Meknes, from Saturday 24 to Friday 30 March]

Saturday 24th.—Went out to go to the Jewish quarter. Man in a red caftan in the market that leads to it. Another fried-food seller. [sketch] The gatekeeper to the Jewish quarter, in red.[166] [sketch]

Entered the house of Abraham's friend. Jews on the terraces standing out against an azure sky with light clouds, like a Veronese painting. [sketch] The

160. Bab el-Qesdir or Bab el-Khebsh. The royal stables, held some one thousand horses. Ten thousand others were housed outside the city (Windus, *Journey to Mequinez*, 174–75).

161. The visitors were free to go about the city only after the audience with the sultan had taken place (*Corr.*, 1:327). Delacroix alone ventured out: "I am escorted, every time I go out, by an enormous band of curious people, who do not spare me the insult of dog, infidel, caracco [imbecile], etc., who push and shove to get close to me and grimace with contempt right in my face" (ibid., 1:325–26). He lodged with Mornay and Desgranges in a luxurious house in Berrima, not far from the Great Mosque (*Voyage*, 5:115).

162. Bab el-Hedim market (*Voyage*, 5:15)?

163. The gates of the city and palace were closed at prayer times.

164. For tapia, moist earth is placed between planks and beaten until compacted; the planks are removed when the earth is dry.

165. The Jewish quarter, or Mellah, built under Moulay Ishmael from 1679 to 1682, was surrounded by walls and closed at night.

166. A Moroccan guard was stationed at the gate of the Jewish quarter to levy a tax on goods that went in (Godard, *Le Maroc*, 54). Delacroix thought of doing one of the watercolors for the Mornay album on this subject. See below p. 2, of the Chantilly notebook (p. 124), and Louvre drawing 1525.

little young woman came in, kissed our hands. The Moors were eating. Painted table. *[sketch]*

The Jews' game at the bride's house. One of them was in the middle, with one foot in an old slipper and giving kicks to whomever he could reach, who in return gave him terrible punches. The king's horses are left outside in winter as in summer. The only thing is that, for the harshest period of forty days or so, they wear a blanket.

Muchtar, who had been given, among other presents, a piece of white cashmere, sent, yesterday the 27th, for another yard of it because he was counting on two outfits.[167]

The Emperor has the gifts meant for his ministers brought to him, chooses what is to his liking, etc.[168]

On the 30th, the Emperor sent us Jewish musicians from Mogador.[169] They are the best in the whole empire.

Abou came to hear them. He took a little piece of paper from his turban to write down our names. My name gave him no small amount of trouble to pronounce.

Jewish cemetery. *[sketch]*

Abraham told us that masons generally built walls without a plumb line, wholly from instinct; and that a worker was incapable of repeating something that he had done before.

[Meknes, Sunday, 1st April]

1st April.—In the morning, the courtyard with the ostriches. One of them got butted by the antelope with its horn.[170] Difficulty stopping the bleeding.

167. Delacroix refers to this appetite for French fabrics in "Notes and Drafts," 2nd unnumbered cahier-b, p. 146. On Muchtar's covetousness, Lagerheim writes: "Whenever I had occasion to write to the Emperor, [. . .] my letter was always enclosed in one to Sidi Mokhtar, and the postman, who was a reliable Arab, also carried presents of sugar, tea, or cloth for a caftan for the secretary of state. He developed such a taste for these despatches that once, when I had not sent anyone to Moulay Abderrahman for a while, and thus had not sent a gift to Sidi Mokhtar, I received from him a veritable love letter expressing his friendship and his regret that mine for him appeared to have cooled—along with many other fine Oriental phrases. The dragoman explained the reason for this letter: Sidi Mokhtar had finished all the tea and sugar I had sent him" (*Minnen*, 65). See 12 April.

168. On this privilege of the sultan's, see "Memories" (fol. 11, p. 39), and "Notes and Drafts," 1st unnumbered cahier-b, p. 141. On Muchtar's trick to get around it, see the latter and also 12 April.

169. Delacroix exhibited a painting on this subject in 1847 (J373). As Arama states (*Voyage*, 5:117 n. 116), Jewish musicians had preserved the musical traditions of Andalusia since their expulsion from Spain in 1492. Dumur (*Delacroix et le Maroc*, 68–69) reproduces a drawing of these musicians highlighted in watercolor and annotated "30 March Mekinez" (private collection).

170. The blow was fatal. Ostriches were among the sultan's gifts to Louis-Philippe, along with a lion, a tiger, two gazelles, a wild ox, an antelope and four horses. In his report of 15 April (*Voyage*, 6:231), Mornay requests a ship to transport this menagerie, "which is becoming very costly because of the care that these animals require and the provisions that must be purchased to feed them." The animals accompanied Mornay and Delacroix all the way back to Paris (see p. 120).

Wen out around one o'clock. Leaving the house, the city gate beyond the mosque. *[annotated sketch]* Another gateway in the street.

Child with flowers at the end of its braid.

Once at the market, looking back. *[drawing]*

In the dark alley. Muslims crouching, brightly lit. *[annotated drawing]* Man in his shop, canna-reeds behind, knife hanging up.[171] *[drawing]*

Seated man on the left, orange caftan. Haik in disorder, which he was readjusting. *[annotated drawing]* View of the mosque in the countryside.[172] *[watercolor]* Naked black man readjusting his haik.

The men building with tapia (rammed earth). *[drawing]* Haik twisted.

Parts of the walls painted yellow; the bottom white, in general, very good for making figures stand out. False gate. *[drawing]*

Little mosque painted yellow.[173] *[drawing]*

The Moorish gatekeeper sleeping. *[watercolor]*

To the house of the Jew who took me onto the terraces.[174] *[drawing]*

Seated woman embroidering a woman's outfit at the house of the Jews' chief.[175] Very bright pink colors on her face, standing out against the white wall. The child nearby. *[drawing]*

The ruined Portuguese house. *[watercolor]* View from the top of the terrace. *[watercolor]*

Other side. City gate.[176] Walls of the Jewish quarter. *[watercolor]*

Gateway to the market, while we were bartering for tobacco. Sky a bit cloudy. *[watercolor with annotations, fig. 6]*

House of the Jew, staircase. *[drawing, fig. 6]*[177]

Gate of the merchants. *[watercolor, fig. 6]*

Fountain before getting to the great square.[178] *[watercolor, fig. 6]*

Large house on the left, on the great square. *[watercolor, fig. 6]* Plan.

171. On a sheet at the Library of Congress, Washington DC (Breckenridge-Long Autograph Collection), which, given an elementary scribal mistake, cannot be genuine, there are numerous drawings and annotations corresponding to this note, including "Man in his shop, canna-reeds behind." The notes and drawings were traced from various originals by Delacroix, some of which are unknown. I will thus point out the parallels, since the fake provides valuable information about the missing originals.

172. The mosque of Sidi Saïd Bou Othman.

173. On the Library of Congress sheet: "Coming back, before the square, little mosque." But the drawing is different.

174. "[. . .] even going up onto the terraces exposes you to stones or gunshots. The jealousy of the Moors is extreme, and it is on those terraces that women usually go to take the air or see one another" (*Corr.*, 1:326).

175. According to Arama (*Voyage*, 5:118 n. 118), the head of the Jewish community was Rabbi Raphael Atsarfati (or Ha-Serfaty).

176. Bab el-Khmis, at the entrance to the Jewish quarter, the Mellah.

177. The same drawing is on the Library of Congress sheet but without the figure at the top, and annotated "Jewish house, staircase, door below."

178. El-Hedim square.

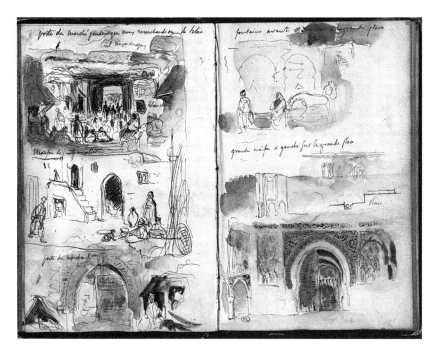

FIGURE 6 Eugène Delacroix, pages from the Meknes notebook, 1 April 1832. Watercolor and ink on paper, 19.3 × 12.7 cm. Paris, Musée du Louvre 1756 (RF 1712 bis), fols. 24v–25r. Photo © RMN-Grand Palais (Musée du Louvre) / Michèle Bellot.

Guardhouse, interior. *[watercolor]*

Interior of the courtyard. *[watercolor of Lalla Aouda square]*

Gateway deteriorating along the bottom *[watercolor of Bab el-Mansour]*

Going down, saint's tomb. Serrated crenellations. *[watercolor, annotated grating].*[179] *[At the bottom of the page, drawings of Arabs, one of which is annotated* white turban, djellaba. *Another drawing, annotated* orange *and* mulatto, *depicting a man holding a scabbard on his shoulder and wearing an orange turban.*[180]*]*

Going up the street; the men white against the walls.[181] *[watercolor]*

The man out of Smirke.[182] *[watercolor]*

179. On the Library of Congress sheet, same ornament and this annotation: "The ornaments crenellated on the saint's tomb outside the walls." On the following line: "the gratings, ditto."

180. This corresponds to an annotation on the Library of Congress sheet: "The man with a scabbard, orange around his head."

181. The same annotation is on the Library of Congress sheet, except that it has "pour" (for), instead of "sur" (against) the walls. This proves that it is not genuine: the copyist confused Delacroix's long "s" with "p."

182. Delacroix is referring to a figure by Robert Smirke, whose illustrations for *The Arabian Nights* (1802) were famous. He later refers to them in the *Journal* of 17 April 1853. William Etty

[Meknes, Monday, 2 April]
2d April.—Bias sent to ask us for a sheet of paper for the Emperor's response.[183]

[Departure. Meknes to Zerhoun, Thursday, 5 April]
5th April.—Left Meknes around eleven o'clock. The day before, worked a lot.
Large arcades against the wall on the left between two gates. *[drawing of Bab
Zine el-Abidine, with its two gateways joined by arcades]* The same gate as you turn
round in the great square. Doors studded with sheet metal. *[drawings, one of
Bab el-Berdaïn.]*
 Beautiful valley on the right, as far as the eye can see. *[drawing]*
 Crossed a Moorish bridge. Paint worn away. The city in the background.
[drawing] Groves of olive trees. *[drawing]*
 Crossed the little river with the oleanders again, in two places.[184] It winds
around a lot. The women who traveled bent over their horses. *[drawing]* The one
standing off the road to let us pass. A black man holding the horse. The chil-
dren who fell asleep on horseback in front of their father.[185]
 The olive trees on the right as we went up the mountain that leads to Der
Hôon.[186] Arriving at Der Hôon, M. Desgranges' horse.[187] Twenty soldiers
jumped on it. They tried to bind it up with ropes. When its two hind legs were
finally caught, it tried gnawing.

[Zerhoun to the Sebu River, Friday, 6 April]
6th April. Saw black tents placed in a circle.[188]
 To the Sebu river.
 Crossed a lot of mountains; large areas of yellow, white, and violet flowers.
[sketch]
 The place where we camped on the riverbank. In the daytime, while we
were resting before getting there, met a courier who brought us letters from
France. Very intense pleasure.[189] *[watercolor]*
.............

reports that Smirke's vignettes were "admired and imitated" in Paris in 1823 (Pointon, *Bonington
Circle*, 70). This note is also on the Library of Congress sheet.
 183. This remark is clarified by a letter to Pierret (*Corr.*, 1:326). Bias is reduced to asking Mornay,
on behalf of the emperor, for a piece of paper, whereas the emperor had just sent Mornay, the
evening before, a saddle of velvet and gold of incalculable value (see the watercolor at fol. 52v of the
Tangier notebook).
 184. Oued Faraun: see 14 and 15 March.
 185. Delacroix later painted a picture on this subject: *Arab Family Travelling* (J399).
 186. Zerhoun. See the drawing annotated "Zerhoun, 5 April, 1st day after Meknes" (Louvre
1523).
 187. The sultan had given Desgranges, Mornay, and Delacroix a thoroughbred horse each.
 188. "Douars—tents arranged in a circle for a few years" ("Notes and Drafts," 1st unnumbered
fol. v, p. 150). Lagerheim, too, describes these somewhat intimidating encampments, guarded at
night by half-wild dogs (*Minnen*, 56, 73, 76).
 189. "I completely understand that you are pining for news, poor little exile! [. . .] I will send
you packets as much as possible, and that will create a little salon where you will have enough

[The Sebu river to Rdat, Saturday, 7 April]
7 April. To Reddat.

Crossed the Sebu. On my horse, went along the Sebu, very pleasant. Tents on the left, douars. *[watercolor]* Crossing of the Sebu. The ostrich on horseback, etc.[190] After lunch, went into some beautiful mountains. Descended into a magnificent valley with a lot of very beautiful trees. Olive trees against gray rocks. *[watercolor]*

Crossed the Wharrah river.[191] Not very deep. Very large bullfrog. Very hot later, before getting to the camp in a lovely spot named Reddat. Mountains in the distance. Went out in the evening after sundown. Melancholy view of this immense and uninhabited plain. Calls of the frogs and other animals. The Muslims were saying their prayers at the same time. *[watercolor]*

In the evening, the servants' quarrel.

[Rdat to Oued Emda, Sunday, 8 April]
8 April.—To Mda

Tiring day. Cloudy sky and sultry weather. Went through a fine and fertile landscape. Lots of douars and tents. Innumerable flowers of a thousand species, creating the most multicolored carpets. Rested and slept near a little hollow filled with water, etc.[192]

In the morning, met another pasha who was going about his business with his soldiers. On the first trip we had had his deputy, who was here. His horse's bridle, covered in finely worked steel. *[watercolor]* Arabs, etc. *[watercolor]* Abou dined with us. Haik rolled up under his turban.

[Oued Emda to Ksar el Kebir, Monday, 9 April]
9th April. To Alcassar El-Kebir.

Mountains. Went past a place where we had had lunch on the way out in a hollow near a fountain. Scent of broom. Blue-colored mountains in the background. When we saw Alcassar, we noticed the soldiers from Tangier camped

conversation for the whole day" (Feuillet de Conches to Delacroix, in Delacroix, *Nouvelles lettres*, 111). The packet of mail was sent by the new route—faster by almost three weeks—via Gibraltar (rather than Toulon) on 29 February by Feuillet, Delacroix's friend, who was an employee in the Ministry of Foreign Affairs; it arrived in Tangier on 2 April, according to an annotation on the envelope. It contained letters from Delacroix's lover, Mme. Dalton, his brother, Charles Delacroix, his friend Pierret, and Feuillet himself (see Delacroix's response to Charles in Delacroix, *Lettres intimes*, 193). A sheet of drawings in the Pierpont Morgan Library is annotated: "6 April—on the bank of the Sebu River. Received the letters from France." Another drawing, later in this notebook, is annotated "banks of the Sebu, 6 April."

190. Comical image of the ostrich intended for King Louis-Philippe (see 1st April). Delacroix recounts the animals' crossing in "Notes and Drafts,"(1st unnumbered cahier-c and 2nd unnumbered cahier-c, pp. 143 and 147.

191. Oued Werra.

192. A drawing in the Nathan collection in Zurich is annotated "8 April, Sunday, having lunch."

in the distance. They are going to Marrakesh. They were in line. Ours did the same. Cavalry charges. The chiefs and soldiers came to see their leader. Kissing their hand after taking the other one. The soldiers kissed his knee.[193] Alcassar's river.[194] *[annotated watercolor]*

Fragments of tapia construction. *[watercolor]*

The milk offered by the women. A pole with a white handkerchief. First the milk to the standard-bearers who dipped their fingertip in, then to the kaïd and the soldiers.[195]

The children who go to meet the kaïd and kiss his knee. The saber on the road; get it explained by Abraham.[196]

[Ksar el Kebir to Tlata Raisana, Tuesday, 10 April]
10th April. To *[blank]*.

Rode M. Desgranges' horse. Beautiful country; mountains very blue, violet, on the right. Mountains violet in the morning and evening, blue in the daytime. Before getting to the Wad el Maghazin river, carpets of yellow and violet flowers. *[drawing]*

Crossed the river and had lunch in the same underbrush. *[drawing]*

Entered the great plain where Don Sebastian was defeated.[197] On the right, very beautiful blue mountains.[198] On the left, a plain as far as the eye can see, carpet of flowers, white, pale yellow, deep yellow, violet. *[drawing]*

Entered a delightful forest of cork oaks. On the left, distant horizons. Flowers. *[drawing]*

Went down and back up before getting to the market of Telati el Rissana, where we had slept on the way out. Little latanier palms on the heights on the left. *[drawing]*

Rested at the entrance to the narrow, twisty valley called the "Camel's Neck." Long and tiring day.

[Tlata Raisana to Ain Dalia, Wednesday, 11 April]
11th April. To Eïn Daliah

193. Customary greetings: between equals, people held each other's hand, then kissed their own hand, but one kissed the knee of a superior (Windus, *Journey to Mequinez*, 46).

194. Oued el Kus.

195. This scene inspired the 1837 painting, *Moroccan Chieftain* (J359), which Delacroix describes in the Salon catalog (1838) in the same terms: "He is at the head of a group of soldiers. Inhabitants of the countryside come up to him to pay tribute. A woman offers him a bowl of milk, in which he dips his finger to bring to his lips." In the painting, the pole with the white handkerchief is on the left.

196. Benchimol. Arama (*Voyage*, 5:125 n. 134) explains that a saber on the road was the sign of a village's peaceful intentions toward an approaching mission.

197. See above, 8 March.

198. Djebel (mountain) Habib.

Rode Caddour's horse, mine being ill.[199] Saw the beautiful olive trees again on the slope of a hill. Observed the shadows cast by the stirrups and feet. Shadow always tracing the contour of the thigh and the leg below. *[drawing]*

The marshal. *[annotated drawing]* Blue kerchief around the guard, damask. The stirrup projecting without the straps showing. The stirrup and the hook of the harness very white without highlight. Gray horse. Bridle on its head, worn white velvet. *[drawing of trees]*

Mass the figures together in a brown color, even if it means lightening them so as to bring them out. *[watercolor]*

Had lunch where we had done on the way out, on the bank of a stream.[200] Continuing on, soldiers on the left standing out against the sky. The men in half-tone, lovely color; the blacks, figures, etc. Brown horses very distinct. *[watercolor]*

Saddle with powder-flask, harness on the pommel, green gun-scabbard. Michelangelo head. White covering. *[drawing]*

Cavalry charges.

The women who came to offer the milk to the standard-bearers and the kaïd.[201]

Passed again by the spot where we had camped the second time on the way out, where the populace had begun to appear threatening.[202] At the top, you see Cape Spartel, the sea, etc.; as you come down: *[watercolor scene, annotated lata-nier palm]*.

Vast marshy plain, really wet on the way out; very dry now. Flags. Men lit from behind. Burnous transparent around the head, likewise the swath that covered the rifle. *[drawing and watercolor, fig. 7]*

Re-crossed a very muddy little river.[203] It is at this spot that we saw cavalry charges for the first time on the journey out.

Began to go up the mountain where the forest of cork-oaks is. Lovely spring on the right that winds down from the top. Flowers in abundance. Isolated boulders like structures on the left. Red earth on the way up, and stones. *[watercolor, fig. 7]*

Magnificent view in the other direction. *[watercolor, fig. 7]*

[Ain Dalia to Tangier, Thursday, 12 April]

The next day, 12th April, left Aïn Dalia with the Pasha's son, escorted on each side by two men carrying a rifle. The horse-bag around their neck. The infantry sometimes wears it that way.

199. Caddour, a soldier from the consulate. See "Memories," fol. 22, p. 47.
200. The Ayasha River. See 7 March.
201. See 9 April.
202. Gharbia: see 6 March.
203. Oued el-Hashef.

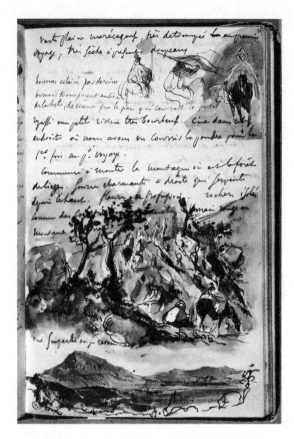

FIGURE 7 Eugène Delacroix, page from the Meknes notebook, 11 April 1832. Watercolor and ink on paper, 19.3 × 12.7 cm. Paris, Musée du Louvre 1756 (RF 1712 bis), fol. 32r. Photo © RMN-Grand Palais (Musée du Louvre) / Gérard Blot.

Half-way along, men and women put a saber in front of him. Get Abraham to explain that.[204] Nearer to the town, children came to greet Abou, who asked them some questions and gave them money.

[Tangier, Thursday, 12 April. Note in the Tangier notebook (fols. 23v–25v), which Delacroix resumes after his return to Tangier on 12 April.]
After the return from Mequinez.
At Abraham's, with Messrs de Praslin and d'Ossonville.[205] *[sketch]*
The girl with a simple kerchief on her head, and her attire. *[sketch]*

204. See 9 April.
205. The duke of Choiseul-Praslin (1805–1847) later became famous because of a scandal that rocked French society at the end of the July Monarchy: his wife, the daughter of Horace Sebastiani who in 1832 was minister of foreign affairs, was found stabbed in their house on 17 August 1847; charged with the crime, Choiseul-Praslin committed suicide. In 1832, he was an attaché to the French embassy in Madrid. Joseph-Othenin-Bernard de Cléron, Viscount d'Haussonville, was secretary in the same embassy; Delacroix would see him again in Paris in the 1850s.

The Negroes who came to dance at the consulate and in the town. Woman in front of them covered in a haik and carrying a stick with a handkerchief at the end to beg.[206]

A bout of fever around 16 April.

On the 20th, went for a walk. My first outing with M. D.[207] and M. Freyssinet to the harbor. Moroccan on the steps of the mosque. The pointed cap without a turban but covered with the haik. Thick-soled shoes. [sketch]

Very young woman who slipped and fell in the street that leads to the tannery when we came back up from the harbor. [sketch with annotations]

At the harbor, picturesque view of the city. [sketch]

Another view. [sketch][208]

Black man grooming a black horse. The Negro just as black and gleaming. [sketch with annotations]

Another black man grooming a horse. [sketch]

A distinguished-looking black man in a haik in his shop. Books, racks, inkwell. [sketch]

The day we dined at M. Fraissinet's before my fever, the wedding. [sketch]

Muchtar, who asks for the most paltry gift.[209]

The Moor who goes off with Marcussen's pocket-knife.[210]

The Emperor having his ministers try out the springy mattress.

The girl asking the man: did you think you would earn 50,000 francs income? [211]

Bias telling Mornay that the Emperor wanted to show him a sign of confidence, etc., in asking him for cloth.[212]

The sharif bestirring himself to have the pleasure of seeing us.

The Pasha wanting to give a present to the Emperor and asking M. Hay for English paper.

The quipus of the Peruvians—knots.[213]

206. This scene differs somewhat from the watercolor showing *Negroes Dancing in a Street in Tangier* and also from the one of *Traveling Players* that Delacroix painted for the Mornay album. See below, note 289.

207. Probably Delaporte, administrator of the consulate; possibly Desgranges, the interpreter.

208. Other views of the city of Tangier, in pencil and in watercolor, and annotated "23 April," are in the Chantilly notebook, pp. 41 and 43.

209. Gifts were a frequent preoccupation of Muchtar's (see 28 March). He asked for "the most paltry gift so that he could keep it," thus getting around the right of the Emperor to take whatever he liked from his subjects (see notes for "Memories," 1st unnumbered cahier-b, p. 141).

210. Marcussen, secretary of the Danish consulate, had just been named interim consul after Schousboé's death. See biographies.

211. The sense of these last two remarks is unclear.

212. Arama (*Voyage*, 5:130 n. 149) points out that this request for cloth gave rise to numerous reminders on Bias's part to Delaporte, who had to consult the ministry. See also 24 March.

213. Bundles of little cords in which the colors and knots were a means of recording events, keeping accounts, sending messages, etc.

Lima founded by Pizarro. Very ancient civilization of that people.
Ramadan sometimes in one month, sometimes in another.

[At this point the Tangier notebook has twenty-three blank sheets, then seven sheets of drawings, most in watercolor: fol. 49v, horseman; fol. 50v, landcape with the ruins of the bridge of Tingis, at the entrance to Old Tangier, commonly known as the "Roman bridge," but actually of medieval Arabic construction;[214] fol. 51v, same scene but from closer up; fol. 52v, saddle; fol. 53r (turning the notebook upside down), woman carrying a child; fol. 53v–54r (turning the notebook upside down), wall and gateway, house; fol. 54v, view of the coast; fol. 55v, mountainous landscape.]

[Tangier, 28 April, note in the Meknes notebook]
Yesterday, 27th April, a procession with music, drums, and oboes passed under our window. It was a young boy who had finished primary school and was being paraded about in celebration. He was surrounded by his friends who were singing, and by his relatives and teachers. People came out of the shops and houses to congratulate him. He was wrapped in a burnous, etc.[215]

In times of distress, the children go outdoors with their tablets and carry them in a solemn procession. These tablets are of wood coated with clay. They write with a reed-pen and a kind of sepia-ink that can easily be erased.[216] These people are right out of antiquity. That outdoor life and those houses kept closed, the women secluded, etc. The other day, quarrel with the sailors who wanted to enter a Moorish house. A Negro threw his slipper in their face, etc.

Abou, the general who led us to Meknes, was seated the other day right on the doorstep. On the bench was our kitchen boy. He *[Abou]* just leaned to the side a little to let us pass. There is something egalitarian in this off-handedness. The grandees of the place go huddle on a street corner, crouching in the sunshine and chatting together, or they perch in some trader's stall.[217]

These people have a fixed number (and rather few) of defined or possible illegalities; some tax or a punishment in a given circumstance; but all that

214. This bridge, on the *Tangere velho* or *viejo* river (in Arabic, *El-Halk*), in the east part of the bay, is reproduced in Baron Taylor's *Voyage pittoresque en Espagne, en Portugal et sur la côte d'Afrique de Tanger à Tétouan* (Paris, Gide fils, 1826, t. II, pl. 82), where it is described as an Arab monument of the Middle Ages, constructed before the arrival of the Portuguese in 1437.

215. A traditional ceremony marking the end of a child's studies: carrying the holy book in their hands, the student's family parades through the town (Windus, *Journey to Mequinez*, 63).

216. Cf. 4 February.

217. In "Notes and Drafts," 2nd unnumbered cahier-d (p. 148), this example illustrates the unceremoniousness of the Moroccan notables, which Delacroix relates to that of the ancients. Here he is contrasting the great general sitting on the steps with the lowly kitchen boy occupying the bench, and Abou's nonchalance with the behavior expected of a general toward the visitors.

without the bother and endless detail with which our modern administrations overwhelm us. Habit and time-honored custom settle everything. The Moor thanks God for his bad food and his shabby cloak. He feels very fortunate to have even them.

Certain age-old, ordinary customs have a majesty that we lack in the most serious circumstances. The women's practice of going on Fridays to visit the tombs with branches sold in the market, the betrothals with music and presents carried behind the parents[218]—the couscous, the sacks of wheat on mules and donkeys, an ox, fabrics piled on cushions, etc.

They must have a hard time understanding the confused mind of Christians and the anxiety that makes us so susceptible to everything new. We notice a thousand things that these people lack. Their obliviousness to them accounts for their tranquillity and their happiness. Are we ourselves close to exhausting what a more advanced civilization can produce?

They are closer to nature in a thousand ways: their clothes, the shape of their shoes. Thus beauty enters into everything they do. In our corsets, our narrow shoes, our ridiculous girdles, we are a pitiful sight. Their beauty takes revenge on our know-how.

[Tangier, Sunday, 29 April. Delacroix, along with Mornay, Fraissinet, and Marcussen, paid a visit to the Bouzaglo family. Jacob Bouzaglo seems to have been a prominent Jew in Tangier.[219] Jamila Bouzaglo (his wife?) commemorated the visit by writing two inscriptions in Judeo-Spanish (Spanish written in Hebrew characters) in the Chantilly notebook. In turn, Delacroix drew her portrait and that of a younger woman, perhaps her daughter.]

[p. 58, in another hand] croix. Mornay. de morne. Marcussen.

[p. 59] Zine[220] Delacroix. *[Drawing of a young woman, with this text:]* Monsieur Delacroix, Monsieur Mornay, Monsieur Frayssinet, Monsieur Marcussen mos han hecho la gracia de visitarme, dia de domingo ventiocho *[sic]* de abril mil ocho cientos y treinta y dos. Tanger, Jamila Bouzaglo.[221] *[The inscription is by Jamila, but the drawing is of a much younger woman than the one identified as Jamila on the next page.]*

218. This refers to Muslim practice. See "Notes and Drafts," 1st unnumbered cahier-c, p. 143.

219. *Voyage*, 5:135.

220. Eugène? "Zine" means "beauty" in Moroccan Arabic.

221. "Monsieur Delacroix, Monsieur Mornay, Monsieur Frayssinet, Monsieur Marcussen, paid me the honor of visiting me, this Sunday 28 April 1832. Tangier, Jamila Bouzaglo." For the specifics of this reading, see *Journal*, 1:238, n. 272. As for the date, Sunday was the 29th, not the 28th. A separate sheet, with different drawings, which sold at Christie's, New York, in 1989, has a transcription of this text in Delacroix's hand (Nineteenth-Century European Paintings, Drawings, Watercolors, and Sculpture, 23 February 1989, lot 328, p. 239, reproduced in Arama, *Eugène Delacroix au Maroc: Les heures juives*, 161).

[p. 61, sheet now removed and mounted separately. Portrait of Jamila, originally accompanied by this inscription in Judeo-Spanish with a transliteration written above, both now erased:] Jamila dibujado [sic] por Monsieur Delacroix.[222]

Journey to Andalusia

[The account of this trip is in the Meknes notebook (Louvre 1756, and drawings are in a notebook in a private collection (Burty no. 30). It was yet another decisive experience for Delacroix: "In the little time that I spent there, I lived twenty times more than in several months in Paris."[223] Despite the Romantic vogue for Spain, the country remained a relatively infrequent destination for travelers, with few amenities, difficult roads, the threat of attacks by bandits, and a highly unstable political situation. Delacroix left Tangier on 10 May with Mornay and Desgranges. The crossing took a day: a drawing of Cádiz seen from the ship, annotated Cádiz, 11 May. Seen from the SE at 4 miles, is in the Chantilly notebook (p. 85). They remained quarantined in the harbor because of the threat of cholera: a second drawing of Cádiz from the ship, annotated Cádiz, 15 May, in the harbor, is also in the Chantilly notebook (p. 87). On the night of the 16th, they received permission to proceed, and on the 17th, they disembarked.

[Cádiz, Thursday, 17 May]
On the evening of 16th May, after a tedious seven-day quarantine, received permission to enter Cádiz. Immense joy. Likewise in the morning, going in.

The mountains opposite the bay very distinct and a lovely color. *[sketch]*

As we approached, the houses of Cádiz white and golden against a beautiful blue sky. *[watercolor]*

Handsome Greeks as we entered the town.[224] Kerchief. *[watercolor, annotated]*

Moroccan leather, like [that of] the merchants from Fez. *[watercolors, annotated]*

[Cádiz, Friday, 18 May]
18th May, Friday. It is tolling midnight at the Franciscan monastery. Singular feeling from such a strange country. The moonlight; those white towers in the moonbeams.

222. "Jamila drawn by M. Delacroix." The inscription is known only from the facsimile. The same word in the feminine, *"dibujada"* ("drawn"), is noted on the Christie's sheet (see previous note). Burty no. 30 (private collection) contains a few drawings of a Jewish woman, one of which is annotated "Gémilla" (fol. 12r).
223. *Corr.*, 1:331, letter to Pierret, 3 June 1832.
224. The drawing suggests figures in traditional Greek dress.

MAP 4 Plan of Cádiz, probably late eighteenth century. Biblioteca Digital Hispánica, MR/42/615. Photo: Biblioteca Nacional de España. Key (north is at the bottom): 51, Franciscan monastery; 45, Augustinian monastery; 60, Capuchin monastery; 30, Dominican monastery; 41, "New" Cathedral.

In my room there are two Debucourt engravings: *The Visits* and *The Orange*.[225] One of them is inscribed: "Published on the first day of the nineteenth century." That made me reflect that I was already in this world; how much time has passed since my early youth!

Walked around in the evening; at M. Carmen's, met Señora Maria Josefa.[226]

M. Gros, the camel-driver, had dinner with us. He's a man of the most gentle appearance, who drank only water with his dinner. As he refused to smoke at dessert, he told us very simply that his moderation was a matter of self-control. Several years ago he smoked three or four dozen a day, drank a bottle of brandy and did not even count the bottles of wine. A little while ago, despite his regimen, he let himself go and drank some beer. He drank six or eight bottles in no time at all. That man was the same with women, with whom he indulged to excess. There's something for E.T.A. Hoffmann in that character.

225. *The Visits. Published the 1st day of the XIXth century, drawn and engraved by P. L. Debucourt* (1800), and *The Orange, or The Modern Judgment of Paris* (ca. 1800); Fenaille, *L'Œuvre gravée de P. L. Debucourt*, no. 65 and 66. Philibert-Louis Debucourt (1755–1832) was a painter and engraver who specialized in color prints.

226. Unidentified. On a page in Burty no. 30 (private collection) is the annotation "Maria Josefa" (fol. 42r).

Extraordinary constitution of that man; he took pleasure in everything, and to the extreme. He told me that being deprived of cigars had cost him more than anything else. He dreamed continually that he had returned to his old habit and reproached himself a lot for having broken his regimen, and then woke up very satisfied with himself. What a life of pleasures he has led! Wine and especially tobacco were for him the source of indescribable bliss.

Around four o'clock, to the Augustinian monastery with M. Angrand.[227] Staircases decorated with faience. The choir of the friars high up in the church, and the long room before with paintings. [watercolor] Even in the bad portraits that line the cloisters, influence of the great Spanish school.

[Cádiz, Saturday, 19 May]

On the 19th, to the Capuchin monastery.[228] The Father who was the caretaker showed us his garden and told us to pick some flowers—if not for ourselves, at least for the ladies. He did not think that the monastery garden was worthy of a visit, given that the wind had wrecked the peas.

On entering, very simple square courtyard, images on the walls, etc. The church on the right, opposite. The Murillo *Virgin*: her cheeks perfectly painted and her eyes celestial.[229] The church very dark. The sacristy. Cupboards of blackish wood, benches. [watercolor] The little garden of the caretaker Father's. The choir behind the [altar?], corridor further on. Painting of a skeleton supine, to the right of the door to the corridor with the infirmary. [watercolor]

Corridors as far as the eye can see. Staircases. Geographical maps on the walls. Little sculpture of a Pietà set into the wall below a little painting of a monk in ecstasy with his hands folded, contemplating the crucifix.—Cloister downstairs, paintings above each arch; death amid the riches of the earth.[230] The garden.

[Cádiz, Sunday, 20 May]

On the 20th in the morning, Dominican monastery. Church very beautiful.[231]

227. The Augustinian monastery, built in 1617, with a baroque church. Two drawings of a church, dated this day, are in Burty no. 30 (private collection), fol. 25r and fols. 25v–26r. Léonce Angrand was the French vice-consul in Cádiz.

228. Founded in 1641, the Capuchin monastery was demolished in 1982; only the church was spared.

229. The famous *Saint Catherine* (1682), Murillo's last work. He died while painting it, after falling from scaffolding (Angulo, *Murillo*, no. 88, Museo de Cádiz).

230. I have not been able to identify these works that the now-destroyed monastery contained. The description of the painting of the monk in ecstasy does not match Murillo's *Saint Francis Receiving the Stigmata* (Angulo, *Murillo*, no. 1914), which was in the monastery. In general, Delacroix's notes are an important source for the contents of the monasteries just prior to their liquidation in 1835.

231. Louvre watercolor 1687, dated this day, depicts this monastery. As Lambert observed ("Delacroix et l'Espagne," 168), Delacroix used it for the décor of his *Christopher Columbus at the Monastery of La Rabida* (J265). The late Mannerist and baroque church still exists.

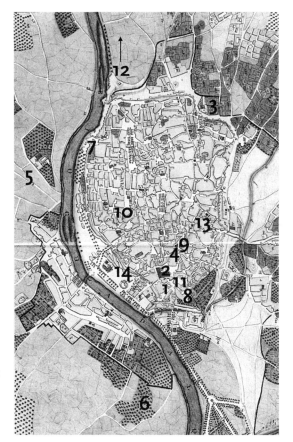

MAP 5 Plan of Seville, 1827. Manuel Spínola de la Quintana, Plano geométrico de los alrededores de la M[uy] N[oble] M[uy] L[eal] M[uy] H[onorable] Ciudad de Sevilla . . . (1° de mayo de 1827). Biblioteca Digital Real Academia de la Historia. Photo © Real Academia de Historia, España. Key: 1, Saint Thomas monastery; 2, Cathedral and Giralda; 3, Capuchin monastery; 4, Calle Abades and Plazuela de las Segovias (Williams residence); 5, Carthusian monastery; 6, San Sebastian cemetery; 7, Terrace of Las Damas; 8, Alcázar; 9, Plaza de San Isidoro; 10, Calle de los Monsalves (Ford residence); 11, Casa Lonja; 12, San Jerónimo monastery; 13, Casa de Pilatos; 14, Bullring.

The cathedral in ruins without being finished.[232] Fiendishly bright sun. The bull.

[Seville, Wednesday, 23 May. Delacroix left his companions, who were going to Gibraltar, to head on his own for Seville. Mornay reported in a letter to Delaporte of 21 May: "The artist [. . .] is abandoning us to go see Seville [. . .]. Spanish women, bull-fights, monks, all of that fires his imagination, and if on his return he's fattened up a bit, then I'll be damned" (Arama, Delacroix: Un voyage initiatique, *233). The annotation "to Xeres" on Louvre drawing 1689, coupled with the mention of Alcalá here, indicates that Delacroix went by coach, which followed this route; on the way back, in contrast, he will take the boat down the Guadalquivir (see 28 May).]*

232. The "new" cathedral, begun in 1722, abandoned in 1769, was in 1832 a cord factory. The works were resumed soon after, and it was finished in 1838.

Seville, 23 May, Wednesday. Relation to the Moors. Great doors every-where.[233] Compartments in the ceilings and woodwork.

The gardens; embankment in brick edged with faience, the earth lower. Crenelated walls.

Enormous keys.

Alcala.[234] Night. Moonlight on the water, melancholy sight. The cry of the frogs. The Moorish gothic chapel, before entering the town near the aqueduct.[235]

[Seville, Friday, 25 May. The following notes (up to "drapery") are not dated. They match up, however, with the ones that come after them and that are explicitly dated "Friday 25th," and with annotations on Louvre drawing 1692. It is probably a single day, or possibly two days (24–25 May) that Delacroix confused. The order of the dated notes, very scrambled, does not follow the actual itinerary; they appear to have been written later. Here is an attempt to reconstruct his movements.

Starting at 7 a.m., accompanied by M. Baron, he visited the Saint Thomas monastery (near the cathedral), the cathedral itself, and its tower, the Giralda; in the cathedral he saw paintings by Zurbaran, Roelas, Murillo, and Goya. Then he went to the Capuchin monastery, where he saw the famous paintings by Murillo; he followed the walls on the way back. At noon he drew Maria Dolores, then dined with Messrs. Hartley and Muller, who took him to see the Cartuja (the Carthusian mon-astery, or Charterhouse) across the river. In the evening he went to the Saint Sebas-tian cemetery, strolled on the terrace of Las Damas, and went to Julian Williams's house.]

In the morning, the cathedral: magnificent obscurity.[236] The Christ up high on red damask. The large grating that surrounds the high altar.[237] The back of the altar, with little windows and the entrance to an underground crypt.

Arcades on the houses. The woman lying in the doorway of the church.[238] Brown arms against the black of the mantilla and the brown of the dress.

233. These enormous wooden doors are typical of Sevillian architecture.
234. Alcalá de Guadaira, "the castle of the Aira river," near Seville, a little town containing excellent examples of Moorish architecture. Its springs fed Seville via an aqueduct.
235. La Cruz del Campo ("the cross of the fields"), a cross in Gothic mudejar-style brick with four pillars and a dome, built seemingly in 1482 and used as the final station in the Good Friday procession that began at the Casa de Pilatos in Seville.
236. One of the largest churches in the world, the cathedral was built in the fifteenth century on the site of a mosque (1184–1198) whose remains are incorporated into it. Many years later, vis-iting Cologne cathedral, Delacroix recalled this effect of grandeur and obscurity that had impressed him in Seville (Journal, 6 August 1850, 1:535).
237. Of gilded iron, executed ca. 1518.
238. A drawing in the Louvre (1692) is annotated "The woman lying in the doorway to the cathedral."

Singular effect, deriving from the fact that there is almost no white, especially around the head.

Stroll in the evening. Terrace that reminded me of my childhood in Montpellier.[239]

Banks of the Guadalquivir. Beforehand, the Capuchin monk in the pulpit. Windows covered with canvas and colored drapery.

Friday 25th. M. Baron came to get me early.[240] Climbed the tower, the Giralda; no steps.[241] Surrounding area looks like that around Paris. Had dinner with Messrs. Hartley and Muller,[242] and went with them by coach to see la Cartuja. Lovely Zurbaran in the sacristy.[243] Fine tombs.[244] Arcanum[245] behind the altar. Cemetery. Orange trees.

Moorish courtyard. Paintings on the walls, and faiences, with faience benches.

At noon, drew Señora Dolores.[246]

239. This stay in Montpellier, which has left no other trace, must have been between 1800 and 1803, when Delacroix's father was prefect of the Bouches du Rhône department. The terrace in Montpellier must be the Promenade du Peyrou; in Seville, the Patin de las Damas, laid out in 1773. Delacroix was often reminded of his childhood in the south in the course of this trip: "Perhaps the vague memory of the southern sun, which I saw in my early youth, is coming back to me" (*Corr.*, 1:310–11, 8 February 1832).

240. At 7 a.m., as an annotation on Louvre drawing 1692 specifies. A Frenchman living in Seville, Baron appears several times in the diary of Washington Irving, who lived in the city from 14 April 1828 until 1 May 1829 (*Journals and Notebooks*, 21 May, 30 June, 23 November, 12 December 1828; 1 January 1829).

241. A Moorish tower at the northeast corner of Seville's cathedral, 96m. high, built in 1196. It was originally part of the mosque. There were no steps, but a series of gently sloping ramps, called "gradas."

242. Antonio C. Muller was a merchant in the Calle Guzmán el Bueno, in Seville, and one of the founders of the bank of Seville. Irving identifies him as a Frenchman of German ancestry (ibid., 202). Hartley is no doubt the "Mr Harley [sic], Toqueros street, no. 26, in Seville," mentioned by Adrien Dauzats in his notebook during his trip to Spain (Guinard, *Dauzats et Blanchard*, 224, 14 January 1837).

243. Located on the right bank of the Guadalquivir, the Cartuja (Carthusian) monastery, or Charterhouse, was founded in 1399, turned into a porcelain factory in 1839, and restored in 1986–1989. Delacroix painted a watercolor dated this day (Louvre 1691) that depicts the cloister. The sacristy held three superb paintings by Zurbaran that were later transferred to the museum, created after the seizure of church property in 1835: *Saint Bruno and Urban II*, *The Virgin of Mercy of Las Cuevas*, and *Saint Hugo in the Refectory* (1655).

244. The finest tombs of the Ribera family, transferred to the chapel of the University of Seville in 1836, were taken back to the Cartuja after the 1986–1989 restorations and reinstated in the chapel of the monks: especially notable are those of Pedro Enriquez Ribera (d. 1492), the work of Aprile de Carona (Genoa, 1606), and Doña Catilina Ribera (d. 1505), the work of Pace Gazini (Genoa, 1519).

245. A hidden, sacred space.

246. "At noon, drew Señora Dolores"; "In the evening to M. Williams. M.D." (same note); "Finished the study of the mantilla at M. Williams'" (26 May): bringing together these notes, it seems that Delacroix drew, at the home of Julian Williams, the British consular agent in Seville (see note 249 below), a woman in a mantilla who was called "M[aria] Dolores." As a letter from the young Benjamin Disraeli dated 26 July 1830 reveals, this was Williams's sister-in-law: "We pass our evenings most agreeably, sitting in his patio, turning over the original drawings by Murillo,

Earlier, to the Capuchins. On their coat of arms, the five wounds of Jesus, the one in the middle larger *[sketch]*, and two arms, one bare as here *[sketch]*. Lovely Murillos, including the saint with the mitre and black robe giving alms. The pink hat on a Madonna.[247]

In the evening, to the cemetery.[248]

Coming back from the Capuchins, followed the walls. Double enclosure— one lower in front at around six or eight feet. *[sketch]*

In the evening, to M. Williams'.[249] M. D.[250] Melancolica. Guitar.

On my way back, the soldier who was plucking on the guitar in front of the guardhouse. Brief moments of various emotions in the evening. The music, etc.

In the morning, in the sacristy of the cathedral. Two saints by Goya.[251]

The horses herded onto the bridge. The men with goatskin coats and breeches; would make a picture. *[sketch]*

Two chains on the door, everywhere that the king has entered.[252]

The refectory of the Carthusians. The bishop; green cap. *[sketch]*

.

while his Spanish sister-in-law, Dolores, sings the bolero" (Disraeli, *Letters 1815–1834*, 139). A drawing of a woman in Burty no. 30 (private collection), fol. 28r, seems to correspond to this day and represents Maria Dolores. See also below, note 255.

247. The twenty-one paintings that Murillo, a native of Seville, painted for the Capuchin monastery, including *Saint Thomas of Villanueva Giving Alms to the Poor* (1668) noted here (Angulo, *Murillo*, no. 66, Seville, Museum of Fine Arts), count among his masterpieces. As for the "pink hat," I do not know what Delacroix is referring to. The monastery was outside the walls, to the east of the town; the church still exists.

248. The main cemetery of Saint Sebastian, now built over, was outside the walls, southeast of the town.

249. This will have been an important meeting for Delacroix. Williams was one of the greatest—and most knowledgeable—collectors of Spanish painting (Richard Ford, *Handbook for Travellers in Spain*, 1:396). The first stop for all artists and art lovers passing through Seville—David Wilkie, Washington Irving, Benjamin Disraeli, Baron Taylor, among others—his house in Calle Abades Alta was the center of artistic life in the city.

Williams owned a magnificent collection of more than three hundred paintings, which would later provide choice works for Louis-Philippe's famous Spanish Gallery, assembled by Baron Taylor in his famous mission to Spain in 1835–1837. Eleven paintings definitely came from Williams's collection, including the famous *Self-Portrait* by Murillo (Angulo, *Murillo*, no. 413, private collection, USA) and Zurbaran's *Saint Bonaventure and the Angel* (Dresden, Gemäldegalerie), but probably as many as forty, since Taylor bought in lots of three, six, and so on. (See Baticle and Marinas, *La Galerie espagnole de Louis-Philippe au Louvre*; and P. Guinard, *Dauzats et Blanchard*). The other acquisitions from Williams included paintings by Murillo, Valdés Leal, Ribalta, Ribera, Roelas, and Zurbaran (see Baticle and Marinas, *La Galerie espagnole*, nos. 168, 174, 176, 181, 187, 221, 231, 243, 248, 255, 348, 358).

In 1832, when the collection was at its height, it contained thirty-seven paintings then attributed to Murillo, forty to Alonso Cano, four to Zurbaran, two to Velázquez, four to Iriarte, and many drawings and engravings (Amador de los Rios, *Sevilla pintoresca*, 471–75; Curtis, *Velazquez and Murillo*; Gonzalez de León, *Noticia artistica historica y curiosa*, 163). While the attribution of several of these works is disputed today, the importance of Williams's collection is not (Glendinning, "Nineteenth-Century British Envoys in Spain," 121). Delacroix certainly saw it but says nothing about it in the notebooks that have come down to us.

250. Maria Dolores (see above, note 246).

251. *Saint Justina* and *Saint Rufina*, the cathedral's patron saints; commissioned in 1817.

252. This Sevillian custom, also noted by Ford (*Handbook*, 1:236), exempted the house from having to have soldiers billeted in it.

[Seville, Saturday, 26 May]
Saturday 26th. Alcázar. Magnificent Moorish style different from the monuments of Africa.[253] The garden extraordinary, and the suspended gallery that partly surrounds it.[254] Finished the study of the mantilla at M. Williams'.[255] Embarrassed.

The famous matador and bullfighting instructor Romero used to make almost no movements to avoid the bull. He was able to bring it right in front of the king to kill it, etc. After delivering the blow, he turned around at that very instant to offer a salute without looking behind him.[256]

The famous Pepillo, a very renowned matador, was killed in Madrid by a bull. He was hit in the side by a horn; he tried, in vain, to extricate himself by lifting himself up onto the very head of the animal, which carried him all around the ring, and slowly, so that the horn went in more deeply with each moment. It carried him, suspended in this way and already dead.

Romero was inconsolable for not having been present. He was convinced that he could have rescued him.[257]

[Seville, Sunday, 27 May]
Sunday 27th.—To M. Williams' in the evening.

Dancers. The little girl who was raising her leg. The older one, very graceful.[258] The beginning of the evening, boring. Mme Ford corrected the music

253. The Alcázar, one of the major examples of Moorish architecture, was begun in 1181 and expanded especially in the fourteenth century. It consists of a palace surrounded by walls and towers, including the famous Golden Tower (1220).

254. A drawing from this gallery, called the "Galeria de Grutesco" (1612–21), is in the Chantilly notebook, with the annotation: "View of the walls and the San Fernando gate from the gallery of the Alcázar garden. Seville."

255. "The mantilla is the most elegant thing in the world" (letter to Pierret, *Corr.*, 1:332). See the watercolor of a woman in a mantilla (reproduced by Lambert, "Delacroix et l'Espagne," fig. 6, formerly in the Maurice Gobin collection), which has been taken, wrongly, in my opinion, to be a portrait of Harriet Ford (Ford, *Richard Ford in Spain*, cat. London, no. 152); and another watercolor of a standing woman wearing a mantilla, in the Art Institute of Chicago (http://www.artic.edu/aic/collections/artwork/32962?search_no=9&index=84/). The model is Maria Dolores (see 27 May).

256. Pedro Romero was one of the first instructors in the school for bullfighting founded in Seville by Ferdinand VII. He is depicted in Goya's *La Tauromaquia* (pl. 30, 1815–16). Goya also painted his portrait (Fort Worth, Kimbell Art Museum).

257. Delacroix did several studies of toreros, matadors, and picadors: two are in Burty no. 30 (private collection), fols. 23r and 24r; others are in the Louvre (nos.1696–1704), and more are reproduced in Maurice Sérullaz, ed., *Mémorial de l'exposition Eugène Delacroix*, nos. 184–85. He describes a bullfighting scene in his "notebook on modern beauty" from 1857 (*Journal*, 2:1792). Here he is alluding to the matador Jose Delgado, called Pepe Illo, "the glory of Spain" (Ford, *Handbook*, 1:282). The scene described by Delacroix took place on 11 May 1801 and is depicted by Goya in *La Tauromaquia* (pl. E, 1815).

258. See the studies of dancers with castanets (Louvre 1710 and 1711). Burty no. 30 (private collection), fols. 28v–29r, has a watercolor of a church annotated "Seville. Sunday 28 [*sic for 27*] May. The dancers in the evening."

for me and I was near her.[259] Then, M. Williams' sister explained to me the words of the song that she gave me.[260] The dancers explained how to use the castanets. The pretty child who put herself between M. D.'s legs. Mme Ford, good-bye in the English style. Coquette. I had been by in the daytime but had not found her home. I had wandered around the streets like a Spanish lover.[261] Streets covered with awnings.

Earlier, sketched in a large room, near the cathedral.[262] Had dinner at M. Hartley's and went to the monastery of San Jerónimo with those gentlemen.[263] The famous Cevallos is there.[264] Saint Jerome by Torrigiano.[265]

[Seville, Monday 28 May]

Monday 28th.—At the casa di Pilata [sic].[266] Magnificent staircase. Faience everywhere. Moorish garden, etc.

259. Harriet Ford was the wife of Richard Ford, an English writer and art connoisseur, and future author of an important *Handbook for Travellers in Spain* (1845). The Fords had gone to Spain in 1830 with their three children and stayed until the end of 1833. In a letter of 12 May to the British ambassador in Madrid, Ford had written, "[. . .] We are expecting the famous French dandy, Charles de Mornay, who is coming from Morocco where he has been as *Plenipo[tentiary]*. He will enlighten the Madrid dandies with some outlandish Paris coat, *couleur de cholera morbus*; if you fall in with him and can get over his outward appearance, you will find him very tolerable. He is an acquaintance of mine, and friend of my wife, which might be predicated of all his English *connoissances*" (Ford, *Letters of Richard Ford*, 90). Ford would have met Mornay during the latter's stay in England. In the end, he was away from Seville when Delacroix visited. Harriet Ford played the guitar and had learned "real Spanish airs" (ibid., 23). All the travelers who have left memoirs mention these evenings of music and Spanish dance that took place at the Williams's (see biographies).

260. No doubt sister-in-law. One of Williams's sisters-in-law, Maria Bedmar y Galindo, aged thirty-one, lived in the same house (Seville, Municipal Archives, L/4669, 1838); the mention of Maria Dolores that follows implies that this "sister" is not she.

261. Of these love affairs of Delacroix's, a letter from one of Mornay's relatives who housed the travelers on their way back to Paris gives an amusing glimpse: "M. Delacroix' amorous secrets were betrayed more than once by M. Charles [de Mornay]; I believe that he left a passion in every place where they stopped a little while. From that, he seems to be very fired up especially about a certain Spanish woman from Seville, of whom we saw a little portrait without his suspecting; or else a young Englishwoman living in Tangier [. . .]" (Piron archive, cat. 68, Musées Nationaux). The letter is addressed to Pauline Villot, the wife of Delacroix's friend Frédéric Villot, at the time herself in love with Delacroix (see *Journal* 1:668 and n. 185, 29 May 1853).

262. The "Casa lonja," or merchants' exchange, later the General Archive of the Indies, is a fine example of Spanish Renaissance architecture. Designed for Philip II by Juan de Herrera, architect of the Escorial, it opened in 1598. It stands opposite the south transept of the cathedral and is sixty-five meters long at its furthest point. On a drawing in the Louvre (363), Delacroix wrote: "Do a large picture—monks in a refectory, for example, or in the large room in Seville that I drew."

263. The San Jerónimo of Buenavista monastery (fifteenth century), situated on a hill about two miles north of the city center, was turned into a crystal factory in 1843 and is today used as a civic center.

264. The statesman Pedro ("Pietro") Cevallos (1764–1840), author of an anti-Napoleonic *Exposition of the Practices and Machinations which Led to the Usurpation of the Crown of Spain* (1808), prime minister under Ferdinand VII in 1814, withdrew from public life in 1820 and retired to the San Jerónimo monastery.

265. Pietro Torrigiano, Florentine sculptor, a contemporary of Michelangelo, born in 1471, died in Seville at the hands of the Inquisition in 1528. His *Saint Jerome* in terracotta (1525) is now in the Museum of Seville.

266. The Casa de Pilatos, or house of Pilate, a splendid palace in Moorish style, built in 1533 on the model of the supposed house of Pilate in Jerusalem, and featuring rich faience reliefs.

Said my goodbyes to M. Williams and his family.[267] It is hard for me to leave, probably forever, these admirable people. Alone with him for a moment. His emotion, etc.

The boat; departure. The woman [dressed?] as an officer.[268]—Banks of the Guadalquivir—dismal night. Lonely among these strangers playing cards in that dark and uncomfortable area below deck. The woman who rolled up her sleeve to show me her wound, etc. Disagreeable awakening and landing at San Lucar. Came back in a *calesa* with the servant from the hotel in Cádiz. Deserted countryside. The man on horseback with his blanket around his neck. *[sketch]*[269]

Oran—Algiers—Return to France

[Apart from the story of the masked ball told by Lagerheim (see the introduction above, pp. 21–22), we know little about the period between Delacroix's return to Cádiz on 28 May and his arrival in Algiers on 25 June, when he uses two pages of the Meknes notebook. On 30 May he left Cádiz aboard La Perle *and arrived in Tangier the following day;*[270] *Mornay and Desgranges returned from Gibraltar on 4 June. The group remained in Tangier until the ninth.* La Perle *then left for Oran, where they stayed from 13 to 18 June, before leaving for Algiers.*[271] *The travelers were in Algiers from 25 to 28 June. A drawing of the coast, annotated* Algiers, 25 June, *is in the Chantilly notebook (p. 103). Notes from the same day are in Louvre 1757 (below, pp. 127–29).*

Apart from a few drawings, such as a watercolor of the Great (Hassan Bacha) Mosque (Louvre 1757, fol. 37) and the watercolor for the Mornay album of "A Coulougli and an Arab," which according to Philippe Burty represents a scene in Oran,[272] *there are only three mentions of the party's stay in Oran in the extant documents. Mornay drafted a report on the new French colony and the situation of the troops: "The city enjoys the greatest tranquillity, but the whole province is in the most terrible state of anarchy. For the last two years, no duties or taxes have been paid. No caravan*

267. Williams had married a Spanish woman, Florentina Bedmar, with whom he had at least four children: a son, Manuel, who succeeded his father as consul in 1866, and three daughters—Florentina, Maria, and Isabel.
268. The sense of "officier" here is unclear. It can also mean "official" or even "steward" in a great house.
269. Delacroix landed at Sanlucar de Barrameda, at the mouth of the Guadalquivir, and took the *calesa*, a light, two-wheeled diligence, to Puerto San Maria, from where he returned to Cádiz—a route, according to Ford, "interesting only to crab-fanciers and salt-refiners" (*Handbook*, 1:345).
270. For the dates, see the passenger list (reproduced in Arama, *Le Maroc de Delacroix*, 204–5) and ship's log (*Voyage*, 6:117).
271. Drawings from the ship—of the coast by Tangier, "Apes' Hill," and Gibraltar, all dated 10 June—are in Burty no. 30 (private collection), fols. 37r, 38r and 39r. In the Chantilly notebook (p. 101), a drawing of the coast, with a view of the mountains, is annotated "Oran, 18 June," and other testimony states that the party left for Algiers on that day (Savary, *Correspondance du duc de Rovigo*, 3:331, letter of 17 June 1832). The ship's log indicates that the boat left on 19 June.
272. Burty's notes are reproduced in Jean Guiffrey, *Description*, 195.

coming from the interior of the country can get through to Oran. There is no work in the cities of Tlemcen, Mascara, and Mostaganem. The bey of Constantine's emissaries frequently manage to revolt, and to incite revolt, against the French occupation. The marabout or sheik of the Amisil Sidi tribe has just captured fourteen chiefs of an enemy tribe and has had them all cut into pieces" (Mornay, report of 5 July, Voyage, 6:235–36).

Of the stay in Algiers we have more information. According to Delacroix's friend Charles Cournault, Victor Poirel, chief engineer of the port, arranged for the chaouch (a kind of orderly employed by the local administration), to take Delacroix to his house, the experience that inspired the painting Women of Algiers in Their Apartment (1834).[273] On 28 June, La Perle left Algiers for Toulon, landing on 5 July (a drawing of the harbor of Toulon is in Louvre 1757, fol. 39). After two weeks in quarantine in the lazaretto of Toulon, during which Delacroix painted, or at least finished, the watercolors for Mornay,[274] the group disembarked on 19 July and left for Paris on the twentieth. In order to avoid entering Paris during the festivities commemorating the July Revolution of 1830, they made a detour to Lizy-sur-Ourcq, thirty-five miles northeast of Paris, where Mornay had family. "While his travelling companion was resting, M. Charles [de Mornay] brought out for us the most precious things he had: wonderful drawings by Delacroix intended to constitute the most unusual and delightful album imaginable, which he gave him as a souvenir of their journey." With the animals intended for King Louis-Philippe still in tow, on which "those gentleman doted with a paternal affection," Delacroix and Mornay left for Paris in the small hours of 30 July and arrived in the city later that day.[275]]

Algiers, [Monday] 25 June.—Stepped onto land around eleven o'clock. The marina. Street going up.[276] Narrow, criss-crossing streets. To the General's.[277] To the Commander's at the port.

273. Cournault, "La Galerie Poirel au Musée de Nancy."

274. Delacroix's letters are unclear as to whether he executed the album during the journey or in quarantine (Corr., 1:334, 408). For the composition of the album, see below, pp. 178–79.

275. These details come from the letter from Mornay's relative to Pauline Villot cited above (note 261): Piron archive, cat. 68, Musées Nationaux.

276. Formerly Thriq bab el Dzira, the Rue de la Marine was the main street in Algiers leading from the port through the Bab el Dzira (Gate of the Island), past the Great Mosque (el-Kebir) to the El-Djedid Mosque (now Mosquée de la Pêcherie). Originally a narrow street crossed by others such as the Thriq Arrabadju (Rue des Sauterelles), Qaa es-Sour (Rue de l'Arc), and Sidi al Gudi (Rue des Trois Couleurs), it was widened and renamed in the first two years following the French conquest of 1830. (It no longer exists, the area having been completely reorganized from 1860 to 1874 and then demolished in 1942.) See Zeynep Çelik, Urban Forms and Colonial Confrontations: Algiers under French Rule, http://ark.cdlib.org/ark:/13030/ft8c6009jk/; Marcel Emerit, "Les Marchés. Les quartiers commerçants d'Alger à l'époque turque," http://alger-roi.fr/Alger/marches/textes/2_quartiers_commercants_algeria25.htm, accessed 19 February 2017; and André Raymond, "Le Centre d'Alger en 1830." In "Memories," Delacroix criticizes these urbanization projects carried out by the French (see above, pp. 42–43).

277. The general in charge of Algiers at this period was Anne Jean Marie René Savary, duc de Rovigo (1774–1833), named to the post on 6 December 1831. In July, his repressive policies would be condemned by a parliamentary commission.

To the Casauba.[278] Dark entrance, painted doorway, fountain. *[sketch]* The roofs in Turkish style on the inside. *[sketch]* Painted ceilings, often planks, not beams. The cypresses above. *[sketch]* Before the dark passageway where the cafes are. *[sketch]* The dey's bedroom. Cupboard. Rich people hang tapestries or brocades on their doors and windows, etc. *[sketch]*

Children playing, their sleeves rolled up.

In Oran. Cupboards in the white walls. *[sketch]*

[After this point, the Meknes notebook contains several sheets inserted or glued in, no doubt by Burty, who first owned it. See appendix A.

On fol. 97v, Delacroix's own notebook resumes, with a drawing of Arabs. From this page onward, the notebook must be turned upside down and read from the back.]

Buy black coat of the Jews.[279] Jew's dress. Woman's jacket.

[in English, in Bell's handwriting:]

Zar Hone near El Kasba de Pharon about 12 miles from Meqnez.[280]

[costume sketch]

[fol. 97r]

	[piastres]	[pesetas]	[ounces]	[blanquilles]
5 pairs of slippers at 1 piastre[281]	5 p.			
1 p[air] of little ones for a woman at—		3 pesetas ½		
4 p[airs] of boots at 2 p[esetas] ½	10 p.			
1 Moroccan leather	1	1p. ½		
faience	3	4 ½		
6 p[airs] of slippers with double sole at 4 pesetas ½	5	2		

278. The Kasbah, or citadel.

279. The *yallak.*

280. Zerhoun, the town sacred to Moulay Idriss I (see above, note 121) who is buried there. The Phoenician and Roman ruins of Volubilis, or "Pharaoh's castle" ("El Kasba de Pharon") are just a few miles away. Delacroix passed by en route to Meknes but did not stop (see above, 15 March). Bell had gone to Meknes in December 1831 and may have visited the site then.

281. In these accounts, five pesetas equal one piastre. Although there is a discrepancy, fifteen ounces seem to equal one piastre, and four blanquilles equal 1 ounce. I calculate a total of 73 (not 74) piastres, 4 ounces and 1 blanquille. Delacroix may have mistakenly counted the crossed-out 5 (pesetas). Some of the items on this list were among those bequeathed by Delacroix to Charles Cournault and are now in the Musée Delacroix: see Font-Réaulx, *Delacroix: Objets dans la peinture*, 167–69.

5 id. at 3 pesetas ½	3	2 ½	
2 pairs small		3 ½	
1 silk shawl	1	2 ½	
5			
2 silk cords [at] 10 [sic for 15?] ounces	2		
2 pieces silver jewelry	4		
1 saber	4		13 ounces
1 dagger	2	2 p. ½	
4 cushions (each 2 p[esetas] and 5 ounces)		9	5 ounces
1 double belt	7		9 ounces
4 leather cushions (1 p[eseta] 2 ounces each)		4	8 ounces
djellaba and paper	6	2 pesetas	3 bl.
	74 p.		1 bl.
	392 f[rancs]	4 ounces	

[fol. 96v]

Child with coat that had a silk hood with flowers. Another one red. [sketch]

[Two pages of watercolors of Arabs follow (fols. 95v and 94v). On fol. 93v, a landscape with two seated Arabs, annotated: Horses and riders in the agaves, a scene that recalls the watercolor from the Mornay album entitled Arab Men Resting near Tangier (Fine Arts Museum of San Francisco). On the same page, three studies of Arabs and a group of Arabs carrying flags.]

[Two pages of sketches of Arabs (fols. 92v–91v), of which the first shows the reception of the group by the sultan on 22 March]

[Portrait of a man in a hat (fol. 90v), with a cigar in his mouth, formerly taken to be Charles de Mornay. This identification is questioned, rightly, in Louvre Inv. where the authors propose Delaporte or "rather" Drummond Hay, "the type" appearing to them to be "somewhat Anglo-Saxon." Ethnic stereotypes aside, this is unlikely on chronological grounds. Its place in the notebook indicates that the drawing was executed during the trip to Meknes, and neither Delaporte nor Drummond Hay went on that trip. Among the Europeans who did, and excluding the servants, the only possibility is Antoine Desgranges, the interpreter. For known portraits of Mornay, which look nothing like the person here, see Louvre 1589 and 1590.]

[self-portrait of Delacroix (fol. 89v)]

[sketch of Moroccans (fol. 88v)]

[watercolor] Meknes, 27th Tuesday March *[fol. 87v]*

[drawing of a camp] banks of the Sebu, 6 April *[fol. 86v]*

[In a pocket, on the inside back cover, two sheets of drawings. On one (20.8 × 13.5), nudes and heads. On the other, people and the gates of Tangier, with annotations: the school. Slippers at the door. The Muslims seated in the mosque. The fisherman. *The sketches and notes on this sheet relate to 15 February. They are on the back of an invitation:* Mme d'Ehrenhoff invites Monsieur Delacroix to pay her the honor of coming to spend the evening at her house, next Wednesday, 15 February, at 8 o'clock. Tangier, 12 February 1832. RSVP.²⁸²*]*

Chantilly Notebook²⁸³

[p. 1]

The king's revenues amount to 17 million on his territorial property, that is from tithes and customs fees.

—2 or 2 ½ million inhabitants, according to the consuls.

—can call up only 23,000 horses according to the little Moor from Mequinez, except in the case of a religious war, etc.

The peas frozen at the monastery.

The massive doors in Seville, etc. Resemblance to the Moors.²⁸⁴

Voyage en Espagne by Antonio Pons. Recommended by M. Hartley as very good for information.²⁸⁵

In M. Duguez's case:²⁸⁶ 2 haiks, an old burnous, a new one, 2 Moorish shirts, a yellow caftan, the red cap and little lamp.

[p. 2]

Jacob's mother.

The school for the little Jewish children.

Interiors of the Jews.

House of the American consul.

282. Mme. Ehrenhoff, wife of the Swedish consul Johann Ehrenhoff who had been recalled to Stockholm in May 1831, had remained in Tangier with her two children in the consular house. "A real shrew," according to Lagerheim (*Minnen*, p. 35).

283. For other notes from the Chantilly notebook, see above, 24–25 January and 29 April.

284. These latter two notes relate to ones in the Meknes notebook: 19 May (in Cádiz) and 23 May.

285. Delacroix saw Hartley on 25 and 27 May in Seville. The *Viage de España* by the painter Antonio Ponz, who was charged with collecting the best works of art from the monasteries of the recently expelled Jesuits (1767), was published in Madrid from 1772 to 1794.

286. Duguez, unidentified.

The door of the tannery from M. Colaço's.[287]

The tailor's house.

Dark house belonging to a Jew, after M. Frayssinet's.

The Jewish house where the wedding was held.

Draw pots and vases.

Draw agaves, etc.

Do for M[ornay]: women at a fountain; horseman practicing a charge; the red soldier at the gate in Meknes;[288] Abou at home; Abraham; the actors; Moorish woman in formal dress; man in his shop; effect of the camp at night.[289]

[sketch]

Yça. Jesus.

Yçaouis. Jesuits.[290]

[p. 3, sketch highlighted with watercolor, annotated Jewish child, and sketch of the coat of arms of Seville]

[p. 4]

In Cádiz, scarves. Silk collar. Cigarette holder. Cigarettes. Hat. Socks. Silk jacket.

[p. 5, reading notes from after the journey: see appendix A.]

[Several pages of drawings and watercolor studies of Jewish women follow (pp. 7, 9–13, 15, 17, 19, 21, 25–27, 29–31, 33, 35, see fig. 8).

Annotation on p. 17: White and lacquer damask. The braid gold and silver. On p. 19, sketch of a man annotated: The man who wanted a violin. At the bottom: Learn how to put on the haik in the Tripoli manner.[291] On p. 37, sketch of Arabs highlighted in watercolor.]

287. A drawing annotated "at M. Colaço's," the Portuguese consul and co-owner, with Benchimol, of the tannery, is further on in the notebook (p. 99). An "insignificant man" with a "large family," he "lived a withdrawn life" and every evening held in his house "a gambling club [...] where whoever wished to would turn up to play cards, and everyone had to chip in for the lighting" (Lagerheim, Minnen, 39).

288. This refers to the soldier at the entrance to the Jewish quarter in Meknes who, as Delacroix noticed, was dressed in red (see 24 March). Delacroix did two sketches of him, one in the notebook and another on a sheet in the Louvre (1525).

289. These are subjects for the album of eighteen watercolors that Delacroix gave to Mornay. Some of them were not retained, or were used for other paintings, such as An Arab Camp at Night (J418) and Women at a Fountain (J394), of which there is also a watercolor that was not part of the Mornay album (Louvre 1574). For an inventory of the album and their locations, see biographies (Mornay, pp. 178–79).

290. Delacroix is referring to the Issawa, or Aïssaouas, a sect founded by Sidi Mohammed ben Aïssa, whose furious ceremonies he depicted in three paintings entitled Convulsionaries of Tangier (J360, J403, and one of the Mornay watercolors). Lagerheim's testimony supports the story that Mornay recounted to Burty, according to which Delacroix observed, from a hiding place, such a ceremony. See the introduction, p. 21 above. As he notes here, incorrectly likening "Yçaouis" to "Jesuits," Aïssa means Jesus in Arabic. But the name comes from the founder of the sect, not from Christ.

291. As Delacroix did not visit Tripoli, he may have known of this from Delaporte, formerly of the French consulate in Tripoli.

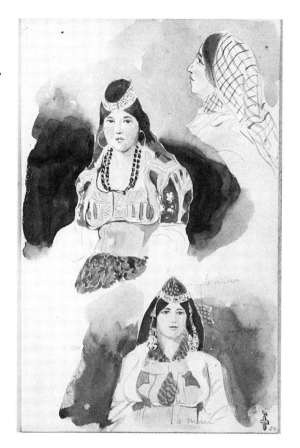

[*p. 39, view of a garden with a house, annotated* 23 April; *p. 41, watercolor view of Tangier, annotated* 23 April; *p. 43, pencil drawing of Tangier; p. 45, watercolor of a doorway with Moorish scalloping in the arch, annotated* 23 April; *p. 47, sketch of a person seated; p. 48, watercolor of an interior; p. 49, watercolor of an interior, annotated* 24 April; *p. 55, watercolor of an interior, head of a woman in pencil seen from behind; p. 57, interior in watercolor with a violet curtain and two women on the right; pp. 58–61, see* 29 April *(above, pp. 109–10); p. 63, interior with women and children seated in front of a tapestry (now detached and mounted on cardboard); p. 65, pencil drawing of a woman and child; pp. 67 and 69, drawings of women highlighted in watercolor.*]

[*pp. 71–73 and 75, drawings of a woman that Delacroix would use fifteen years later for a watercolor done for the Duc de Montpensier, in which the painter also mixes details from the study on p. 63 of women and children in an interior (notably*

*the tapestry): see Journal, 22 February 1847. From their location in the notebook,
they were done in late April–early May 1832.²⁹²]*

[pp. 77 and 79, drawing of a woman seen face on and from the back; p. 81,
watercolor drawing of a woman, with an annotation in the upper right Sol, Solica;²⁹³
p. 83, Borj ben Amar, the bastion of the Kasbah of Tangier, seen from the sea; p. 85,
view of Cádiz, annotated Cádiz 11 May, seen from the SE at 4 miles; p. 87, another
view of Cádiz annotated Cádiz, 15 May in the harbor; p. 89, drawing annotated
View of the walls and the San Fernando gate done from the gallery of the gar-
den of the Alcassar, Seville; p. 91, landscape in watercolor; p. 93, top, landscape
with figure in watercolor, bottom, head of a horse in pencil, landscape in ink; p. 95,
landscape with mountains, man on horseback, annotated To soap down [?] he
bought [?] meat;²⁹⁴ p. 97, sketch annotated 8 June and Moorish courtyard; p. 99,
sketch of a woman holding a child, annotated At M. Colaço's;²⁹⁵ p. 101, pencil view
of the coast, annotated Oran 18 [written over 17] June; finally, p. 103, view of the
coast in pencil, annotated Alger 25 June.]

[Twenty-five blank sheets follow; the travel notebook itself ends here. But turning
it upside down and starting from the back, there are numerous jottings, notably of
items to take back to France. Some of these are now in the Musée Delacroix (see
above, note 121):]

Moroccan leather for Bertin²⁹⁶
Moorish shorts
caftan, dimity and serge
burnous
spurs

292. The same figure is on a drawing in the Louvre (1564).
293. Sol (diminutive Solica) was a feminine name among the Jews of Morocco. Abraham
Benchimol seems to have had a daughter of this name, who later married her cousin David Azençot
(Dumas, *Mon Cher Delacroix*, 128; Arama, *Le Maroc de Delacroix*, 222): the drawing is probably of
her. However, Arama suggests that the annotation may refer to Sol Hatchouel (*Delacroix: Un voyage
initiatique*, 124). This story rocked Moroccan society in the early 1830s and would soon have a tragic
end. Sol Hatchouel was a young Jewish girl from Tangier who was beheaded in Fez in 1834 on the
basis of false testimony that she had expressed the wish to convert to Islam. Taken before the
governor—Sidi El-Arby (whom Lagerheim describes as especially cruel to Jews)—she refused to
convert and was jailed. Abd al-Rahman summoned her to Meknes and allegedly wished to release
her, but the affair was by then exercising public opinion among both Jews and Muslims, spreading
from Tangier to the other major cities. She was executed in 1834 in the main square of Fez, and
buried in the Jewish cemetery, where she was venerated as a saint and her grave became a site of
pilgrimage. Drummond Hay mentions the matter in his diary entry of 9 June 1834 (Vance, *Mar-
tyrdom of a Moroccan Jewish Saint*, 26). Some accounts place the start of the story in 1832, but I have
been unable to confirm this (Rey, *Souvenirs d'un voyage au Maroc*, 146).
294. Difficult to read: perhaps "buy" instead of "he bought." It may be related to the note in
"Notes and Drafts," 2nd unnumbered cahier-c: "To buy soap." Soap was made from animal fat in
Morocco in this period.
295. The Portuguese consul.
296. Probably Armand Bertin (see the introduction, p. 8), to whom Delacroix wrote on 2 April
to give him "some news of the land of lions and leathers" (*Corr.*, 1:327).

The name of God in the play and the spectators who respond[297]
Cassaba—shirt (get it in linen)
Other cushions for R.C.[298]
Pointed cap
Tricolor fouta (kerchief that the women wear around their hips)[299]
Fibulae for M. Auguste[300]
Common slipper for women
ditto, for men with a part rolled down
mats
Convent of the Candelaría and the road that continues[301]

[Here there is the trace of ten sheets that were cut out, including the four from the Piron and Roger-Marx archives published at 24–25 January above.[302] See appendix B.]

[p. 172, sketches of Arabs in pencil and watercolor, annotated tête nue *and* femme.*]*

[p. 171]
[. . . they] speak so as to speak [. . .][303]

caschaba—sleeveless shirt
mousoria—ditto, for a woman
mjaroued—ditto, with sleeves, for a man
sarouel—breeches[304]

[The notes on pp. 170–60 postdate the journey. See below, pp. 129–32 and appendix A.]

Louvre Notebook 1757

[Inside cover. Notes written in Algiers, 25–28 June 1832.]
See the lamps in the evening at the shops
De Santeul. Ad[olphe?]. Aug[uste?]

297. It is unclear what Delacroix is referring to here: perhaps a scene with the traveling actors whom he twice painted (see below, p. 154 note 63).
298. Hippolyte Royer-Collard, head of the arts and sciences division at the Ministry of the Interior, had asked Delacroix for some items from Morocco. See *Corr.*, 1:297.
299. See Louvre drawing 1559, and the annotation on a drawing in the Museum of the City of Poitiers (inv. 882.1.349): "worker. The fouta around her hips. Another on her head."
300. The Orientalist painter Jules Robert Auguste (1789–1850) was a friend of Delacroix's.
301. On Louvre drawing 1712: "See, when I return to Cádiz, the convent of the Chandeleur and the road that continues." The convent was demolished in 1873.
302. Guiffrey writes that there were eleven sheets, but there are in fact ten, which makes a quire (*Fac-similé* 1913).
303. The meaning is unclear. It is the sequel to a missing page.
304. *Sarouel* or *sirwal* are baggy trousers gathered above the calf or ankles.

rue Philippe n° 14[305]

Buy:

serge caftan

dimity caftan open in the front

shirt with sleeves

ditto sleeveless

for a woman. Way of rolling up the sleeve

Soulam[306]

Soldier's knife

[fol. 1r]

Rue de la Marine.[307] Turkish café and Moorish music.[308]

Country house of General Feuchères[309]

Ravine near Babaloued before getting to the garden of the Dey.[310] (Curious also.)

General's house

Casauba[311]

Mustapha Pasha (house)[312]

305. The name "M. de Santeul" and the address are also on Louvre drawing 1610, depicting women in their native dress, perhaps in view of *Women of Algiers*. The address is the "Dar-el-Hamara," or "Maison rouge," built by the dey Hussein, which in Delacroix's time served as the headquarters of the French army corps of engineers. A. de Santeul was aide-de-camp for marshal Caraman, a general in the artillery, who was in Algiers during Delacroix's visit as part of an inspection of military installations (Savary, *Correspondance du duc de Rovigo*, 1:607, 3:349). An "Auguste de Santeul" who on 31 December 1842 was appointed secretary-general to the Interior department in Algiers, would have been only twenty-one in 1832 and does not seem to have been in Algeria at the time (*Algérie: Bulletin officiel des actes du gouvernement*, no. 141 [February 1843], 293, and Archives d'outre-mer, Births, Algiers 1846, no. 347).

306. A type of burnous, white and hooded, worn by the military ("Mémoire militaire de l'empire du Maroc . . . par le capitaine Buret," in Napoleon, *Correspondance de Napoléon avec le ministre de la Marine*, 2:115).

307. The main street in Algiers. See Meknes notebook of 25 June (above, p. 120).

308. Seven cafés lined the north side of the street, including the so-called "Grand Café" (Kahwa al-Kebira).

309. Baron Adrien-Victor de Feuchères (1785–1857) was commander of the second brigade in Algiers. He had taken over the country house of Hamdan ben Othman Khodja, "a very rich Moor who has travelled in Europe and built himself a residence fit for his tastes" (Savary, *Correspondance du duc de Rovigo*, 1:582–83, letter of 23 June 1832). At this very moment, the house had become a diplomatic and political issue: Hamdan ben Othman Khodja asked for the house back, a request that Rovigo, the governor-general, wished to grant, since he needed Khodja as a liaison with the Arabs. But Feuchères refused to give it up and had to be ordered to do so.

310. Bab el-Oued, "gate of the river," site of a fortress on the north side of Algiers built by the French. On the garden of the dey, see "Memories," fol. 15 (p. 42).

311. The Kasbah, or citadel of Algiers, served as the palace of the deys until the French conquest.

312. Built in 1799–1800 at current 12, Ahmad and Muhammad Mecheri Street, as a summer residence for Mustapha Pasha, dey of Algiers from 1799 to 1805, this house is today the Musée de

Bouggaria [sic for Bouzaria] plateau

At the café Paul: the son of Mustapha Pasha[313]—in love with the woman from the café

Ker Porter (Persepolitan monuments). Library.[314]

Little windows with lattice. Stained glass behind.[315] [sketch]

[fol. 1v, sketch of Arabs seen from behind]

[The rest of the notebook consists of sheets of sketches and drawings. On fols. 2v–3r, a pastel of the sea at sunset (see Johnson, Pastels, no. 20). On fols. 28v–29r, sketches of walls and of a plain with mountains, annotated Mekinez; on fol. 30r, sketch of Arabs; fol. 32r, watercolor of the coast, annotated Mars el Kebir, thus en route to Oran. Several drawings, most in watercolor, depict interiors, costumes, panoramic views, etc., including the Great (Hassan Bacha) Mosque of Oran (fol. 37). On fol. 45r, sketches for the portrait of Mornay and Demidoff in Mornay's apartment.[316]]

[The following notes are from after the journey, but pertain to it. Those that do not pertain to the journey can be found in appendix A.]

Chantilly Notebook

[p. 170]

The cicada chrysalis at a depth of 24 feet[317]

[p. 167–66]

Saboula (saber), in Spanish sable. Sciabla in Italian. In Morocco this designates the little straight sword.

The Arabs are very abstemious. When they are on an expedition or required to go long distances, they put into their bag a type of flour made of barley that

la miniature, de l'enluminure et de la calligraphie. See http://www.discoverislamicart.org/database_item.php?id=monument;ISL;dz;Mon01;13;en/ (accessed 26 May 2017).

313. E. Pellissier wrote in 1836: "Ibrahim, son of Mustapha Pasha, is the most useless and inoffensive inhabitant of the Regency. He lives in Algiers where he enjoys great affluence. In a trip that he took to Paris in 1832 he was decorated with the Legion of Honor, for no reason or purpose. He is, nonetheless, a very decent man" (Annales algériennes, 2:387). The Bouzaria plateau (407 m.), about three miles west of Algiers, affords a magnificent view of the city and the Mediterranean.

314. Robert Ker Porter (1777–1842), Scottish painter and diplomat, author of Travels in Georgia, Persia, Armenia, Ancient Babylonia during the Years 1817, 1818, 1819, 1820, containing illustrations of the ruins of Persepolis, the ancient capital of the Persian kings. Delacroix is reminding himself to consult it at the Royal (now National) Library in Paris.

315. Mashrabiya, one of the most common elements of Islamic architecture.

316. The painting (J220) was exhibited at the Salon of 1833.

317. The cicada larvae live many years deep underground.

has been roasted and ground. They mix that with water and make little balls that they swallow. Cooks often mix it with oil or rancid fat, etc.

In Morocco the Numidian race, small in size, is found in the Atlas mountains. They fight dressed only in a haik with a large bayonet rifle. Often they have no saddle.

The Riffians[318] are probably the descendants of the Carthaginians. They are big and strong.

Toga, from *tegere*.[319]

One of the three saints' tombs in ruins near Tangier is that of Ben Abou's grandfather. He was pasha of Tangier and had for a long time maintained his independence from the Emperor. He was killed or assassinated and his head taken to the Emperor, who said: "He was a human being and did not deserve this fate."[320]

M. Delaporte once gave Ben Abou 7 or 8 piastres for having kept watch over a shipwrecked vessel off Cape Spartel. They take what is given and attach no sense of shame to such a paltry sum, whatever their status.[321]

When the agave has produced its long spike, it dies.

Allah-ou Ak-Barr,[322] war cry of the Arabs in the Crusades, etc.

Yellow is the color of the Abassids or Fatimists.[323] Green, the color of Mohammed.

318. Natives of Rif province, along the Mediterranean coast; they were highly reputed warriors (see below, p. 131).

319. To cover, protect.

320. This note seems to amalgamate two stories about Ben Abou that are preserved in John Hay's memoirs: one deals with the saintly ancestor whose tomb is honored; the other with the ancestor who was beheaded. The events recounted in the first story supposedly took place when the British controlled Tangier (1662–1684). Ben Abou's ancestor sent an army to take the city; he perished during an attack by the British on the Moroccan camp, above the Bubana river to the southwest, near Tangier; the site, which became sacred ground, was, and still is, called "Mujahidin" (warriors of the faith), and tombs were erected for the Moroccan chiefs. Edward Drummond Hay confirms the Ben Abou ancestry and reports that the tomb contained an inscription in Arabic: "The great kaid who fought twice against the Portuguese and once against the Spaniards" (Bodleian Library, Oxford, MS Eng.hist.e.354, p. 26).

The events recounted in the second story took place allegedly at the time of the war between Spain and Britain in 1805. Ben Abou's grandfather, pasha of Tangier, the friend of the Spanish representative with whom he was allied against the British, had granted the Spaniard some privilege that was not authorized by the sultan, Moulay Suleiman. The sultan sent an executioner to cut off his head and ordered it to be placed above the gateway of the Spaniard's residence (Hay, *Memoir of Sir John Drummond Hay*, 192). It was in recognition of his friendship that the Spanish government had given to the unfortunate pasha the model of a Spanish vessel that Hay takes as the *Santissima Trinidad*, whose mast served as a bridge. Delacroix mentions this in "Memories," fol. 28 (p. 50). On Ben Abou, see biographies.

321. See "Notes and Drafts," 1st unnumbered cahier-b (p. 141).

322. "God alone is great."

323. The Abassids, Sunnis, descendants of Al-Abbas, the Prophet's uncle; the Fatimists, Shiites, descendants of the Prophet through his daughter Fatima.

8 August 1834. Had lunch with M. Delaporte.

The Riffians border the regency of Algiers. They are big and strong, fight among themselves. The Berbers or Shilha smaller, slight. Brave mountain people. The Emperor's troops almost always defeated by them.[324]

The beautiful horses in the province of Oran, Tlemcen, etc.

[pp. 165–64]

Among the Moors, eyebrows that join up are a sign of the evil eye.

When they suspect someone of having this influence, they display five fingers without the person noticing.[325] If he asks, "how many children do you have," they answer "five." And so on for everything.

Or they mark their children with a little saliva or charcoal.

The finest horses have their ears slit for this reason.[326]

[327]The Scelocchi, who inhabit mainly the various parts of the Atlas range south of Marrakesh, live less from their flocks than from agriculture and several types of industry. Instead of in tents and caves, they live in villages and houses, etc. [. . .] They differ esssentially from the Berbers by language, dress, and their less robust physical constitution, a darker complexion, and a natural disposition for the arts and industry far superior to that of the Berbers.[328] They are generally more slender, industrious, etc. [. . .], and more intelligent. Some believe that they descend from the Portuguese, etc. This great divide appears to have always existed. Even now in the places where they are neighbors, they live apart. Their languages are very different from one another.

324. The Shilha, Berbers living in the western Atlas and the Souss plain (see note 329). In the book by Gråberg di Hemsö quoted by Delacroix, they are described as intrepid in war and, in the insurrection against Moulay Suleiman (1818–1822), "indomitable" (*Specchio geografico*, 224).

325. The number five was both unlucky and an apotropaic amulet; according to Jackson, the five fingers represented the hand of power or tyranny. These symbolic hands, *hamsa*, were very common in Morocco among both Jews and Muslims. Painted on doors or walls of buildings, inscribed in documents, they were supposed to absorb or send back the harmful influence, like the gesture described by Delacroix here. Drummond Hay notes that the Muslims of Tangier used the gesture, but did not represent the hand visually (Bodleian Library, Oxford, MS Eng.Hist.e.354, p. 198). He cites the curse "Hamsa ala ainak," "Five fingers in your eyes" (ibid.). Jackson cites "Five be upon thee" (*Account of the Empire of Marocco*, 165).

326. Children and horses were considered especially vulnerable to the evil eye, hence the measures for protecting them (Windus, *Journey to Mequinez*, 61). Delacroix mentions this same custom in the marginalia to "Memories" (cahier 2-a, p. 134).

327. This paragraph is a summary in French of a passage from the work in Italian by Gråberg di Hemsö referred to at the end (pp. 75–76). The book had just been published, on 26 July 1834; it must have been pointed out, and probably shown, to Delacroix by Delaporte during their lunch together on 8 August.

328. The Italian actually reads "*less* by language [. . .] *than* by their less robust physical constitution," etc. "Berber" here refers to the Amazigh, the main group of Berbers, but the Shilha are in fact Berbers, too.

Where character is concerned, it could be said that the Shilha are the French of Magh'reb el Acsà and that the Berbers are the Belgians. Amazirghi.[329]

Specchio geografico e statistico del impero di Marocco. Del cavaliere conte Jacopo Gråberg di Hemsö, già officiale consolare in quello impero per [le] LL. MM. svezzese e sarda, etc. Genova, dalla tipografia Pellas, 1834.

329. *Geographical and Statistical Mirror of the Empire of Morocco.* By the noble Count Jakob Graberg di Hemsö, former consular official in that empire for their Swedish and Sardinian Majesties. Gråberg di Hemsö's ethnic prejudices aside, he is here describing the two main branches of the indigenous peoples of Morocco: the Amazighs, inhabitants of the Atlas from Rif to Tedla, and the Shilha, inhabitants of the mountains of the south and west.

MARGINALIA TO "MEMORIES OF A VISIT TO MOROCCO"

[The following notes appear in the margins of Memories *and were not integrated into the narrative by Delacroix.]*

[cahier 1-a]

We [. . .]. The visit to Fontainebleau. Not all barbarians are in Barbary.[1]

[1-b]

The dinner where I met Royer.[2]

[cahier 2-a]

On the other hand I did not see the mountains of water that you have in most storms. Physicists, they say, hardly a poetic race, are convinced that the biggest wave could not exceed thirty feet. So we are very far from these *[unfinished]*

The walls of Meknes, of beaten tapia[3]

Elephantiasis common[4]

The barber's shop seemed to me like something out of *The Thousand and One Nights*, the meeting-place for gossips—I will not say the idle because there seems to be nothing else.

1. This note is clarified by Delacroix's letter to Pierret of 8 January 1832 (*Corr.*,1:303–4): "By the way, I saw Fontainebleau in passing. There is some really bad vandalism going on. It is unimaginable that insanity could go so far as to wreck the wonderful remains of the paintings there, to make way for the scaffolding and brushes of M. Alaux le Romain. I am convinced that I will find nothing so barbaric in Barbary." The paintings by Niccolò dell'Abate had been assigned to Jules Alaux for restoration. This reference also helps to date the narrative: see appendix B.

2. Hippolyte Royer-Collard (mentioned in the Chantilly notebook above, p. 127); or else Alphonse Royer (1803–1875), who had traveled to Algeria around 1830.

3. See 23 March.

4. See marginalia to fol. 35, p. 136.

The horses whose ears are clipped as a brand—left outdoors[5]

The size of the Jewish and Moorish women of Morocco as opposed to our women.

[2-c]

The Pasha of Tangier, who wraps up the cheese and says that he is dealing with affairs of state.

The dispute between the Englishman, the groom, and the soldier from the consulate.

The quarrel between the sailors and the Moroccans.[6]

Huguet at the consulate—the ship's joker.[7]

[cahier 4-b]

Louis-Philippe's 12th-century tomb.

Napoleon's, Renaissance-style.[8]

The Taleb who writes verses from the Qu'ran and puts them in water as a cure, etc.[9]

The Guadalquivir made famous by the poets. Its melancholy.

[4-c]

The beautiful and the useful still fight their eternal battle in that land. The British manage at great expense to disfigure the grandiose look of the rock of Gibraltar with all their little lines of defense and their little narrow embrasures at the foot of the rock. No monument that would suggest a love of the beautiful.[10]

[fol. 18]

Geoffroy Saint-Hilaire told me on my return: you have seen the land of long clothes. There are, my dear sir, just two categories of men, etc.[11]

5. See 10 and 24 March, as well as p. 165 of the Chantilly notebook (above, p. 131).

6. For these scenes, cf. 7 March, 29 January, and 28 April.

7. Perhaps Simon-Auguste Huguet (1780–1860), captain of the frigate *Adonis*, which had been part of the Algerian campaign in 1830 and still made runs in the Mediterranean.

8. For Lefranc's tomb for Louis-Philippe at Dreux (1839–1843), and Charles Marochetti's design for a Renaissance-style tomb for Napoleon at the Invalides (1840–1841), see appendix B. This reference helps to date the narrative.

9. Delacroix takes up this note again in the margin of fol. 18: "Their medicine. Written verses from the Qu'ran and gruel for people with cholera." In the book by Gråberg di Hemsö mentioned by Delacroix in the Chantilly notebook (above, p. 132), the author states: "According to their Malek *[interpreter of the Qu'ran]*, the best medicine consists in taking a cup [. . .] or a little bowl, writing in it a few verses from the Qu'ran, pouring water in it, and making the sick drink it" (*Specchio geografico*, 175). See also "Notes and Drafts," 1st unnumbered cahier-b, p. 141.

10. See "Notes and Drafts," 1st unnumbered fol. v, p. 150.

11. That is, those who wear long and those who wear short clothes. See "Notes and Drafts," 2nd unnumbered cahier-a, p. 145. Étienne Geoffroy Saint-Hilaire (1772–1844), the famous naturalist, had been part of Napoleon's expedition to Egypt in 1798.

[fol. 22]

Mingled with the cry of the guards who keep watch at night and patrol the streets.

We saw those big trumpets, probably the same as they had used during Ramadan, at Alcassar.[12]

The cries of the guards when I discuss the evenings spent on the terraces.[13]

The baths of Oran.

[fol. 29]

The character of Moorish ornamentation, as opposed to Turkish and to what we saw in Algiers.

Excursions in the surrounding area. Abundance of rivers. Jews' River. The women hanging the laundry. The one who was washing her feet. In the country they are not afraid to show themselves; in Tangier, the opposite.[14]

[fol. 31]

Among those people, so many contrasts.

It seemed to me that their imperturbability was only between themselves.

Abou's pipe, which was a cheap German pipe.

Insults in the streets, threats, clenched fists.[15]

The men who followed me in Meknes.

Shopkeepers in their shops gesturing with their hand.[16] The little stool.

Regarding mosquito nets, the story of Botta's sacks against fleas.[17]

12. On 8 March Delacroix mentions the trumpets that greeted their entry into Alcassar.

13. That is, he must mention the cries of the guards when he comes to the section about the evenings spent on the terraces.

14. As noted above, Delacroix returns to this scene at the end of "Memories" (see pp. 54–55); it is also the subject of a watercolor for the Mornay album. The "Jews' River," dried up, was west of Tangier. A drawing of a woman hanging laundry, dated 26 January, is in Burty no. 30 (private collection), fol. 9r.

15. See 23 March, note 161.

16. Out of indifference. See "Notes and Drafts," 1st unnumbered cahier-d (p. 144).

17. In his *Relation d'un voyage dans le Yemen, entrepris en 1837 pour le Museum d'histoire naturelle* of 1841 (pp. 104–5), Paul-Émile Botta, the archaeologist who excavated Khorsabad in 1841–1842, describes the Yemenis' remedy against fleas: "[. . .] the inhabitants are obliged to sleep in canvas sacks, closing the opening over their head after having crawled into them fully dressed and fully armed. It is often strange to hear them, after they are thus closed up in a kind of bag, continue their conversations for hours. Unable to breathe within such curtains, and on the other hand unable to resign myself to being devoured alive, I preferred, in spite of the cold, to sleep outdoors, to the great surprise of my hosts, for whom my habit of sleeping with my head uncovered was as strange as their own practice seemed to me." Although Delacroix probably knew Botta from Paris salons such as Mary Clarke's (see *Journal*, 2:2141–42 and 2:1261), and thus could have heard this story in person, he probably read it in Botta's book, which was announced in the *Bibliographie de la France* on 2 October 1841 (no. 4731, p. 487). He notes the same story on fol. 7 bis r (p. 140).

[fol. 35]

Nights on the terraces, the murmur of the sea.

He's British, you do not feel shame, etc. Need one feel shame before dogs? This could be put somewhere else, with their hatred of us.[18]

The finest encounter of this type that we had, the women at the stream. The contrast between the women at the stream and those who have elephantiasis.[19]

Cato polishes your boots, etc.[20]

18. See the end of "Memories," above, p. 54.

19. For this story, see the end of "Memories" (pp. 54–55). Delacroix mentions elephantiasis in the marginalia to cahier 2-a (p. 133). This illness, caused by a parasitic infection transmitted by mosquitoes and characterized by a swelling of the lower limbs and by wrinkled skin, was one of the most common in Morocco at this period (Lagerheim, *Minnen*, 46; cf. Gråberg di Hemsö, *Specchio geografico*, 175 and Jackson, *Account of the Empire of Marocco*, 193).

20. Cf. "Memories," fols. 17–18, p. 44.

NOTES AND DRAFTS FOR "MEMORIES OF A VISIT TO MOROCCO"

[Delacroix made these notes, in cahiers and on loose sheets, in view of "Memories" (see above, pp. 24–55). I cite parallels in a footnote at the end of each section.]

[Cahier 6-d. This cahier, which mainly contains a continuous narrative (see above, p. 36), ends with a series of notes. Delacroix crossed out those that he used or that he transferred into the margins of the manuscript of the second part. I indicate these notes here with a cross.]

M. le comte de M[ornay], the French envoy

+The Mouna from the very next day+

+The streets less imposing than one might have imagined from the view from afar+

Description of Tangier

The rocks at the seashore

+The Kasbah+

+Visit to the Pasha.+ Garden with masonry paths and arbors. In Spain likewise.

+The horses fighting+

Arrangements for the gifts. The watch with Persian figures.

+Ramadan+

+The Courban Bairam+

The goldsmiths. The simplicity of their techniques at Meknes.

+Jews and Jewesses—observance of the Sabbath.+ +Caddour's scruples.+ +Jewish ceremonies+

The tradition about the French going all the way to Meknes, etc.[1]

+The walls of Tangier built in large part by the Portuguese+

+Following a brief occupation, the British blew them up, etc.+

1. I do not know what Delacroix means here.

+Old Tangier+

+The bridge made of the ship's mast+

The nights on the terraces. The beauty of the sky. The sound of the sea.

+The view of Tarifa always on the horizon+

+The lovely groves of orange trees. The gardens of the consuls. The fig trees, and the apricot+

Climate of Tangier fairly temperate

+Prickly pears and agaves aplenty, with a large type of reed that serves everywhere as fencing+

+The houses uniform. The courtyard, square. All the rooms long. The carpets as a result+

+Lit only by the doorway. Uneven steps.+

The ceilings, the painted beams

+They have an aversion to windows+

+Exquisite elegance of the architecture. Faience, marble+—the character of that architecture different from Turkish, especially for the ornamentation—the mats.

+The women in the street. You see hardly any with their face uncovered except slaves. They sometimes have the not very pleasant habit of coloring their heels with henna.+

+Kohl for their eyes: peculiar effect when you are not used to it+

+The dilapidated look of all those buildings+

The subjection of the Jews and yet they live in mutual understanding with the Moors.[2]—+The obligation to remove their shoes when passing in front of the mosques+

The situation of Tangier. Life outdoors. They do not visit one another at home.

+The entrance to the houses always curved, so as to hide the interior+[3]

[fol. 7 bis r. This sheet was originally the continuation of the narrative part of cahier 6-d (see above, p. 36), but Delacroix then abandoned it and used it for more notes.]

2. "Despite this state of oppression, the Jews do rather well out of the Moors. [. . .] They find in the resources of their ingenuity the means of compensating for their humiliation" (Chénier, *Recherches historiques sur les Maures*, 3:131–33).

3. *Cross-references to cahier 6-d.* Mouna, fol. 11, p. 39. Streets, fol. 13, p. 40. Rocks, fol. 29, p. 50. Horses, fols. 25–27, pp. 48–49. Bairam, fol. 23, pp. 47–48. Caddour's scruples, fols. 22–23, pp. 46–47. Walls of Tangier, fol. 29, p. 50. Bridge, fol. 28, p. 50. Nights on the terraces, etc., marginalia to fol. 35, p. 36. Tarifa, fol. 30, p. 51. Orange, fig, apricot trees, fol. 34 (p. 53) and a marginal note to fol. 30: "the fig tree and apricot tree under which we could all fit. Talk about them with the big olive trees during the trip *[to Meknes]*." Prickly pears, etc., fol. 30, p. 51. Ceilings, 26 January and the marginal note to fol. 15 (note 46). Windows, fol. 13, p. 41. Architecture different from Turkish, marginalia to fol. 29, p. 135. Henna and kohl, fols. 19–20, p. 45. Subjection of Jews, 2nd unnumbered cahier-c (p. 148) and fol. 20 bis (pp. 45–46). Entrances to the houses, fol. 14, p. 41.

Petunia

Syringa

Elderberry[4]

+It is a truly delightful sensation to wake up the day after *[unfinished]*+

Waking up is truly delightful the day after your arrival in *[unfinished]*+

The main characteristic of this race is the special, indefinable color of their eyes—the little flattening of the end of their nose and the thickness of their lips as well as the distance of their lips from their nose.

Some are blond. It is the sun that turns them brown. The children are lovely.

I have never been able to distinguish racial differences clearly.

+The countryside furrowed by boars in the outskirts of Tangier. The excursions on horseback. Country houses like fortresses.+

+Waking up.—Waking up. Waking up in the morning in places that are strange and completely new, which you have come from so far away to discover, is one of the most agreeable sensations that you can experience. Your curiosity, temporarily satisfied the night before, when you arrived, by that faculty *[unfinished]* +

The beams painted

+The Moors whom I tempted to the consulate to sit for me feared public humiliation+

Description is not painting. The least sketch, etc.

Every description always comes down to saying: it is a gorgeous or a sublime sight. It is with this latter touch that you finish every portrait, or depict a storm, a green landscape, the dance of a bayadère[5] or *[unfinished]*

The Negro from Timbuktu whom I drew. His seriousness when he stopped being in front of an audience.

Muchtar, with a cleverness worthy of Aesop, etc.[6]

Nations go forward or backward on the scale of civilization according to blind chance.[7] The loss of one great battle can wipe out a nation. How did the Moors lose the distinctive qualities of their ancestors? How did the Indian tribes native to Mexico, etc., decline from their ancestors who lived in palaces, to the point of sheltering in hovels, etc.? Barbarism is always at our doorstep.

4. These are European, not Maghrebi plants. Delacroix spent time at his cousin Riesener's in Normandy in February and March 1842, and in April 1843, and at George Sand's in July 1843; he later set up a garden of his own when he started going to Champrosay in June 1844.

5. Originally a sacred Hindu dancer, *bayadère* came to mean a professional dancer.

6. No doubt an allusion to Muchtar's ruse of asking for the smallest gift so that it would not be taken by the sultan. See 12 April.

7. This is a recurrent idea in Delacroix's thought: see *Journal* 23 April 1849, 22 March 1850, 21 September 1854 (1:443–44, 496–98, and 839–40), and his article *Des variations du beau* (On the Variations of the Beautiful) of 1857. The theme informs his decorations for the two libraries then under way (Michele Hannoosh, *Painting and the* Journal *of Eugène Delacroix*, chapter 4).

Our arrogant civilization, which thinks it is always progressing, has gone backward in many respects.

The ancient Moors were much more civilized than the ancient *[fol. 7 bis v]* Spaniards, who now are far ahead of the Moors. But what has happened to that powerful Spanish empire that extended across two hemispheres, etc.

Who would dare say at present that the civilization of Europe is superior, etc. What nation now holds the cards in Europe and imposes its customs on the others? Britain alone, etc.

The problem of mosquitoes. The mosquito net. Botta's story about fleas.[8]

[1st unnumbered cahier-a]
+Cato polishes your boots. Brutus hands you your clothes. The spy from the consulate who was paid 20 cents a day to find out the news, true or false, that was circulating in the town was a handsome old man; actually no, I'm wrong, the term "old man" is not right for this type of person, another must be found. He was Agamemnon king of kings.+

The servants who do not serve because of religion.

+In Marrakesh poisonous creatures, snakes and especially scorpions, are so common that the rooms are faced with faience, with a little water channel at the bottom for drowning them.+

What's reported about the leanness of the Arab race has become a commonplace. I saw nothing of the sort. On the contrary: the finest build possible, but not the Greek type. It is a different look.

Memories of a Visit to MOROCCO.

One of our servants fell ill in Meknes. I was among those who got him to take quinine during his fever; I might have killed him.[9]

The voices of the officers chanting their prayers in the camp and the towns, in the evening and at dawn: melancholy effect.

The evening on the banks of the Sebu.

The ridiculous crossing of the river. The trouble getting the horses onto the boat. There was not even an oar on our crude boats, pushed by men in the water who went to one bank and came back to get us.[10]

The fish that M. Cuvier had asked me to bring him. The meeting with him before I left. He preferred tafia[11] and little vats to jars. Imagine my predicament.

8. *Cross-references for fol. 7 bis.* Boars, fol. 33, p. 53. Country houses, fol. 34, p. 53. Waking up, fol. 7, p. 36. Moors who sit for Delacroix, fol. 13, p. 40. Description, fol. 1-c, pp. 26–27. Botta, marginalia to fol. 31, p. 135.

9. There is no other mention of this incident and it is unclear what Delacroix means. Was quinine the wrong treatment? Did the servant have a reaction?

10. *Cross-references for 1st unnumbered cahier-a.* Cato, etc., fols. 17–18, p. 44. Servants, fol. 21, p. 46. Snakes and scorpions, fol. 14, p. 41. Banks of the Sebu, 11 March. River crossing, 12 March.

11. Tafia, a kind of brandy, evidently to conserve the specimens.

The news of his unfortunate death put my conscience at ease.[12]—In any event, whatever science does, it surely will resume its pursuit of immortal and fecund Nature. I remember that, in some fishing that we did just in the harbor of Oran while we were waiting for lunch, we took in such an incredible variety— pointed heads, snouts, looking like demons, I really doubt that they have been classified.

The dragnet on the seabed brought back monsters of a *[1st unnumbered cahier-b]* different sort, etc.

What Geoffroy Saint-Hilaire said. The sheik who told him: there are 10,000 fish in the sea.

They considered my drawings pathetic.[13]

Bias telling me: you will be taking me with you.[14]

Cholera in Tangier. The Moors not doing anything at first and accepting the calamity as heaven sent it. They noticed, however, that some Europeans had escaped it thanks to taking remedies. They gathered the ill in the caravanserai and gave them spoonfuls of gruel.[15]

I hear that they die very stoically. In executions in Algiers they show the greatest self-control in front of others, and as though it were part of life's ups and downs. They thus practice unwittingly all the teachings of philosophy: renunciation of life and worldly goods, control over the passions of the soul.

It is only their profound avarice that gives the lie to such fine qualities. They bury their money. It is almost the most prominent mark of that race. Acquisitiveness and tight-fistedness are the enduring passions that keep all their faculties constantly alert. The highest-ranking people do not consider it demeaning to accept the smallest gift of money. After Abou had kept watch on Cape Spartel to rescue a French ship, the consul sent him a few piasters, which he happily accepted.

Thus the Emperor unscrupulously selects from the gifts that are given to his ministers and officers.

Muchtar's wiliness in asking for the most paltry gift so that he could keep it. The same, in appearing drunk before the Emperor.

Bias saying that they did not build a bridge and roads so that they could arrest thieves.

From that, and from many other characteristics that they did not mind giving us, we gleaned a great idea of their importance. Making throngs of people pour onto our route as we passed.

12. Cuvier died on 13 May 1832, sparing Delacroix the embarrassment of not having collected fish specimens.

13. They, that is, the Moroccans.

14. In a picture. Delacroix did a portrait of Bias for the Mornay album.

15. Verses from the Qu'ran mixed with water to form a gruel.

While we listened to the music that Abou ordered to be performed for us, he watched our faces for effects of surprise, etc., thinking that it would amaze us. It is the best that they had in the Empire.

Barbary and the rest of the world. That's what their geography amounts to. (Put with the story of the fish.)[16]

Bias' shrewdness in political negotiations.—At the end of the meeting nothing was actually decided, when everything seemed to be settled.

Their notorious bad faith. *Fides punica.*[17]

[1st unnumbered cahier-c]

Their way of fighting with the flag in front. Where the flag goes, the troops follow and rush in.[18]

In general fighting in a crescent, the cavalry in the wings.

I always saw them in a single line.[19]

The soldiers on horseback resemble Roman soldiers. Kaïd [in charge] of 15, kaïd of 50, etc.

They receive land in lieu of pay—another similarity with the Romans.

The tablets that the children use in school, similar to antiquity.

In those assemblies of soldiers, you would have thought you were seeing a flower bed because of the variety and brilliance of the colors. Their way of waiting for us sitting on their heels.

The crossing over the first river was a kind of ford. I had been advised to follow one of the soldiers carefully, etc. I had to take my chances.

Difficulty climbing up the slippery bank.

Gunshots from both sides and lasting half an hour. Passed under an arch formed by the rifles that were fired as we progressed.

The way they tie up their ferocious animals. It is usually the Jews who have that task.

The adventure of the ostrich with the antelope or bubal.[20]

16. *Cross-references for 1st unnumbered cahier-b.* Cholera and gruel, marginalia to cahier 4-b (p. 134). Acquisitiveness, Chantilly notebook, p. 166 (p. 130). Emperor takes from ministers, 24 March (note from the 28th). Muchtar's wiliness, 20 April. No bridges and roads, 12 March. Geography, 12 March and margin of fol. 18 ("Their notions of geography"). 10,000 fish, margin of fol. 18 ("The 10,000 fish").

17. "Punic trustworthiness": treachery, among the Romans.

18. Cf. 28 April. Some of these details can also be found in the description of *The Sultan of Morocco and His Entourage* from the catalogue of the 1845 Salon (J370).

19. Pidou de Saint-Olon alone describes this manner of fighting, in almost the same terms: "They divide their cavalry in two and put it in the wings, the infantry fills the middle, so that the whole takes the shape of a crescent; they never put more than two lines of soldiers" (*Relation de l'empire de Maroc*, 115).

20. The bubal was a subspecies of hartebeest, or African antelope, that ranged north of the Sahara from Morocco to Egypt. It is now extinct.

Crossing the Sebu on the return trip. Trouble getting the ostrich onto the saddle of one of the cavalry horses.[21]

The bubal's crossing. One of the Moors drops the rope; the animal pursues the other one. Endless trouble pulling it out of the water after it had drifted away.

Delarue with his parasol.[22] The Jew's terror at seeing him usurp the sovereign's power.

The saddle covers. Magnificent underneath, uniformly red above.

To work in: it is difficult to recount to the public something in which you yourself play a role.

Jewish weddings the whole time. In Meknes, ditto.

The Moorish wedding. The procession, the gunshots, the cage.[23]—The presents a few days beforehand.

The *toga praetexta*[24]—the child that the parents parade around.

Ancient customs. The *bulla*.[25]

[1st unnumbered cahier-d]

Our music undoubtedly has no appeal for them. Although theirs seems barbaric at first, it is far from lacking in character.

What independence amid this supposed servitude. First, fashion: appearances do not seem to hold much weight for them.

The art of the tailor requires no effort of the imagination. The clothes that they wear have been of the same type for centuries. When he emerges from adolescence, a Moor is rolled up in a cloak that he uses to wrap himself in at night, and to go about his business in the daytime; it will also be his shroud when he is laid to rest in the earth.

+The pretty Jewish women, so I have heard, sacrifice a bit more to the frivolity of fashion, etc.[26]

21. *Cross-references for 1st unnumbered cahier-c.* Writing tablets, 28 April. Arch of rifles, 6 March. Crossing the Sebu, 1st and 7th April, and 2nd unnumbered cahier-c (p. 147).

22. This is the only mention of Baron de La Rue, staff lieutenant-colonel at the Ministry of War, and in 1832 battalion chief in Algiers (*Annuaire militaire*, 1832). In 1836, he returned to Meknes, to negotiate a new treaty with the Sultan after the breakdown of relations between marshal Clauzel and Abd el-Kader (Lambert, *Histoire d'un tableau*, 18–20).

23. Chénier describes this ceremony (*Recherches historiques sur les Maures*, 3:211–13). At nightfall, the groom is led in a procession to the sound of gunshots, until he reaches his house. The bride then leaves her father's house. Seated in a square or octagonal cage carried by a mule, she is escorted by relatives and neighbors, some brandishing torches, others firing shots, up to the groom's house. Lagerheim specifies that the procession is led by slaves carrying the dowry (clothing, oil), and that the groom rides on horseback to the bride's house (*Minnen*, 84).

24. A white toga with a purple border, worn by Roman boys (as well as some magistrates).

25. A lead or silver locket worn by Roman boys to protect them from evil spirits.

26. Pidou de Saint-Olon also observes that the Jewesses "take more care with their hair and attire" (*Relation de l'empire de Maroc*, 84).

The humiliation of the Jews: having to take off their shoes when passing near the mosques. It is heart-breaking to see these pretty Jewish women putting their adorable bare feet on the ground and carrying their little red slippers. The richest are not exempt from this humiliating ceremony. +In general those feet are charming.+ Since they are not constrained by shoes, as in our country, you see the real foot that Nature gave to Venus. I doubt that the feet that seem to us the most charming, imprisoned in pretty shoes such as we have at home, would have much success compared to feet used to fresh air and whose toes are not cramped, twisted, and squeezed together, etc.

As a contrast.

The houses have the look of hovels, and at every step you encounter things of a ravishing elegance and good taste. That is what you do not see in our modern towns, drawn in perfectly straight lines and perfectly plotted.

Another drawback. As our fashions change in buildings as well as in clothes, you are constantly unnerved by the disparate styles that they present, one next to the other.

The shopkeepers in their shops. Their off-handedness. You would think that you have to beg them to sell to you.

They wave their arm indifferently without bothering to move—tell you a price and do not look at you again.[27] They lack that obsequious eagerness that ours have. As soon as you stop in front of a shop, like a spider that hurries over, etc.[28]

[2nd unnumbered cahier-a]

The mark that parents put on their children to protect them from the evil eye.

The merchant from Fez whose portrait I did. His mark.[29]

The symbolic hand. That sign is everywhere.

On the bride's house in Tangier, with a hand dipped in white.[30]

Ceremonies for the Jewish wedding.

Ditto the wedding in Meknes. The couple very young.[31]

27. *Cross-references for 1st unnumbered cahier-d.* Moors' cloak, fol. 1 bis v, p. 155. Humiliation of Jews, fols. 20 and 20 bis, pp. 45–46. Moors' indifference, marginalia to fol. 31, p. 135).

28. Delacroix is comparing French shopkeepers to a spider that hurries to grasp its prey, the potential customer in front of the window.

29. This portrait has not been identified.

30. Drummond Hay states that the Jews of Tangier painted the open hand, against the evil eye, on the outside walls of their houses, especially before a ceremony such as a marriage (Bodleian Library, Oxford, MS Eng. hist.e.354, p. 193).

31. Drummond Hay reports being told by a rabbi that Jewish girls were often married at eight and boys at twelve or thirteen (Bodleian Library, Oxford, MS Eng.hist.d.491, p. 128).

The onerous hospitality in Meknes. Everywhere, you had to sit down and eat. Their horrible stews with saffron, strong butter, honey. The smell of those dwellings.

The Jews' game that consisted in kicking one another.

Jewish tombstones have a different design in every town. The charm of the Moorish tombstones along the routes. +Since the conquest of Algiers a voyage to Morocco has lost much of its interest.+[32]—However, the Moroccans are true westerners. Their name "maugrabin."[33]

The term "oriental" is generally applied to the whole race of turban-wearing people, dressed in long clothes, etc. Geoffroy Saint-Hilaire told me: "You have just seen long clothes. There are only two main categories among men: long clothes and short clothes;" and that that designation, which appears frivolous at first glance, is considered as reasonable as it is picturesque.

What could present a starker contrast with our habits and our continual agitation than this ample, majestic costume, etc.

They do everything in those billowing clothes. What would we say of a hussar or a member of the Horse Guards saddled with five or six cloaks one atop the other, seemingly more wrapped in his clothes than a judge in his robe and hat at a trial, whose majestic attire conjures up ideas of calm and reflection.

The laborers in the fields calmly drive their plough in their toga and pallium.[34] They sow with the seed placed in a fold of their cloak.[35]

Their heads shaven, with no veil or cap in full sun.

The Moors travel during the heat of the summer, in a countryside cracked from drought, carrying *[2nd unnumbered cahier-b]* their slippers at the end of a pole.

With a soldier and a permit from the Emperor, you can cross the whole Empire in this land that seems inaccessible to Europeans.

This respect for the Emperor has something peculiar about it. It is the quality of emperor, or rather of the descendant of Mohammed, that they respect, instead of the person endowed with that supreme quality. They change

32. This was the discreet point of departure for Delacroix's critique of the "barbarous" actions of the French in Algiers (fol. 15, p. 41).

33. *Maugrabin*, Arabic for "westerner;" *Maghreb* means "sunset" or "west."

34. Pallium: a woollen cloak formed of a rectangular cloth, worn by Roman men. It was associated with Greek dress and, by the second century AD, with intellectuals and philosophers. See Cleland et al., *Greek and Roman Dress from A to Z*, p. 137.

35. *Cross-references for 2nd unnumbered cahier a.* Merchant from Fez, 3rd unnumbered fol. r, p. 153. Hand symbol, Chantilly notebook, p. 131 (note 325 above). Jewish wedding, 21 February. Jews' game, 24 March. Jewish and Moorish tombs, fol. 29, fols. 31–32 (pp. 50–51 and 52). Long and short clothes, marginalia to fol. 18, p. 134. Sow from cloak, 14 March and n.

sovereign with the greatest ease; but they will not replace him with anyone other than a prince (*sharif*), or descendant of Mohammed.

Spanish is spoken everywhere. With *bueno* you can have adequate conversations, etc.

What's strange is that the Spanish language is thought to have acquired those gutturals, which are so surprising, and have virtually no parallel in other European languages, from the Moors' presence in Spain. However, the Moors pronounce Spanish with infinite softness, and all the letters that are pronounced hard in Spanish, such as the *j*, have a soft pronunciation there, e.g. *ojos, Josè*.[36]

Sugar and tea are the currency of every transaction. There is no gift that is not accompanied by sugar and tea.

They are also very keen on serge-cloth and other fabrics, but especially serge.

Their firearms are poor, badly loaded, and often fail. They slip misshapen ingots into the barrel. They have a bag for bullets and one for powder and they fill it, giving it their all.—Their sabers are, for the most part, blades manufactured in Europe, to which they add a handle of their own; British bayonets on the saddletree, or hanging by their side.—The Greeks, at the start of the war with the Turks, used to break the butt of the rifles from Europe that they were sent. The disdain of one of them for my pocket pistol.

The soldiers who lead the charge are the brave ones.—They put a kerchief at the end of their rifles, as a kind of banner identifying them to their comrades amid the action.

The flags, the number of them that they have. Their variety as signs and colors. Have a delightful effect from afar. *[Here an X to cross-reference the 1st unnumbered cahier-c, which also deals with flags.]*

[2nd unnumbered cahier-c]

The episode with Ben Abou in the charge, his burnous torn to shreds.

His irritation in the camp.

Keeping watch in pairs, as well as fatigue duty.

Their way of standing guard while asleep. The horses stolen in the middle of the camp.

The Pasha of Larache. My visit to him. That evening, the story of the Jew and the sheep that was sacrificed to ask forgiveness.[37]

36. Haketia, the variety of Spanish (in fact Judeo-Spanish) spoken in Morocco before the occupation of Tetuan by Spain in 1860, indeed retained the old palatal pronunciation of the *j* (as well as of the *g* and the *x*), close to the *j* in French.

37. A fine drawing of the pasha of Larache is in Louvre 1757, fol. 20r.

The dinner with Abou and desire to laugh. Certain eructations, etc.[38] The music box that would not stop.

The intrigues of the Pasha of Larache and his brother to get a musical snuff-box.

On the way back, the Pasha with his two executioners on each side. The whip draped across his chest.

The slippers without lifting up the back. Riding on horseback easily with all the paraphernalia that seems so cumbersome. The instep almost always bloody because of the stirrup. The handkerchief that they put on it.

These handsome clothes, and especially the harness, carelessly maintained. Contrast with a certain sense of cleanliness, for example in the linen that is on the caftans. To buy soap.

The look of Tangier. The low houses. Lack the imposing aspect of those in Algiers.—Life lived outdoors.

The Kasbah.

The meeting with the Pasha of Tangier.

The Kasbah, fantastic from the seashore.

Rusted bits of cannons on the coasts, without gun-carriages, or on flimsy slats.[39]

The cavalry charges. The man thrown off his horse that slipped.

The sick man in Meknes who asked me for drugs.

The animals that we brought back. The noise they made in the camp in the mornings.—The death of one of the ostriches at Meknes.—The way the other one crossed the Sebu river, as well as the crossing of the other wild animal.

The Moors in the Toulouse coach who think that it is pulled by Jews.[40]

The monkeys on Gibraltar. It has been claimed that they came from Africa via an underwater conduit. Why not think that He who created men and monkeys just wanted to put some there?

The Emperor holds an audience only on horseback. The custom of a warrior people.[41]

38. Belches were considered a compliment to the host for the meal (Capell Broke, *Sketches in Spain and Morocco*, 2:77).

39. Lagerheim likewise alludes to these cannons "so rusty that they could not be used"; eight gunboats lay on the coast "without protection against the sun, and now so cracked and damaged that they would never again float on water" (*Minnen*, 51).

40. The meaning of this note is obscure and it is unclear when Delacroix would have met any Moors in the Toulouse coach. In Morocco, Jews were given the most difficult and dangerous tasks, such as carrying passengers on their shoulders from boats to land, transporting the sick, etc.

41. In fact, it was a position of authority. See 22 March for Delacroix's description of the audience.

Subjection of the Jews, and yet they live in mutual understanding with the Moors.[42]

[2nd unnumbered cahier-d]

These people are unceremonious in the extreme. The example of Abou, who addresses his soldiers while sitting on the steps.

Coming back from Meknes on his mule.

Who among our generals would not be ashamed to be seen on a mule? Recall the laughter of the Parisians when they saw the Pope arrive riding a mule in the procession for the coronation at Notre-Dame.[43]

They have inherited a lot from the ancients in this respect, as in many others. The lashes that the Pasha of Tangier's master of ceremonies doled out did not in the least offend those who received them.

The sheep bled, stripped, and quartered, all in a few minutes.

The Mouna that was sent to us at the camp.[44] Bullocks, sheep, chickens in truly Biblical plenty. The dish of couscous brought in a rug (the soldiers eating it).

The simulated battle of the soldiers at the camp.

The shops, generally set up in the main street. The houses are in streets that run into that one, or in remoter parts of town. They do not live in them, closing them at night and returning home.

The women never appear. Those that are seen in the streets are only wretched slaves, which does not prevent those bundled figures, as shapeless as they are, from having something enticing, as at a masked ball.[45]

What is especially striking is the striking [*sic*] analogy with ancient practices. Their dress, everyday life, houses.

Their shoes. Thick soles like the statues of the muses. A sign of luxury.

[1st unnumbered fol. r]

It is cruel to be ignorant; it is hard not to be able to sprinkle your narrative as needed with learned tidbits, which have the advantage of letting your creative faculty rest and of extending the text, etc.

42. *Cross-references for 2nd unnumbered cahier b-c.* Desire for fabric, 24 March. Firearms, fol. 1 bis v, p. 156. Ben Abou's torn burnous, 12 March. Sacrificed sheep, 11 March. Music box, 7 March. Cuts from stirrup, 11 March. Soap, Chantilly notebook, p. 95 (above, p. 126)? Pasha of Tangier, fols. 7–10, pp. 37–39. Kasbah, ibid. Bubal, 1 and 7 April, and 1st unnumbered cahier-c (p. 143). Monkeys, cahiers 3-c and 3-d, pp. 30–31. Subjection of Jews, fol. 20 bis and cahier 6-d (above, note 3).

43. For Napoleon's coronation on 2 December 1804, the Pope's carriage was preceded by his chaplain riding a mule: "[. . .] the spectators could not help laughing, even roaring with laughter, at the Pope's mule, its caparison and the figure of the person riding it" (report by Dubois, Prefect of Police, reprinted in Aulard, *Paris sous le premier Empire*, 1: 421).

44. Mouna, gift of provisions.

45. *Cross-references for 2nd unnumbered cahier-d.* Abou on the steps, 28 April. Pasha's lashes, fol. 1 bis v, p. 158. Mouna, fol. 11, p. 39, and below, p. 149. Women covered, fol. 35, p. 54.

You need a pen that is very able, and especially very experienced in moving easily from the grotesque to the sublime, if that is even possible, to describe the half-primitive *mores* of these people adequately.[46]

Regarding Zar Hone, or Pharaoh's city, I have heard that in the Orient all ruins of towns, or of anything that resembles a town, have this name.

The beauty of Ben Abou in the cavalry charges. The horses taking off like thunder.

Gives an idea of the knights of old. Overturns all our modern notions of a warrior. Our generals have the calmest of demeanors. A little sword that they never draw. Where is Tancredi, where is Rinaldo?[47]

The three days of rain during the trip. My hat full of water. Obliged to put on waterproof coats.

The apathy of the Moors whom we saw opposite our tent.

On the Moorish saddle and its advantages. I am the only one who did not fall off.

They gallop or saunter. Stand up in the stirrups when galloping.

The spurs.—The flank of the horses all bloody. No pity, no concessions for the horses. They are just machines for transport.

Going down the steepest slopes at a gallop.

+Give the impression of waking up the day after the arrival. Impatience to see again the things that had struck me the night before.+

For the person who recounts such a delightful journey, regret at not being able to stop at every step and describe the sunrise, the sunset, all the little extras that create the feeling of a place or add so much to it.

+From the very next day we were brought the *Mouna*, or provision of food-stuffs of all sorts, which was sent to us by the Emperor and was continued for the whole of our stay. There were dozens of fowl, enormous baskets of oranges and lemons, fruit, vegetables, meat.+

They admire horses only in accord with the services they can render. A horse is always fine when it is a good runner.

The episode with Desgranges' horse.

[1st unnumbered fol. v]

They shoot almost at random. Propping the gun only a little against their shoulder, sometimes shooting with one hand.

Their wild shouts.

46. "You would seem to need to change style every second to be able to speak in the right terms of a country like the one that I had come to visit. Aristotle does not allow such licence under any circumstances, and no doubt he is right" (draft of fol. 20 bis).

47. Heroes of Tasso's *Jerusalem Delivered* and Ariosto's *Orlando furioso*.

Noise, dust, the variety of objects, the different look, the river and the oleanders before getting to Meknes. Fatigue, fury, anger about the derisory honors.

Ruins topped with those ragged apes. The Emperor's nephew whom I sent packing.

With few exceptions, Europeans can get food only from Spain and Madeira, which made the little provision of Bordeaux wine very valuable. It needed special care when we crossed the rivers and on difficult parts of the route, but especially when we crossed the rivers.

The gifts likewise. Obliged to lift them up as high as possible on the backs of the mules and horses that were carrying them.

We were very worried about the box of candy. It was at risk of melting several times.

The success of said candy. The ladies asked for more in Meknes.

The *douars*—tents arranged in a circle for a few years.[48] The herdsmen or ploughmen move on when the earth no longer produces as easily.

The Moors keep the keys to their houses in Seville or Cordoba.[49]

You can see in this wish, this aspiration to a more temperate climate, that people in extreme climates always tend to want the same thing, etc. Let us therefore appreciate the benefits of our moderate temperatures, etc.

May the good be always the companion of the beautiful.

It is always the same story.

We were arriving among people who are very near to being primitive. With their little lines of defense, their embrasures at every level, their harbor booms, their horses in the line, they have managed to spoil the town of Gibraltar.[50] What do you find *[unfinished]*

[2nd unnumbered fol. r]

The fertility of that country is such that, as I was told, in years of abundance it often happened that the kaïd had to force the grain sellers to take away their merchandise instead of just leaving it when it had not sold. They retain the very ancient practice of using silos in which they bury the grain for the lean

48. *Cross-references for 1st unnumbered fol.* Need for contrasts, fol. 17 (p. 43) and above, note 46. Rain en route, 8–9 March. Waking on arrival, fol. 7, pp. 36–37. Mouna, fol. 11, p. 39. Desgranges' horse, 5 April. Oleanders, 15 March. Douars, 6 and 7 April.

49. This reminder of the important place that the memory of their expulsion from Andalusia in 1492 had in the Moroccan imagination is also mentioned by Lagerheim (*Minnen*, 58). The families who claimed descent from the Moors of Andalusia retained the titles, and even the keys, to their houses in Granada, Cordoba, or Seville. Cf. Chénier, *Recherches historiques sur les Maures,* 3:119–20.

50. As this indicates, these "primitives" are the British on Gibraltar. The same idea is expressed in a marginal note to cahier 4-c ("Marginalia," p. 134). A boom is a structure built to block entry to a port.

years;[51] for their indolence is so great that they are often exposed to famine in really bad years. They need hardly scratch the surface of that fertile earth to obtain harvests that would amaze the most industrious farmers who put out the most assiduous efforts.

The suffering of the man handed over to the children who, in one of those years of famine, had stripped a dead man.[52]

Respect for the dead and patriarchal authority.

Women are for them a type of animal.

They are no longer those Moors renowned for their chivalric gallantry. The condition of women in those lands, as in all the lands of the Orient, is very inferior to that of men. However, they are capable of feeling true love. I remember the melancholy that one of the servants who accompanied us to Meknes felt at finding himself separated from his wife. The kaïd Ben Abou himself, as we observed, seemed distinctly in love with the woman whom the Emperor had given him in Meknes and whom he brought back with him.—Say elsewhere how she traveled, etc.

His languid posture on his tranquil mule did not at all resemble the brilliant warrior whom we were used to seeing, always the most fervid and indefatigable in the charges. In truth, the kaïd Ben Abou could be considered, as I have already said, a rare breed in that country and, by his demeanor and habits, brought to mind exactly what we imagine about the Moorish knights of old who conquered Spain.

Every year the walls are repainted white, which has the disadvantage of smothering the moldings somewhat, but creates a very pleasing effect against the blue of the sky.

Their moldings are arranged very ingeniously with the help of bricks (with the part on the mason-architect).

Out of a kind of Puritanism, there are no precious metals in their decoration. The handle of the sabers is sometimes of precious horn. It is perhaps for that same reason that they cover their saddles, which are often magnificently worked, with plain-colored cloth etc.

[2nd unnumbered fol. v]

It is believed, wrongly, that every Muslim has dozens of wives at his disposal. In fact, Islamic law allows them four legitimate wives and as many slaves

51. According to Lagerheim, one risked falling into these holes, called *matamores*, which were located along the roadsides and were not filled in. He describes the rather surreal sight of a camel that had got caught in one and stretched its long neck over the side (*Minnen*, 52).

52. An annotation, "man handed over to the children" is on fol. 4r of the Meknes notebook. The sense is unclear: Delacroix seems to contrast the composure of the man who could strip a corpse, with his torment at being abandoned to a group of children.

as they think fit. But in this, parsimony or poverty becomes a natural brake on concupiscence, and there are few men rich enough to have more than one wife.[53] What is even more strange, and suggests that there is more prejudice than we realize in our own passions, which we think are inspired by natural feelings, is that these women, when they are several, live tolerably well together.[54] They do not quarrel any more than, etc.

However, after our return from Meknes, we heard in the town that Abou's wife had been very irate and driven to despair by the intrusion of her rival. Perhaps her jealousy was increased even further by the fact that, for a while, she had attracted the attention of the august leader of the faithful, a fact that for us had nothing enticing about it, yet was perhaps the only one that, in Ben Abou's eyes, tipped the scales in her favor.

During the journey[55]

The peasants who bring Abou milk in which he dips his finger, etc.

The children who come in a procession to meet him. The compliments that he gives them. The spear that is placed in front of his horse across the road.[56]

Our prison of marble and faience at Meknes. Peculiar sensation, etc.

On their perseverance, etc., and the difficulty of subduing them, when discussing the ease with which a horseman sets off for vast distances with everything he needs.—I was told by a Spanish officer who was already very old that, in his youth, when he was aboard a warship that was temporarily at Oran, at the time under the control of Spain, the governor took him along the fortifications that overlooked the entire countryside, and where they were totally under cover, to do the honors of the fort. The countryside that could be seen here and there through the narrow embrasures [unfinished][57] They keep watch with the patience of a cat, and that patience is far from being apathy or the result of inertia.

General Alava[58]

[the rest of the page blank]

53. Chénier makes the same remark (Recherches historiques sur les Maures, 210).
54. Cf. Pidou de Saint-Olon, Relation de l'empire de Maroc, 91 and cf. 52.
55. To Meknes: this part of "Memories," if it ever existed, is missing.
56. Cross-references for 2nd unnumbered fol. Abou and chivalry, 1st unnumbered fol. r, p. 149. Architects, fol. 1 bis v, p. 155. Peasants bringing milk, spear on road, 9 April.
57. The countryside was dotted with enemy fighters.
58. This story is clarified by an unsigned article on the French military situation in Oran, published in the Revue française (15 June 1837, p. 332): "General Alava, whom we saw in 1836 when he was Spanish ambassador to Paris, was visiting Ceuta in his youth, and wished to climb up on the ramparts to observe the countryside: the officer who accompanied him stopped him and asked him to raise his hat on the tip of his sword. Immediately a shot was fired from the underbrush: 'Young man, said the officer, remember that here, whenever a Castilian appears, there is an Arab to aim at him." The article was republished in 1841 as part of a book by Jean-Jacques Baude (L'Algérie 2: 6). Delacroix seems to have heard this story firsthand. Miguel Ricardo de Alava (1771–1843) was a Spanish general and politician who began his career in the navy, took part in the battle of

[3rd unnumbered fol. r]

They use the reed-pen like the Ancients (except that they only take one side of it, etc.) The children write on tablets coated with clay.

Respect for the Spanish monks. Padre Pavón.[59]

Singular look of those plants—they go with the people, the camels, etc. The merchant from Fez. The mark on his forehead.

Arabic names garbled.[60] Emir el Moumenine: Mirabolin. Moula al Raschid: Mulet Archy. Mourad bey: Lamorabaquin.[61]

We disfigure their names with amazing composure: Tandja. Eldjezair. Abderama. Fatime.[62]

+The tombs are of a different design in each region. In Algiers, more like Turkish ones. Those of the Jews of Morocco different even from one town to another.+

+How much more interesting those tombs dispersed along the routes are than our little groomed and tidy cemeteries, etc. Those piles of corruption, etc. Laid out in this way, the idea of corruption vanishes. The proximity of a field, a fountain—the shade of a tree.+

+In our cemeteries everything is sepulchral. You feel sorry for the pitiful vegetation that we maintain on that pile of corruption and that feeds off it. The deceased are rushed away; the field of dust seems less a place meant for the pious preservation of respected remains than a little spot that we disavow and abandon to corruption, where we pile the dead to get rid of the sense of disgust, etc.+

+There, it is sometimes a simple surround formed of humble stones placed on the ground by the hand of a friend and with grass growing in the middle.+

.

Trafalgar, became aide-de-camp to Wellington in 1812, and was present at the battle of Waterloo. He also had a career in politics: a representative for the province of Alava to the Cortes in 1820, he was charged with negotiating with the French after their victory at Trocadero in 1823. The restoration of Ferdinand VII to the Spanish throne led him to retire to Gibraltar, and then to England. Ambassador to London in 1834, and to Paris in 1835–1836, he died in Barèges, in the Pyrenees. Delacroix could have met him through Mérimée, a friend of Alava's (Mérimée, *Correspondance générale*, 12:124 [1958]). Spain controlled Oran until 1792, when it was sold to the Ottomans.

59. Lagerheim's memoirs identify Padre Pavón as one of the four Franciscan monks in the Spanish monastery in Tangier presided over by Padre Andreas. While the latter spent his time exclusively visiting the houses of Catholics, Padre Pavón "was not so difficult, but rather took part in our picnics, drank champagne with us heretics and danced the tambourine when he had had a few drinks" (*Minnen*, 43). See biographies.

60. That is, by Westerners. The names that follow give Westerners' renditions of Arabic names.

61. Emir el Moumenine, "Commander of the faithful," the title designating the supreme power of the caliphs in Muslim society and the official title of the Emperor of Morocco. Moulay Rachid (Rachid II), emperor of Morocco from 1664 to 1672. Murad (or Amurad) Bey I (1326–1389), Ottoman sultan who reigned from 1360.

62. The names given are transliterations of the original Arabic ones for Tangier, Algiers, Abd al-Rahman, Fatima.

+Sometimes, and for important personages, it is a little structure (yet another link with the Ancients) in the countryside that stands out in the distance, on which your gaze stops and rests as it surveys the landscape.+

+A country house suggests anything but a place of enjoyment. Invariably you see a large square building without external decoration, without the least opening, and having at best a door that cannot be seen. The owner seems to have to scale the walls to breach it.+

+We said that Moorish houses gave no sense of their interior. It is the same for their country houses.+

[3rd unnumbered fol. v]

They put the milk in goatskins, which gives it a bad taste.

Each age has its nobility and its dignity. The old man does not put on ridiculous airs, etc. The old women are imposing. Middle-aged ones are Agrippinas, etc.

It all depends on dress. To wit, modern Turks who look ill, etc.—For every civilized man who has suffered the tyranny of tailors and shoemakers, those artisans of hell and torture, the greatest good in this world would surely seem to be to live in slippers and a dressing gown. Well, here is a people who had the good luck of being born with those advantages and who enjoy them until their very end. A feverish rush to civilization, etc. Boots, suits, tight trousers, etc.

Discuss short clothes and long clothes.

The songs that consist of shouting at the top of your lungs and that seem to come all the way from their toes.

The practice battle at one of our encampments.

The actors in the open air in Tangier.[63]

The Issawa[64]

[fol. 1 bis r][65]

The nights on the terraces.

The storks on the houses in Alcassar.

Our vulnerability, which made us pass through the town without stopping.[66]

63. Delacroix depicts this scene in his painting *Arab Players* (J380), described in the catalog of the 1848 Salon in the same terms ("They [. . .] perform in the open air"); it is also one of the watercolors for the Mornay album (Los Angeles County Museum of Art).

64. *Cross-references for 3rd unnumbered* fol. Merchant from Fez, 2nd unnumbered cahier-a, p. 144. Tombs, fol. 29, p. 50, compared to French cemeteries, fols. 31–32, p. 52. Country houses, fol. 34, p. 53. Short and long clothes, 2nd unnumbered cahier-a, and marginalia to fol. 18 (pp. 145 and 134). Issawa, Chantilly notebook, p. 2 (above, p. 124) and the introduction, p. 21.

65. The first two paragraphs of this sheet of notes are a draft version of the beginning of the narrative and are thus not printed here.

66. Hostility to the French in the current climate?

The fury of the consul's horse. The man it had half eaten. The one who got himself out of his djellaba, which he then abandoned.

Those dear mountains where we ran risks at every moment.

Those dear Moroccans who made appalling faces at us.

The enticing sight of the veiled women in the streets.—They draw aside their veil for Christians.

On the haik and the toga.

Instruments. Long trumpets of Jericho, violins, rebec,[67] etc.

+The women go visit the graves on Fridays. False devotion.+

+Caddour blocking his nose, so as not to smell the smoke from my cigar.+

+Because they are so devout, Fridays belong to Muslims, Sundays to Christians, the sabbath to Jews. You get no service.+

The more I have seen of people, the more I have found them the same in every country.

Before we saw the British close up, after having been separated by war, and [fol. 1 bis v] based on the word of Voltaire and eighteenth-century writers, etc.—There is no people more stuck in their ways, more bourgeois, etc.—Likewise the Arabs. I found under the turban the same hodgepodge of fools, simpletons, rogues and hypocrites who, in their frock-coats and round hats, are the eternal subject of the comedy of our world.

Everything surprised me at first. After a short while you feel at home and as though you know all these types.

Man is not made to be shut up in dwellings of stone and plaster. He needs the pure, open air of fields or deserts. He becomes denaturalized and withers if imprisoned in [blank]

Amid those vast plains full of flowers and herbs, which released their scent as our horses passed over them, you feel a different being altogether, you are a man.

Living in tents, etc. The douars in circles. Changing place. Folding up the tents in the morning. It took us an infinitely long while to shake off our torpor.

Those children of the desert were on their feet in an instant. They slept in their clothes.—The haik that serves as their coat will also be their shroud.

The architect in Tangier. His way of building.

The master of ceremonies of the Pasha of Tangier. That big shady rascal doling out great whiplashes to the crowd.

67. Like many nineteenth-century travelers, Delacroix uses "rebec" (a medieval form of violin) to mean its ancestor, the Arabic *rebab*, a bowed stringed instrument that he depicts in his painting *Jewish Wedding in Morocco* and describes in his article (see above, p. 57) as "a kind of two-stringed violin that is special to the country." The actual violin, as opposed to the *rebab*, is called *kamantcha*. He took one of each back to France (see Font-Réaulx, *Delacroix: Objets dans la peinture*, nos. 53 and 54). The "trumpets of Jericho" presumably refer to the long trumpets represented in depictions of the Battle of Jericho.

The women on the terraces. The *lou lou lou*.[68]

Reception the second or third day by the Pasha in the Kasbah.

The ruined look of all those buildings. The indifference of those people.

The lighthearted merriment of the storytellers en route, and their songs. Accompaniment with knives on pieces of iron, as in Spain.

They are unaware of cartridges, load their guns with their hands, miss their shot.

Such is the indifference of the Moors that there is not even a pier at Tangier. They carry you from the rowboats on their backs.

The carpets of flowers of different colors on the trip.

Descriptions of the Moors' dress. Bayonette. No coffee. Tea. No pipe. Except kif. But those who smoke it are noticed.

Life outdoors like the Ancients.

Ancient-style sandals of the women. Thick sole. Strong butter.[69]

68. Lagerheim also alludes to the cries of the women, which he transcribes differently: *I—aa, e-ya* (*Minnen*, 46, 82).

69. *Cross-references for fol. 1bis.* Nights on the terraces, marginalia to fol. 35, p. 136. Storks, 9 March. Consul's horse, fols. 25–27, pp. 48–49. Veiled women, fol. 35, p. 54. Women at the graves, fol. 31, p. 52. Caddour blocking his nose, fol. 22, p. 47. Holy days, fol. 21, p. 46. Haik, 1st unnumbered cahier-d, p. 143. Architect in Tangier, 2nd unnumbered fol. 1, p. 151. Whiplashes, 2nd unnumbered cahier-d, p. 148. Reception in the Kasbah, 26 January, and fols. 9–10 (pp. 38–39) Guns, 2nd unnumbered cahier-b, p. 146. No pier at Tangier, 25 January and cahier 5-c (p. 34). Strong butter, 2nd unnumbered cahier-a, p. 145.

APPENDIX A

Supplementary Material from the Notebooks

The following notes date from after the journey and are unrelated to it.

Louvre Notebook 1757

[fol. 53v. The quotation from Atar Gull *is erased.]*

"What an existence [. . .]! The ocean, always the ocean! [. . .] a life without love and women. I feel an immense need to suffer, to weep at the feet of a woman. I no longer have a mother! Alone, isolated, I really need to love someone . . . and for a woman's lips to console me or pity me." (Atar Gull)[1]

Fresco by Titian. St Christopher. Almost the only one that is in Venice. Ducal Palace. Little stairway that leads from the Doge's rooms to the chapel. In Padua there are three. Scuola San Antonio, etc.[2]

[fol. 54r, turning the notebook upside down]

Revue britannique from May. "Famous Artists of our Age." Lawrence.[3]

Chantilly Notebook

[p. 170]

"The lessons of misfortune and necessity produce two effects: they make a person better or cruel. The dog that suffers is more tame, the wounded tiger

1. Eugène Sue, *Atar Gull*, 332–33. The novel was published in 1831.
2. Saint Christopher (1523). The frescoes of the Scuola del Santo in Padua (1511) depict *The Miracle of the Newborn*, *Saint Anthony Curing a Young Man*, and *The Jealous Husband*. A watercolor by Delacroix after *The Miracle* is in the Musée des Beaux-Arts, Dijon (Prat, "Dessins inédits de Delacroix à Dijon," 103–5). I do not know the source of these notes.
3. Not May, but December (1831). Under this title, the *Revue britannique* launched a series of portraits of contemporary artists, beginning with Thomas Lawrence (whom Delacroix had met in England in 1825 and about whom he had written an article in 1829). In May (1831), in contrast, there is an article from a similar series, "Powerful Intellects of our Age," on the Scottish anatomist Charles Bell (1774–1842).

becomes furious . . . As for me, I think that the soul that undergoes the deeply distressing test of misfortune, without letting itself be dragged down by it, is great and beautiful. It is then that the disciple becomes a master and that, in turn, one gets the better of fate." (Duchesse d'Abrantès)[4]

[At the bottom, turning the notebook upside down:] Mr Delacroix, quai Voltaire n° 15[5]

[p. 168. Drawing of a color triangle:]

 RED

 orange *violet*

YELLOW *green* *BLUE*

From the 3 primary colors are formed the 3 binary ones. If, to the binary tone you add the primary one that is its opposite, you cancel it out, that is, you produce the necessary half-tone. Thus, to add black is not to add the half-tone; it is to dirty the tone whose true half-tone is found in the opposite tone, as we said. Thus, green shadows in red.[6]

The heads of the two little peasants.[7] The one that was yellow had violet shadows. The one that was more sanguine and red, green shadows.

[p. 162. Notes from ca. 1845. I give the reference to the Johnson catalogue raisonné in square brackets.]

4. "La Princesse Pauline," an article published in the *Revue de Paris* of June 1833 (51:214), republished in *Histoires contemporaines* in 1835 (pp. 158–59). Delacroix knew the Duchess and her daughter, as shown by an unpublished letter (Artcurial sale, 24 November 2008, lot 122), in which he regrets having missed her visit : "Please ask Mademoiselle Julie to excuse the bad drawing that I was so wrong to do in her album! I hope on your return to acquit myself a bit better of my promise, but not of all my gratitude for your kind welcome, the memory of which, Madam, must remain with me. The hope of seeing you again softens the regret that I feel at knowing you are leaving without my being able to say goodbye." The letter dates from 1833 to 1834.

5. Delacroix lived at this address from January 1829 to October 1835.

6. Without being an exact quotation, this note is similar to a passage in Léonor Mérimée, *De la peinture à l'huile* (1830) *[The Art of Painting in Oil and Fresco]*. In chapter 7, "Theory of the Principles of Harmony in Coloring," Mérimée includes a color wheel in which the colors are laid out in the same way as here, and explains that the three simple colors (yellow, red, and blue), "united in pairs [. . .] give birth to three other colours as distinct and brilliant as their originals," that is, orange, violet, and green (*The Art of Painting*, 245). He also describes the discoloration noted by Delacroix: "[. . .] by mixing together the primitive and secondary colours a complete discoloration is effected. [. . .] But in the chromatic circle the arrangement is such, that the colours diametrically opposed to each other always offer the union of the three primitive colours; if one be simple, [and] the other is a compound of two, they are always reciprocally complementary. As, for instance, [. . .] opposed to red we have green, a mixture of blue and yellow [. . .]. [. . .] Black and white are not true colours [. . .] the mixtures *[of the primitive colors]* were only greys [. . .]" (ibid., 247–48, 251). Delacroix later traces a similar triangle, but inverted, on a sheet of drawings for his painting *The Entry of the Crusaders into Constantinople* of 1840 (Johnson, *Delacroix*, pl. 34, and Gage, *Colour and Culture*, 173).

7. The reading is uncertain. Some have read "fish" ("*poissons*," rather than "*paysans*").

To Mlle Bakounine, *Medea,* pastel[8]

Mme Sand, *Lelia,* id.[9]

In my boxes, id., id.[10]

A Cave in Nanterre to Mme Sand *[J(L)199]*

Lions, watercolor to Mme de Forget[11]

Sketch of the Homer in the Luxembourg, to Gisors *[J(L)224]*

S[ain]t Jerome to Gautier *[J(L)225]*

Hippocrates to Desmaisons[12]

The Annunciation, sketch done for S[aint] Denis du S[ain]t S[acremen]t *[J425]*

Guido in the Dungeon, to Halevy *[J(L)146]*

Christ on the Cross, pastel to Mme Rang[13]

Hamlet in the Graveyard, to Mme Cavé[14]

id., same size, different effect. With me. To Diaz.[15]

Sketch of *Don Juan* in the boat, on paper[16]

The Bishop of Liège on paper, to Diaz *[J136]*

Tasso in prison Gaultron *[J268]*

[p. 161]

Lion, to my brother, painting *[J172]*

Macbeth on paper *[J108]*

Romeo and Juliet on the Balcony [J283]

Froissard, pencil drawing[17]

Faust and Wagner, sketch to Riesener[18]

8. Eudoxia Bakunina, Russian painter, former student of the Academy of Saint Petersburg. She was in Paris from 1839 to 1843. For the *Medea,* see Johnson, *Pastels,* no. 8.

9. Ibid., no. 18.

10. That is, another *Lélia* in pastel (ibid., no. vii).

11. Robaut, *L'Œuvre complet de Eugène Delacroix,* no. 1053, now in Harvard University Art Museums.

12. Ibid., no. 1724 (see J269).

13. Johnson, *Pastels,* no. 36.

14. J(L)148 and 3rd Supplement, p. 336, private collection. See *Delacroix. La naissance d'un nouveau romantisme,* no. 62.

15. J(L)158, Marcel Landowski collection (see ibid.).

16. J(L)157. A letter in the Piron archive (cat. 59, Musées nationaux) implies that, on 22 April 1857, Delacroix gave to Frédéric de Mercey a "beautiful sketch" depicting a "shipwreck scene," which was the "first idea of the canvas of several square feet." The painting of *The Shipwreck of Don Juan* (J276) indeed measures 1.5 × 1.96 m. A sketch of the painting is known (J275), but it is certainly too large (81.3 × 99.7 cm.) for Delacroix to call it "a little sketch," as he does in a letter to Mercey (*Corr.,* 3:386). The entry in this list must refer to the sketch given to Mercey. See *Journal,* 1 April 1857 (1:1135 n. 434).

17. Drawing (unlocated) for an illustration, engraved by Wacquez, for *Le Plutarque français. Vie des hommes et des femmes illustres de la France,* 2nd ed., 6 vols. (Paris, Langlois et Leclercq, 1844–1847), tome 2, 1846.

18. Louvre 140?

Charles V as a Monk, sketch, Mme Cavé *[J259a]*
Hamlet and the Ghost for Dumas *[J(L)99]*
Christ on the Cross on panel, ditto *[J432]*
St Paul (conversion of), watercolor on colored paper[19]
Orpheus, sketch for the Chamber of Deputies. Watercolor, colored paper.[20]

[Notes from ca. 1847]

Christ on the Cross, painting, canvas size 25 for Barroilhet *[J433]*
See above the sketch on panel for Dumas
Musicians from Mogador, three figures, canvas size 12, painting *[J373]*
Rebecca Carried off by the Templar, canvas size 40 *[J284]*
Marguerite in Church—M. Colot *[J285]*
2 Moroccans, canvas size 5. One standing, from the back. White shirt *[J377]*
Otello, final scene: Desdemona asleep. Canvas size 12 *[J291]*
Two Moroccan Soldiers Sleeping, nocturnal setting. [Canvas size] 15 *[J374]*

[p. 160][21] *The Emperor of Morocco*, large painting in Toulouse *[J370]*
Sketch of the same, oriented sideways: done soon after my return *[J369]*
The Emperor of Morocco, small painting, canvas size 15 *[J401]*
Man Mauled by a Lion. Canvas size 15 *[J178]*
Same subject, as a sketch with ink drawing, canvas size 5 *[J177]*
Two Moroccans, a man and a child both seated in a landscape. Same subject as a watercolor. Sent to Marseille. 1844 or 5 *[J368]*
Watercolor of the preceding subject and almost the same size[22]
View of Tangier. Moors seated. Tomb of a saint. Watercolor from a long time ago. 1836 or 7.[23]
A Taleb or Scholar Writing at a Table. A man standing near him. The taleb has a sky-blue caftan. Watercolor 1842.[24]
Lion, large watercolor exhibited in 1846 belonging to Dumas. Begun a very long time ago.[25]

19. Louvre Rec. 38.
20. Robaut, *L'Œuvre complet de Eugène Delacroix*, no. 831 (New Haven, Yale University Art Gallery); see J527.
21. This set of notes is from even later, probably from early 1848. Except for the small *Emperor of Morocco* (J401), all the works date from 1845 to 1847; Dumas's *Lion*, sold by Dumas in May 1848 (see below, n. 25), furnishes a *terminus ante quem*. But J401 is dated 1856; and the identification seems right, for J401 is in fact a canvas size 15 (65 × 54 cm). Delacroix could have begun this painting well before: the composition of the central group is fairly close to that of the drawing published in *L'Illustration* on 21 September 1844.
22. Coll. Bivort, Paris; see J368.
23. Morgan Library, New York; see J390.
24. Reproduced in Alain Daguerre de Hureaux, *Delacroix. Moroccan Journey*, 89.
25. The watercolor *Lion and Snake*, dated 1846 (Walters Art Gallery, Baltimore, R985), had been exhibited at the Salon of that year (no. 1915). It was sold by Dumas to Charles Mahler in May 1848 (see *Journal*, 2:1053, and J114 n. 1).

[p. 5. Except for the note written in another hand, these are reading notes that Delacroix copied from his so-called "heliotrope notebook" (Journal, 2:1556ff.).[26] From the place where they fall in the "heliotrope notebook," they are from after 1842.]

. . . For people who are very highly organized, there is a sort of confidence about things that must be done. They think that obstacles may be difficult, but never impossible.—Alph. Karr[27]

[In another hand, probably Mme. de Forget's]

Ennui is an illness of the soul of which pleasure is more often the cause than the remedy.[28]

Misfortune is to well-bred souls as a storm is to the air that it clears.[29]

The greatest drawback to violent passions is not the grief that they cause but the ennui that follows them.[30]

[In Delacroix's hand]

. . . In great minds, maturity and old age are the time of great harvest, the period of the most powerful meditations. It is the last word of experience. Men of little value return in old age to childhood.

Ph. Chasles[31]

. . . You will enter into the affairs of the nation young and you will do well: for with statesmen as with actors, there are tricks of the trade that genius does not reveal; they must be learned.

Balzac[32]

One of civilization's powerful tools is the constraint that it imposes, the bond of social relations and the feeling of the good that it produces. When you see that every sacrifice is amply compensated, you submit without resistance,

26. The notes from the "heliotrope notebook" are earlier: a parenthetical addition by Delacroix, which is clearly marked as such in the "heliotrope notebook," is copied into the Chantilly notebook as though it was part of the original text (*Journal*, 2:1557).

27. Alphonse Karr, *Midi à quatorze heures*, 128.

28. Quotation from Edme-Pierre Chauvot de Beauchêne, *Maximes, réflexions et pensées diverses* (1817), 28.

29. Quotation from the *Réflexions et maximes* of M. de Lingré (1814), cited in the *Memoirs* of Mme de Genlis (1826, 7:130).

30. Cf. "Une Vieille Gloire" by Madame Ancelot (1843), published in *Méderine* (1:182): "The greatest drawback to passions, it is said, is not the torment that they cause but the ennui that follows them." The maxim is inspired by Chamfort: "The great disadvantage to passions is not the torment that they cause but the mistakes that are made because of them" (*Maximes et pensées*, in *Œuvres complètes* 2:24).

31. Philarète Chasles, "Revue littéraire de la Grande Bretagne" (1842), 440.

32. *Le Lys dans la vallée* (The Lily in the Valley), in *La Comédie humaine* (9:1104).

and you develop the habit of this useful and reasoned submission, as opposed to the unchecked freedom of the savage.

Revue britannique[33]

Meknes notebook. These sheets were inserted or glued in by Philippe Burty:
fols. 47v and 48r, sheet of drawings of heads of Arabs, with the seal of Delacroix's posthumous sale; fols. 49 to 78 are blank; fol. 79v, drawing of a sculpted head on a capital; fol. 81v, drawing of capitals; fol. 82v drawing of a room with a cupola in which a person is sitting, bearing the stamp of the posthumous sale and annotated mat; *fol. 83v, upside down, drawing of human figures, annotated* Men and a woman; *fol. 85v, upside down, drawing of an Arab horseman, annotated in another hand:* Probably a tracing (Robaut?) from the Moreau-Nélaton album, p. 23 *(Louvre 1757).*

33. "Îles Sandwich" (in *Revue britannique*, 1826, 6:125), adapted from an anonymous article on *Journal of a Tour around Hawaii, the Largest of the Sandwich Islands*, by a Deputation from the Mission on those Islands, published in the *North American Review* in April 1826. In Delacroix's "heliotrope notebook" the extract is longer (see *Journal*, 2:1557).

APPENDIX B

History of the Manuscripts

Seven notebooks and albums of drawings from the journey passed in Delacroix's posthumous sale (no. 663)[1] and were acquired by the painters Prosper-Louis Roux, Pierre Andrieu, Adrien Dauzats, and Léon Riesener, and the art critic Philippe Burty.[2] Of the seven, six are currently known:

1. Louvre notebook 1755 (RF 39050), the provenance of which is uncertain but which must have been one of the two bought by Delacroix's disciple and assistant, the painter Pierre Andrieu.[3] It was bought at auction by the Louvre in 1983. It is an album covered in green paper, consisting of fifty-six sheets that measure H. 16.5 × W. 9.8 cm. It contains notes and drawings running from 26 January to 3 March 1832, plus a few later notes. As it largely covers the period spent in Tangier, it is here designated the "Tangier notebook."[4]

2. Louvre notebook 1756 (RF 1712.bis), bought for 475 francs at the posthumous sale by the art critic Philippe Burty and bequeathed by him to the Louvre. It is an album covered in brown paper, consisting of ninety-five sheets that measure 19.3 × 12.7 cm., plus an inserted sheet, folded in two, to make ninety-seven. It contains, like the preceding one, notes and drawings. Dealing

1. *Catalogue de la vente qui aura lieu par suite du décès de Eugène Delacroix.*

2. The auctioneer's report of the posthumous sale (Archives de Paris D48E3/55) specifies buyers and prices: "no. 663 (836), two albums, Mr Roux, 60 ff.; (837), two albums, Mr Andrieu, 310 ff.; (838), one album, Mr Burty, 475 ff.; (839), one album, Mr Dauzats, 700 ff.; (840), one album, Mr Riesener, 260 ff." The address noted at the first appearance of Roux's name at no. 256—16, rue Navarin—identifies him as Prosper-Louis Roux (14 February 1817–6 April 1903), a painter and student of Paul Delaroche, who exhibited at the Salon from 1839 to 1877.

3. Taking into account the provenances that are certain, this notebook can only come from Andrieu or Roux. The low prices of those bought by Roux would exclude them, since this notebook is very substantial in size, text, and the number and quality of its images. The availability of the text of this notebook in the years around 1890 also points to Andrieu, who was then very involved in the publication of the first edition of Delacroix's *Journal.*

4. In the first edition of the *Journal* (1893–1895), prepared by Paul Flat, the text of the Tangier notebook had been erroneously published as part of the Meknes one (Louvre 1756). When Jean Guiffrey pointed out the mistake, Flat "unfortunately could not remember where these notes had come from" (Guiffrey, *Fac-simile* 1909, p. 11).

mostly with the journey to Meknes and Andalusia, it runs from approximately 6 March to 29 May, with some gaps and supplementary entries. It is here designated the "Meknes notebook."

3. Louvre notebook 1757 (RF 9154), bought for 260 francs at the posthumous sale by Delacroix's cousin, the painter Léon Riesener; in February 1869 it passed in the sale of the painter Adrien Dauzats, who must have got it from Riesener, and was acquired by Eugène Lecomte, a stockbroker and art collector; he gave it to Étienne Moreau-Nélaton in 1905.[5] It is an album in red cloth consisting of fifty-three sheets (and the trace of one missing) that measure 15.8 × 2.12 cm. It contains mostly drawings, with some notes.

4. The Chantilly notebook (Musée Condé, MS 390), acquired at the posthumous sale for 700 francs by Adrien Dauzats on behalf of the Duc d'Aumale. It consists of eighty-six sheets and traces of ten more cut out, of which I have restored four; the sheets measure 19.4 × 12.7. It contains mainly drawings dating from 23 April to 25 June, plus a few notes from after the journey.[6]

5. A notebook that was formerly part of the Andrew Mellon Collection and was sold to a private collector at Sotheby's, Paris, on 22 March 2018 (lot 27). It had already figured in a sale organized by the dealer Pierre Bérès in 1976.[7] It is very small (6.1 × 8.8 cm) and consists of twenty sheets or forty pages, of which twenty-eight pages (including four double-pages) have drawings. It covers the period 8–14 March. It is one of the two notebooks acquired by Prosper-Louis Roux at Delacroix's posthumous sale. I call it the "ex-Mellon notebook."

6. A notebook in a private collection, with drawings and annotations from Tangier, Cádiz and Seville, as well as from the ship leaving Tangier. It consists of sixty-two folios (124 pages) ranging from 26 January to 10 June. A label on the front is similar to that on no. 5 above, suggesting that it was from the same source, probably Prosper-Louis Roux. In classifying Delacroix's drawings for the posthumous sale, Philippe Burty assigned the number "30" to this

5. It is usually said that Dauzats bought this notebook at Delacroix's sale, but it was actually Riesener, who would have subsequently sold it to Dauzats (cf. Guiffrey, *Fac-simile* 1909, pp. 165–66). This agrees with a remark that Burty made about the sources of his 1865 article, "Eugène Delacroix au Maroc," p. 146: "The notes were transcribed by ourselves from the album that was acquired by M. le duc d'Aumale *[the Chantilly notebook, see n° 4]* and from the one that was in our possession *[the Meknes notebook]*. A third album, which became the property of M. Riesener, contains, amid precious watercolors and different sketches, almost nothing but dates." This latter description corresponds to the notebook at hand (Louvre 1757). In addition, a letter from Burty that is inserted into this notebook refers to his article: Burty thanks his (anonymous) addressee for having lent him the album and says that "the notes that I took from it will be useful for a study *[on Delacroix's journey]* that I have been thinking about ever since I had the honor of classifying his drawings." The addressee of this letter would thus be Riesener. The auctioneer's report of the posthumous sale confirms that Dauzats bought only one of the Moroccan notebooks, for 700 francs, that is, the Chantilly one (no. 4).
6. I will return to this notebook below.
7. Sotheby's, Paris, 22 March 2018, "Œuvres sur papier," lot 27. "Livres du XIXe siècle," Paris, Pierre Bérès, 1976, lot 77.

notebook and recorded some of its contents.[8] I call it "Burty no. 30" and refer to it in the footnotes.

The remaining notebook that figured in the posthumous sale (belonging probably to Andrieu) is unlocated. It corresponds to Burty's no. 34: it contained two notes that we also find in the Meknes notebook, but which are not from it, since Burty assigns the no. 33 to the Meknes notebook.

Research for the 2009 French edition of Delacroix's *Journal* greatly enriched the corpus of texts concerning his journey to the Maghreb: a large cache of manuscripts and materials relating to Delacroix was discovered in the archive of his executor and heir, Achille Piron, and numerous manuscripts of his were identified in the Claude Roger-Marx collection. Two documents were of particular importance and are translated here. The first consists of four sheets cut out of a notebook, of which the first three were in the Piron archive and the fourth, which is their sequel, was in the Claude Roger-Marx collection.[9] Piron separated the first three sheets, dated 24 and 25 January, intending to publish them as the beginning of "Memories of a Visit to Morocco," the draft of which he had found among Delacroix's papers. The fourth sheet also relates to 25 January, after which point Delacroix put the notebook aside, taking it up again only on 12 February. In none of the other notebooks is there any account of these first two days (24 and 25 January); the Tangier notebook begins only on the twenty-sixth.

Moreover, a study of the manuscript revealed that these pages had been cut out of the Chantilly notebook, which has the same dimensions and, in particular, bears the exact trace of the cut.[10] They are here reintegrated into the Chantilly notebook and designated by this name, but the manuscript pages themselves are in BNF Est. YB³ 983 [2] 4° Rés. and in a private collection I have placed them at the start of the notebooks, where they fall chronologically.

8. Notes by Burty in the INHA, Cl. Roger-Marx collection, carton 120, autog. 1397/31.

9. The first three sheets, measuring H. 19.5 × W. 12.6 cm and written recto-verso, form six pages, numbered 4 to 9 in pencil in the upper left. Piron mentions their content in the introduction to his *Eugène Delacroix: Sa vie et ses œuvres*, but did not print or quote them (p. 89); now we have the full text. The fourth sheet was mixed in among the sheets of the Moroccan narrative (above, pp. 24–25). Also written recto-verso, this sheet forms two pages numbered 10 and 11 in pencil, in the upper right, and contains the continuation of the sentence that ended p. 9 from the Piron archive. When Piron set this sheet 10–11 aside, he copied onto the bottom of p. 9 the first words from p. 10 that completed the sentence: there is therefore no doubt about the join. The first three sheets (Piron archive, cat. 5) are now in a private collection and the fourth in the BNF (Est. Yb3 983 [2] 40 Rés).

10. Delacroix had at first used a few pages of the Chantilly notebook; then he returned to it later, turning it upside down and starting at the back: the 172 pages of the "intact" notebook proceed in this (inverse) sense. (I use the term "page" rather than "fol. r" and "fol. v," following the current numbering of the notebook in Chantilly.) At the end of the notebook, the stubs of ten sheets that were cut out (an entire quire) are visible: written in inverse order relative to the other 172 pages, the eight rediscovered ones correspond to pages 181 (our p. 11) to 188 (our p. 4) of the notebook: the edge of the sheets joins up exactly with what remains of these pages in the Chantilly notebook. As I indicated above, Piron removed them when preparing his book on Delacroix.

The second document is the narrative, "Memories of a Visit to Morocco." This remained unpublished among Piron's papers.[11] I found the larger portion, twenty-nine quarto sheets, numbered 7–35 by Delacroix, in the Piron archive in 1996. The beginning, six double sheets that each formed four pages and were numbered 1–6, was found in the Claude Roger-Marx collection by Sophie Join-Lambert, then curator at the musée des Beaux-Arts de Tours, and its identification confirmed by Lee Johnson after discussions with me; the notes and drafts for "Memories" was also in that collection. On one of the first pages of the narrative, Piron wrote: "Journey to Tangier." On one of the pages of notes, he wrote: "Draft and fragments of the journey to Morocco."[12]

According to a note in the Piron archive, this narrative was to occupy pages 359 to 380 in the manuscript of Piron's book on Delacroix, right after the text on the Jewish wedding (pp. 354–358).[13] As the number of reserved pages suggests, Piron planned to publish only the second part of the text (fols. 7–35), which dealt with the stay itself. He intended to omit the first part (cahiers 1–6), on the sea-journey to Tangier, as well as the notes and drafts, which were very messy, less polished, and full of unfinished thoughts and abbreviated notes. For this first part, he meant to substitute the far more legible pages from the Chantilly notebook that he had cut out for this purpose. Dated 24 and 25 January, these dealt with the party's arrival in Tangier.[14]

However, a note by the printer on p. 359 of the manuscript of Piron's book indicates that the pages of the narrative that were meant to be inserted were not in fact there. Even the text of the second part, therefore, which Piron had intended to include, was omitted at the last minute, no doubt to facilitate his

11. Delacroix's friend Charles Rivet made use of it for an article that he drafted about Delacroix, and gave it back to Piron's heirs after Piron's death (unpublished letter, INHA ms. 254). Rivet's article was not published, but Raymond Escholier drew from it a long quotation from the Moroccan narrative (*Delacroix: Peintre, graveur, écrivain*, 2:31–32). The text published by Escholier has numerous mistakes. Jean Guiffrey, inspired by Piron's remark (see the introduction above note 49), looked for this narrative when preparing his facsimile. On 25 August 1908, he wrote to Maurice Tourneux: "I found in a château near Senlis *[the château de Fontaine]* two watercolors from the Mornay album that was dispersed at auction in 1877. I'm on the trail of an account of the journey, written, I've been told, by Delacroix and given to Count Mornay. If that's true, it would be extremely interesting. But perhaps it is instead a travel journal written by M. de Mornay himself? Even that would be very intriguing. I will keep you posted about any results that I get on that score" (INHA carton 98, dossier Burty, autog. 788). Guiffrey's search was fruitless (*Fac-simile* 1909, p. 42). Yet this story, somewhat incredible in itself (in the form that we have it, the narrative is too much of a rough draft for Delacroix to have given it to Mornay), should not be rejected outright, since its source was close to Mornay: Countess Mailly-Châlons, owner of the two watercolors in question (*The Kaïd Ben Abou* and *A Coulougli and an Arab*, see biographies, Mornay), was Mornay's descendant and heir.

12. The most up-to-date version of the Moroccan narrative is published in the 2009 edition of Delacroix's *Journal* (1:264–321).

13. On a folded piece of paper, Piron wrote: "Journey to Morocco. Journal 1832. From page 359 to p. 380." The manuscript of Piron's *Eugène Delacroix, sa vie et ses œuvres* is in the INHA, ms. 578.

14. The separation of the notes into two lots was done by Piron for this reason.

task of bringing the book to completion. It would have been impossible for Piron, already very ill, to decipher and edit such a manuscript. He corrected the proofs of the book on his deathbed.[15]

The Date of "Memories of a Visit to Morocco"

A correction by Delacroix in the manuscript raises the question of the narrative's date. On fol. 16, discussing the conquest of Algiers, he mentions "the twelve years that have passed since that conquest . . . ," situating the writing in 1842, the French conquest having taken place in July 1830. But "that conquest," added in the margin, replaces a different phrase in the text, which is crossed out—"the twelve years that have passed since *I set eyes on those sights*,"—which would instead indicate 1844, the journey having taken place in 1832. It is of course possible that the writing stretched out over two years, or that Delacroix began the article in 1842, only to take it up two years later. But the writing seems to be continuous and all of a piece. In any case, we should not give too much weight to a correction of this kind. Speaking about the conquest, seeking at the same time a literary formula to locate the moment of writing, he could easily have confused the two points of reference: twelve years since the 1830 conquest or since he observed its effects in 1832, the mistake would be natural. In this case, the first state of the formula ("since I set eyes on those sights"), written all at one go before the correction, would seem the more reliable.[16]

On the other hand, a certain number of indications about dating can be found in the notes themselves—fragmentary, scattered suggestions, which must be grasped in passing, as it were, but which are still significant. The most telling is an unfinished note in cahier 1-b. Discussing their stop in Avignon en route to Marseille, Delacroix states that the travelers had much regretted the fate of the Palace of the Popes, which was then serving as a barracks. There follows this fragment of a sentence that he writes at the bottom of the page and references by the number (1) in the text: "We have learned that the Minister has just ordered, etc." In fact, the Palace of the Popes, first turned into a military

15. Letter from Piron's son-in-law Adrien Collas de Courval to Charles Rivet, 11 June 1868 (Piron archive, INHA ms. 578). Courval took charge of the final stages of publication after Piron's death. Despite the 1865 printed on the title page, the book did not appear until 1868.

16. There are other moments when Delacroix's dating is not always precise: in cahier 1-a he situates his departure for Tangier "a year and a half after the conquest of Algiers," which is correct, the surrender of Algiers having taken place on 5 July 1830; whereas, on fol. 15, he alludes to the same temporal distance for his stay in Algiers, which did not take place until June 1832, two years, and not one and a half, after the conquest: "I saw in Algiers, just a year and a half after the conquest . . ."

barracks in 1810, was the object of frequent claims in these years, notably on the part of Mérimée who, as early as 1835, had protested about the degradation of the paintings then attributed to Giotto and the poor state into which the Saint-Jean tower, which housed them, had fallen. Within the Commission for Historic Monuments, Mérimée argued for funds to protect the building: at the meeting of 27 January 1843, the commission approved a conservation and restoration plan for the tower, which was to be carried out under the auspices of the Ministry of the Interior, including the construction of a staircase that would allow the room with the paintings to be separated from those used by the army. In the minutes of the commission's meetings and the reports by Mérimée on ministerial projects for the years 1840–1846, this is the only order relating to the Palace of the Popes.[17] Delacroix's note would presumably have been written shortly after that meeting, that is, early in 1843. He could have learned about the decision through Mérimée, who was a friend, or through other members of the Commission whom he knew (the arts administrator Édmond Cavé, the critic Ludovic Vitet, the architect Félix Duban).

Other indications in the narrative are consistent with a date early in 1843. In cahier 4-b a marginal note alludes to two topical matters: "Louis-Philippe's 12th-century tomb. Napoleon's, Renaissance style." Delacroix does not explain these remarks, which he perhaps intended to elucidate when speaking of Moorish architecture: he praised this for being extremely simple on the outside and of magnificent elegance on the inside, in contrast to contemporary European architecture, which he saw as false and archaizing. The tomb for the current king, Louis-Philippe, was part of a commission awarded in 1839 to the architect Pierre-Bernard Lefranc (1795–1856) to enlarge the funerary chapel of Saint-Louis at Dreux; the former chapel, which was in the shape of a Greek cross, was thus redone in gothic style. The works began in April 1839 and continued until 1845, with most of the activity taking place between 1839 and 1843.[18] In 1842 Delacroix provided the drawing for one of the eight stained-glass windows representing the story of Saint Louis that decorate the crypt ("Saint Louis on the Bridge of Taillebourg").

Significantly, the tomb of Napoleon was frequently debated in the years 1840–1843 as a result of the decision, announced in May 1840, to bring the Emperor's ashes back from St. Helena in the south Atlantic, where he had died, to Paris, where he had wished to be buried. Appointed by the minister Charles de Rémusat to execute the tomb, Charles Marochetti proposed, in July

17. Mérimée, *Correspondance générale*, nos. 512 (8 August 1839), 762 (6 February 1843), 1631 (3 October 1850); id., *Rapport au Ministre de l'Intérieur. Liste des monuments auxquels des subventions ont été accordées depuis 1840 jusqu'en 1846*; Bercé, *Les Premiers Travaux de la Commission des monuments historiques, 1837–1848*, p. 235.

18. The works were discussed in the *Moniteur* of 30 July 1843.

1840, a design in Renaissance style like that of Louis XII at Saint-Denis. A model was erected at the Invalides around 20 July. Revised over the summer, the project was reproduced and published in the press toward the end of October; the *aedicula* was to be surmounted by an equestrian statue of Napoleon inspired by the tomb of Louis de Brézé in Rouen (attributed to Jean Goujon), with, at the corners, four allegorical figures like Michelangelo's for the Medici tomb in Florence. Highly criticized in the press and at the Academy of Fine Arts from July up to the end of the year, Marochetti's project stagnated.[19] Pressured from all sides, the government finally announced a public competition (*Moniteur*, 17 July 1841). The plans were exhibited from 27 October to 21 November 1841 and the report of the committee judging them was published in the *Moniteur* on 16 January 1842. The new commission was awarded to Visconti on 1st April 1842 and his plan, not at all in Renaissance style, was approved by the ministry on 31 December 1842.[20] After the beginning of 1843, therefore, there was no longer any question of a tomb in Renaissance style, and Delacroix's remark would have lost its point completely. Once again, Delacroix's jotting points to a date of early 1843.

What is without doubt is that the relations between France and Morocco were, when Delacroix was writing, very tense: he speaks of a journey "to a country that today is attracting attention" (fol. 1 bis r) and of "our troubles with the Moroccans" (cahier 4-a). Does this mean the war of 1844? As explained in the introduction, the "troubles" between France and Morocco date to much earlier, as relations between the two countries were never entirely separate from the Algerian conflict.[21]

Delacroix's indications within the narrative thus suggest a date shortly after January 1843, the date of the ministerial decision about the Palace of the Popes. The dramatic events of the 1844 war, such as the bombing of Tangier, a city that he represented so often in his works, would have left a deeper trace than the laconic remarks found in the narrative, even if we allow for some reserve on his part. The similarity of the various political and military crises over the two years prior to the war makes dating difficult, but the available evidence points to the first months of 1843.

19. The fall of the Thiers government on 15 October 1840 also removed its patrons.

20. Delacroix would have been aware of the committee's deliberations, since many of its members were acquaintances of his: Pierre-Jean David d'Angers, Cavé, Édouard Bertin, Augustin Varcollier, and Théophile Gautier. He personally knew Marochetti, who came to consult him about another project at the same period (letter from Marochetti to Delacroix, 11 May 1840, Piron archive cat. 59, Musées Nationaux). For the history of the commission, see Michael Paul Driskel, *As Befits a Legend: Building a Tomb for Napoleon 1840–1861*.

21. As attested by an article by A. Rey, "Le Maroc et la question d'Alger," published in the *Revue des deux mondes* of 1 December 1840, which examines the role of Morocco in the "drama" taking place in North Africa. See the introduction above, pp. 11–13.

BIOGRAPHIES

. .

ABD AL-RAHMAN, MOULAY (1778–1859), ALSO WRITTEN ABD ER-RAHMAN. Sultan of Morocco from 1822 to 1859. At the death of his father in 1795, he was too young to claim his right to the throne, which was taken by his uncle, Moulay Suleiman (Gråberg di Hemsö, *Specchio geografico*, 200). He acceded to the throne on 28 November 1822. Gråberg di Hemsö describes him as a sovereign who "succeeded in gaining the affection of all by his mild and affable manners, his good judgment and firmness, an innate uprightness, and an inflexible love of justice, tempered, however, by clemency. He terminated the civil wars and insurrections of the Scheloques, which had desolated the country for upwards of four years. Once in peaceable possession of the throne of his ancestors, he constantly sought the love rather than the fear of his subjects. A zealous Mussulman, although less fanatical than Scheriffs generally are, he does not hate Christians, nor does he oppress or persecute the Jews. Unlike his predecessors, he has hitherto shown himself prudent and humane in his administration, merciful as a dispenser of justice, circumspect and moderate in his political relations, simple and kind in private life. Since the time of King Saïd-Ouatas [*Saïd III, r. 1471–1500*] and of Sultan Ahamed Scheriff [*r. 1524–1550*], which is regarded as the golden age of Morocco, the empire was not governed by a less sanguinary and more pacific Sovereign than Abd-el-Rahman. His great firmness, the energy of his character, and his well-known leaning towards everything that is just and reasonable, could alone conquer and reduce to submission the ferocious and seditious hordes of the Amazirgue tribes [. . .]. The person of Abd-el-Rahman is more graceful and agreeable than imposing and severe; his constitution is robust, and his stature majestic. He generally dresses in the simplest manner [. . .]. If he be not remarkable for address in bodily exercise, we know that his mind is not without cultivation, and his sentiments and conversation are generally noble and interesting. He is said to treat women with much kindness and affability, contrary to the practice of his predecessors and the generality of the princes of that barbarous country" (article from *La Presse*, cited in the *Times*, 15 July 1844). Lagerheim confirms that Abd al-Rahman was not cruel, but presents him as "weak and indecisive, such that his subjects have often rebelled against him " (*Minnen*, 62). "Simple in taste and manner, he scorns pomp and circumstance," wrote A. Rey in 1840. "The sultan is perhaps the man with the healthiest judgment in the whole Empire, with consummate tact in administration, commerce, and politics" ("Le Maroc et la question d'Alger," 640–41).

However, a letter published in *L'Algérie* (see the *Times*, 5 July 1844, 6), no doubt war propaganda, depicts a "brutal and cruel" Abd al-Rahman. He had his predecessor, Moulay Suleiman, poisoned and, with this crime ever "before his eyes," he was constantly afraid of being poisoned himself: "No one can approach him except his son; he alone is permitted to serve him, and he must first taste each dish." His eldest son, Sidi Mohammed, born in 1805, and his youngest son, Moulay Ali, were allegedly born of an Englishwoman, "called in the language of the country Rahmouna."

ABOU, MOHAMED BEN-, ABD EL-MALEK (1798–1858). Kaïd (commander) who accompanied the Mornay mission from Tangier to Meknes. Born in Tangier to a family of pashas originally from Rif province, he was appointed governor of Tangier under Moulay Suleiman, Abd al-Rahman's predecessor. When Abd al-Rahman ascended the throne in 1822, Ben Abou sided with him and helped to consolidate the emperor's power. Kaïd of Rif province in 1842, he was in Tangier during the French bombardment of 1844: he took charge of the city and, according to Godard (*Histoire et description du Maroc*, 611), "himself blew out the brains of the leader of a gang of pillagers, at the gate of the French consulate, and [. . .] by his efforts saved part of the Europeans' property." From 1845 to 1853, he was khalifa (deputy) to Sidi Bou-Selam, governor of the northern provinces, in Tangier. In 1853, he became kaïd of Tangier province and pasha of Rif. In 1857, after a trip to Fez to hand over the province's taxes to the sultan, he was arrested and imprisoned for thirteen months. Once freed, he was preparing to return to Tangier when he was gripped by numbness in his legs and violent pain in his abdomen, and died suddenly. It was rumored that he had been poisoned (Godard, *Le Maroc*, 70).

The version of this episode transmitted by John Hay, son of the British consul Edward Drummond Hay whom Delacroix knew (Hay, *Memoir of Sir John Drummond Hay*, 184–85), clarifies a detail in Delacroix's notes. Hay writes that Ben Abou, before leaving on his trip, had deposited with Hay some bags full of gold so that they would not fall into the hands of other sheiks or the sultan. Hay accepted them for safekeeping. Ben Abou then went to the court, where the sultan told him that he was not satisfied with the accounts and that he was going to have him arrested. Ben Abou died in prison after seeing his son, Fatmeh, who, when Hay questioned him, clearly knew nothing about the gold. Hay gave it to him and, in return, Fatmeh offered him the model of a Spanish ship that the Spanish government had given to his grandfather, who, as pasha of Tangier at the time of the war between Spain and Britain, had sided with the Spanish. In his memoir, Hay claims that it was the model of the *Santissima Trinidad*, "the masts of which served as a Moorish bridge" (see 29 January, fol. 28 of "Memories," p. 50 and p. 130).

Hay (*Memoir of Sir John Drummond Hay*, 193) confirms Delacroix's impression of Ben Abou: "Benabu was the best Governor I have known during the forty years I was at Tangier. Under his iron but just rule, murder, robbery, and even theft became unknown after the first year of his government. He made terrible examples of all criminals." Likewise Godard: the pasha "was able to establish security and make crimes and misdemeanors very rare across the whole extent of his reign" (*Histoire et description du Maroc*, 69). Delacroix recounts numerous anecdotes about Ben Abou (8 and 12 March; 12 and 28 April; "Memories," "Notes and Drafts," 1st unnumbered cahier-b and 2d unnumbered f⁰). He portrayed him several times, notably on a sheet of drawings in the Nationalmuseum, Stockholm (annotated "Abou" and dated "Thursday 8 March"), and in one of the watercolors for the Mornay album (see below, Mornay entry). In addition, he is in several of Delacroix's paintings of Moroccan subjects, such as *Moroccan Chieftain Receiving Tribute* (J359), *Arab Soldier by Grave* (J362), *The Sultan of Morocco and His Entourage* (J370), and *Arab Soldier Seated and His Horse* (J371).

ANGRAND, LÉONCE-MARIE (8 AUGUST 1808–11 JANUARY 1886). Diplomat and ethnologist. After studying in Paris, he visited Britain around 1820, then began his career as secretary to Bertin de Vaux, ambassador to the Netherlands. On 1 August 1830, he was appointed French vice-consul to Cádiz, where Delacroix met him; on 11 May 1833, he was sent to Lima, going via Brazil and Argentina. He stayed in Peru from 1834 to 1839; after a few

years in Santiago de Cuba (1839–1842), he returned to Cádiz as consul, remaining until 1845. There, he rendered important services during the Moroccan War and was awarded the Legion of Honor. Consul and chargé d'affaires in Bolivia (1847–1849), he transferred to Guatemala (July 1851), where he served as consul general until 1857. He retired in 1870. During his time in Latin America he acquired extensive expertise in local customs, archaeology, architecture, literature, and ethnology. He collected a large number of texts and documents, which he left to the Bibliothèque nationale de France. A talented draftsman and watercolorist, he also left notebooks, drawings, watercolors, maps, and architectural photographs to the BNF (Est. VH240 Rés.), along with a sum of money intended to found a quinquennial prize for the best work on pre-Columbian civilizations. His collection of pre-Columbian artefacts is now in the musée du Quai Branly.

BELL, JOHN (1795/1796–1863). British vice-consul at Tangier from July 1831, after having filled the same role from April 1830 for Tetuan. In December 1831, he was sent on a mission to Meknes, accompanied by Edward Drummond Hay, son of the British consul. In April and May 1833, he was agent and interim consul. Appointed vice-consul to Oran in March 1837, he became consul at Algiers on 15 January 1851 and consul general on 22 July 1854. He retired in April 1863 (Foreign Office, Great Britain, *Foreign Office List*, July 1863, 165). According to John Hay, Bell, a doctor, had been surgeon aboard Lord Yarborough's yacht *Falcon*, and during the cholera epidemic in Tangier had spent his free time treating the sick (*Memoir of Sir John Drummond Hay*, 23–24). In his letters to the Foreign Office, the elder Drummond Hay praises him highly, especially for his "invaluable medical knowledge, which he imparts in the kindest manner," and the "charitable services" that he rendered: "He is an excellent person. [. . .] His medical skill, friendly disposition, and cool courage is my main hope and stay [. . .]." Drummond Hay states that, when the Danish consul Schousboë and the American consul Leib were dangerously ill, they were saved "by the prompt and unremitting aid of the worthy vice-consul" (London, The National Archives, FO 174 no. 162, pp. 46–47, letter of 4 November 1831).

BENCHIMOL, ABRAHAM. Dragoman of the French consulate in Tangier. From a large family of Jewish businessmen, Benchimol had occupied his post since 1814, having succeeded his father Moses who was interpreter from 1803 to 1813. Abraham's sons later succeeded him in 1846 (Miège, *Chronique de Tanger*, 272). Delacroix did a portrait of him for the Mornay album of watercolors (unlocated), and he is prominently represented in a watercolor depicting a visit to a Jewish bride (see Johnson, "Delacroix's *Jewish Bride*," fig. 39). See 25 January 1832.

BENCHIMOL, JACOB. Brother of Abraham.

BIAS, SIDI ETTAYEB. *Amin*, or customs administrator, in Tangier, chief negotiator for the sultan Moulay Abd al-Rahman with Mornay. Lagerheim writes: "He was a small man, of around eighty *[sic]* years old, clever, lively and cheerful, who, without neglecting his duty of watching over the governor, could not help talking business, and received with gratitude the little gifts of tea, sugar, and cloth that I sent him as signs of my wish to establish friendly relations with him. He received me lying on a mat in a corner, so wrapped in shawls that, of his entire body, I saw only his gleaming eyes and his long white beard. [. . .] His conversation dealt with women, which seemed to be his favorite subject. He asked me if I had brought my wife with me. When I answered no, he asked me how I would manage.

[. . .] As for him, he had been living apart from his wives for several months already, but he could not stand such hardship for long and was going to send for them. I congratulated him on having such youthful ideas at such an advanced age" (*Minnen*, 33–34). Having played an important role in ending the revolt of the Oudayas in 1830, he enjoyed the sultan's favor (see Mornay's reports of 28 January and 4 March, *Voyage*, 6:199, 211). While Mornay alludes to his "excessive venality" and his "greed" as weaknesses to exploit (*Voyage*, 6:211), Delacroix, rather, notes "Bias' shrewdness in political negotiations. At the end of the meeting nothing was actually decided, when everything seemed to be settled" ("Notes and Drafts," 1st unnumbered cahier-b, p. 142). Delacroix did his portrait for the album of watercolors that he gave to Mornay (Louvre 1607). In 1836, Bias led the negotiations with Colonel de La Rue. According to Rey ("Le Maroc et la question d'Alger," 650), the sultan considered Bias, who later became governor of Fez, a possible successor to Sidi Mokhtar (q.v.) after the latter's death. But in 1850, Delacroix learned from Delaporte that Bias had been disgraced (see *Journal*, 10 April 1850); this may allude to his support, in 1842, of a conspiracy led by Moulay Abd-el Rahman bin Suleiman, the sultan's cousin, to assassinate the sultan.

COLAÇO, JORGE JOSÉ (1783–1859). Portuguese consul in Tangier during the visit of the Mornay mission. The Colaço family, established in Tangier as early as 1584, had held diplomatic posts there since the second half of the eighteenth century (Miège, *Chronique de Tanger*, 72). Lagerheim (*Minnen*, 39) describes Colaço as "an insignificant man who did not lack influence with the Moroccan government because his family had long been consuls. He had a large family and a low salary, was not always paid on time, and lived a withdrawn life. In his house there was a gambling club every evening, where whoever wished to would turn up to play cards, and everyone had to chip in for the lighting." Delacroix visited Colaço's home, as an annotated sketch in the Chantilly notebook (p. 99) indicates.

DELAPORTE, JACQUES-DENIS (14 APRIL 1777–23 JANUARY 1861). Diplomat, administrator of the French consulate during the visit of the Mornay mission. After completing his studies under Silvestre de Sacy at the École des langues orientales in Paris, he was part of the Commission des Sciences et des arts of Napoleon's Expédition d'Égypte in March 1798. Secretary and interpreter assigned to General Cafarelli, he became librarian of the Institut d'Égypte (1800–1801). He took back to France more than two hundred Coptic manuscripts now in the Bibliothèque nationale de France. Chancellor-interpreter to the French consulate in Tripoli (Libya), he wrote a book on the ruins of Leptis Magna and a history of the Mamlukes, and from 1813 to 1816 he directed the consulate. Appointed interim chancellor-interpreter in Tangier on 8 October 1816, vice-consul in 1819, he was not promoted at the death of the consul Sourdeau in 1828. The post of vice-consul was eliminated in 1831, but he remained in Tangier through 1832. Mornay recommended him for the consular position in his report of 16 February to the minister of foreign affairs, writing that Delaporte "is held here in general esteem, which he has deserved through his steady, honorable conduct. [. . .] His knowledge of the Arabic, Spanish, and Italian languages, and his long residence in North Africa have put him in a position of knowing the habits, prejudices, and character of the Moors perfectly" (*Voyage*, 6:207, report of 16 February 1832). Lagerheim, in his haughty conservatism, is less flattering: "The French pro-consul M. Delaporte was a man without education and an intriguer with whom the better society did not associate. Also there was the fact that he was married to a serving girl. The only thing that might make him interesting is that he had for a long time managed to hide in his house,

and then to get smuggled into Europe, the well-known [René] Caillié who, dressed as an Arab, had visited Timbuktu and finally, half-dead, arrived in Tangier where he feared being recognized by the Moors and executed" (*Minnen*, 37). Indeed, Caillié who, posing as an Arab, was the first Frenchman to visit Timbuktu, had been sheltered by Delaporte on the way back in 1828. In his memoirs, Caillié pays tribute to this "generous man" who "showered him with attention and kindness," and to his "enlightened prudence" and the "qualities of his heart": "that excellent man cared for me as a loving father would have [. . .]: may I here give him the public expression of all my gratitude!" (*Journal d'un voyage à Tombouctou*, 3:134–39). Chief interpreter to the army of Africa and director of Arab Affairs in Algiers from 1 May 1833, consul to Mogador in 1836, he retired in 1842 and returned to France the following year. In Tripoli he had married Angelina Regini (April 1792–18 October 1871), whose portrait Delacroix painted (J215; Alger, musée des Beaux-Arts). Delacroix gave Delaporte two other paintings as well: *Arab Horseman Practicing a Charge* (J349) and a watercolor depicting a Moroccan chieftain (*Delacroix: Le Voyage au Maroc*, cat. Paris, no. 72; Manon Hosotte-Reynaud, "Un Ami méconnu et deux œuvres inédites de Delacroix"). The two men continued to see one another in Paris (see above, p. 130, and *Journal*, 24 janvier 1849, 10 avril 1850, address list 1857, 1:412, 499, 1054). A letter from Delacroix to Delaporte was in the Piron archive (see *Journal*, 1:1054, n. 19). Delacroix also knew his son, Pacifique-Henri Delaporte (1815–1877), who was consul in Baghdad and then Cairo; the young Delaporte gave the painter a case and a sheath of worked silver from Morocco (letter of Charles Cournault, INHA ms. 254), as well as two leather purses (Font-Réaulx, *Delacroix: Objets dans la peinture*, 168).

DESGRANGES, ANTOINE-JÉRÔME (1784–1864). Official interpreter to the Mornay mission to Morocco. The existence of two people of the same name in this period, both interpreters of Oriental languages, has given rise to much confusion. The companion to the Mornay mission was Antoine (and not Mathieu-Florentin-Antoine, called Allix Desgranges, his brother [1793–1864]), as attested by the passenger list published in *Voyage* (6:120). Desgranges had taken part in missions to Basra (1808), Constantinople (1811 and 1816), and Tunis (1824). Lagerheim describes him as "an older man and pupil of Talleyrand, who with the modest title of interpreter of Arabic was to be the mentor of Count Mornay during this first step in the latter's diplomatic career" (*Minnen*, 96). In a letter to Mornay of 13 December 1831, Horace Sebastiani, minister of foreign affairs, wrote: "I felt it necessary to send a trusted interpreter with you to Morocco, and I designated for this role M. Desgranges, one of our official interpreters for Oriental languages. M. Desgranges has already fulfilled several missions of this type in North Africa, to the government's complete satisfaction, and I have no doubt that his experience, combined with his perfect knowledge of the customs and languages of the Orient, will make him extremely useful to you." Delacroix saw him again in Paris in 1850 and 1852.

EL-ARBY BEN ALI SAÏDI, SIDI. Pasha of Tangier during the visit of the Mornay mission. Lagerheim's memoirs contain a number of details about him, for the most part unfavorable, as do Drummond Hay's letters (London, The National Acrhives, FO 174 no. 162, p. 76). According to Lagerheim, he had been pasha of two other provinces in the interior of the country before becoming pasha of Tangier, but whenever he attained a certain wealth, he had been plundered by the emperor and beaten until he had given up everything; and when nothing was left, he was given another province to govern. Lagerheim describes him as a "great crook," susceptible to bribes, and particularly creative in

devising ways to extract money from the Jews, whom he persecuted (*Minnen*, 48–49). As an example of this latter trait, he recounts that, during the winter of 1831, when the streets were flooded from rain, El-Arby ordered that Jewish women should go barefoot for five weeks, so that through this mortification, the Supreme Being would restore good health to the emperor, who was unwell. The Jews begged for mercy, but were told that this would only be granted for a payment of 500 piastres; they offered 200, which was rejected, and rather than give more, they waded for two weeks in the mud before paying the sum. El-Arby then claimed that they were so despicable, Moulay Abd al-Rahman should not use the money, and gave them their slippers back. The consuls often had to unite against El-Arby and threaten to intervene directly with the emperor to demand justice.

ERMIRIO, GIROLAMO (1791/1792–AFTER 1867). Sardinian consul at Tangier during the visit of the Mornay mission. Originally from Vennuzza (Genoa), he was charged in 1812 with the cadastral register in Tuscany. Secretary of the Sardinian legation in Florence during the Restoration, appointed vice-consul in Portoferraio (Elba) on 27 November 1819, then vice-consul in Madrid, he arrived in Tangier on 1 February 1825 (Miège, *Chronique de Tanger*, 335). Lagerheim (*Minnen*, 40) characterizes him as "a real Italian, an intriguer, [. . .] with loose habits and equally loose opinions, closely connected with Ehrenhoff [the former vice-consul whom Lagerheim replaced], and, according to rumor, even more so with his wife. He was a regular at the gambling den, where he usually won, and handled the cards with a skill that showed that he had fortune in his hands. His honorable wife and two daughters were rarely seen in society, but sometimes held receptions." It was at Ermirio's that the costumed ball took place to which Delacroix went dressed as an Arab (see the introduction above, pp. 21–22). He remained in Tangier until 2 May 1836, then was appointed consul general to Alexandria. Named consul to Marseille on 8 February 1837, he is in the census as "Jérôme Ermirio, Sardinian consul, 54 years," with his wife, Adrienne, née Angiolucci, of the same age as himself (Marseille, Archives municipales, 2F/156); one of their daughters, Maria Caterina Ridolfa Giuseppina, was born 30 May 1819 (Crollalanzo, Giovanni Battista di, et al., *Annuario della nobiltà italiano* XVII [1895]: 1089). From 1843 he was a member of the Society of statistics, history, and archaeology of Marseille; after retirement, he settled in Genoa (meeting of 9 December 1852, *Répertoire des travaux de la Société de statistique de Marseille*, 16:527). He is last mentioned in 1868 and may have died that year (*Atti della Società ligure di storia patria*, 1908, 41:179).

FORD, HARRIET, NÉE CAPEL (1806–1837). Wife of Richard Ford, the author of an important *Handbook for Travellers in Spain* (1845) and various writings on art. The daughter of George, the fifth Earl of Essex, a patron of Turner's, Harriet Ford was a cultivated woman who drew and painted. She married Ford in 1824. Because of her health, the Fords lived in Seville with their three children from 1830 to 1833, first in a house on Plazuela San Isidoro no. 11, then in a magnificent Renaissance mansion on the Calle Monsalves, where they received many visitors to the city. They spent six months sketching in the Alhambra in 1831 (several of Harriet's drawings are reproduced in Brinsley Ford, *Richard Ford in Spain*, cat. London). The couple separated after their return to England. Portraits of her were painted by George Hayter and José Gutierrez (ibid.).

FRAISSINET, JEAN-ANTOINE (1786/1787–1835). Dutch consul in Tangier from November 1827. Lagerheim's memoirs shed much light on Fraissinet, who had been little known but was a good friend of Delacroix's during the latter's stay in Tangier. Born in Algiers, he was

the son of the consul general for Holland, Antoine-Pierre Fraissinet, of the prominent Marseillais family of merchants and traders, and Claire Chaix. His father had become Dutch consul through a connection with the Dutch branch of the Fraissinets. Jean-Antoine's brother, Auguste, became consul in Algiers in 1832 and in Tangier from 1835. Jean-Antoine was, for Lagerheim, "of all my collegues [. . .] the one I valued most highly and with whom I had the closest links. I've also seldom known anyone who has combined all the qualities of a man of the world. He spoke several languages, was a good poet, played the guitar well, had a fine voice, painted landscapes and seascapes like an accomplished artist and was perhaps the most skilful portrait painter in southern Europe. He was [in 1832] around forty, large and well-proportioned, with flashing black eyes, a good horseman and marksman, and the finest critic of food. Apart from these talents, he was also a gifted conversationalist: his conversations were entertaining, lively, and amiable. He never lectured, never exhausted a subject or took an argument to the extreme. Yet even he had his faults. The main one was his unbridled attachment to the opposite sex. His very attractive figure always aroused notice both in Algiers and Tangier, and he often risked both his job and his life by intrigues with Moorish women. Another weakness was a fear or notion that often came to him that he would die young. This became a reality all too soon. In 1834 *[sic for 1835]*, he went to Marseille on leave to visit his family, was struck down by cholera, and died in a few days." His death certificate indicates that he was forty-eight when he died, visiting Marseille, on 25 July 1835 (Marseille, Archives municipales 1E 631). He was unmarried.

HAY, EDWARD WILLIAM AURIOL DRUMMOND (4 APRIL 1785–28 FEBRUARY 1845). Consul-general of Great Britain in Tangier during the visit of the Mornay mission. Born in Alnwick, Northumberland, Hay came from a Scottish family related to the Stuarts. He was the son of a clergyman, Edward Auriol Hay-Drummond, and his wife Elizabeth de Vismes. He studied at Christ Church, Oxford, entered the military, and was an officer in the 73rd regiment of the infantry. He was wounded at Waterloo and retired in 1816. In 1823, he was appointed Lyon Clerk and Keeper of the Records in Scotland. In August 1829, he became consul at Tangier. A skilled diplomat, he was admired and somewhat feared in the consular circles there, and he enjoyed great favor with the pasha and sultan. A cultured man, a friend of Walter Scott's, he seems to have admired Delacroix, whom he often received in his home during the painter's stay. Lagerheim's memoirs provide a number of amusing anecdotes about Drummond Hay's proud self-assurance, even though he was very fond of him: "He received me very hospitably several times a week [and] there was no dinner or reception to which I was not invited and given pride of place" (*Minnen*, 70). For example, while the official language of diplomacy was French, Drummond Hay alone insisted on writing his circulars in English (even though he spoke French well and knew that several other consuls did not know English); he claimed that he was under government orders to do so. One time, Lagerheim decided to respond in kind: as the first consul to receive Drummond Hay's circular, he responded in Swedish. The other consuls, at first alarmed and then amused, followed his example, each answering in his own language, such that Drummond Hay received his answer in seven or eight different languages, most of which he did not know: "He threatened to complain about me in London and Stockholm, and was near to challenging me to a duel. [. . .] My decision was final, that I would use my own language as long as he used his. He was very angry for a few days but admitted I was right. Things soon improved, and he set the English language aside" (ibid.). The Foreign Office archives suggest that Drummond Hay wavered on this point:

in several letters, he defended himself for sometimes writing in Spanish (London, The National Archives, FO 174 no. 162).

He died in 1845 after a trip to Marrakesh, where he had gone to try to persuade the sultan to accept the demands of the French; he in fact succeeded, but the Prince de Joinville bombarded Tangier before Drummond Hay had returned. In a letter, he wrote that he "had hoped the French would have waited until my report reached Tangier or myself arrived there and told them all" (Hay, *Memoir of Sir John Drummond Hay*, 67). He was convinced that the hostilities did not have the approval of the sultan, whom he pitied (ibid., 68). His son, John Drummond Hay (1817–1893), succeeded him as consul in 1845 and in 1860 became the first ambassador of Great Britain to Morocco. The younger Hay wrote memoirs, which were published after his death by his daughters Alice Emily Drummond Hay and Louisa Brooks, from which I have drawn some of these biographical details. Edward Drummond Hay had married Louisa Margaret Thomson in 1812. At the time of Delacroix's visit, the couple had eight children, including three daughters: Louisa (1817–1893) who married a Swede, Lieutenant Norderling, in 1838; Elizabeth Catherine (1818–1911) who married W. Greenwood Chapman in 1840; and Theodosia (1823–1885), who married Pierre-Victor Manboussin in 1844; and five sons: Edward (1815–1884); John (1816–1893), Thomas (1821–1883), George William (1827–after 1880), and Francis (1830–1905). Two more children—Henrietta (1833–1868), who married Henry Chandos-Pole-Gell in 1851, and James (1834–1886)—were born later. See http://townsley.info/webtrees/individual.php?pid=I47869&ged=tree2/ and GENI, *Burke's Peerage*, and Walford's *Country Families of the United Kingdom*.

Drummond Hay wrote memoranda on the geography of Morocco and on Berber grammar; and he finished *Etymons of the English Language* begun by his father-in-law, J. Thomson. His papers are in the Bodleian Library, Oxford, and in The National Archives, London (see bibliography).

LAGERHEIM, ERIK JULIUS (1786–1868). Swedish diplomat, consul to Tangier in 1832. Having filled various administrative posts at the Ministry of Foreign Affairs from 1803, he took part in the Paris peace negotiations in 1809–1810, became secretary in the ministry in 1814, and councillor to the chancellery in 1817. Consul general in Algiers (1825–1830), he was in Sweden when the French conquest made the future of the Swedish embassy uncertain. He was sent to Tangier, where the consul general, Ehrenhoff, had compromised Sweden's situation with respect to Moulay Abd al-Rahman (Ehrenhoff supposedly neglected to pay his country's annual tribute to the Moroccan government, keeping it for himself). Charged with reestablishing firm and friendly relations between the two governments, Lagerheim arrived in Tangier in May 1831 and, when Ehrenhoff was recalled to Stockholm, remained until November 1832. His manuscript memoirs provide a valuable account of the period and clarify life in Tangier during the time when Delacroix was there; the visit of the Mornay mission is recounted at length. In 1836, he was named marshal of the Swedish court and charged with receiving foreign diplomats, including Mornay, who had been appointed minister to Stockholm. In 1840 he was living in Vadstena.

MARCUSSEN, MARC-PAUL (1798–1870). Adjunct consul of Denmark to Tangier. After the death of the consul Schousboé, he became interim consul from 26 February 1832 until the arrival of Carstensen, the new consul. He married Carstensen's daughter, Emilie Birgitte Gertrude. According to his friend Lagerheim, Marcussen, "a well-bred man, the ladies'

chief cavalier, [. . .] was said to be the son of Prince Christian of Denmark, his mother's lover" (*Minnen*, 39), presumably the notorious Christian VII (r. 1766–1808).

MOKHTAR EL-JAMAÏ, SIDI [MUCHTAR]. Minister of the Moroccan government during the visit of the Mornay mission. According to Lagerheim, he held a position similar to that of secretary of state; all the business of foreign envoys went through him. Lagerheim (*Minnen*, 65) also states that he enjoyed a favor equal to that of Bias (q.v.). Drummond Hay, less harsh than Lagerheim on Mokhtar's "notorious" greed and his love of gifts (see p. 99, note 167), considered him skilled (London, The National Archives, FO 174 no. 162, p. 86, letter of 10 January 1832). According to A. Rey ("Le Maroc et la question d'Alger," 641), he was "a cultured man, adroit, tactful, firm, and indefatigably industrious," who, having had the emperor's full confidence, was compromised after his death by a secret correspondence.

MORNAY, CHARLES-HENRI-EDGAR, COUNT (4 FEBRUARY 1803–5 DECEMBER 1878). Diplomat. Son of Auguste-Joseph-Christophe-Jules, comte de Mornay, who died less than a year after he was born (December 1803), and Louise-Augustine Caulaincourt (1776–8 October 1832), who remarried and became Countess d'Esterno, Mornay became aide-de-camp to the Duc de Reggio (1823–1824), then Honorary Gentleman of the King's Chamber (1829). Through his relations with marshal Soult, whose daughter was married to Mornay's brother, he was charged in 1831 with the mission to the sultan of Morocco that Delacroix accompanied. He met the painter through his lover, the actress Mlle. Mars ("Mlle Mars is pregnant, it's said. M. de Mornay's handiwork," wrote Stendhal, [*Corr.*, 3:519–520, letter of 13 juillet 1825]). After the Moroccan mission, he became minister to the Court of Baden (1833), and, in September 1835, plenipotentiary minister to Stockholm. Knight of the Legion of Honor (1833), officer (1837), grand officer (1846), and finally commander (1854), he was raised to the peerage on 13 April 1845. At the end of the journey, Delacroix gave him a magnificent album of eighteen watercolors, which, amid the Swedish gloom, inspired this remark: "Listlessly I direct my gaze to my album from Morocco, and I find that, despite the fatigue we incurred, the African sun is [. . .] invigorating" (letter of 15 september 1837, Piron archive, cat. 37).

The album included the following works (the titles are not Delacroix's, but are taken from the Mornay sale of 29 March 1877): 1. *A Camp Opposite the Town of Alcassar El-Kebir, on the Battlefield where the Infante Don Sebastian of Portugal Perished* (unlocated). 2. *View of the Town and Port of Tangier* (private collection). 3. *A Moorish Woman with Her Servant on the Bank of a River* (Cambridge, Harvard University Art Museums). 4. *A Moorish Man and Woman on Their Terrace* (New York, Metropolitan Museum of Art). 5. *Abraham Benchimol, Dragoman of the French Consulate* (unlocated). 6. *A Negress Slave Going to Fetch Water* (private collection). 7. *Amin Bias, Minister of Finance and Foreign Affairs* (Louvre). 8. *The Wife and Daughter of Abraham Benchimol* (New York, Metropolitan Museum of Art). 9. *Scene of "Convulsionaries" in Tangier* (unlocated). 10. *Negroes Dancing in a Street in Tangier* (Cambridge, Harvard University Art Museums). 11. *Arab Horsemen Resting Near Tangier* (Fine Arts Museum of San Francisco). 12. *A Fantasia or Cavalry Charge before the Main Gate of the City of Meknes* (Louvre). 13. *Moulay Abd er-Rahman, Emperor of Morocco* (formerly collection of Tony Mayer, reproduced in Lambert, *Histoire d'un tableau*). 14. *Soldiers Sleeping in a Guard House* (private collection). 15. *Arabs in a Market Area* (private collection). 16. *The Kaïd Ben Abou, Military Commander* (private collection). 17. *A Coulougli and an Arab Seated at the Door of their House* (private collection). 18. *Traveling Players* (Los

Angeles County Museum of Art). See L. Johnson, "Towards a Reconstruction of Delacroix's Mornay Album," 92–95.

These watercolors were dispersed at auction on 29 March 1877 during Mornay's lifetime, though his posthumous inventory indicates that he still owned three of them when he died: *A Camp Opposite the Town of Alcassar el-Kebir, Abraham Benchimol, Dragoman of the French Consulate*, and *Arabs in a Market Area* (8 January 1879, Mouchet, notary, A. N. AP402 16). The first two are unlocated; Robaut did a drawing after the watercolor of *Abraham Benchimol* (BNF, reproduced in Johnson, "Delacroix's *Jewish Bride*," fig. 44). His heirs were his nieces and nephews (see *Journal*, 2:228§).

Delacroix remained friends with Mornay, and painted his portrait (J231), his mother's (J216), and a double portrait of Mornay and his friend Count Anatole Demidoff (J220); three family portraits, for which the artist is not identified, were in Mornay's posthumous inventory and may be these. Mornay owned several other paintings by Delacroix as well (see *Journal*, 1:479 n. 31, 18 January 1850). Removed from his duties as minister of France to Sweden in 1848 by a decree of the provisional government (letter from Lamartine, minister of foreign affairs, 7 March 1848, A. N. 402/AP/16), he married, on 7 June of that year, Countess Julie Samoïloff; they had no children. He owned a house in Groussay near Montfort l'Amaury, Seine et Oise, where Delacroix visited him.

PAVÓN, PADRE JOSÉ (??–1851). One of the four Franciscan monks in the Spanish monastery in Tangier during Delacroix's stay. He arrived in Tangier in 1803 and remained until his death (Miège, *Chronique de Tanger*, 249). Lagerheim recounts that he did not limit himself to the pious activities of the others, but rather took part in the Europeans' picnics, enjoying the champagne, and dancing to the sound of the tambourine. "On one such occasion he expressed his sincere regret that Napoleon had not retained control of Spain, for that country had need of such a man to be regenerated and raised to same level of civilisation and enlightenment as the rest of Europe. Padre Pavón was particularly kind to me, which did not prevent me from trying to avoid his society, especially at table, for, according to the rules of the order, he had to wear the same clothes day and night, and in that warm climate he was surrounded by an atmosphere that was nothing less than aromatic" (*Minnen*, 43).

RICO, JOSÉ. Spanish vice-consul in Tangier during the time of the Mornay mission. Rico held this position from 1828 to 1834. Lagerheim characterizes him as "a fanatical ultra-royalist who cruelly persecuted the liberals who escaped to Morocco under Ferdinand VII"; "he had a beautiful young wife, who like her husband, lacked formal education, and neither one spoke any language but Spanish. Thus they rarely mixed with other Christian families" (*Minnen*, 39). Lagerheim tells a number of stories about Rico, all unfavorable. Having asked the sultan to hand over some liberals so that he could have them shot, Rico was told that, for the sultan, they were only unfortunate people who had sought refuge in his country, that his religion required him to have pity for them, and that he did not intend to hand them over against their will; on the contrary, he gave them succour (ibid., 50). Another time, Lagerheim himself helped a Spanish liberal escape: Don Lopez y Espila had been tricked into entering the Spanish consul's house, where he was bound and gagged, then taken to the beach to be sent to Tarifa, where he would be shot. The gag was meant to prevent him from appealing to the Muslims and thus from escaping Rico's persecution. However, the harbor captain declared that no one could leave the country while gagged, and, despite Rico's protests, he had it removed. The prisoners immediately shouted, "*La*

ilaha, il allah," "There is no God but God," the credo of Islam, indicating that they wished to convert, and they were thus saved (ibid., 102–6). Espila recounts some of this story in his own memoirs, in which he states that he eventually escaped with the help of Mornay's secretary, Ferrary (Leon López y Espila, *Los Cristianos de Calomarde y el renegado de fuerza*, 181ff.).

WILLIAMS, JULIAN BENJAMIN (??–18 APRIL 1871). Consul and collector. A merchant established in Seville since at least 1818, the owner of olive groves at Alcalá (Ford, *Handbook*, 1:356), he was also, from 6 April 1831, British consular agent or "vice-consul" at Seville; he became consul on 5 June 1856. Mentioned by all travelers to Seville at the time—David Wilkie, Washington Irving, the young Benjamin Disraeli, Baron Taylor, to name a few— Williams occupied a central place in the artistic life of the city and was one of the most important figures in the reception of Spanish art in the nineteenth century (Glendinning, "Nineteenth-Century British Envoys in Spain and the Taste for Spanish Art in England," n. 18). One of the first to appreciate Spanish paintings, he was, as his contemporaries noted, one of the best connaisseurs of it and had assembled a collection that was judged "priceless" and "exquisite" by all (e.g. Irving, *Journals*, 189 and passim; Inglis, *Spain in 1830*, 77–78; Disraeli, *Letters, 1815–1834*, 139; Ford, *Handbook*, 1:396; González de León, *Noticia*, 163; Amador de los Rios, *Sevilla pintoresca*, 472). Forty or so paintings from his collection came to constitute the core of Louis-Philippe's famous Musée Espagnol, after Baron Taylor purchased them during his trip to Spain in 1835–1837 (Guinard, *Dauzats et Blanchard*, 144, 223–24). For the contents of his collection, see 25 May 1832. Frank Hall Standish (*Shores of the Mediterranean*, 21) indicates that he was also an artist: "Mr Williams [. . .] joins the qualities of a connoisseur to the talents of an artist (things not always conjoined, for I have sometimes found artists sad judges of pictures)." He married a Spanish woman, Florentina Bedmar, with whom he had at least four children: a son, Manuel J. Williams, who succeeded him as consul on 26 June 1866, and three daughters—Florentina, Maria, and Isabel. A cultured and cordial man, he was praised by all his guests, who describe magnificent evenings at his house in the Calle Abades Alta no. 26, and later in the Plazuela de las Segovias no. 7, looking at the works of Murillo (of which Williams had thirty or so) and, like Delacroix, listening to Andalusian music (Disraeli, *Letters*). He reportedly financed the 1831 stay in Madrid of the young painter Antonio María Esquivel (1806–1857) (Menéndez Pidal, *Historia de España*, 374). His portrait by José Domínguez Bécquer (1805–1841), signed and dated 1838, is in a private collection in Seville (Calvo Serraller, *Iconografía de Sevilla*, cat. 268, repr. 316). Williams retired officially on 14 July 1866 and died on 18 April 1871 (Foreign Office, Great Britain, *Foreign Office List 1884*, 204). I have been unable to determine his date of birth, though a record in the Seville Municipal Archives notes that he came from Watchet, Somerset (Nacimientos 1854, vol. 83, no. 714).

GLOSSARY OF MOROCCAN TERMS
......................

Abassids	Sunnis, descendants of Al-Abbas, the Prophet's uncle
Amazigh	The main group of Berbers
Amin	Customs administrator
Bonhali	Idiot
Burnous	A cloak, often striped, without sleeves, with a hood
Caftan	A tunic, normally blue or yellow
Caschaba	A sleeveless shirt of white wool
Djellaba	A long, rough woollen cloak with holes for the arms, resembling a sack
Douar	Tents placed in a circle
Fatimists	Shiites, descendants of the Prophet through his daughter Fatima
Fondouk, fondac	Caravanserai, a large courtyard surrounded by buildings in which travelers could stable their animals and spend the night
Fouta	Scarf worn by women around their hips
Haik	A woollen garment draped like a toga over and under the arms (on women, it also covers the head and forehead)
Kaid	Commander; sometimes used for pasha, or governor
Kasbah	Citadel
Kohl	A cosmetic of antimony used as an eyeliner
Marabout	Holy man
Meschla	A rough cloak like a burnous
Mjaroued	Shirt, with sleeves, for a man
Mouna	Gift of provisions
Mousoria	Sleeveless women's shirt
Oued	River
Rebec	Arabic *rebab*, a bowed stringed instrument
Saboula	A straight sword
Sarouel	Baggy trousers gathered above the calf or ankles
Shilha	Berbers living in the western Atlas and the Souss plain
Soulam	A type of burnous, white and hooded, worn by the military
Taleb	Priest, scholar

BIBLIOGRAPHY
......................

Archival Collections

Archives de Paris. Archives judiciaires. Commissaires-priseurs. Étude de maîtres Talon,
Bonnefous, Pillet, Chevallier et Baudoin: D48E3.

Archives d'outre-mer, Aix-en-Provence. Births, Algiers 1846.

Archives municipales, Marseille. Series E (état civil) and F (Population, économie
sociale, statistique).

Archives nationales, Paris (A.N.). Archives personnelles, famille de Mornay: 402/AP/16.

Archives of the US Department of State, Washington, DC. Ralph J. Bunche Library.

Archivo municipal de Sevilla.

 Registros civiles, 1841–82 (available at familysearch.org).

 Registros históricos de población, 1838.

Bodleian Library, Oxford. Papers of the Drummond Hay family. MS Eng.hist.e.351-354;
c.1075, 1088; d.491–492.

Claude Roger-Marx collection (former). Items now in Paris, Institut national d'histoire
de l'art (INHA): carton 120, autog. 1397; and Paris, Bibliothèque nationale de France,
Département des estampes et de la photographie: Rés. Yb3 983 [2]40.

The National Archives, London. Foreign and Commonwealth Office papers.

 Consulate and Legation, Tangier. General Correspondence 1831–32: FO 174, no.
 162.

 Embassy, consulate and legation, Spain. Registers of correspondence: To Foreign
 Office 1 January 1830–30 June 1836. FO 187, no. 9.

Piron archive. Vente Eugène Delacroix. Auction sale catalog. Caen: Hôtel des ventes du
Théâtre. Tancrède and Lô Dumont, commissaires priseurs. 6 December 1997.

Other Sources

Abrantès, Laure Junot, duchesse d'. "La Princesse Pauline." *Revue de Paris* 51 (1833):
207–34. Republished in Abrantès, *Histoires contemporaines*, 1:141–207. Paris:
Dumont, 1835.

Amador de los Rios, José. *Sevilla pintoresca, o, descripción de sus más célebres monumentos
artísticos.* Seville: Francisco Alvarez, 1844.

Ancelot, Virginie. "Une vieille gloire." In *Méderine*, 1:113–93. Paris: Berquet et Pëtion, 1843.

Angulo-Iñiguez, Diego. *Murillo: Su vida, su arte, su obra.* Vol. 2, *Catálogo*. Madrid:
Espasa-Calpe, 1981.

Arama, Maurice. *Delacroix: Un voyage initiatique.* Paris: Non Lieu, 2006.

———. *Eugène Delacroix au Maroc: Les heures juives.* Paris: Non Lieu; Casablanca:
Memoarts, 2012.

———. *Le Maroc de Delacroix.* Paris: Les Éditions du Jaguar, 1987.

Atti della Società ligure di storia patria 41 (1908). Genoa: Tommaso Ferrando, 1908.

Aulard, François-Alphonse. *Paris sous le premier Empire: Recueil de documents pour l'histoire de l'esprit public à Paris.* 3 vols. Paris: Cerf, 1912.

Baedeker, Karl. *Spain and Portugal: Handbook for Travellers.* Leipzig: Karl Baedeker, 1901.

Balzac, Honoré de. *Le Lys dans la vallée* (The Lily in the Valley). In *La Comédie humaine.* 12 vols. Paris: Gallimard, 1976–81.

Barrucand, Marianne. *L'Architecture de la Qasba de Moulay Ismaïl à Meknès.* Études et travaux d'archéologie marocaine 6 (1976). 2 vols. Vol. 1 (Texte).

Baticle, Jeannine, and Cristina Marinas. *La Galerie espagnole de Louis-Philippe au Louvre, 1838–1848.* Paris: Réunion des musées nationaux, 1981.

Baude, Jean-Jacques. *L'Algérie.* 2 vols. Paris: Arthus Bertrand, 1841.

Beauchêne, Edme-Pierre Chauvot de. *Maximes, réflexions et pensées diverses.* Paris: Goujon, 1819.

Bercé, F. *Les Premiers Travaux de la Commission des monuments historiques, 1837–1848: Procès-verbaux et relevés des architectes.* Paris: Picard, 1979.

Botta, Paul-Émile. *Relation d'un voyage dans le Yemen, entrepris en 1837 pour le Museum d'histoire naturelle.* Paris: B. Duprat, 1841.

Burty, Philippe. "Eugène Delacroix à Alger." *L'Art* 32 (1883): 76–79, 94–98.

———. "Eugène Delacroix au Maroc." *Gazette des beaux-arts* 19 (1 August 1865): 144–54.

———. *Maîtres et petits maîtres.* Paris: G. Charpentier, 1877.

Caillié, René. *Journal d'un voyage à Tombouctou et à Jenné dans l'Afrique centrale.* 3 vols. Paris: Éditions Anthropos, 1965.

Calvo Serraller, Francisco et al. *Iconografía de Sevilla, 1790–1868.* Seville: El Viso, 1991.

Capell Broke, Arthur de. *Sketches in Spain and Morocco.* 2 vols. London: Henry Colburn and Richard Bentley, 1831.

Catalogue de la vente qui aura lieu par suite du décès de Eugène Delacroix. Hôtel Drouot. Francis Petit et Tedesco, experts, Charles Pillet et Charles Lainné, commissaires priseurs, 22–29 February 1864. Paris: J. Claye, 1864.

Çelik, Zeynep. *Urban Forms and Colonial Confrontations: Algiers Under French Rule.* Berkeley: University of California Press, 1997.

Chamfort, Nicolas. *Œuvres complètes.* 2 vols. Paris: Maradan, 1812.

Chasles, Philarète. "Revue littéraire de la Grande Bretagne." *Revue des deux mondes* 29 (February 1842): 431–57.

Chénier, Louis de. *Recherches historiques sur les Maures et histoire de l'empire du Maroc.* 3 vols. Paris: chez l'auteur, 1787.

Cleland, Liza, Glenys Davies, and Lloyd Llewellyn-Jones. *Greek and Roman Dress from A to Z.* London: Routledge, 2007.

Cournault, Charles. "La Galerie Poirel au Musée de Nancy." *Courrier de l'art* 2, no. 41 (1882): 483–86.

Crollalanza, Giovanni Battista di, et al. *Annuario della nobiltà italiano.* Bari: Direzione del Giornale Araldico e dell Annuario della nobiltà italiano, 1895.

Curtis, Charles Boyd. *Velazquez and Murillo: A Descriptive and Historical Catalogue of the Works of Don Diego da Silva Velazquez and Bartolomé Estéban Murillo.* London: S. Low, Marston, Searle, and Rivington, 1883.

Daguerre de Hureaux, Alain. *Delacroix: Moroccan Journey. Watercolors.* Paris: Bibliothèque de l'Image, 2000.

Delacroix, Eugène. *Correspondance générale d'Eugène Delacroix.* Edited by André Joubin. 5 vols. Paris: Plon, 1935–38.

———. "Des variations du beau." In *Écrits sur l'art*. Edited by François-Marie Deyrolle and Christophe Denissel. Paris: Seguier, 1988.

———. *Journal*. Edited by Paul Flat and René Piot. 3 vols. Paris: Plon, 1893–95.

———. *Journal*. Edited by Michèle Hannoosh. 2 vols. Paris: José Corti, 2009.

———. *Lettres intimes*. Edited by Alfred Dupont. Paris: Gallimard, 1954. Repr. 1995.

———. *Nouvelles lettres*. Edited by Lee Johnson and Michèle Hannoosh. Bordeaux: William Blake, 2001.

———. *Le Voyage au Maroc*. Edited by Maurice Sérullaz, Arlette Sérullaz, and Maurice Arama. 6 vols. Paris: Sagittaire, 1992.

Delacroix. Exhibition catalog, The Metropolitan Museum of Art. New York: The Metropolitan Museum of Art, 2018.

Delacroix: La naissance d'un nouveau romantisme. Exhibition catalog. Musée des Beaux-Arts de Rouen. Paris: Réunion des musées nationaux, 1998.

Delacroix: Le Voyage au Maroc, catalog of the exhibition at the Institut du monde arabe Paris: Flammarion, 1994.

Disraeli, Benjamin. *Letters, 1815–1834*. Edited by John Matthews, J. A. W. Gunn, Donald M. Schurman, and M. G. Wiebe. Toronto: University of Toronto Press, 1982.

Driskel, Michael Paul. *As Befits a Legend: Building a Tomb for Napoleon, 1840–1861*. Kent: Kent State University Press, 1993.

Dumas, Alexandre. *Impressions de voyage: Le Véloce*. Paris: Michel Lévy, 1871.

———. *Mon cher Delacroix*. Edited by Claude Schopp. Amiens: Encrage, 2003.

Dumur, Guy. *Delacroix et le Maroc*. Paris: Herscher, 1998.

Emerit, Marcel. "Les Marchés: Les quartiers commerçants d'Alger à l'époque turque." *Algeria [sic] et l'Afrique du nord illustrée*, no. 25 (February 1952): 6–13.

Escholier, Raymond. *Delacroix: Peintre, graveur, écrivain*. 3 vols. Paris: H. Floury, 1926–29.

Font-Réaulx, Dominique de, ed. *Delacroix: Objets dans la peinture, souvenir du Maroc*. Paris: Musée du Louvre/Le Passage, 2014.

Ford, Brinsley, ed. *Richard Ford in Spain*. Exhibition catalog. London: Wildenstein, 1974.

Ford, Richard. *Handbook for Travellers in Spain*. 3 vols. London: John Murray, 1845.

———. *The Letters of Richard Ford 1797–1858*. Edited by Rowland E. Prothero. London: John Murray, 1905.

Foreign Office, Great Britain. *Foreign Office List*. London: Harrison, 1863, 1884.

Foreign Quarterly Review 13 (February 1834), "The French in Algiers,": 74–106.

Gage, John. *Colour and Culture: Practice and Meaning from Antiquity to Abstraction*. London: Thames and Hudson, 1993.

Gautier, Théophile. *Histoire de l'art dramatique en France depuis vingt-cinq ans*. 2 vols. Paris: Hetzel, 1859.

Genlis, Stéphanie Félicité, comtesse de. *Memoirs*. 8 vols. London: Henry Colburn, 1825–26.

Genty de Bussy, Pierre. *De l'établissement des Français dans la Régence d'Alger, et des moyens d'en assurer la prospérité*. 2 vols. Algiers: Imprimerie du Gouvernement, 1833.

Glendinning, Nigel. "Nineteenth-Century British Envoys in Spain and the Taste for Spanish Art in England." *Burlington Magazine* 131, no. 1031 (1989): 117–26.

Godard, Léon. *Description et histoire du Maroc*. Paris: C. Tanera, 1860.

———. *Le Maroc: Notes d'un voyageur, 1858–1859*. Alger, 1859.

Gonzalez de León, Felix. *Noticia artística histórica y curiosa de todos los edificios públicos, sagrados y profanos de esta ciudad de Sevilla.* Madrid: Imprimería de J. Hidalgo, 1844.

Gråberg di Hemsö, Jacopo. *Specchio geografico e statistico dell'impero di Marocco.* Genova: dalla tipografia Pellas, 1834.

Guiffrey, Jean, ed. *Le Voyage d'Eugène Delacroix au Maroc: Description des albums conservés au Louvre, au Musée Condé et dans les collections Étienne Moreau-Nélaton et Mornay.* Paris: A. Marty, 1909.

———. *Le Voyage d'Eugène Delacroix au Maroc: Fac-simile de l'album du musée de Chantilly.* Paris: J. Terquem, P. Lemare, 1913.

———. *Le Voyage d'Eugène Delacroix au Maroc: Fac-simile de l'album du musée du Louvre.* Paris: A. Marty, 1909.

Guinard, Pierre. *Dauzats et Blanchard, peintres de l'Espagne romantique.* Bordeaux: Féret et fils, 1967.

Hannoosh, Michèle. *Painting and the* Journal *of Eugène Delacroix.* Princeton: Princeton University Press, 1995.

Hay, John Hay Drummond. *A Memoir of Sir John Drummond Hay, Sometime Minister at the Court of Morocco Based on His Journals and Correspondence.* London: John Murray, 1896.

Hecre, Emmanuel. "Des objets d'Orient et 'M. Cournault, de Malzéville.'" In Font-Réaulx, *Objets dans la peinture* (q.v.), 42–53.

Hosotte-Reynaud, Manon. "Un Ami méconnu et deux œuvres inédites de Delacroix." *Hespéris: Archives berbères et Bulletin de l'Institut des hautes études marocaines* 40 (1953): 534–39.

"Îles Sandwich." *Revue britannique* 6 (1826): 122–60. Adapted from an article on *Journal of a Tour around Hawaii, the Largest of the Sandwich Islands,* by a Deputation from the Mission on those Islands (Boston, Crocker and Brewster, 1825). *North American Review* 22 (1826): 334–64.

Inglis, Henry David. *Spain in 1830.* London: Whittaker, Treacher and Co., 1831.

Irving, Washington. *Journals and Notebooks.* Edited by Wayne R. Kime and Andrew B. Myers. Boston: Twayne Publishers, 1984.

Jackson, James Grey. *An Account of the Empire of Marocco [sic] and the Districts of Suse and Tafilelt, compiled from miscellaneous observations made during a long residence in, and various journies through, these countries. To which is added an account of ship-wrecks on the western coast of Africa and an interesting account of Timbuctoo.* 3rd ed. London: William Bulmer, 1814 (orig. 1809).

Johnson, Lee. *Delacroix.* New York: W. W. Norton, 1963.

———. *Delacroix: Pastels.* London: John Murray, 1995.

———. "Delacroix's *Jewish Bride.*" *Burlington Magazine* 139, no. 1136 (1997): 755–57.

———. "Delacroix's Road to the Sultan of Morocco." *Apollo* 115 (1982): 186–89.

———. *The Paintings of Eugène Delacroix: A Critical Catalogue.* 7 vols. Oxford: Clarendon Press, 1981–2002.

———. "Towards a Reconstruction of Delacroix's Mornay Album." *Burlington Magazine,* 145, no. 1199 (2003): 92–95.

Karr, Alphonse. *Midi à quatorze heures.* Paris: Lange Levy et Cie, 1842.

Lagerheim, Julius. *Minnen från mitte vistande i Africa: Marocco 1831 och 1832 (Memoirs of my stay in Africa: Morocco, 1831–1832).* Uppsala, Bibliothèque universitaire, X.416c.

Lambert, Élie. "Delacroix et l'Espagne." *Revue des arts* 2 (1951): 159–71.

———. *Histoire d'un tableau: L'Abd er Rahman, sultan du Maroc, de Delacroix*. Paris: Larose, 1953.

Legré-Zaidline, Françoise. "Louise Rang-Babut, une amie de Delacroix." *Bulletin de la Société des Amis d'Eugène Delacroix* 4 (2006): 17–25.

Lingré, Jean-Jacques de. *Réflexions et maximes*. Paris: Didot, 1814.

López y Espila, León. *Los Cristianos de Calomarde y el renegado de fuerza*. Madrid: D.E. Fernández Angulo, 1835.

Menéndez Pidal, Ramón. *Historia de España*. Vol. 35, pt. 2, Madrid: Espasa-Calpe, 1989.

Mérimée, Léonor. *The Art of Painting in Oil and Fresco*. Translated by W. B. Sarsfield Taylor. London: Whitaker & Co., 1839.

Mérimée, Prosper. *Correspondance générale*. Edited by Maurice Parturier. 17 vols. Toulouse: Edouard Privat, 1941–64.

———. "Letters from Spain—No. I: From the French of Prosper Mérimée." *Dublin University Magazine* 3 (April 1834): 391–93.

———. *Rapport au Ministre de l'Intérieur: Liste des monuments auxquels des subventions ont été accordées depuis 1840 jusqu'en 1846*. Paris: Imprimerie royale, 1846.

Miège, Jean-Louis, ed. *Chronique de Tanger, 1820–1830: Journal de Bendelac*. Rabat: La Porte, 1995.

Musée du Louvre. *Inventaire général des dessins. École française. Dessins d'Eugène Delacroix, 1798–1863*. Edited by Maurice Sérullaz, with the collaboration of Arlette Sérullaz, Louis-Antoine Prat, and Claudine Ganeval. 2 vols. Paris: Réunion des Musées nationaux, 1984.

Napoleon I, *Correspondance de Napoléon avec le ministre de la Marine*. 2 vols. Paris: Delloye et V[ict]or Lecou, 1837.

Pellissier de Reynaud, Eugène. *Annales algériennes*. 3 vols. Paris: Anselin et Gaultier-Laguionie, 1836–39.

Pichon, Louis-André. *Alger sous la domination française: Son état présent et son avenir*. Paris, 1833.

Pidou de Saint-Olon, François. *Relation de l'empire du Maroc*. Paris: chez la veuve Mabre Cramoisy, 1695.

Piron, Achille. *Eugène Delacroix: Sa vie et ses œuvres*. Paris: J. Claye, 1865 [1868].

Pointon, Marcia. *The Bonington Circle: English Watercolour and Anglo-French Landscape, 1790–1855*. Brighton: Hendon Press, 1985.

Porter, Robert Ker. *Travels in Georgia, Persia, Armenia, Ancient Babylonia during the Years 1817, 1818, 1819, 1820*. London: Longman, Hurst, Rees, Orme and Brown, 1821–22.

Prat, L. A. "Dessins inédits de Delacroix à Dijon." *Revue du Louvre* 2 (1981): 103–8.

Raymond, André. "Le Centre d'Alger en 1830." *Revue de l'Occident musulman et de la Méditerranée* 31 (1981): 73–84.

Répertoire des travaux de la Société de statistique de Marseille 16 (1853). Marseilles: Vial. 1853.

Rey, A. "Le Maroc et la question d'Alger." *Revue des deux mondes* 24 (1 December 1840): 617–62.

———. *Souvenirs d'un voyage au Maroc*. Paris: Au bureau du journal *L'Algérie*, 1844.

Robaut, Alfred. *L'Œuvre complet de Eugène Delacroix, 1813–1863*. Paris: Charavay frères, 1885.

Rozet, Claude Antoine. *Voyage dans la Régence d'Alger, ou description du pays occupé par l'armée française en Afrique.* 3 vols. Paris: Arthus Bertrand, 1833.

Sachs, Curt. *The History of Musical Instruments.* New York: W. W. Norton, 1940.

Sand, George. *Letters of a Traveller.* Translated by Eliza A. Ashurst. Edited by Matilda M. Hays. London: E. Churton, 1847.

Savary, Anne Jean Marie René, duc de Rovigo. *Correspondance du duc de Rovigo.* Edited by Gabriel Esquer. 3 vols. Algiers: Adolphe Jourdan, 1914–21.

Sérullaz, Maurice, ed. *Mémorial de l'exposition Eugène Delacroix organisée au musée du Louvre à l'occasion du centenaire de la mort de l'artiste.* Paris: Éditions des Musées nationaux, 1963.

Standish, Frank Hall. *The Shores of the Mediterranean.* London: R. Lumley, 1837–1838.

Stendhal [Henri Beyle]. *Correspondance.* Edited by Victor del Litto. 6 vols. Paris: Honoré Champion, 1997–99.

Sue, Eugène. *Atar Gull.* Paris: Renduel, 1831.

Vance, Sharon. *The Martyrdom of a Moroccan Jewish Saint.* Leiden: Brill, 2011.

Windus, John. *A Journey to Mequinez.* London: Jacob Tonson, 1725.

INDEX

....................